SPORTS ILLUSTRATED is a registered trademark of Time Inc.

ISBN: 1-883013-72-0
Manufactured in the United States of America
First printing 2001

SPORTS ILLUSTRATED Director of Development: Stanley Weil

SPORTS ILLUSTRATED YEARBOOK 2001

Editorial Director: Morin Bishop
 Project Editor: John Bolster
 Managing Editor: Theresa M. Deal
 Researchers: Andrew Blais, Kate Brash, Ward Calhoun, Jeff Labrecque
 Copy Editor: Lee Fjordbotten
 Photography Editor: John S. Blackmar
Designers: Barbara Chilenskas, Jia Baek

SPORTS ILLUSTRATED YEARBOOK 2001 was prepared by
Bishop Books, Inc.
611 Broadway
New York, New York 10012

TIME INC. HOME ENTERTAINMENT
President: Rob Gursha
Executive Director, Branded Businesses: David Arfine
Executive Director, Marketing Services: Carol Pittard
Director, Retail & Special Sales: Tom Mifsud
Director, Branded Businesses: Maarten Terry
Product Managers: Dana Pecoraro, Dennis Sheehan
Assistant Product Managers: Ann Gillespie
Editorial Operations Director: John Calvano
Book Production Manager: Jessica McGrath
Associate Book Production Manager: Suzanne DeBenedetto
Fulfillment Manager: Richard Perez
Assistant Fulfillment Manager: Tara Schimming
Executive Assistant: Mary Jane Rigoroso

We welcome your comments and suggestions about SPORTS ILLUSTRATED Books.
Please write to us at:
SPORTS ILLUSTRATED Books
Attention: Book Editors
PO Box 11016
Des Moines, IA 50336-1016

If you would like to order any of our
hardcover Collector's Edition books,
please call us at 1-800-327-6388.
(Monday through Friday, 7:00 a.m.— 8:00 p.m. or Saturday, 7:00 a.m.— 6:00 p.m.
Central Time).
Please visit our website at **www.TimeBookstore.com**

10 9 8 7 6 5 4 3 2 1

CONTENTS

Year of the Tiger

In a year of dark deeds by sports figures in and out of competition, Tiger Woods was an incandescent counterpoint ■ Merrell Noden

01.10.00 *01.17.00* *01.24.00* *01.31.00*

When, exactly, did 2000 become the Year of the Tiger? Did it happen as early as June, when Earl Woods's precocious, ferocious son won the U.S. Open at Pebble Beach by a record 15 strokes? Or was it in July, when he traveled to St. Andrews, golf's most hallowed ground, and blew away a strong international field with rounds of 67, 66, 67 and 69? Or was it as late as August, when he appeared simultaneously on the covers of both TIME and *The New Yorker* (albeit in cartoon likeness), launching his Q rating even higher than his wedge shots?

Most likely it happened later in August, at the PGA Championship, where Woods finally got a real scare—from little-known Bob May, of all people—and showed his mettle by birdieing the final two holes of regulation to get into a three-hole playoff, which he essentially put away with a 20-foot birdie putt on the first hole. That was staring down pressure. That was the stuff of legends.

Woods's fellow pros reacted to his dominance with either grumpy defiance or a resigned shrug of acceptance. But in their heart of hearts, most had to agree with Mark Calcavecchia, who said, "He's the best who ever played, and he's 24."

If we disregard a certain iciness of focus and the fact that he hawked a Nike ball he wasn't using at the time, Woods's only real misstep came at the U.S. Open when, apparently unaware that there was a mike on the 18th tee, he unleashed a string of profanity after hitting his drive out of bounds. Much was made of this spewing, and Woods duly apologized. But to all but the most prissily proper listeners, it was no big deal, a humanizing by-product of the extreme perfectionism that fuels his success. And compared to the behavior of many of his fellow athletes, Tiger's tirade was really quite tame.

This was the year of Men Behaving Badly, in which incident after incident underscored growing questions about the price we are willing to pay for athletic success, the dangerous drugs athletes take and the special dispensations we grant our sporting heroes—and, in at least one case, their coaches.

Bad behavior by athletes is nothing new, of course. This year, however, on top of the usual long rap sheet of larceny, sexual exploitation and thuggery, several top athletes were actually charged with murder. Baltimore Ravens linebacker Ray Lewis was at the scene of an early-morning brawl that left two men dead outside an Atlanta nightclub following Super Bowl XXIV. He was charged with murder the day after the NFL's biggest night. Wide receiver Rae Carruth of the Carolina Panthers was alleged to have hired someone to shoot his

pregnant girlfriend. (She died; the baby survived.) Murder charges against Lewis were ultimately dropped, and in a plea agreement he received one-year's probation for a misdemeanor obstruction of justice. He rejoined the Ravens before the 2000 season and went on to have the best year of his career, winning the NFL Defensive Player of the Year award. But the Mecklenberg County (N.C.) district attorney's office announced that it planned to seek the death penalty against Carruth, whose trial began in late October. The two cases made the NFL's ongoing campaign against taunting and excessive celebration seem a bit misplaced and the high-octane ads for the XFL, the new "extreme" football league, seem particularly tasteless. And they made the National Rifle Association's buying ad time on several NFL regional broadcasts in September seem simply absurd.

Not that football players had a monopoly on reprehensible behavior. Almost every major sport had its share of embarrassment. Baseball had John Rocker, the Atlanta Braves reliever whose bigoted, homophobic rant about New Yorkers to SPORTS ILLUSTRATED writer Jeff Pearlman earned him a two-week suspension at the start of the season and a special security detail when he appeared at Shea Stadium following the publication

of his remarks. The National Hockey League had Marty McSorley, a career goon who wound up in a Vancouver courtroom, charged with assault, for slashing Donald Brashear across the right temple with his hockey stick. College football had Marvin (Snoop) Minnis, Florida State's top receiver and a criminology major, who was declared academically ineligible for the Orange Bowl after he failed two courses, one of them criminology. And then there was Bob Knight, who embarrassed not only college basketball but also Indiana University and higher education in general through acts of bullying that no one could continue to ignore. Even the Olympic Games, which presented their usual crop of fresh-faced heroes, did so amid a troubling swirl of drug allegations.

With foils like that, Woods stood out like a ray of pure sunlight. His position as arguably the world's top sports figure was all the more impressive in a year that did not lack for exciting new faces. Sure, slam-dunking Vince Carter and goateed Kobe Bryant do not yet possess Michael Jordan's supreme drive to win, but they showed this year that they are capable of the same high-flying wizardry as His Airness. And for examples of extraordinary persistence we had cancer survivor Lance Armstrong, who dominated the Tour de France for the

03.27.00

04.03.00

04.10.00

04.17.00

04.24.00

second straight year, and Kurt Warner, who led the St. Louis Rams to a Super Bowl title in early 2000, five years after he seemed on his way out of football and was forced to support himself by stocking shelves at an Iowa grocery.

Warner couldn't maintain his superb form, though, and neither could he stem the NFL's run of bad tidings, which began with the off-field troubles of Lewis and Carruth and continued with the sad news of the deaths of two Hall of Famers: Tom Landry, who coached the Dallas Cowboys to 250 regular-season wins and two Super Bowl titles, and former Chicago Bears great Walter Payton, the NFL's alltime rushing leader with 16,726 yards in 13 seasons. Sweetness, as Payton was known, had been suffering for months from a liver ailment. Another terrible shock was the death of Derrick Thomas, the Kansas City Chiefs' All-Pro linebacker, who died from a blood clot caused by injuries he sustained in a car accident.

The league also said goodbye to the playing days of Miami quarterback Dan Marino and 49ers signal-caller Steve Young, both of whom retired in 2000. Marino set countless passing records in his 17-year career, including career yards (61,361) and career touchdowns (420). Young, the NFL's career leader in passing efficiency (96.8), called it quits after

suffering the sixth reported concussion of his career.

On the field, parity was the theme of the brand-new NFL season: division and wild-card races went down to the very last week, and 10–6 or 9–7 records were as common as dog bones in Cleveland Browns Stadium (though the tenants of that structure didn't have one: the Browns, who were reinstated in the NFL in '99 after a three-year hiatus, went 3–13 in 2000). In the NFC West, both the Saints and the defending champion Rams finished at 10–6, with St. Louis relegated to wild-card status because of New Orleans's better record within the division (7–1). The Rams had lost Warner to injury for five games during the regular season, but he returned in December, and most observers believed the quarterback would have the Rams firing on all cylinders come playoff time. Surprise: St. Louis was bounced out of the playoffs in the first round by the upstart Saints, who won without starting quarterback Jeff Blake and leading rusher Ricky Williams. And the 31–28 game was only close at the end, when the Rams staged a desperate comeback.

With the defending champions out of the way, the playoff picture widened even farther. Minnesota, whose 265-pound quarterback, Daunte Culpepper, commanded a potent offense, looked like a Super Bowl–contender after blowing out the

Saints 34–16 in the divisional playoffs. In order to get to the Super Bowl, the Vikes would have to get past the surprising Giants, owners of the NFC's best record (12–4), who had eliminated Philadelphia and its speedy quarterback, Donovan McNabb, to reach the NFC title tilt.

The AFC East came down to the wire as Miami (11–5) and Indianapolis (10–6) won on the season's final day to advance to the playoffs and leave the Jets (9–7), who lost their last three games, on the outside looking in. Miami eliminated Indianapolis in an overtime thriller, then was blanked 27–0 by Oakland (12–4) in the next round. Baltimore and its record-setting defense, which allowed an alltime-low 165 points during the regular season, knocked off Denver and Tennessee to reach the AFC championship. The Titans, who went 13–3 to win the AFC Central, had been the pick of many experts to represent the AFC in the Super Bowl. Nevermore, quoth the defense-oriented Ravens, who would play the high-powered Raiders for a trip to Tampa and Super Bowl XXXV.

Against all odds, college football's unwieldy BCS system was vindicated yet again, as the Oklahoma Sooners ran the table, knocking off Florida State by the unlikely score of 13–2 in the Orange Bowl to go 13–0 and leave no doubt as to who was the best team in the land. Few fans outside of Norman, Okla., believed in the Sooners, but their unassuming quarterback, Josh Heupel, and their proud coach, Bob Stoops, were confident that they would restore bygone Sooner glory. Stoops, a former assistant coach at Florida under Steve Spurrier, won a national title in only his second year in charge at Oklahoma.

Another coach who enhanced his résumé in 2000 was Zenmeister Phil Jackson, who won six NBA titles with the Chicago Bulls in the 1990s. In June 1999 Jackson signed a five-year, $30 million contract to coach the underachieving L.A. Lakers, knowing full well that this was a make-or-break situation for his coaching reputation. Many detractors had sniped that any coach with Jordan in his lineup would look good. Well, the Lakers were stocked with superstars Shaquille O'Neal and Bryant, and they had made several coaches look *bad* in their unfulfilled quest for a championship. Smart man that he is, Jackson knew that his first priority was to persuade the two superstars to mesh their yin-yang, inside-outside games. They did so and then some, finishing the regular season at 67–15 and then squeaking by Portland in the Western Conference finals before dispatching Indiana in six games for the title. O'Neal had his best season ever, winning the league

06.26.00

07.03.00

07.10.00

07.17.00

07.24.00

scoring title (29.7 points per game) as well as the regular-season and Finals MVP awards.

College hoops was turned upside down in the quarterfinals of the Conference USA tournament, when Cincinnati star Kenyon Martin, the player of the year, broke his leg in a game against St. Louis. The Bearcats lost the game and a sure No. 1 seed in the NCAAs, where they fell to Tulsa in the second round. Martin recovered and was the first pick in the 2000 NBA draft, going to the New Jersey Nets.

On the eve of the tournament CNN/SI aired a report in which former Hoosier player Neil Reed accused Knight of choking him, a charge Knight steadfastly denied. Perhaps distracted by the controversy, Indiana lost badly to Pepperdine in the first round. A videotape subsequently surfaced that starkly repudiated Knight's denial, and six months later, the man they called the General was gone: IU president Myles Brand, citing the university's zero-tolerance policy, instituted in the wake of the Reed episode, fired Knight in September after the coach had an altercation with another undergraduate. Knight, who won three national titles in 29 years at IU, was succeeded by his former assistant Mike Davis.

The Hoosiers' Big Ten competitors Wisconsin and Michigan

State both reached the Final Four, where they were joined by North Carolina (18–13 in the regular season) and young, run-and-gun Florida. Michigan State point guard Mateen Cleaves had decided to return for his senior year instead of entering the NBA draft and then broke his foot during the preseason, missing 13 games. But Cleaves eventually got what he came back for—an NCAA title—as he scored 18 points to help the Spartans beat upstart Florida 89–76 in the final. It was MSU's first title since Magic beat Larry in '79. Despite losing Cleaves, the Spartans stood a good chance of repeating as champs in 2001.

The New Jersey Devils prevented the Dallas Stars from repeating as NHL champions, outlasting the Stars in a physical, six-game Stanley Cup final. The Devils won three road games to claim the Cup, and they clinched it with Petr Sykora, their leading goal scorer in the playoffs, in the hospital after a bone-rattling hit by Dallas defenseman Derian Hatcher.

The first month of the 2000 baseball season was dominated by the saga of John Rocker, but that soon was eclipsed by the astonishing explosion of power hitting. "I don't like to give up home runs, but in this day and age it's not a big deal," said Tim Hudson of the A's. May was a merry month for sluggers, who clouted 1,069 homers, more than in any other single

month in baseball history. On May 21 there were six grand slams, a single-day record. Suspicions about a juiced ball were so prevalent that the commissioner's office actually enlisted Jim Sherwood, an engineer at the University of Massachusetts-Lowell, to test the ball independently. His conclusion: The ball was essentially the same as in previous years, though the MLB logo may have made it easier for hitters to pick up.

In the end, though, the power numbers flattened out, while other batting categories ballooned. Red Sox shortstop Nomar Garciaparra batted .372 to win his second straight batting title, while Todd Helton of the Colorado Rockies also batted .372 to win the NL title. The last time the batting champs of both leagues topped .370 was in 1937, when Joe (Ducky) Medwick hit .374 for St. Louis and Charlie Gehringer hit .371 for Detroit. Poor Darin Erstad of the Angels got 240 hits—a number that hadn't been reached since Wade Boggs did it in 1985—and didn't even win the batting title. All of this made Boston pitcher Pedro Martinez's ERA of 1.74 even more astounding. It beat AL runner-up Roger Clemens's ERA by nearly two runs.

The San Francisco Giants had the best record in baseball, with 97 wins. In the American League the surprise team was the resurrected Chicago White Sox. After finishing 1999 in second place in the Central Division, $21\frac{1}{2}$ games behind Cleveland, the White Sox led the American League with 95 wins. Their improvement was due in part to DH Frank Thomas, who finished the season with 43 home runs (a career best), 143 RBIs and a .328 batting average, sure MVP numbers except that Jason Giambi of the A's went 43-137-.333 and Carlos Delgado of the Blue Jays went 41-137-.344, and they both play first base. Giambi won the award. The Yankees won the World Series for the third year in a row, defeating their crosstown rivals, the Mets, four games to one in the first Subway Series in 44 years. As exciting as the matchup was for baseball and for the New York area, it, too, was not without a bit of nastiness: In Game 2, Roger Clemens threw a piece of a broken bat toward Mike Piazza (see page 129).

Even tennis had its share of ill will. At the U.S. Open, Martina Hingis and Lindsay Davenport publicly announced their intention to prevent an all-Williams final between sisters Venus and Serena Williams. They accomplished that but couldn't stop Venus from winning the tournament. The elder Williams sister, who began the year battling tendinitis in both wrists, also won the Wimbledon and Olympic singles

10.02.00 *10.09.00* *10.16.00*

10.23.00 *10.30.00*

titles. The Williams sisters have not yet faced each other in a Grand Slam final, but that day is surely coming.

On the men's side, Pete Sampras defeated Patrick Rafter in the finals of Wimbledon for his record 13th Grand Slam title. But at the U.S. Open, Marat Safin, a handsome 20-year-old Russian, used a booming serve to beat Sampras in straight sets. Safin looks like an heir apparent to Sampras.

The Sydney Olympics kicked off in grand style on Sept. 15 when Cathy Freeman, a 400-meter runner of Aboriginal descent, lit the Olympic torch in an emotional crescendo to a great opening ceremony. These were in almost every way a superb Games, though that fact was lost on those stuck watching NBC's tape-delayed, feature-heavy coverage. Many who went to Sydney called them the best in Olympic history. Not only was the city itself gorgeous, but the enthusiastic Australians embraced the Games with infectious giddiness.

Still, there was the perception that the Games were awash in performance-enhancing drugs. China left 27 athletes home, most for failing preliminary drug screening; a coach from Uzbekistan was caught carrying human growth hormone through customs at Sydney Airport; and all but one member of the Bulgarian weightlifting team was sent home after three

of its members tested positive for steroids. Tiny Andreea Raducan, the all-around women's gymnastics champion, was stripped of her gold medal for testing positive for the mild stimulant pseudoephedrine, which she'd been given for a cold by the Romanian team doctor. Drugs didn't ruin these Games, but they were an unspoken subtext in many sports and openly discussed in others.

But they hardly detracted from the Games' many highlights. Nowhere was the excitement more palpable than at the Aquatic Centre, where the swimming-mad Aussies were able to cheer on national heroes like Ian Thorpe, the 17-year-old with the size-17 paddles for feet. Thorpe won the 400 freestyle in world-record time, as expected, but his greatest moment came on the anchor swim of the 4 x 100 free relay, when he chased down and outtouched the brash American Gary Hall Jr. amid a din that former Boston Celtic John Havlicek called the "loudest noise I've ever heard in an arena." But the U.S. remained the world's swimming power, led by gold medalists Lenny Krayzelburg, the transplanted Ukrainian who won both backstrokes, Megan Quann (100-meter breaststroke) and Brooke Bennett (400 and 800 free).

The brightest swimming star was Inge de Bruijn of the

Netherlands, the only swimmer to win three individual events (the 50 and 100 freestyles and the 100 fly), who then had to endure waves of innuendo. "It's sad," said Jacco Verhaeren, who is de Bruijn's coach and boyfriend. "If you swim fast, you're treated like a criminal."

There were many upsets. The legendary Cuban baseball team suffered its first Olympic loss, to the Netherlands of all teams, and then was shut out 4–0 in the gold medal game by Tommy Lasorda's U.S. team. Hicham El Guerrouj, the world-record holder in the mile and the 1,500, lost the latter to Noah Ngeny of Kenya. Twenty-nine-year-old Wyoming farm boy Rulon Gardner pulled off the biggest shocker of the Games, defeating the mighty, 6' 4", 290-pound Alexander Karelin of Russia 1–0 in Greco-Roman wrestling. Karelin had not lost in 14 years of international competition. There was also one near-upset that would have been colossal: Lithuania came within two points of defeating the NBA All-Star–studded team from the U.S. in the men's basketball semifinals.

Finally, there was Marion Jones, who was aiming for an unprecedented five gold medals in track and field. She didn't pull it off, but she impressed everyone with her grace under pressure as she won three gold medals and two bronzes while dealing with the distractions caused by reports that her husband, world shot put champion C.J. Hunter, had tested positive for drugs four times during the summer. Which generated perhaps the biggest mystery of these Games: What exactly did he and Mrs. Jones have going on? Was she dabbling in performance-enhancing substances as well? No evidence to that effect ever surfaced. It is a tribute to Jones's effervescent personality that she seemed to escape the shadow even though the cloud was hovering right above her.

In the end, though, 2000 was unquestionably Woods's year. When he signed a five-year, $100 million endorsement deal with Nike in September, no one questioned for an instant whether he was worth it. Perhaps they were recalling the way he'd won the Canadian Open a week earlier by launching yet another "career" shot, this one to beat Grant Waite: a 218-yard six-iron out of a fairway bunker. Over a greenside pond. Right at the flag. No hesitation. Poor Waite could only shake his head: "The guy fires at the flag with the tournament on the line? I told him, 'You're not supposed to do that.' "

So heave a sigh of relief, pro golfers, as we bid farewell to the Year of the Tiger. Now, what can you do to stop him from owning the next decade, too?

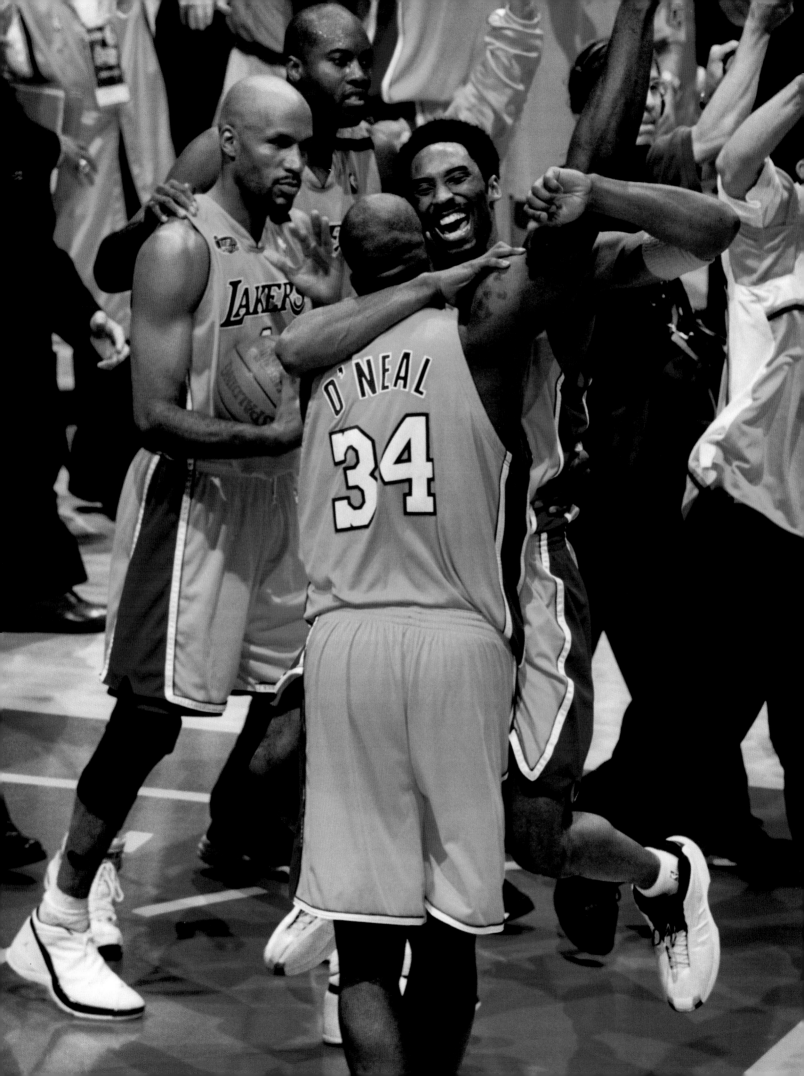

Hollywood Thriller

A season with triumph, tragedy and subplots enough for a Tinseltown epic ended, appropriately, with a title for Los Angeles ■ Marty Burns

The 1999–2000 NBA season had all the ingredients of a good Hollywood movie: triumph (Vince Carter's regular season) and tragedy (Bobby Phills, Malik Sealy), a comeback (Sean Elliott) and a farewell (Charles Barkley), a hero (Kobe Bryant) and a villain (Isaiah Rider).

There was even a surprise ending of sorts (Shaq finally wins the big one!).

So perhaps it was only fitting that when the curtain fell, it would be the team from Tinseltown—the Los Angeles Lakers—that raised the championship trophy. With center Shaquille O'Neal and shooting guard Bryant successfully meshing their considerable talents, and new coach Phil Jackson calling the shots, the Lakers brought Showtime back to L.A. and defeated the Indiana Pacers in six games to win the NBA Finals.

Even the championship series featured story lines right out of a Hollywood screenwriter's imagination. Could O'Neal, the league's MVP, finally win the title that had eluded him his first seven NBA seasons? Or would Indiana rally behind star shooting guard Reggie Miller (the theatrical string bean from UCLA) and soon-to-be-retiring coach Larry Bird (the longtime Lakers antagonist) and win one for the underdog? Call it Mission Impossible meets Hoosiers.

With the usual array of celebrities ringing the Staples Center court, the Lakers opened the Finals by easily taking Games 1 and 2. O'Neal led the way, scoring a combined 83 points and grabbing 43 rebounds. Not even Indiana's Hack-a-Shaq defense—based on the assumption that O'Neal, a horrendous free throw shooter, could be contained if he were constantly sent to the line—could slow him down. The Pacers put Shaq on the foul line a Finals-record 39 times in Game 2, but he made 18—just enough to foil the strategy. Miller, for his part, made only one of 16 field goals in a disastrous Game 1 and was held to two points in the fourth quarter of Game 2.

Like so many silver screen underdogs, however, Reggie and the Pacers refused to die. With Bryant unable to play in Game 3 because of a sprained left ankle, Miller and forward Jalen Rose combined for 54 points as the Pacers got back in the series with a 100–91 victory at Conseco Fieldhouse. Though Shaq had another monster night, scoring 33 points and pulling down 13 rebounds, it was clear that he missed the penetration and scoring of his 21-year-old sidekick, Bryant.

Fortunately for the Lakers, Bryant returned for Game 4, and his presence would indeed prove crucial. In a Finals classic, Bryant scored eight of his 28 points in overtime, including two on a balletic reverse tip-in, to propel L.A. to a 120–118 victory and a commanding 3–1 series lead. Even O'Neal, who had 36 points and 21 rebounds before fouling

While O'Neal (34) and Bryant formed the superstar centerpiece of the Lakers' championship season, leading the team to 67 regular-season victories and the NBA title, role players like Ron Harper (left, with ball) and Glen Rice (background) made valuable contributions as well.

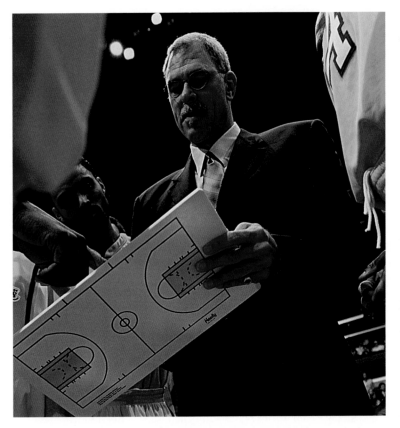

After former L.A. coaches Del Harris and Kurt Rambis fell short of a championship with roughly the same group of players, Jackson (above), who won six NBA titles as coach of the Bulls during the 1990s, stepped in and succeeded where his predecessors had failed, leading the Lakers to their first NBA title since 1988.

threw down a 360-degree windmill dunk and a jaw-dropping, between-the-legs tomahawk slam.

Vince-tantaneously, Carter became the talk of the NBA. He was besieged with endorsement offers, invited to appear on late-night talk shows, and his agent at the time, Tank Black, estimated that Carter would earn $20 million in off-court income. Though he sometimes bristled at the demands of instant stardom, Carter showed he was more than just flash. He finished the year with better numbers than he had during his 1998–99 Rookie of the Year season and helped lead the Raptors to their first postseason appearance.

As breathtaking as Carter's All-Star performance was, it paled in comparison to what San Antonio Spurs forward Elliott accomplished simply by putting on his uniform. On March 14, Elliott became the first pro athlete ever to play after having a kidney transplant. With 26,708 fans in the Alamodome looking on—including his older brother, Noel, who had donated the kidney—Elliott took the floor as a starter and scored two points in 12 minutes as the Spurs defeated the Atlanta Hawks.

Elliott's successful return (he would go on to average 6.0 points and 2.5 rebounds in 19 games) was one of the feel-good stories of the year in sports and gave the Spurs renewed hope of defending their NBA title. Unfortunately for San Antonio, star forward Tim Duncan suffered torn cartilage in his left knee in a late-season game and was forced to sit out the team's first-round playoff series against the Phoenix Suns. Without their superstar, Elliott and the Spurs were eliminated in four games.

It was that kind of up-and-down season for the Spurs—and the entire NBA. For every personal triumph, such as Elliott's comeback, there was a corresponding heartbreak, such as the deaths of Charlotte Hornets swingman Phills and Minnesota Timberwolves shooting guard Sealy in separate auto accidents. For every happy return, such as Jordan's taking over as president of the Washington Wizards, there was a sad farewell, such as the retirement of Houston Rockets forward Barkley, who suffered a ruptured knee tendon in a game on Dec. 8 in Philadelphia and returned only to play in his team's final game, on April 19 against the Vancouver Grizzlies, before calling an end to his 16-year Hall of Fame career.

out in overtime, had to admit, "Kobe was the hero tonight."

Though the Pacers bounced back and whipped the Lakers 120–87 in Game 5 to send Bird off a winner in his final home game and force a Game 6 in L.A., there would be no Hoosiers finish for Indiana fans. O'Neal (41 points) and Bryant (26 points) combined to lead L.A. to a 116–111 victory and wrap up the 12th championship in franchise history, the first since '88. Afterward O'Neal, who averaged 38.0 points and 16.7 rebounds per game and was the unanimous choice for Finals MVP, broke down in tears with the trophy.

"I've held the emotion for about 11 years—three years in college and eight years in the league," said O'Neal, the sometime actor and rapper whom critics had said lacked the dedication to win a title. "It just came out. It just came out."

While Shaq established himself as the game's dominant player in 1999–2000, it was Carter, the high-flying Raptors forward, who became its most popular. In just his second pro season, the 6' 7" Carter received 1,911,973 votes from fans for the All-Star Game, second only to Michael Jordan's '97 tally of 2,451,136. He then catapulted himself into the realm of megastar with an electrifying performance at the Slam Dunk Contest, in which he

Along the way there were the usual plot twists and colorful characters to spice up an NBA season. In Philly, Sixers guard Allen Iverson continued his war of wills with coach Larry Brown. In New York,

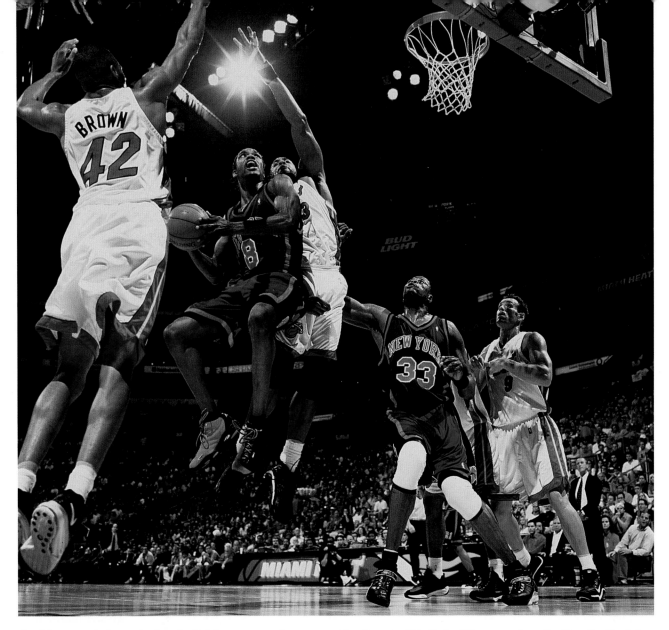

the debate raged about whether the Knicks were better with or without their aging franchise center, Patrick Ewing. And in Dallas, Dennis Rodman made a brief comeback, at the behest of new Mavericks owner Mark Cuban, only to wear out his welcome and get waived a few weeks later.

Still, when it came to controversy no player came up bigger than Hawks shooting guard Rider. Acquired in a trade with the Portland Trail Blazers before the season, the talented but troubled Rider was supposed to find peace with a fresh start in Atlanta under the steady hand of veteran coach Lenny Wilkens, the NBA's alltime winningest coach. Instead Rider continued his pattern of showing up late for practices and games, performed indifferently at times, and generally became a cancer in the locker room.

By March the Hawks had seen enough. With the team well on its way to a 28–54 finish, the worst in Wilkens's 27-year coaching career, Atlanta cut Rider even though it meant the franchise would

have to pay him the rest of his $5.4 million annual salary. Rider, looking as carefree as ever in a floppy fishing hat and flip-flops, said at a farewell press conference that he had been made a scapegoat for the team's poor play and vowed to return to the NBA next season.

The Rider episode was an unwelcome p.r. blow for a league still suffering in the aftermath of Jordan's retirement and the '99 lockout. TV ratings stayed flat for the second straight year, and attendance sagged in many cities that didn't have a winning team or a new arena. At the same time, alternative pursuits such as pro wrestling and so-called extreme sports were drawing more eyeballs to TV sets and threatening to cut into the league's younger demographics.

That's not to say, however, that the NBA didn't have reason to be optimistic. Thanks to new rules to crack down on physical play, which were implemented before the season, the game flowed better than it had in years, and scoring increased

Cooling the Heat: In the second round, Patrick Ewing (33), Latrell Sprewell (8) and the Knicks eliminated P.J. Brown (42), Dan Majerle (9) and Miami from the NBA playoffs, the third consecutive year that New York put the Atlantic Division champions' title hopes on ice.

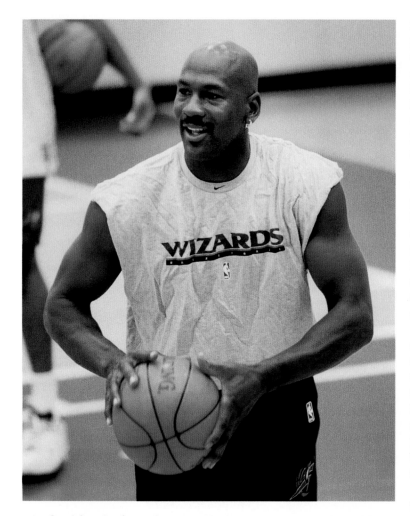

Jordan (above), who returned to the NBA as part owner and president of basketball operations for the Washington Wizards, took to the court to inspect the troops in January.

Cooper (opposite) found herself in the eye of a confetti storm after leading the Houston Comets past the New York Liberty for the WNBA title, Houston's fourth in the league's four years of existence.

about six points per game per team. Teams like the surprising Orlando Magic, which despite an austere rebuilding plan somehow finished .500 with dynamic rookie coach Doc Rivers, showed that parity was alive and well. And the NBA's sister league, the WNBA, continued to thrive in its fourth year of existence, drawing average crowds of 8,536 and making stars of players such as Cynthia Cooper, Chamique Holdsclaw and Sheryl Swoopes.

In L.A. the NBA also had that rare jewel that all pro sports leagues crave: a potential dynasty in the nation's second-largest market. Once a collection of talented underachievers with no leadership, the Lakers came together in spectacular fashion under Jackson, reeling off winning streaks of 16, 19 and 11 games to firmly establish themselves as the league's best team. They finished the regular season at 67–15, a whopping eight games ahead of division runner-up Portland, a team with a league-high $74 million payroll.

O'Neal produced his best season ever, leading

the league in points per game (29.7) and field goal percentage (57.4), and ranking second in rebounds (13.6). Despite facing double and triple teams on a nightly basis, he was unstoppable. In addition to his Finals MVP award, Shaq took home co-MVP honors at the All-Star Game (with Duncan) and won his first regular-season MVP award, joining Jordan and Willis Reed as the only players ever to sweep all three in the same year.

Clearly the biggest difference for L.A., however, was the calming presence of Jackson, the Zen-preaching former Bulls coach. Lured out of his Montana off-season residence by a five-year, $30 million contract, Jackson immediately began working to mend the frayed relationship between the team's two young stars, O'Neal and Bryant. Flashing his six championship rings from his Chicago days, he convinced them that only by playing together could they achieve their ultimate goals.

Jackson's influence also proved vital in the playoffs, when the Lakers repeatedly struggled to close out opponents. Against Portland in the Western Conference finals, L.A. blew a 3–1 series lead and trailed by 15 points in the fourth quarter of Game 7 before rallying furiously to win the game and the series, thus avoiding a colossal embarrassment. Jackson never panicked or took drastic measures, brushing the difficulties off as growing pains for a team still learning how to win a title.

The championship gave Jackson his seventh title—his first without Jordan—in just his first season coaching a team that had been ousted from the playoffs in each of O'Neal and Bryant's three previous seasons together. "I want to thank Phil Jackson, the real coach of the year," Shaq said in the euphoria of the Lakers' victory celebration.

Jackson also brought his own touch of Hollywood to the Lakers. In an effort to get his various messages across to his club, he occasionally spliced clips from movies such as *American History X* and *The Green Mile* into their scouting videos. In fact, as Jackson and the Lakers rejoiced on the Staples Center floor after Game 6 of the Finals, with gold and purple confetti swirling around them, it was clear they had discovered an old Tinseltown formula for success: find two marquee stars, surround them with a good supporting cast, then get the right director to make sure they follow the script.

With the Lakers closest rivals—Miller's Pacers, Robinson's Spurs, Ewing's Knicks and Scottie Pippen's Blazers—aging or breaking up, the question for the rest of the NBA was how many sequels would L.A. be able to produce?

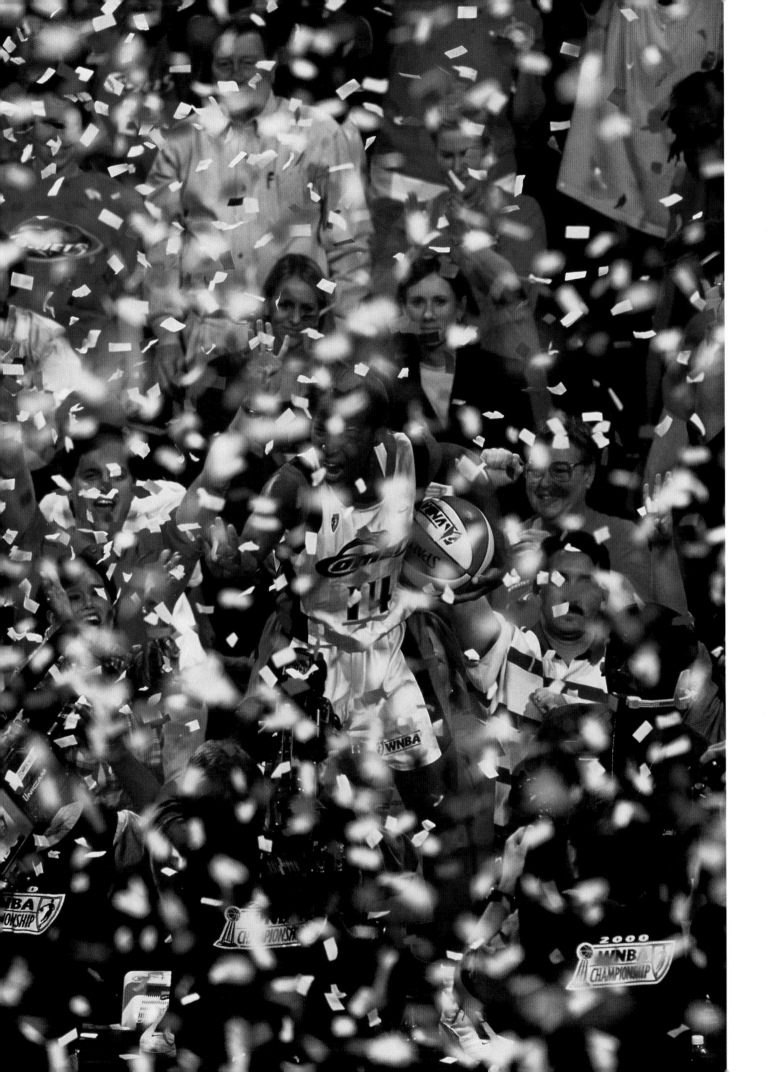

PHOTO GALLERY

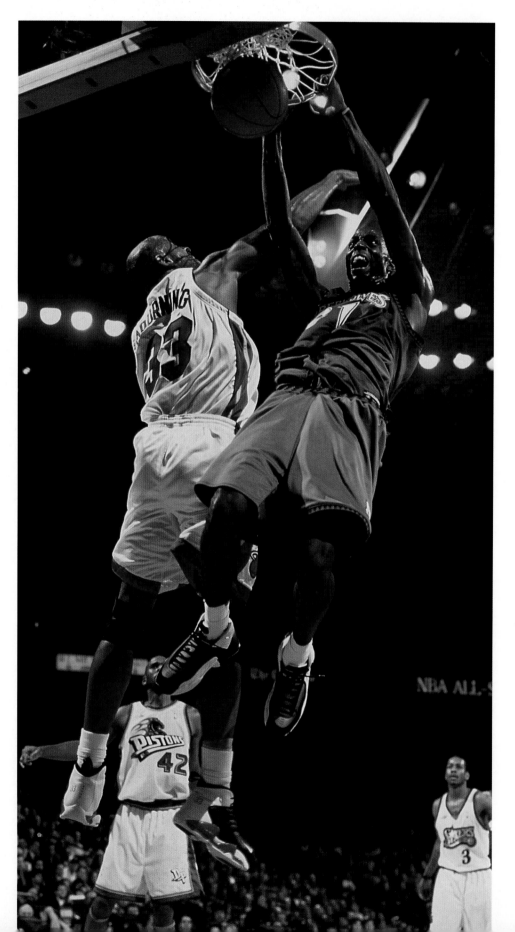

Two Points, with Feeling: Minnesota's Kevin Garnett threw down an emphatic dunk over Miami's Alonzo Mourning (33) during the NBA All-Star Game in February (left). Garnett scored 24 points to lead the West to a 137–126 victory.

The Lakers' Kobe Bryant slashed hoopward past New Jersey's Kendall Gill but faced an obstacle in Jim McIlvaine (right, 22). The 2000 season, though, was all about overcoming barriers for Bryant, who scored 22.5 points per game and helped the Lakers win the NBA title.

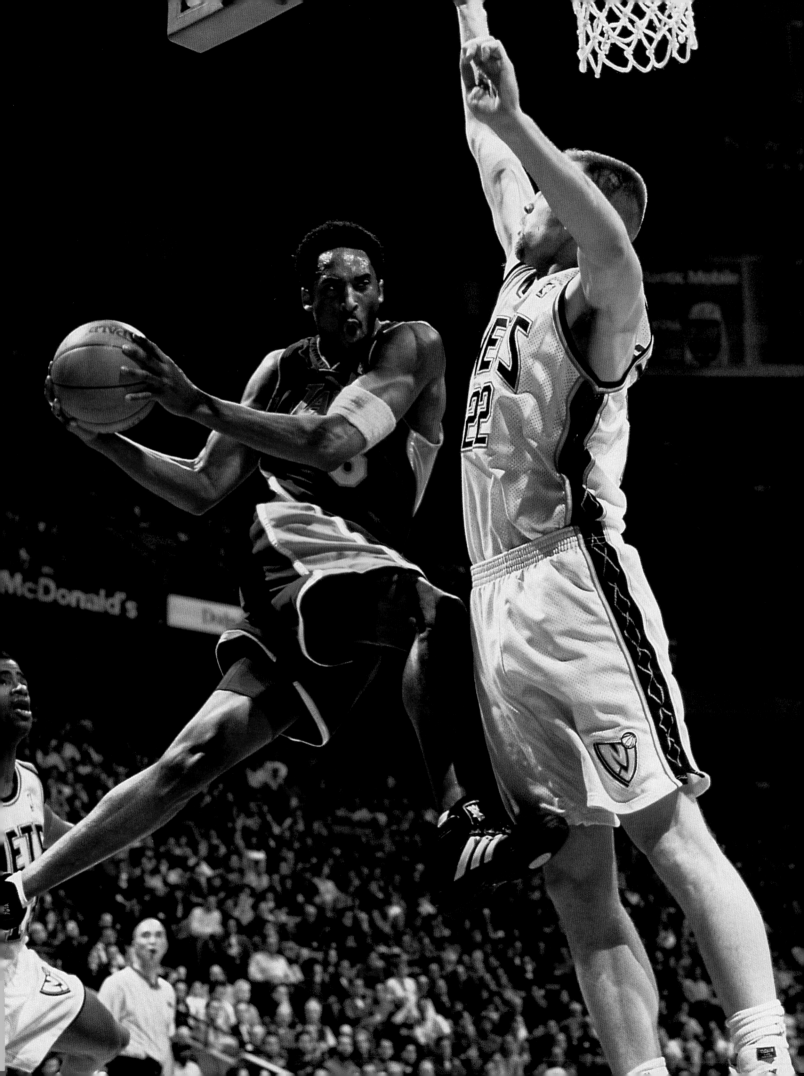

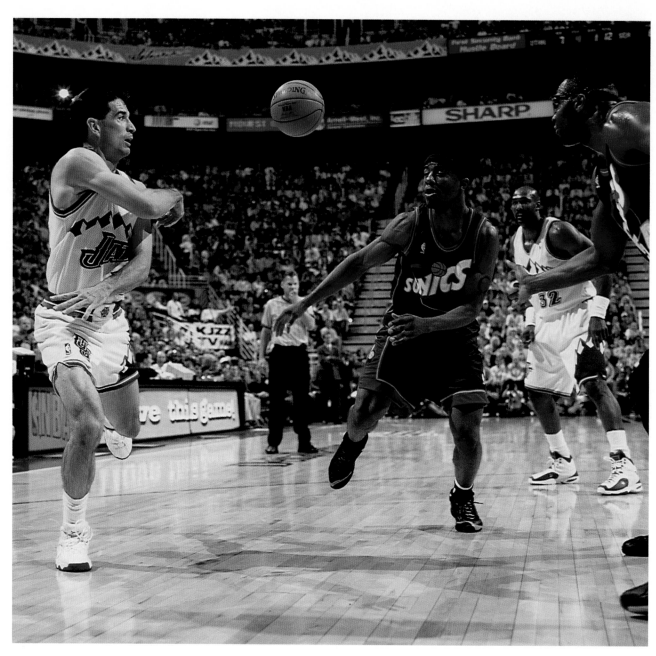

Tracy and Hepburn, Fred and Ginger, Stockton and Malone: Legendary partners have an ingrained sense of their counterpart's whereabouts, often without the need to look, as Utah's John Stockton demonstrated with a slick pass to Karl Malone in a first-round playoff series against Seattle.

D-Up: New York swingman Latrell Sprewell (8) put a body on Indiana sharpshooter Reggie Miller during the Eastern Conference finals, but the Knicks couldn't stop Miller or the Pacers, who won the series four games to two to advance to the NBA Finals for the first time in the 24-year NBA history of the franchise. Miller scored 34 points in the clinching Game 6.

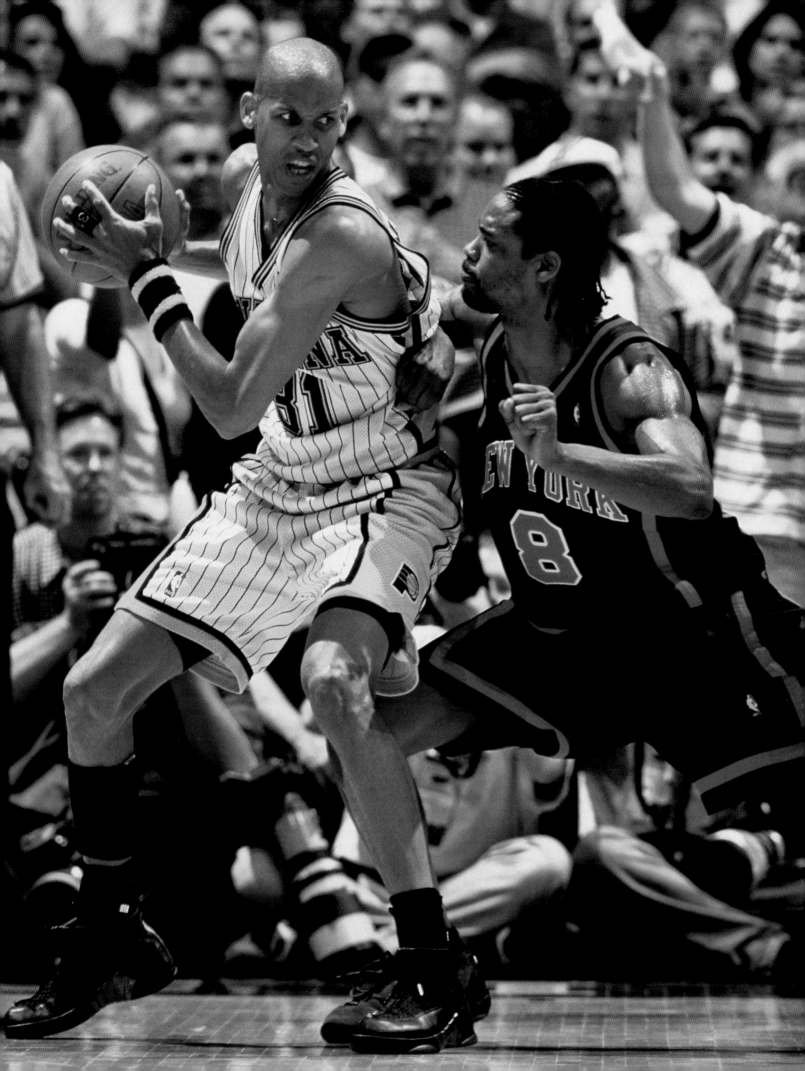

Raptor on the Rise: Toronto's Vince Carter soared to the rim during the NBA Slam Dunk Contest at the All-Star Game in Oakland. Carter, who scored 25.7 points per game in 2000, won the dunk competition with a jaw-dropping, between-the-legs tomahawk slam, a flourish that, along with his consistently superb play, caused many to believe he could ascend to the NBA throne vacated by Michael Jordan.

24

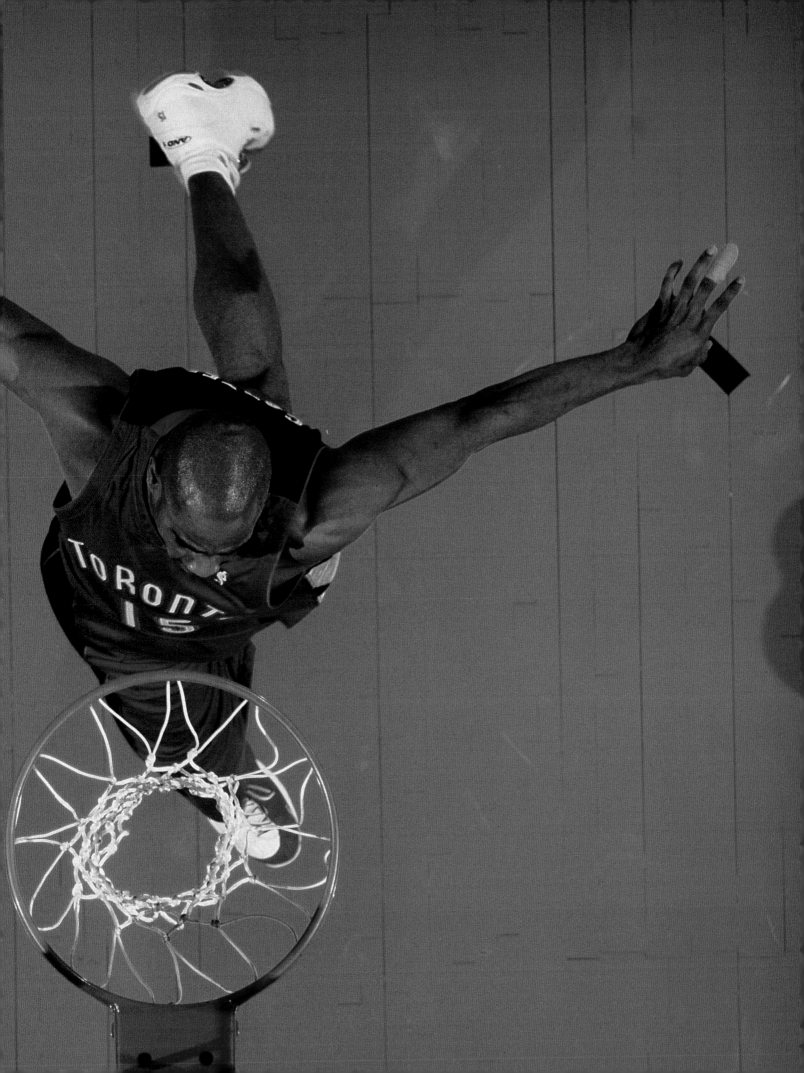

PROFILES

KOBE BRYANT

I had a dream that jealousy
Was a thing of the past.
And we all understood
It's all vanity and it won't last
　　　　—Visions, *a song by Kobe Bryant*

Most mornings Kobe Bryant (opposite) awakens to an ocean view. Before his feet touch the Italian marble floor, he sees the Pacific sparkling outside his bedroom window, a vast blue blanket beneath an endless sky. It's an awesome tableau, yet you suspect that when Bryant gazes at it, there might be something even more spectacular in his mind's eye. He has a way of seeing things that others don't; it's little wonder that his favorite cut from his soon-to-be-released hip-hop album, *K.O.B.E.*, is a wistful tune entitled *Visions*.

Bryant's visions have been ridiculed, but that has never deterred him. When he was nine years old and living in Milan, other kids would laugh at his certainty that he would one day be an NBA star. In response he would scribble his name on scraps of paper and hand them to his doubters. "You might want to hold on to this," he would say. Bryant smiles sheepishly at the memory, but he relishes having had the last laugh. He has a way of making cockiness seem lovable, which is one of the keys to his popularity. Why shouldn't he be impressed with himself? If those kids had listened to him, they would have the autograph of a two-time NBA All-Star who, at the tender age of 21, is perhaps the best shooting guard in the league.

Some of Bryant's visions are eerie. When he was chosen 13th in the 1996 NBA draft by the Charlotte Hornets, who promptly traded him to the Los Angeles Lakers for center Vlade Divac, Kobe told his father, former NBA player Joe (Jelly Bean) Bryant, that someday he'd play for Phil Jackson and his assistant Tex Win-

ter—although Jackson and Winter were coaching the Chicago Bulls at the time. In February of 1999 Kobe phoned Winter to pick his brain about the triangle offense. Not until four months later did the Lakers sign Jackson, who took Winter and the triangle to L.A. "Freaky, isn't it?" Bryant says.

It doesn't take a visionary to see a championship in the Lakers' near future. With a 67–13 record through April 16, Los Angeles has secured home court advantage throughout the playoffs, and it looms as the kind of prohibitive favorite that few people expected to see so soon after the dissolution of Michael Jordan's Bulls. The Lakers' brilliant year has been largely the result of Jackson's orchestration, Shaquille O'Neal's domination and Bryant's maturation. These days Bryant is far less inclined than he was as recently as a year ago to indulge in one-on-one forays, which often delighted fans but irritated teammates. Instead he integrates his flights of improvisation into the Los Angeles offense. …

The 6' 7", 210-pound Bryant has also recognized how many ways he can leave his imprint on a game. Not only does he score, but he also initiates the Lakers' attack and has developed into a fierce defensive stopper. "Kobe's a model of what a young player should aspire to be," says Philadelphia 76ers coach Larry Brown. "Year by year he has learned and made his game more solid, and now he's not just a highlight-film guy but an accomplished NBA player."…

If Bryant has been annoyed at being overshadowed by O'Neal and [rising Toronto star Vince] Carter, he has hidden it well. "It's actually perfect," he says. "I can learn every facet of the game without everyone analyzing every move I make. It's funny how much people wonder about jealousy. Am I jealous of Shaq? Is he jealous of me? Am I jealous of Vince? I'm not about that. Shaq's been unbelievable, and nobody wants to see

him play this way more than I do. Vince? I'm very, very happy for Vince. I love what he's doing."

Bryant and Carter should feel more sympathy than envy for each other, because they are both doomed to be held up to Jordan's standard. Thanks to His Airness, the definition of a superstar has forever changed. It's not enough to be a perennial All-Star, an essential part of a winner, a sneaker-company pitchman. A player can't separate himself from the pack unless he is all those things and more: a corporate mogul, a player in the entertainment world, the leader of a dynasty. Bryant is doing his best to reach the bar Jordan has raised. In December he purchased half-ownership of an Italian basketball team, Olimpia Milano, and he has endorsement deals with Adidas, Mattel and Sprite, among others, that will generate more annual income than his six-year, $ 71 million deal with the Lakers. …

An NBA title would seem to complete the picture of Bryant as an all-around success, the rare young player who has found a balance between sport and celebrity. But to measure up to Jordan, Bryant will have to be the player who leads a team to several championships. He's not in a position to do that with the Lakers. It's hard to be Michael Jordan when your team needs you to be Scottie Pippen.

That's why Bryant's willingness to tone down his game is significant. It doesn't mean, however, that he's content to take a backseat indefinitely. His visions don't include an image of himself as a career-long second banana. "Somewhere down the line when Shaq comes to me and says, 'Kobe, I don't want to have to put up the big numbers every night, you've got to help me out,' I'll be ready," Bryant says. If O'Neal never makes such a request? "I'm only 21," Bryant says. "When I'm 28, Shaq will be what, 40?" He smiles at his exaggeration, knowing O'Neal will be only 35 then. "Point is, my time will come."…

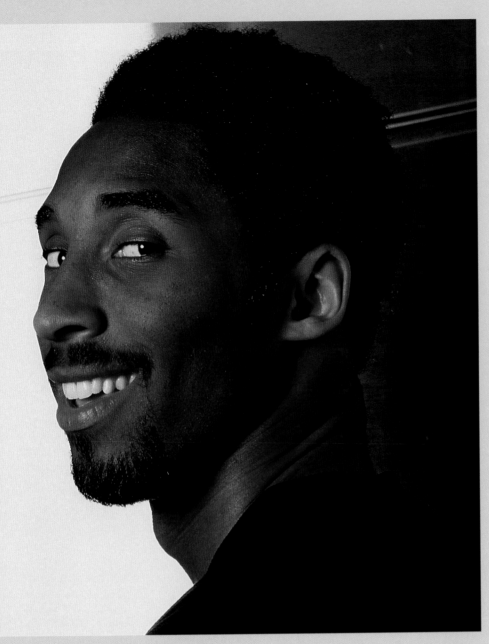

had to figure out how to attack in a different way. I've got it pretty much figured out now—not completely, but almost." And when he figures it out completely? "Then," says Bryant, "I'll be ready for more."

Favorite children's book: Curious George, by H.A. Rey. He's always looking for an adventure, just like me.
 —From Bryant's Web site

It's curiosity that brings him to longtime Lakers assistant Bill Bertka in search of tapes of great players of the past, such as Pete Maravich. Curiosity led Bryant to seek out exceptional defenders like Eddie Jones, Gary Payton and Scottie Pippen and ask them for tips on how to improve his own defense. When he was traded to Los Angeles, he immediately called the coaching staff and asked for tapes of guards around the league he would soon be facing.

Bryant learned his lessons well. He has added a new dimension to the Lakers' defense with his ability to smother small, quick guards. His work against the 76ers' Allen Iverson during an 87–84 win in February was masterly. With a seven-inch height advantage, Bryant barely let Iverson see daylight in the second half, hounding him into 0-for-9 shooting in the fourth quarter and stuffing his final shot.

Given that kind of performance, it's no wonder that Bryant is curious, above all, about his gifts. ... "People say I've made it, but I haven't come close to being where I want to be. It intrigues me to see how far I can go with this thing." ...

Bryant seems unlikely to become some malcontent consumed by his ego or by jealousy, but he may be consumed by his curiosity. The Lakers have a bright student on their hands who needs to be constantly challenged, and as they move toward what seems to be an inevitable championship, they would be wise to begin planning his next lesson.

Kobe was 13 when his family moved back to the U.S. He'd been born in Philadelphia but moved to Italy when he was six, and he had a hard time assimilating to life in America. The slang baffled him, but he soon picked it up, absorbing it without even realizing he was doing it.

[Similarly,] it wasn't until the 1999–2000 season that Bryant began to fit in, taking in the occasional movie on the road with teammates, joking around more on the team bus and plane. ...

His relationship with O'Neal was the trickiest, but the days when Shaq would publicly express thinly veiled displeasure with Bryant's play are, if not gone, increasingly rare. O'Neal's appearance at Bryant's 21st birthday party last August was the Lakers' equivalent of the end of the cold war, and the two seem at ease with each other on and off the court. "Me and Kobe are cool," says Shaq. "We got to know each other, and we found that there's room in this offense for us both to do our thing."

The triangle helped O'Neal and Bryant learn to coexist. The new offense called for more movement and cutting than the systems used by previous coaches Del Harris and Kurt Rambis. "Basically it was just Shaq in the post and four guys on the perimeter, waiting to see what happened," Bryant says of the old offense. "You couldn't feed off each other in that setup."

Bryant believes one reason he and O'Neal struggled to get along is that they are so similar. "We're both attackers," he says. "We both want to get 40 points. I

—Phil Taylor
excerpted from SI, April 24, 2000

STEVE FRANCIS

A blanket of humidity has spread over southeast Texas on this lazy summer afternoon. Not that the oppressive heat (or much of anything else) fazes Steve Francis (left), the Houston Rockets' star point guard and 2000 NBA co-Rookie of the Year. He has just completed his daily off-season workout and is splashing around in the crescent-shaped pool that consumes the bulk of his backyard, affably holding court and, as ever, drawing little distinction between what he thinks and what he says. When one of the guests complains about the weather, Francis notes the visitor's pallid skin tones and responds, "Well, it's obvious you don't get outside much." The other guest, whose clipped British accent Francis has been mocking all afternoon, removes his shirt to reveal a pillowy midsection before hopping into the pool. Naturally, Francis is all over him. "Man, how much of that English beer have you been drinking?" he asks.

To spend an afternoon poolside with Francis is to be on the business end of a disarming, discursive filibuster. … "He's been like that all his life, talking until he gets on your nerves," says Terry Francis, 26, who lives with his younger brother in the Houston suburb of Sugar Land. "The problem was, he used to be so small you couldn't hit him. Now he's so big, you don't want to try."…

Picked second in last year's draft by Vancouver, Francis was demonized for shunning the Grizzlies and effectively extorting a trade to Houston. Once he set foot on the court, his logorrhea quickly earned him the wrath of half the league. In the preseason alone he went jaw-to-jaw with the Seattle SuperSonics' Gary Payton (hardly a singular feat, granted), who dismissed him as a "punk-ass rookie bitch." Detroit Pistons guard Jerry Stackhouse opined, "Somewhere down the line, someone's going to wire [Francis's] jaw shut." Karl Malone simply instructed Francis to "shut the f--- up."…

His incessant talking, it turns out, is less a mark of an unreconstructed egomaniac than of an irrepressible personality. He admits that he could have handled the Vancouver situation more professionally but raises a fair point when he wonders why team-spurning predecessors such as John Elway and Danny Ferry weren't pilloried half as badly. What's more, as a Rocket he has stepped out of line less often than a Rockette, never so much as arriving late for practice. "I can't tell you how much I like him," says Rudy Tomjanovich, not one given to hyperbole. "He was one of the young guys who helped rejuvenate me."

That the 6' 3", 193-pound Francis is a sensational player didn't hurt his image rehabilitation either. Blessed with a 43-inch vertical leap and a preposterously quick first step, Francis is on the short list of NBA stars on the make. Despite having rarely played the point at Maryland, he averaged 18.0 points and 6.6 assists last season. He also finished fourth among guards in rebounding (5.3 per game) while pleasing highlights junkies with a compendium of breathtaking dunks. …

Francis says his personality was molded by the two women who raised him, his mother, Brenda, and his grandmother, Mabel Wilson. Brenda was, as Francis puts it, "my rock," until she died of cancer in 1995. "All the time I hear her voice saying, 'Stevie, just be yourself,' " says Francis, staring at the tattoo on his right arm of a crucifix sandwiched by the words IN MEMORY and BRENDA. As for Mabel, she still wields so much influence over her grandson that he told his recent guests, "I would offer you a beer, but my grandma doesn't want me to keep alcohol in the house." Never mind that Francis turns 24 in February and Mabel lives 1,300 miles away in Ashton, Md. …

As for his unshakable joie de vivre, Francis surmises that it's been sustained by the unlikely trajectory of his career. In an era when players with even an ounce of NBA potential hear sweet nothings from agents and college recruiters, Francis was a 5' 9" sophomore just trying to make the varsity. He traversed the back roads to the pros… .

"I get to live like this and play basketball as my job," he says. "What more could I ask for?"

As he floats in his pool and stops to ponder his question, for the first time all day he is engulfed by the sound of silence.

—L. Jon Wertheim
excerpted from SI, Aug. 21, 2000

VINCE CARTER

The plane was ready to take off, and so, in a sense, was Vince Carter. He was at the airport in Toronto on Feb. 10, about to board a spacious private jet with Raptors teammate Tracy McGrady and several team executives, bound for an NBA All-Star weekend in Oakland that would change his life. Caterers had stocked the flight with a feast fit for the man who two days later would be Slam Dunk King, including shrimp cocktail, prime rib and champagne, but Carter and McGrady had a different meal in mind. An airport courtesy van was dispatched to McDonald's, and by the time the jet was off the ground, Carter was munching on a 20-piece pack of Chicken McNuggets.

Gobbling fast food while flying in luxury is typical of Carter's life these days—he's trying to stay grounded while enjoying his soaring popularity. If the 1,911,973 votes he received from fans for the All-Star Game, second only to Michael Jordan's 1997 tally, weren't proof enough of his appeal, his electrifying performance in winning the dunk contest catapulted him from emerging star to megastar Vince-tantaneously. Shoe companies clamored for his endorsement; entertainers buzzed about his acting potential; legends of the game such as Julius Erving and Magic Johnson trekked to the locker room just to pay homage; and kids across North America fantasized about replicating his 360, windmill dunk and his between-the-legs tomahawk slam. Two of his 12 points in the next day's All-Star Game came on a double-clutch sidewinder dunk off a lob from Allen Iverson. …

Although he politely tries to steer clear of Jordan comparisons, the parallels are unavoidable—from the ties to North Carolina to the shaved heads to the gravity-defying acrobatics. At times it seems as if His Airness has passed through a Xerox machine. "Am I tired of Jordan questions? Yeah," Carter says. "It's a great compliment, but everybody in the league has flashes of playing like Mike sometime. I'm more interested in establishing my own identity." …

The dunk contest may have been a turning point in his career, but the slams he comes up with in games are often more thrilling because they happen so suddenly. Where lesser leapers would settle for short jumpers, Carter continues floating to the basket for stuffs that didn't seem possible when he left the floor. Though these glides to the basket begin gracefully, they end viciously when he jams the ball with a snap of his arm like the crack of a whip.

But Carter (opposite, with ball) wants to be known as more than just a rim rattler, in much the same way that Ken Griffey Jr. is uncomfortable being pigeonholed as a home run hitter. "Dunkers come and go," Carter says. "You can go down to the playground and find a bunch of guys who can do fancy dunks. The great players excel at all aspects of the game. That's what I want to be." He spent much of the off-season working on his jump shot, and the effort has paid off, especially beyond the three-point arc, where he has improved his accuracy from 28.8% last season to 36.3%

through Feb. 20. His scoring average (24.7 points, sixth in the league), rebounds (6.0), assists (3.8), steals (1.4) and shooting percentages (45.5 from the field, 79.7 from the line) were up as well. "I remember the first time I played against him, I said, 'If this kid gets a jump shot, he's going to be awesome,' " says Heat swingman Dan Majerle. "He developed a jump shot pretty quick. So if he continues to work on his game and not be satisfied, the sky's the limit."

Carter's turnaround jumper, especially his fadeaway from the baseline, is almost as reminiscent of Jordan's as his stuffs are, but overall his midrange game remains the weakest part of his repertoire. "I think he needs to handle the ball better, but he certainly has the ability to do that," says Denver Nuggets coach Dan Issel. Others cite this flaw in the 6' 7" forward who spends so much time above the rim: "He could be a better rebounder," says Portland Trail Blazers point guard Damon Stoudamire, "but that's nitpicking."

Defensively, Carter is no ball hawk. He's like an outfielder who can outrun his mistakes, tending to rely more on his athleticism than on positioning to contain an opponent. In a 91–70 win over the New York Knicks on Feb. 15, Carter lost track of Latrell Sprewell, who slipped open for a baseline jumper, but recovered in time to get over and block Sprewell's shot. "He's about 60 percent of what he could be as a player," says Raptors coach Butch Carter (no relation). "Eventually, he's going to come out and play at a level every night that will amaze you. Do I think that's going to happen in his second year in the league? Absolutely not." …

Although he has brought more Canadian viewers to the NBA, the only way Carter can attain high-level star power in Canada is if he trades in his jump shot for a slap shot. The night he won the slam dunk contest, TSN's *Sports Desk*, the Canadian equivalent of ESPN's *SportsCenter*, opened with nine minutes of NHL highlights before getting to the news of his victory. The next morning, the *Toronto Sun* sports section had a photo from the Maple Leafs–Vancouver Canucks game on the front page instead of one of Carter. …

The Raptors hope that Carter will appreciate not having every member of the Toronto media tracking his every move, and that he won't be lured by a U.S. market when his contract runs out. His four-year deal expires after 2001–02, with the Raptors retaining the option to keep him for a fifth season. Carter is offering them encouraging signs, but he is careful to remain noncommittal. "I just play," he says. "It's never mattered to me where I was playing as long as I'm comfortable with the organization and the city."

It's too early for either side to spend much time worrying about that, anyway. There is much that can change during the next two years because, hard as it is to believe after watching him soar through the air, Vince Carter is still rising.

—Phil Taylor
excerpted from SI, Feb. 28, 2000

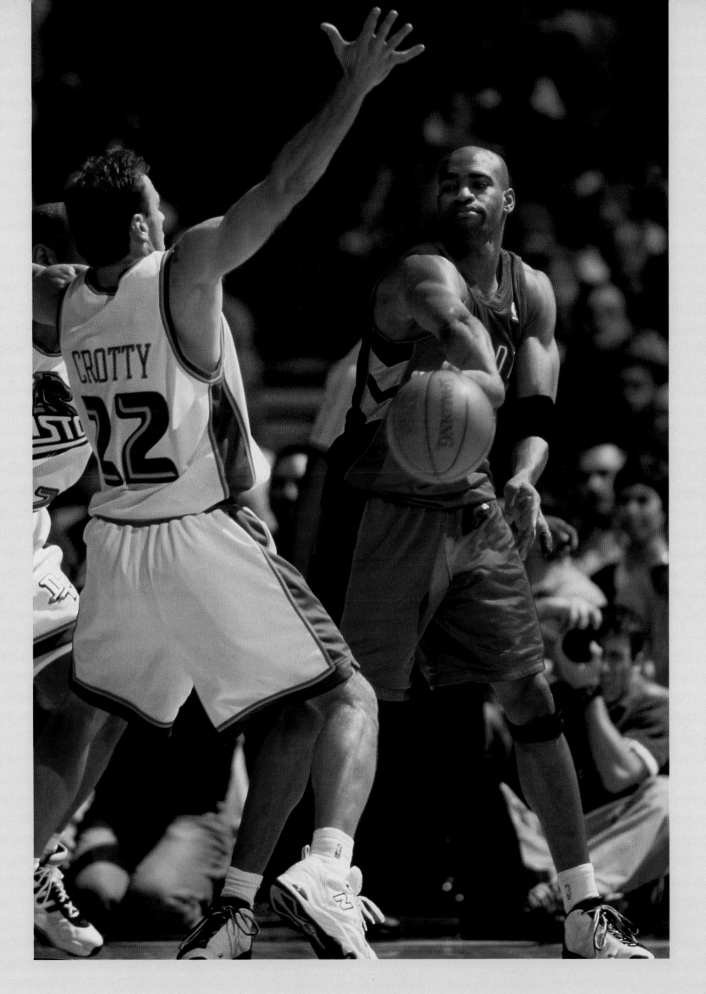

NBA Final Standings

EASTERN CONFERENCE
Atlantic Division

TEAM	W	L	PCT	GB
Miami	52	30	.634	—
New York	50	32	.610	2
Philadelphia	49	33	.598	3
Orlando	41	41	.500	11
Boston	35	47	.427	17
New Jersey	31	51	.378	21
Washington	29	53	.354	23

Central Division

TEAM	W	L	PCT	GB
Indiana	56	26	.683	—
Charlotte	49	33	.598	7
Toronto	45	37	.549	11
Detroit	42	40	.512	14
Milwaukee	42	40	.512	14
Cleveland	32	50	.390	24
Atlanta	28	54	.341	28
Chicago	17	65	.207	39

WESTERN CONFERENCE
Midwest Division

TEAM	W	L	PCT	GB
Utah	55	27	.671	—
San Antonio	53	29	.646	2
Minnesota	50	32	.610	5
Dallas	40	42	.488	15
Denver	35	47	.427	20
Houston	34	48	.415	21
Vancouver	22	60	.268	33

Pacific Division

TEAM	W	L	PCT	GB
LA Lakers	67	15	.817	—
Portland	59	23	.720	8
Phoenix	53	29	.646	14
Seattle	45	37	.549	22
Sacramento	44	38	.537	23
Golden State	19	63	.232	48
LA Clippers	15	67	.183	52

NBA Individual Leaders

SCORING

	GP	PTS	AVG
Shaquille O'Neal, LA Lakers	79	2344	29.7
Allen Iverson, Phil	70	1989	28.4
Grant Hill, Det	74	1906	25.8
Vince Carter, Tor	82	2107	25.7
Karl Malone, Utah	82	2095	25.5
Chris Webber, Sac	75	1834	24.5
Gary Payton, Sea	82	1982	24.2
Jerry Stackhouse, Det	82	1939	23.6
Tim Duncan, SA	74	1716	23.2
Kevin Garnett, Minn	81	1857	22.9

STEALS

	GP	STEALS	AVG
Eddie Jones, Char	72	192	2.67
Paul Pierce, Bos	73	152	2.08
Darrell Armstrong, Orl	82	169	2.06
Allen Iverson, Phil	70	144	2.06
Mookie Blaylock, GS	73	146	2.00
Jason Kidd, Phoe	67	134	2.00
Terrell Brandon, Minn	71	134	1.89
Gary Payton, Sea	82	153	1.87
Kendall Gill, NJ	76	139	1.83
John Stockton, Utah	82	143	1.74

THREE-POINT FIELD-GOAL PERCENTAGE

	FGA	FGM	PCT
Hubert Davis, Dall	167	82	.491
Jeff Hornacek, Utah	138	66	.478
Matt Bullard, Hou	177	79	.446
Rodney Rogers, Phoe	262	115	.439
Allan Houston, NY	243	106	.436
Terry Porter, SA	207	90	.435
Lindsey Hunter, Det	389	168	.432
Tracy Murray, Wash	263	113	.430
Jon Barry, Sac	154	66	.429
Wesley Person, Clev	250	106	.424

ASSISTS

	GP	ASSISTS	AVG
Jason Kidd, Phoe	67	678	10.1
Sam Cassell, Mil	81	729	9.0
Nick Van Exel, Den	79	714	9.0
Terrell Brandon, Minn	71	629	8.9
Gary Payton, Sea	82	732	8.9
John Stockton, Utah	82	703	8.6
Stephon Marbury, NJ	74	622	8.4
Mike Bibby, Van	82	665	8.1
Mark Jackson, Ind	81	650	8.0
Eric Snow, Phil	82	624	7.6

REBOUNDS

	GP	REB	AVG
Dikembe Mutombo, Atl	82	1157	14.1
Shaquille O'Neal, LA Lakers	79	1078	13.6
Tim Duncan, SA	74	918	12.4
Kevin Garnett, Minn	81	956	11.8
Chris Webber, Sac	75	787	10.5
Shareef Abdur-Rahim, Van	82	825	10.1
Elton Brand, Chi	81	810	10.0
Dale Davis, Ind	74	729	9.9
David Robinson, SA	80	770	9.6
Jerome Williams, Det	82	789	9.6

BLOCKED SHOTS

	GP	BS	AVG
Alonzo Mourning, Mia	79	294	3.72
Dikembe Mutombo, Atl	82	269	3.28
Shaquille O'Neal, LA Lakers	79	239	3.03
Theo Ratliff, Phil	57	171	3.00
Shawn Bradley, Dall	77	190	2.47
David Robinson, SA	80	183	2.29
Tim Duncan, SA	74	165	2.23
Raef LaFrentz, Den	81	180	2.22
Greg Ostertag, Utah	81	172	2.12
Marcus Camby, NY	59	116	1.97

FREE-THROW PERCENTAGE

	FTA	FTM	PCT
Jeff Hornacek, Utah	180	170	.950
Reggie Miller, Ind	406	373	.919
Darrell Armstrong, Orl	247	225	.911
Terrell Brandon, Minn	208	187	.899
Ray Allen, Mil	398	353	.887
Predrag Stojakovic, Sac	153	135	.882
Derek Anderson, LA Clippers	309	271	.877
Jim Jackson, Atl	212	186	.877
Sam Cassell, Mil	445	390	.876
Mitch Richmond, Wash	340	298	.876

FIELD-GOAL PERCENTAGE

	FGA	FGM	PCT
Shaquille O'Neal, LA Lakers	1665	956	.574
Dikembe Mutombo, Atl	573	322	.562
Alonzo Mourning, Mia	1184	652	.551
Ruben Patterson, Sea	661	354	.536
Rasheed Wallace, Port	1045	542	.519
David Robinson, SA	1031	528	.512
Wally Szczerbiak, Minn	669	342	.511
Karl Malone, Utah	1476	752	.509
Antonio McDyess, Den	1211	614	.507
Othella Harrington, Van	830	420	.506

NBA Awards

ALL-NBA TEAMS

First Team
G Gary Payton, Seattle
G Jason Kidd, Phoenix
C Shaquille O'Neal, LA Lakers
F Kevin Garnett, Minnesota
F Tim Duncan, San Antonio

Second Team
Allen Iverson, Philadelphia
Kobe Bryant, LA Lakers
Alonzo Mourning, Miami
Karl Malone, Utah
Grant Hill, Detroit

Third Team
Eddie Jones, Charlotte
Stephon Marbury, New Jersey
David Robinson, San Antonio
Chris Webber, Sacramento
Vince Carter, Toronto

NBA ALL-DEFENSIVE TEAMS

First Team
G Gary Payton, Seattle
G Kobe Bryant, LA Lakers
C Alonzo Mourning, Miami
F Tim Duncan, San Antonio
F Kevin Garnett, Minnesota

Second Team
Jason Kidd, Phoenix
Eddie Jones, Charlotte
Shaquille O'Neal, LA Lakers
Scottie Pippen, Portland
Clifford Robinson, Phoenix

ALL-ROOKIE TEAMS (CHOSEN WITHOUT REGARD TO POSITION)

First Team
Elton Brand, Chicago
Steve Francis, Houston
Lamar Odom, LA Clippers
Wally Szczerbiak, Minnesota
Andre Miller, Cleveland

Second Team
Shawn Marion, Phoenix
Ron Artest, Chicago
James Posey, Denver
Jason Terry, Atlanta
Chucky Atkins, Orlando

2000 NBA Playoffs

EASTERN CONFERENCE

1st Round	Semifinals	Finals
Indiana	Indiana (3–2)	Indiana (4–2)
Milwaukee		
Charlotte	Philadelphia (3–1)	
Philadelphia		Indiana (4–2)
New York	New York (3–0)	
Toronto		New York (4–3)
Miami	Miami (3–0)	
Detroit		

NBA Finals

LA LAKERS (4-2)

WESTERN CONFERENCE

Finals	Semifinals	1st Round
LA Lakers (4–1)	LA Lakers (3–2)	LA Lakers
		Sacramento
	Phoenix (3–1)	San Antonio
LA Lakers (4–3)		Phoenix
	Portland (3–1)	Portland
Portland (4–1)		Minnesota
	Utah (3–2)	Utah
		Seattle

NBA Finals Composite Box Score

INDIANA PACERS

PLAYER	GP	FIELD GOALS		3-PT FG		FREE THROWS		REBOUNDS		A	STL	TO	BS	AVG	HI
		FGM	PCT	FGM	FGA	FTM	PCT	OFF	TOTAL						
Miller	6	43	41.3	15	40	45	97.8	0	16	22	5	8	2	24.3	35
Rose	6	50	46.7	8	16	30	83.3	2	27	18	5	17	2	23.0	32
Croshere	6	24	54.5	4	10	39	86.7	8	36	5	2	7	6	15.2	24
Smits	6	27	46.6	0	0	6	100.0	8	24	3	3	8	7	10.0	24
Jackson	6	19	41.3	8	20	12	80.0	3	32	46	5	11	0	9.7	18
Davis	6	23	57.5	0	0	6	54.5	19	60	6	2	0	6	8.7	20
Perkins	6	11	37.9	11	23	3	75.0	1	24	6	3	4	0	6.0	10
Best	6	14	46.7	2	4	5	83.3	4	7	13	4	4	1	5.8	14
Bender	2	2	66.7	0	0	3	75.0	0	1	0	1	0	0	3.5	4
McKey	6	3	50.0	1	2	4	66.7	6	19	1	2	5	1	1.8	4
Mullin	3	1	50.0	0	1	2	66.7	0	0	1	1	1	1	1.3	4
Tabak	3	1	50.0	0	0	0	—	1	1	0	0	0	0	0.7	2
Totals	**6**	**218**	**46.3**	**49**	**116**	**155**	**85.2**	**52**	**247**	**121**	**33**	**65**	**26**	**106.7**	**120**

LOS ANGELES LAKERS

PLAYER	GP	FIELD GOALS		3-PT FG		FREE THROWS		REBOUNDS		A	STL	TO	BS	AVG	HI
		FGM	PCT	FGM	FGA	FTM	PCT	OFF	TOTAL						
O'Neal	6	96	61.1	0	0	36	38.7	34	100	14	6	13	16	38.0	43
Bryant	5	33	35.2	2	10	10	90.9	6	23	21	5	6	7	15.6	28
Rice	6	22	40.0	12	19	13	65.0	1	15	10	5	9	1	11.5	21
Harper	6	26	46.4	6	15	7	70.0	4	20	29	8	12	1	10.8	21
Horry	6	22	51.2	3	15	8	72.7	8	31	17	5	9	6	9.2	17
Fox	6	11	61.1	5	8	13	86.7	3	10	6	3	4	0	6.7	11
Fisher	6	12	42.9	7	12	5	83.3	2	6	23	5	3	0	6.0	10
Green	6	12	57.1	0	0	6	85.7	9	20	3	1	2	0	5.0	7
Shaw	6	8	21.6	0	12	2	100.0	3	17	17	2	5	0	3.0	6
Knight	4	2	66.7	0	0	1	50.0	2	2	0	0	1	0	1.3	3
Salley	4	2	66.7	0	0	0	—	1	3	0	1	0	0	1.0	4
George	1	0	00.0	0	1	1	50.0	0	0	0	0	1	0	1.0	1
Totals	**6**	**246**	**48.0**	**35**	**92**	**102**	**57.0**	**73**	**248**	**140**	**41**	**65**	**31**	**104.8**	**120**

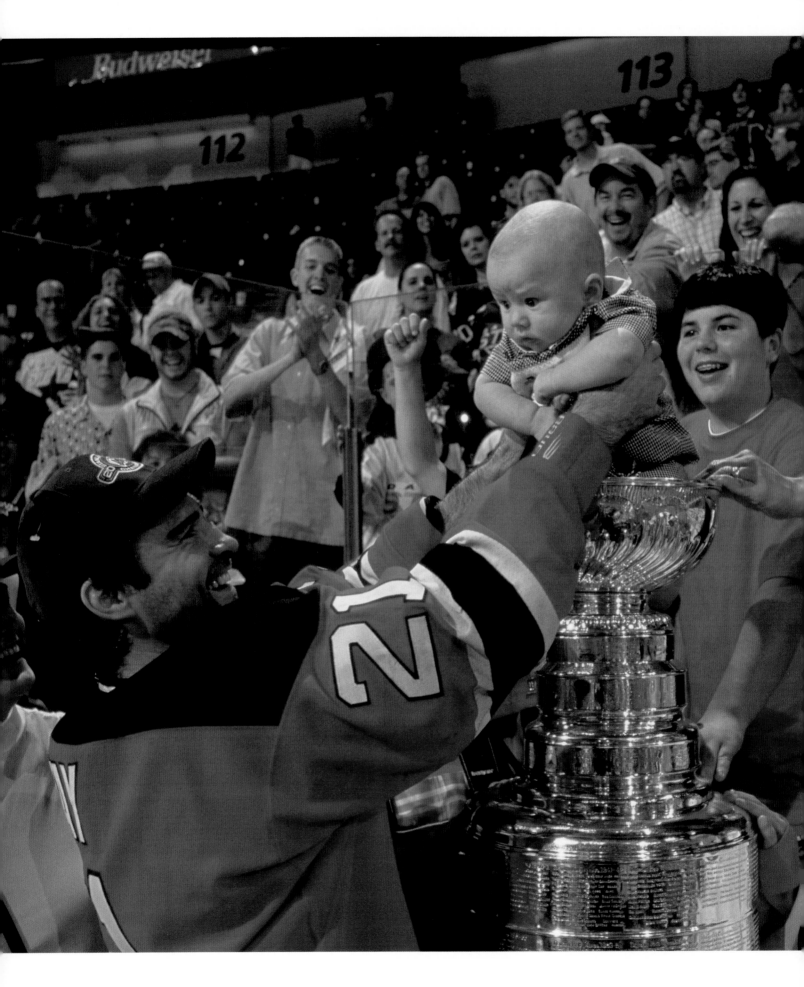

Devils' Triumph

A heartstopping postseason and a thrilling Cup run by New Jersey overshadowed some fiendish behavior on and off the ice
■ David Fleming

He was three miles away, sitting in a hospital bed at the Baylor University Medical Center in downtown Dallas, but there were subtle reminders everywhere of New Jersey winger Petr Sykora after the Devils won the Stanley Cup across town in Reunion Arena. Devils coach Larry Robinson donned Sykora's jersey when it was his turn to hoist Lord Stanley's trophy. During the locker room celebration a cell phone passed from player to player so teammates could chat with Sykora as they sipped champagne and then beer from the Cup. And later, winger Patrick Elias walked through a cloud of cigar smoke inside the Devils' locker room wearing his injured teammate's jersey backward so that Sykora's name was facing front.

Sykora had been knocked off balance by Stars defenseman Sylvain Coté and then leveled by Derian Hatcher, who sent him sprawling to the ice, where he lay flat and motionless for several minutes. The Devils' leading goal scorer in the playoffs, Sykora was eventually strapped to a board and taken to the hospital. Fortunately, his CAT scan was normal, but he was kept in the hospital overnight anyway. "I'll take the Cup to him in the hospital myself, if I have to," said Devils winger Jason Arnott.

While Arnott may not have transported the trophy to the hospital, he certainly delivered the Cup

Oh Baby! New Jersey wing Randy McKay celebrated the Devils' second Stanley Cup triumph in six years by dipping his four-month old son, Dawson—who appeared to be the only one not enjoying the gesture—in the fabled trophy.

35

McSorley (above), who received the longest suspension in NHL history (23 games) for his attack on Brashear, was tried in a British Columbia court in October and found guilty of assault with a weapon. He received probation but no jail time.

to the Devils. With 8:20 left in the second overtime of Game 6, the 25-year-old winger flicked the puck from the top of the Dallas crease over Stars' goalie Ed Belfour and into the top of the net for the Cup-winner. The goal was especially sweet for Arnott, who had been knocked out of Game 4 by Hatcher (the Body Snatcher), who dealt him a blow to the head so vicious it broke Arnott's six-tooth bridge. But afterward the only player on Arnott's mind was Sykora. "We said we have to do this for our boy [Sykora]," said Arnott. "So there's no question that goal was for him."

Of course, the goal made a lot of other people pretty happy, too. In addition to securing the Devils and their faithful their second championship in six years, Arnott's championship winner provided an ideal sendoff for New Jersey owner John McMullen, who, with much public handwringing, was in the process of selling the Devils for $175 million to George Steinbrenner's YankeeNets. (McMullen bought the Devils in 1982 for a measly $10 million.) The triumph also vindicated general manager Lou Lamoriello, who made the gutsy and controversial decision to dump Devils coach Robbie Ftorek with eight games remaining in the regular season—a move that infused the sluggish club with new life. "We did it the hard way," said goalie Martin Brodeur. "It's so nice to win with all that adversity."

Indeed, the Devils were nearly rubbed out of the playoffs by Philadelphia in the Eastern Conference finals. New Jersey rallied from a three-games-to-one deficit in that series, a feat unmatched that deep in the playoffs during the last 33 years. The first champions of the 21st century, the Devils were both a throwback to old-time hockey (tough defense, heart-on-the-sleeve loyalty to their fallen teammate) and a promising vision of the NHL's future (taut, quality hockey contested by increasingly diverse players, such as the Devils' Rookie of the Year forward, Scott Gomez, the league's first Hispanic player.)

The undisputed leader of this unique and selfless bunch was captain Scott Stevens, a hard-charging defenseman. The Conn Smythe Trophy winner as the playoff MVP, Stevens played the entire postseason with a stinging pinched nerve in his neck. Yet he rose to the occasion whenever it mattered most.

"I've never seen a player so physically dominat-

ing," said Devils center Bobby Holik. "Teams were like, 'Oh, hey, let's not go this way, there's Scott Stevens.' "

Another player the Devils' opponents tried to bypass, but couldn't, was Brodeur. The New Jersey netminder was nearly flawless in the double-overtime Game 6 as he held up his end of a tremendous goaltending duel with Belfour, his Dallas counterpart.

In Game 4 of the Eastern Conference semifinals, the Penguins and the Flyers staged a similarly tense and high-quality duel as they battled for seven hours and most of five overtimes. The third-longest game in NHL history (2:32:01), it was settled by Keith Primeau, who wristed in the game-winner with 7:59 left in OT No. 5, the eighth period of hockey the teams had played that night. The Flyers were too exhausted to celebrate, as were most of the 5,000 die-hard fans who had stayed until 2:35 a.m. to see the 2–1 win. Said Pittsburgh superstar Jaromir Jagr, "You don't even know you're playing hockey. You're skating, but you can't even think."

Mind-altering action on the ice has long been Jagr's specialty. The dazzling right-winger scored 42 goals and led the league with 96 points in 1999–2000. His peers voted him the league's most outstanding player, and he lost out to St. Louis defenseman Chris Pronger for the Hart Trophy by one vote. Florida forward Pavel Bure, who led the league with 58 goals, tied Jagr for second in the Hart voting. Fully recovered from an ACL injury he suffered a year ago, Bure became just the second European player to score a hat trick in the NHL All-Star Game. In a 13-game span during December, Bure scored 12 goals and passed off for 10 assists, prompting teammate Scott Mellanby to say, "What he brings to the team is, obviously, the entire offense."

Bruins defenseman Ray Bourque was similarly valuable to Boston in the '80s and '90s, when he was often the only star on the roster. In March the Bruins gracefully complied with his wish to go to a contender to pursue his Stanley Cup dream. Alas, Bourque and his new team, Colorado, were eliminated by Dallas in Game 7 of the Western Conference finals.

The classy move by Boston to let Bourque go, the scintillating play of the league's stars and the heartstopping postseason were welcome antidotes to a year plagued by ugly incidents and bad news on and off the ice. In Montreal the league lost an icon and one of its alltime greats when Hall of Famer Maurice (the Rocket) Richard died at the age of 78 in May. The Rocket's 50 goals in 50 games

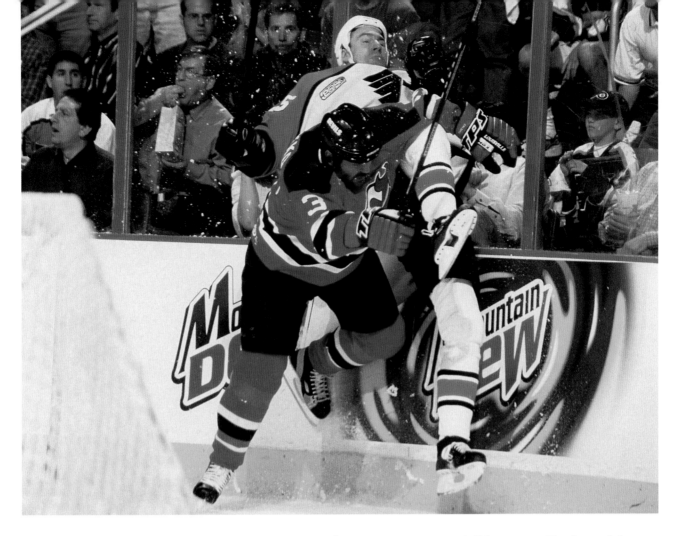

in the 1944–45 season are an NHL landmark. He led the league in goals five times and led his hometown Canadiens to eight Stanley Cups.

In Ottawa, in what became one of the sporting world's ugliest contract squabbles, Senators forward Alexei Yashin sat out the entire season (his third holdout in his six-year career), refusing to honor the fifth year of the $13.5 million contract he signed in 1995. In an unprecedented move, disgruntled fans in Ottawa tried in vain to sue Yashin for not playing. An arbitrator later ruled that Yashin would remain under contract to the Senators for one more year.

In Philadelphia, the Flyers minted their title as Team Controversy. Even though the team had stripped him of his captaincy, Eric Lindros made a courageous but perhaps ill-advised return to the ice after a two-month layoff following his fourth and fifth concussions. By comparison to coach Roger Neilson, Lindros got off easy. When Neilson wanted to return to the bench after undergoing cancer treatment, the team replied with a curt no thanks and left Craig Ramsay in charge. Neither Neilson nor Lindros felt much Brotherly Love in Philly.

But of all the unseemly and embarrassing incidents in the NHL in 2000, none compared to Bruins defenseman Marty McSorley's actions in the closing minutes of a Boston-Vancouver game in February. McSorley skated up behind the Canucks' Donald Brashear, and in an attempt to entice Brashear into a brawl, whacked him in the temple with his stick. Brashear fell backward and hit his head on the ice. He suffered a severe concussion that left him bleeding and twitching on the ice. The entire scene was caught on videotape and replayed ad nauseam as the sports world's ugliest incident in 1999–2000. A 17-year veteran, McSorley was immediately suspended for the remaining 23 games of the season (the harshest penalty ever handed down by the NHL for an on-ice infraction) and was later tried on criminal charges by prosecutors in British Columbia.

Thankfully, though, no amount of bad news could overshadow what the Devils accomplished in the postseason. As they left Reunion Arena hours after Game 6, Stevens and defenseman Scott Niedermayer paused for a quiet moment near a loading dock. There, sitting on a dolly by itself in the still Dallas night, was the Stanley Cup. Niedermayer and Stevens walked over and gave the trophy one final rub before it was wheeled off and shipped to its first house call. Sitting up in his hospital bed well after doctors had told him to get some sleep, Petr Sykora waited for the Cup to arrive.

New Jersey defenseman Ken Daneyko upended Flyers center Primeau during the Eastern Conference finals. The Devils rallied from a three-games-to-one deficit to win the series and become the first team in 33 years to recover from such a disadvantage so late in the playoffs.

PHOTO GALLERY

Detroit's Pat Verbeek (far right) worked the puck up ice during the Red Wings' play-off opener against Los Angeles. Detroit won the game 2–0 and swept the series in four games but could not get by Colorado in the next round, losing in five games.

Six-time NHL All-Star Eric Lindros (left) has battled injuries for much of his career, limiting him to only one Stanley Cup appearance ('97) and no titles in his eight years in the league. During Game 7 of the 2000 Eastern Conference finals against the Devils—a 2–1 Flyers loss—Lindros suffered his sixth concussion, an injury that put his career in jeopardy.

Despite playing in only 63 games during the 1999–2000 season, Pittsburgh's electrifying right wing Jaromir Jagr (right) led the NHL in scoring with 42 goals and 54 assists for 96 points.

Stars goalie Ed Belfour (above), defenseman Sergei Zubov (top, right) and left wing Brenden Morrow (45) teamed up to stop New Jersey winger Jason Arnott during Game 3 of the Stanley Cup in Dallas.

Quelle Joie! When his teammate Jason Arnott scored the double overtime, Stanley Cup–winning goal at the opposite end of the ice, Devils goalie Martin Brodeur (opposite) jumped for joy in front of his goal in Reunion Arena.

Penguins center Tyler Wright (left, 29) grappled with Philadelphia defenseman Mark Eaton (44) during Pittsburgh's 4–1 victory in Game 2 of the Eastern Conference semifinals. Five days later the Flyers beat the Pens 2–1 in the third-longest game in NHL history, a quintuple overtime thriller.

PROFILES

SCOTT GOMEZ

The New Jersey Devils were deep into their NHL-mandated sensitivity training in mid-December—the echoes of ethnic slurs in their sport reverberating faintly in their ears—when the diversity counselor turned to rookie Scott Gomez and simply asked him what he wanted out of life. Gomez is the first native-born Alaskan to play in the NHL. His father was born in California to illegal Mexican immigrants. His mother was born in Colombia. If affirmative action demands a first-generation Alaskan-Hispanic center-left wing, the list of job applicants will be short. Gomez considered the counselor's question with all the solemnity due the moment before blurting, "I want to date a model."

"This is a really serious session, and we're, like, Ohmigod!" Devils goalie Martin Brodeur says. "He cracked us up. This kid's unbelievable."

There has been some debate about this episode in the past 10 weeks—Gomez swears he was kidding, while teammates insist he was as serious as an audit—but that's the beauty of the world of Scott Gomez: He can have it both ways. He can prattle on at breakneck speed over lunch, a bundle of nerves, his knees jiggling under the table, his eyes darting, yet, with game time 10 minutes away and his teammates getting psyched up to play, he can sprawl on a couch in full gear in the Devils' lounge, absorbed in a *USA Today* story about Jennifer Aniston, his favorite actress. "I've been in the league 18 years, and I'm more nervous than he is," says New Jersey captain Scott Stevens. "Guys are always telling him to watch his heartbeat because as far as we can tell, he doesn't have one."…

This season has been a series of firsts for Scott: the first real job, the first apartment, the first time he absolutely had to be on time, the first paycheck. The difference between Gomez and the roughly 600 other NHL players is that when he received that first check—with bonuses, he could make close to $1 million in 1999–2000—he looked at the total and never at the deductions. He was introduced by the public address announcer during a New Jersey Nets game. He had never been singled out as a celebrity before, unless you count the time at the Thursday-night fights at the Egan Center in his hometown, Anchorage, when the P.A. man told the crowd that Scott Gomez, the two-time Alaska high school hockey player of the year, was in the house. …

Gomez playing for the Devils is like Peter Pan getting a corner office at The Firm, which is also the nickname given to the New Jersey organization by some veterans in the early 1990s. There's blunt general manager Lou Lamoriello, who has shaped a team that led the Eastern Conference by eight points through February. There's clench-fisted coach Robbie Ftorek. There's a hardened core of players who have been around the block and been embittered by stunning early playoff exits the past three years. The Devils are decidedly light on whimsy. "Maybe Scott represents a clash of cultures, but I think his approach is great for this team," says fourth-liner Jay Pandolfo, Gomez's roommate on the road. "He's always smiling, having fun. Older guys see how happy he is and think how happy we should all be, given where we are and what we take for granted."

Gomez (opposite)does more than put a smile button on the New Jersey logo. He adds numbers, enough of them to be the leading scorer on the most prolific team in the East and the odds-on favorite for the rookie of the year award. …

Gomez is a knock-kneed and pigeon-toed skater who scuttles around the ice hunched like a question mark. His shot is so unprepossessing that teammates predicted he would score a hat trick against Buffalo Sabres goalie Dominik Hasek last week because Hasek would get bored waiting for the puck to reach the net. Gomez settled for one goal. His hands, however, are lullaby soft, and his passing is as accurate as it is sometimes needlessly bold. "No doubt Scott's a great passer and has great vision," Ftorek says. "That's not something you're born with. That came from good coaching or good advice from a coach or a father or a linemate, someone who could show him the fine points of the game."

Gomez was largely self-taught in hockey, having studied the geometry of the sport in his living room with a stick and a tennis ball. He would pretend to play for the Hartford Whalers—he figured the Carolina Hurricanes' forebears were the team most in need of a star—and simulate games against the dashing Edmonton Oilers of the 1980s. He would keep detailed notes of his one-man tournaments, a boy's love letters to a game that had gripped him from the second time he played.

The first time, he wanted to quit. "He was four. He told me he didn't like it and wanted to quit, so I said, 'Sure,' " says his mother, Dalia, who works at an Anchorage hospital as a breast-feeding counselor. "I'm like that."

"He fell on his butt a couple of times. He was a mama's boy, and he was whining," [his father] Carlos says. "I'd just spent $50 for a new pair of skates. No way in hell am I going to let him quit the first day. My wife and I worked out a deal that kept her away from hockey. She could baby him after."

While his background may be unique for a hockey player—he hails from a state that has produced only four NHL players—Gomez took a fairly standard path to the NHL: three years of high school hockey; one year of Tier II in

and Telemundo interviews in English, undermining the marketing impact of the NHL's nominal Hispanic star. ...

Maybe in three years or so Gomez will be different. If any franchise can squeeze the joy out of the game and transform him into an emotionally desiccated shell, New Jersey can. ...

"Sure I have my bad days, but never really in hockey," Gomez says. "You've got to look at the big picture. As a kid this is all that's on your mind, chasing a dream. And I'm doing it. That's pretty good, right?"

There have been so many moments for him in such a short time. He had a hat trick at Madison Square Garden against the New York Rangers with his parents in the stands. ... He sat next to Mark Messier in the dressing room at the All-Star Game, and Wayne Gretzky sauntered in, complimented Gomez on his start and posed with him for a picture. But the best moment of the season occurred before it even began. Some of the Devils were in an Atlanta hotel lobby waiting for him to join them and go to dinner on the eve of the opener, but Gomez lingered in his room, looking around at his swell digs and soaking in his good fortune. It was only mid-afternoon in Anchorage, and he knew his parents wouldn't be home, but he picked up the telephone anyway. He left a message: "Wow, I'm here. I don't know how long it will last, but I'm here."

—Michael Farber
excerpted from SI, March 6, 2000

South Surrey, B.C., (and an $1,800 phone bill because of homesickness); and two seasons of major junior for Tri-City in Kennewick, Wash. The Devils then landed him with the 27th pick in the first round of the 1998 draft after trading a pair of second-rounders to move up.

His parents' histories are more rococo. Carlos was born 47 years ago in Modesto, the sixth of 10 children of migrant crop pickers. The family was sent back to Mexico when Carlos was young, but he returned to San Diego—he was a U.S. citizen by birth—at six because an aunt who lived there thought he'd have better opportunities in America. When some of

his older brothers moved to Alaska to work in construction in the 1960s and '70s, Carlos, an ironworker, joined them. He has been an Alaskan since '72, six years after Dalia arrived. She'd moved from Medellin to Brooklyn with an aunt in '61, and they relocated to Alaska to be with family. Carlos met Dalia when she was in high school and they eloped within a year.

While Dalia was fluent in Spanish, Carlos spoke what he calls "border Spanish," so they compromised and spoke English around the house, a decision that is now tinged with regret. Scott, who understands Spanish but doesn't speak it well, has had to do PEOPLE EN ESPAÑOL

CHRIS PRONGER

Not since Bobby Orr blazed end-to-end trails for the Bruins in 1971–72 has a defenseman won the Hart Trophy. The Blues' Chris Pronger (below right) possesses little of Orr's otherworldly offensive magnificence, yet if the hockey writers who vote for league MVP take to heart the criterion for the Hart—"the player adjudged to be the most valuable to his team"—the 25-year-old Pronger will have to clear space on his mantel. "He's the most dominant player in the league," says Flyers right wing Rick Tocchet. "He shuts everybody down."

As the captain and defensive lifeblood of the NHL's best and stingiest team—St. Louis was 50-18-11-0 through Sunday, April 2, and had allowed only 1.94 goals per game—Pronger was logging a league-high 30:13 of ice time per game. His stamina allows the rest of the Blues' defensemen to remain rested and has enabled St. Louis to weather injuries that sidelined star blueliner Al MacInnis for 21 games.

At 6' 6" and 220 pounds, Pronger takes control of a game with his formidable strength and reach. The puck may enter the Blues' zone on an opponent's stick, but it most often comes out on Pronger's. He had been on the ice for a minuscule 43 even-strength goals-against this season, and he has helped hold the NHL's top five scorers—the Penguins' Jaromir Jagr, the Panthers' Pavel Bure, the Flyers' Mark Recchi, the Sharks' Owen Nolan and the Blackhawks' Tony Amonte—without an even-strength point in 14 games.

Pronger also had 58 points and a +49 rating, both second among league defensemen, and his Hart candidacy has added legs to what would otherwise be a match race between Jagr and Bure. Jagr is the NHL's most irrepressible offensive force (league-best 1.56 points per game, but he missed 14 games in the last six weeks because of injuries), and Bure is its most explosive entertainer (NHL-leading 55 goals). With the exception of Sabres goalie Dominik Hasek, who won the Hart Trophy after the 1996–97 and 1997–98

seasons, the award has gone to a high-scoring forward every year since Orr won it. "A defenseman is as important as a star forward or a goalie," says Pronger. "A lot of times that gets overlooked. Maybe we can change that."

The we includes premier blueliners such as the Kings' hard-hitting Rob Blake and the Red Wings' silky Nicklas Lidstrom and ferocious Chris Chelios. So fine is that back line batch that even as we give Pronger our vote for the Hart, he's only our runner-up for the Norris Trophy. The Norris goes to the defenseman who demonstrates "the greatest all-around ability in the position," and this

season that has been Lidstrom. Less imposing than Pronger but far smoother, Lidstrom led defensemen with 20 goals and 73 points while also playing nearly perfect positional defense. This is the year to rock the vote: Lidstrom deserves the Norris; Pronger, the Hart.

—Kostya Kennedy
SI, April 10, 2000

Pronger did win the 2000 Hart Trophy, and he also took the Norris as the top defenseman, but the Blues, who finished with a league-best 114 points in the regular season, were bounced out of the playoffs in the first round by San Jose. —Ed.

CHRIS SIMON

Without left wing Chris Simon (above, 17), the Avalanche might not have won the Stanley Cup in 1996. Colorado trailed the Blackhawks two games to one in the second round of the playoffs that year when Chicago enforcer Bob Probert delivered a crushing check to high-scoring Avalanche center Joe Sakic early in Game 4. Simon, who is 6' 4" and 230 pounds, has fists the size of country hams and had amassed 250 penalty minutes in the regular season, sought to avenge the hit. Late in the first period he cornered Probert and pummeled him. The other Colorado players got fired up, and coach Marc Crawford credited Simon with inspiring the Avalanche, who rallied to win the series in six games.

After he and Colorado couldn't break a stalemate over terms of a new contract, Simon was traded to the Capitals in a five-player deal in November 1996. On his most recent trip to Chicago, on Feb. 18, Simon watched from the bench as Probert exchanged blows with the Caps' newly acquired heavyweight, Jim McKenzie. Simon's contribution to Washington's

5–4 win? He had a goal and two assists. "I love it," he says. "Scoring is much more fun than fighting."

Simon has been having plenty of fun lately. Through March 5, his 22 goals led the Capitals, who had gone 22-5-6-0 since Dec. 27, to pull even with the Panthers atop the Southeast Division. Capitalizing on the superb passing of center Adam Oates, Simon has used a wicked wrist shot and his strength around the net to show a side of himself few fans had ever seen.

Though he had 72 goals and 142 points in 110 junior games from 1989–90 through '91–92, Simon was so physically imposing and such a first-rate fighter that he was typecast as a goon when he arrived in the NHL at the start of the '92–93 season. He played minimally, spending much of his time in the penalty box, and his rough-housing exacerbated a chronically injured right shoulder that limited him to a total of 93 games over the last three years. Before the 1999–2000 season Simon had only 43 goals in 239 NHL games.

Then, on a Dec. 22 flight from Vancou-

ver, Simon heard words that, he says, "changed my life." He had missed that night's match with a neck strain, but had scored in each of the three previous games. Somewhere over middle America, general manager George McPhee took Simon aside. "I told him I wanted him to fight less and play more," says McPhee. "I was tired of losing him to a penalty when the other team would only lose some guy who couldn't play. And I didn't want him getting injured. I told him we needed him on the ice."

Simon's new role was cemented when the Caps signed McKenzie off waivers on Jan. 20, to, in the words of coach Ron Wilson, "take the pressure off Si." The pressure on Simon now is to convert Oates's soft passes. That isn't to say the old Simon has completely disappeared. "You can still tell that at some point he might go off," says Red Wings forward Kris Draper. "It's just that now you also have to be careful he doesn't score on you."

—Kostya Kennedy
SI, March 13, 2000

45

NHL Final Standings

EASTERN CONFERENCE
Northeast Division

	GP	W	L	T	RT	GF	GA	PTS
Toronto	82	45	30	7	3	246	222	100
Ottawa	82	41	30	11	2	244	210	95
Buffalo	82	35	36	11	4	213	204	85
Montreal	82	35	38	9	4	196	194	83
Boston	82	24	39	19	6	210	248	73

Atlantic Division

	GP	W	L	T	RT	GF	GA	PTS
Philadelphia	82	45	25	12	3	237	179	105
New Jersey	82	45	29	5	5	251	203	103
Pittsburgh	82	37	37	8	6	241	236	88
NY Rangers	82	29	41	12	3	218	246	73
NY Islanders	82	24	49	9	1	194	275	58

Southeast Division

	GP	W	L	T	RT	GF	GA	PTS
Washington	82	44	26	12	2	227	194	102
Florida	82	43	33	6	6	244	209	98
Carolina	82	37	35	10	0	217	216	84
Tampa Bay	82	19	54	9	7	204	310	54
Atlanta	82	14	61	7	4	170	313	39

WESTERN CONFERENCE
Central Division

	GP	W	L	T	RT	GF	GA	PTS
St. Louis	82	51	20	11	1	248	165	114
Detroit	82	48	24	10	2	278	210	108
Chicago	82	33	39	10	2	242	245	78
Nashville	82	28	47	7	7	199	240	70

Pacific Division

	GP	W	L	T	RT	GF	GA	PTS
Dallas	82	43	29	10	6	211	184	102
Los Angeles	82	39	31	12	4	245	228	94
Phoenix	82	39	35	8	4	232	228	90
San Jose	82	35	37	10	7	225	214	87
Anaheim	82	34	36	12	3	217	227	83

Northwest Division

	GP	W	L	T	RT	GF	GA	PTS
Colorado	82	42	29	11	1	233	201	96
Edmonton	82	32	34	16	8	226	212	88
Vancouver	82	30	37	15	8	227	237	83
Calgary	82	31	41	10	5	211	256	77

RT=regulation ties—games lost in overtime; worth 1 pt.

NHL Individual Leaders

SCORING
Points

PLAYER AND TEAM	GP	G	A	PTS	+/−	PM
Jaromir Jagr, Pitt	63	42	54	96	25	50
Pavel Bure, Fla	74	58	36	94	25	16
Mark Recchi, Phil	82	28	63	91	20	50
Paul Kariya, Ana	74	42	44	86	22	24
Teemu Selanne, Ana	79	33	52	85	6	12
Tony Amonte, Chi	82	43	41	84	10	48
Owen Nolan, SJ	78	44	40	84	-1	110
Joe Sakic, Col	60	28	53	81	30	28
Mike Modano, Dall	77	38	43	81	0	48
Steve Yzerman, Det.	78	35	44	79	28	34
Brendan Shanahan, Det	78	41	37	78	24	105
Jeremy Roenick, Phoe	75	34	44	78	11	102
John LeClair, Phil	82	40	37	77	8	36
Valeri Bure, Cal	82	35	40	75	-7	50
Luc Robitaille, LA	71	36	38	74	11	68
Mats Sundin, Tor	73	32	41	73	16	46
Ron Francis, Car	78	23	50	73	10	18
Nicklas Lidstrom, Det	81	20	53	73	19	18
Doug Weight, Edm	77	21	51	72	6	54
Milan Hejduk, Col	82	36	36	72	14	16

SCORING (CONT.)
Goals

PLAYER AND TEAM	GP	G
Pavel Bure, Fla	74	58
Owen Nolan, SJ	78	44
Tony Amonte, Chi	82	43
Paul Kariya, Ana	74	42
Jaromir Jagr, Pitt	63	42

Game-Winning Goals

PLAYER AND TEAM	GP	GW
Pavel Bure, Fla	74	14
Jeremy Roenick, Phoe	75	12
Four tied with nine.		

Assists

PLAYER AND TEAM	GP	A
Mark Recchi, Phil	82	63
Adam Oates, Wash	82	56
Jaromir Jagr, Pitt	63	54
Nicklas Lidstrom, Det	81	53
Viktor Kizlov, Fla	80	53
Joe Sakic, Col	60	53

SCORING (CONT.)
Power Play Goals

PLAYER AND TEAM	GP	PP
Owen Nolan, SJ	78	18
Mariusz Czerkawski, NYI	79	16
Steve Yzerman, Det	78	15
Six tied with 13.		

Short-Handed Goals

PLAYER AND TEAM	GP	SHG
John Madden, NJ	74	6
Tony Amonte, Chi	82	5
Seven tied with four.		

Plus/Minus

PLAYER AND TEAM	GP	+/−
Chris Pronger, StL	79	52
Chris Chelios, Det	81	48
Scott Stevens, NJ	78	30
Joe Sakic, Col	60	30
Pierre Turgeon, StL	52	30

Goaltending

Goals Against Average (Minimum 25 games)

PLAYER AND TEAM	GP	MINS	GA	AVG
Brian Boucher, Phil	35	2038	65	1.91
Roman Turek, StL	67	3960	129	1.95
Jose Theodore, Mtl	30	1665	58	2.10
Ed Belfour, Dall	62	3620	127	2.10
John Vanbiesbrouck, Phil	50	2950	108	2.20
Dominik Hasek, Buff	35	2066	76	2.21
Olaf Kolzig, Wash	73	4371	163	2.24

Wins

PLAYER AND TEAM	GP	MINS	W	L	T
Martin Brodeur, NJ	72	4312	43	20	8
Roman Turek, StL	67	3960	42	15	9
Olaf Kolzig, Wash	73	4371	41	20	11
Curtis Joseph, Tor	63	3801	36	20	7
Arturs Irbe, Car	75	4345	34	28	9
Ed Belfour, Dall	62	3620	32	21	7
Patrick Roy, Col	63	3704	32	21	8

Save Percentage (Minimum 25 games)

PLAYER AND TEAM	GP	GA	SA	PCT	W	L	T
Ed Belfour, Dall	62	127	1444	.919	32	21	7
Jose Theodore, Mtl	30	58	659	.919	12	13	2
Dominik Hasek, Buff	35	76	861	.919	15	11	6
Mike Vernon, Fla	34	83	937	.919	18	13	2
Brian Boucher, Phil	35	65	725	.918	20	10	3
Olaf Kolzig, Wash	73	163	1794	.917	41	20	11
Curtis Joseph, Tor	63	158	1696	.915	36	20	7

Shutouts

PLAYER AND TEAM	GP	MINS	SO	W	L	T
Roman Turek, StL	67	3960	7	42	15	9
Martin Brodeur, NJ	72	4312	6	43	20	8
Chris Osgood, Det	53	3148	6	30	14	8
Olaf Kolzig, Wash	73	4371	5	41	20	11
Arturs Irbe, Car	75	4345	5	34	28	9
Martin Biron, Buff	41	2229	5	19	18	2
Fred Brathwaite, Cal	61	3448	5	25	25	7
Jose Theodore, Mtl	30	1665	5	12	13	2

NHL Awards

AWARD	PLAYER AND TEAM
Hart Trophy (MVP)	Chris Pronger, StL
Calder Trophy (top rookie)	Scott Gomez, NJ
Vezina Trophy (top goaltender)	Olaf Kolzig, Wash
Norris Trophy (top defenseman)	Chris Pronger, StL
Lady Byng Trophy (for gentlemanly play)	Pavol Demitra, StL
Adams Award (top coach)	Joel Quenneville, StL
Selke Trophy (top defensive forward)	Steve Yzerman, Det
Jennings Trophy (goaltender on club allowing fewest goals)	Roman Turek, StL
Conn Smythe Trophy (playoff MVP)	Scott Stevens, NJ

2000 Stanley Cup Playoffs

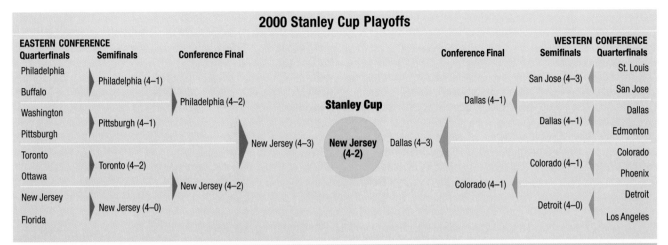

EASTERN CONFERENCE

Quarterfinals	Semifinals	Conference Final		Conference Final	Semifinals	Quarterfinals

WESTERN CONFERENCE

Philadelphia

Buffalo
→ Philadelphia (4–1)
→ Philadelphia (4–2)

Washington

Pittsburgh
→ Pittsburgh (4–1)

Toronto

Ottawa
→ Toronto (4–2)

New Jersey

Florida
→ New Jersey (4–0)
→ New Jersey (4–2)
→ New Jersey (4–3)

Stanley Cup

New Jersey (4-2)

Dallas (4–3)

Dallas (4–1)

Dallas (4–1)

Colorado (4–1)

Colorado (4–1)

Detroit (4–0)

St. Louis

San Jose
← San Jose (4–3)

Dallas

Edmonton
← Dallas (4–1)

Colorado

Phoenix
← Colorado (4–1)

Detroit

Los Angeles
← Detroit (4–0)

Stanley Cup Championship Box Scores

GAME 1

Dallas	1	0	2—	3
New Jersey	1	3	3—	7

First Period

Scoring: 1, NJ, Arnott 5 (Sykora, Elias), 7:22. 2, Dall, Sydor 1 (Lehtinen, Keane), 13:13. Penalties: None.

Second Period

Scoring: 3, NJ, Daneyko 1 (Brylin, Madden), 2:52. 4, NJ, Sykora 7 (Elias, Arnott), 10:28. 5, NJ, Stevens 3 (Pandolfo, Rafalski), 16:04. Penalties: Hatcher, Dall (slashing), 18:20.

Third Period

Scoring: 6, NJ, Brylin 2 (McKay), 2:21. 7, NJ, Sykora 8 (Arnott, Elias), 3:02. 8, NJ, Arnott 6 (power play) (Holik, Sykora), 5:12. 9, Dall, Sim 1 (Carbonneau), 7:43. 10, Dall, Muller 2 (Carbonneau), 7:43. Penalties: Thornton, Dall (roughing), 3:35; Manson, Dall (slashing), 12:05; Manson, Dall (elbowing), 19:55.
Shots on goal: Dallas—5-7-6—18. NJ—7-9-10—26.
Power-play opportunities: Dall 0 of 0, NJ 1 of 4. Goalies: Dall, Belfour (18 shots, 12 saves), Fernandez (8 shots, 7 saves), NJ Brodeur (18 shots, 15 saves). A: 19,040.
Referees: Koharski, McCreary. Linesmen: Scapinello, Sharrers.

GAME 2

Dallas	1	0	1—	2
New Jersey	1	0	0—	1

First Period

Scoring: 1, Dall, Hull 10 (Modano, Matvichuk), 4:25. 2, NJ, Mogilny 4 (Gomez, Stevens), 12:42. Penalties: Lemieux, NJ (holding), 8:20; Sloan, Dall (roughing), 10:56; Rafalski, NJ (roughing), 10:56; Matvichuk, Dall (roughing), 13:52; Holik, NJ (roughing), 13:52; Matvichuk, Dall (roughing), 18:27.

Second Period

Scoring: None. Penalties: None.

Third Period

Scoring: 3, Dall, Hull 11 (Lehtinen, Modano), 15:44. Penalties: Sim, Dall (hooking), 10:48.
Shots on goal: Dall—3-7-7—17. NJ—9-8-11—28.
Power-play opportunities: Dall 0-of-1; NJ 0-of-2.
Goalies: Dall, Belfour (28 shots, 27 saves), NJ, Brodeur (17 shots, 15 saves). A: 19,040.
Referees: Fraser, Marouelli. Linesmen: Broseker, Schachte.

GAME 3

New Jersey	1	1	0—	2
Dallas	1	0	0—	1

First Period

Scoring:1, Dall, Cote 2 (power play) (unassisted), 13:08. 2, NJ, Arnott 7 (Rafalski, White), 18:06. Penalties: Nemchinov, NJ (slashing), 12:46; Malakhov, NJ (interference), 13:51; Lemieux, NJ (cross checking), 15:02.

Second Period

Scoring: 3, NJ, Sykora 9 (power play) (Arnott, Rafalski), 12:27. Penalties: Hull, Dall (interference), 8:09; Cote, Dall (elbowing), 11:03.

Third Period

Scoring: None. Penalties: Brodeur, NJ served by Arnott (Delay of game), 15:45.
Shots on goal: NJ—10-16-5—31. Dall—7-9-7—23.
Power-play opportunities: NJ 1-of-2; Dall 1-of-4.
Goalies: NJ, Brodeur (23 shots, 22 saves), Dall, Belfour (31 shots, 31 saves). A: 17,001.
Referees: Gregson, Koharski. Linesmen: Scapinello, Sharrers.

GAME 4

New Jersey	0	0	3—	3
Dallas	0	1	0—	1

First Period

Scoring: None. Penalties: Morrow, Dall (tripping), 14:38; Manson, Dall (slashing), 17:27; Niedermayer, NJ (holding), 19:34.

Second Period

Scoring: 1, Dall, Nieuwendyk 7 (power play) (Sydor, Hull), 18:02. Penalties: Sykora, NJ (hooking), 5:45; Keane, Dall (boarding), 8:45; McKay, NJ (hooking), 11:59; Malakhov, NJ (cross checking), 16:38.

Third Period

Scoring: 2, NJ, Brylin 3 (Mogilny, Malakhov), 2:27. 3, NJ, Madden 3 (shorthanded) (Nemchinov, Daneyko), 4:51. 4, NJ, Rafalski 2 (Elias), 6:08. Penalties: White, NJ (interference), 3:17; Sim, Dall (slashing), 11:43.
Shots on goal: NJ—8-8-15—31. Dall—6-7-4—17.
Power-play opportunities: NJ 0-of-4; Dall 1-of-5.
Goalies: NJ, Brodeur (17 shots, 16 saves), Dall, Belfour (31 shots, 28 saves). A: 17,001.
Referees: Fraser, McCreary. Linesmen: Broseker, Schachte.

GAME 5

Dallas	0	0	0	0	1—	1
New Jersey	0	0	0	0	0—	0

First Period

Scoring: None. Penalties: Hatcher, Dall (hooking), 11:01; Holik, NJ (interference), 11:43.

Second Period

Scoring: None. Penalties: Sykora, NJ (high sticking), 17:01.

Third Period

Scoring: None. Penalties: Morrow, Dall (tripping), 13:45.

Third Overtime

Scoring: 1, Dall, Modano 10 (Hull, Lehtinen), 6:21.
Shots on goal: Dall—11-6-5-5-12-2—41. NJ—7-11-9-10-8-3—48. Power-play opportunities: Dall 0-of-2; NJ 0-of-3. Goalies: Dall, Belfour (48 shots, 48 saves); NJ, Brodeur (41 shots, 40 saves). A: 19,040.
Referees: Marouelli, Koharski. Linesmen: Scapinello, Sharrers.

GAME 6

New Jersey	0	1	0	0	1—	2
Dallas	0	1	0	0	0—	1

First Period

Scoring: None. Penalties: Daneyko, NJ (slashing), 4:46; Sim, Dall (elbowing), 6:54; Daneyko, NJ (high sticking), 13:45.

Second Period

Scoring: 1, NJ, Niedermayer 5 (shorthanded) (Lemieux, Pandolfo), 5:18. 2, Dall, Keane 2 (Thornton, Modano), 6:27. Penalties: Rafalski, NJ (holding), 3:30; Stevens, NJ (roughing), 13:48; Hatcher, Dall (roughing), 13:48; White, NJ (roughing), 19:21; Thornton, Dall (roughing), 19:21.

Third Period

Scoring: None.

Second Overtime

Scoring: 3, NJ, Arnott 8 (Elias, Stevens), 8:20.
Shots on goal: NJ—11-13-7-11-3—45. Dall—7-9-13-1-1—31. Power-play opportunities: NJ 0-of-1; Dall 0-for-4. Goalies: NJ, Brodeur (31 shots, 30 saves); Dall, Belfour (45 shots, 43 saves). A: 17,001.
Referees: Gregson, McCreary. Linesmen: Broseker, Schachte.

Heart and Soul

Michigan State had plenty of the former and helped college basketball recover the latter in a season of self-doubt and scandal ■ B.J. Schecter

Nearly lost amid the tales of seedy summer coaches and greedy agents, half buried by the steady flow of players leaving school early, and almost obscured by the increasingly popular notion that the college game has lost its luster, were a coach and a team that reminded us why we fell in love with NCAA basketball in the first place. When it appeared that the game may have suffered irreparable damage, along came Tom Izzo and Michigan State. Izzo's Spartans proved that the lure of the NBA and the temptations of agents had not drained the college game of all of its top players or its core values, which include the notion that to win a national championship you need wisdom and experience—i.e., upperclassmen—to go along with heart and desire.

Nobody epitomized heart and desire more than Michigan State's senior point guard Mateen Cleaves, who put the NBA on hold and returned to East Lansing for his senior season, only to suffer a broken right foot in preseason practice. He would miss the Spartans' first 13 games, but Cleaves handled the situation remarkably well and without complaint until Michigan State's nationally televised game at North Carolina on Dec 1. At the shootaround the day before the game, Cleaves had to choke back tears as he gazed up at Michael Jordan's jersey in the rafters and then at his broken foot, wondering if he had made a huge mistake by coming back to school. Frustrated by his injury

and what he perceived as the Spartans' lackadaisical attitude during the shootaround, Cleaves unleashed his anger with a fiery speech to his teammates in the locker room before the game, which the Spartans, duly inspired, won 86–76.

And when he rejoined the team in January, Cleaves's determination had redoubled. His game was a little rusty, but his leadership skills were as sharp as ever. When the Spartans weren't playing well, Izzo never had to worry about the team missing his message: Cleaves was always there to drive the point home. Sometimes he even went further. When No. 1–seeded Michigan State trailed Syracuse by 10 points at halftime in the second round of the NCAA tournament, it was Cleaves, not Izzo, who delivered a profanity-laced tirade to the team in the locker room. The Spartans rallied to win the game 75–58.

In the Midwest Regional final against second-seed Iowa State, Cleaves made two steals, blocked two shots and scored 10 points to propel the Spartans to a hard-fought 75–64 victory and into the Final Four for the second consecutive year. There the Spartans faced their Big Ten rivals, the Wisconsin Badgers, who lived up to their nickname with a harassing defense. The eighth-seeded Badgers had scratched their way past three favored opponents, including No. 1–seed Arizona, to reach the Final Four.

The Spartans' inspirational leader all season, Cleaves (opposite, with ball) scored 18 points and bounced back from a sprained ankle in the title game to lead Michigan State to victory over Florida.

49

Kelly Schumacher (11) and Connecticut rejected Tennessee's claim on the women's national title, blasting the Vols 71–52 in the NCAA championship game after the teams had split two regular-season meetings.

Michigan State had beaten Wisconsin three times during the season, most recently in the semifinals of the Big Ten tournament, but this game was anything but easy. It wasn't easy on the eyes, either. The first half was uglier than a Pop Warner football game, with a score to match, as Michigan State led 19–17 at the break. The early pace played right into the Badgers' claws, but Izzo and Cleaves kept their team composed and the Spartans gradually pulled away, winning 53–41. Michigan State had more rebounds (42) than the Badgers had points. Cleaves was just happy it was over. "Whenever you play Wisconsin it's going to be an ugly game," he said. "I'm just glad I don't have to play them again. Ever."

Florida coach Billy Donovan was probably thinking the same thing about Cleaves after the point guard's performance against his Gators in the national championship game. The youthful Gators were one of the biggest surprises of the season and perhaps gave us a glimpse of where college basketball is headed. Inexperienced but talented, naive but bold, Florida dashed to the championship game with upset victories over top-seeded Duke and third-seed Oklahoma State before knocking off North Carolina, another dark horse team, in the semifinals. Donovan, 34, a former Providence College star and Rick Pitino disciple, marshaled a run-and-gun group that went 12 deep. More important, Donovan's Gators regularly forced turnovers with a swarming, suffocating defense.

Some observers thought Florida might surprise Michigan State, but the Spartans proved early on that they could muzzle the Gators and their vaunted defense. Cleaves, his backcourt mate Charlie Bell and forward Morris Peterson were flawless, forcing Donovan to abandon the press 16 minutes into the first half. Michigan State led 43–32 at intermission and appeared to be in control, but the young Gators made a run early in the second half. They'd cut the Spartans' lead to six when things almost came crashing down entirely for Michigan State. Attempting a layup, Cleaves got tangled with Florida guard Teddy Dupay. Dupay grabbed Cleaves and inadvertently hooked his right foot around Cleaves's right ankle, sending the Spartan point guard awk-

wardly to the floor. Cleaves's ankle wrenched grotesquely on impact. His face registering excruciating pain, he looked toward the Michigan State bench and mouthed, "It's broke, it's broke."

Thinking Dupay had deliberately tried to hurt Cleaves, Izzo was livid. He gathered his team together and said, "We're going to war! They took out our leader. Who's going to step up?" The entire team responded. Bell ran the point as smoothly as he had during Cleaves's 13-game absence in the regular season; Peterson took control inside with silky moves to the hoop; and A.J. Granger and Mike Chappell were deadly from three-point range. During the 4 1/2 minutes that Cleaves was out, Michigan State increased its lead.

While his teammates held the fort, Cleaves writhed in agony as trainers worked on his ankle. "I dropped a couple of tears," he said, "but I told the trainer he'd have to amputate my leg to keep me out of this one." Cleaves limped back to the Michigan State bench, about to pull a Willis Reed. He hobbled past Izzo to the scorers' table, and the RCA Dome thundered with the cheers of the Spartan faithful. Cleaves didn't score a point during the final 12 minutes (he finished the game with 18), but he didn't have to. His return was like an adrenaline injection to his teammates, who ran away with the game 89–76.

When the final buzzer sounded, Cleaves hugged everyone from his mother, Frances, to Michigan State legend Magic Johnson, but the impact of the accomplishment had yet to hit him. A few minutes later, leaning on a pair of crutches at midcourt, he watched a video monitor replay highlights of the tournament to the tune of the song "One Shining Moment." When the Spartans appeared onscreen at the end, Cleaves stared, mouth agape, and began to sob. His mother embraced him, and all Cleaves could say was, "Oh, my god, we did it. We actually did it."

There were plenty of shining moments in the early rounds of the NCAA tournament but few of the perennial stunning upsets. St. Bonaventure and Butler, No. 12 seeds both, almost pulled off shockers, but each lost to No. 5 seeds in the first round. The Bonnies had Kentucky on the ropes, forcing two overtimes before losing 85–80. Butler, the host school for the Final Four in Indianapolis, led Florida by one point with 8.1 seconds to play in overtime, but the Gators' Mike Miller broke the underdogs' hearts with a buzzer-beater, and Florida escaped with a 69–68 victory. The Big Dance of 2000 will be remembered as the year Cinderella stayed home. In fact, the Sweet 16 included only one team (Wisconsin) that had not been ranked in the Associated Press Top 25 during the regular season.

An unfortunate subplot to the tournament was the career-threatening injury to Cincinnati star and national player of the year Kenyon Martin. Thanks largely to Martin's dominance, the Bearcats were ranked No. 1 in the nation for most of the season; this was supposed to be their year. Like Cleaves, Martin had spurned the NBA draft to return for his senior season and a shot at a championship. But a few days before the tournament began, Martin's, and Cincinnati's, season crumbled in an instant. The star forward broke his leg in a tangle beneath the basket during a quarterfinal Conference USA tournament game against Saint Louis. The Bearcats lost the game and, a week later, their previously guaranteed status as a No. 1 seed in the NCAAs. Demoted to the second seed in the South Regional, Cincinnati beat UNC Wilmington in the first round but lost to Tulsa in round 2. Happily, Martin recovered from his injury, and the New Jersey Nets made him the No. 1 pick in the 2000 NBA draft.

Lacking Cinderella, the 2000 tournament had Wisconsin, marginally more talented and considerably less attractive. The Badgers and their wily coach, Dick Bennett, resembled another team from Wisconsin with a crafty coach—Vince Lombardi's Green Bay Packers. Earthbound, scrappy, the Badgers emphasized defense and… defense. The five players Wisconsin put on the floor were far inferior to their counterparts from Fresno State, Arizona, LSU and Purdue, yet the Badgers beat every one of them to advance to the Final Four. "If we had to play teams one-on-one we'd lose every time," said Wisconsin junior forward Mark Vershaw.

The Badgers' run demonstrated that college basketball is above all a team game, and coaches like Bennett and North Carolina's Bill Guthridge can make a difference if they get all of their players on the same page. That took a while to happen this year in Chapel Hill, but when it did, the Tar Heels provided one of the tournament's most cheering story lines. Before the field was selected, there was talk that North Carolina (18–13) might miss the NCAAs for the first time since 1974. All season hoop-crazed Tar Heel fans were calling for Guthridge's head. After a loss to Wake Forest, one headline screamed: GUT-TER BALL. The Tar Heels lost twice to Wake and were swept by archrival Duke during the regular season. But they put it all

51

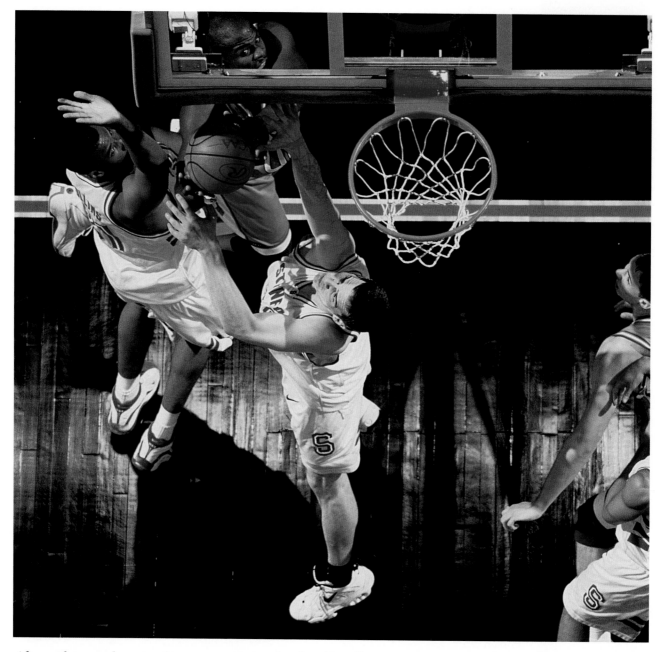

After a subpar regular season, Brendan Haywood (behind glass) and North Carolina exploded in the NCAAs, winning four games, including a 60–53 triumph over No. 1–seed Stanford.

together come tournament time, knocking off top-seeded Stanford and tough fourth-seed Tennessee en route to their second Final Four in three seasons under Guthridge. In Indianapolis, center Brendan Haywood pointedly said that any fan wishing to hop back on the Carolina bandwagon should "go root for [North Carolina] State."

If Carolina's regular season was bad, the rest of college basketball's was worse. Several players, including UCLA's JaRon Rush and his brother Kareem, a freshman at Missouri, were suspended for multiple games for illegally accepting money from their AAU summer-league coach. Programs

from UNLV to Duke were investigated for possible NCAA violations. And Indiana coach Bob Knight continued his tiresome antics. At the Big Ten Conference media day, much was made of the fact that Knight and former Hoosier star guard Steve Alford, the first-year coach at Iowa, didn't acknowledge one another. Apparently in response to the media, Knight entered the court behind the Iowa bench and shook Alford's hand prior to tip-off of a January meeting between the two teams in Bloomington. He then ripped reporters for making the Knight-Alford relationship an issue. On the eve of the NCAA tourna-

ment, CNN/SI aired a report in which former Hoosier Neil Reed accused Knight of choking him during a practice. Knight steadfastly denied the allegations, and a member of the Indiana board of trustees went so far as to say that he would "put no stock in" Reed's charges. A few weeks later CNN/SI obtained a copy of a 1997 practice tape showing Knight choking Reed.

Several other damning allegations—that he showed his team a soiled piece of toilet paper, berated a secretary and threatened the Indiana athletic director—later came to light, and it appeared that Knight would be fired. In early May the board of trustees ended their investigation and left the decision to school president Myles Brand. Brand caved in. Instead of removing Knight, he suspended the coach for three games, fined him $30,000 and instituted a zero-tolerance policy. Brand said that he had been ready to fire the man known in Bloomington as the General but that Knight, in an eleventh-hour meeting, convinced the president he could change. "He made a personal pledge to me to change his behavior," said Brand. "And I believe him." But Knight failed to uphold that pledge, and after a September incident with an IU undergrad, his 29-year career in Bloomington came to an end. Brand fired him.

Thankfully, the women's game was devoid of any sordid drama or controversy. The two best teams in the country, Connecticut and Tennessee, met for the title in a rubber match of what has become the best rivalry in women's college basketball. In 10 games against each other, each team had won five times, and in every encounter either a No. 1 ranking, a Final Four berth, an appearance in the championship game or the national title had been at stake. The two teams split during the regular season as UConn won in Knoxville and Tennessee handed the Huskies their only loss of the season, in Storrs.

It had been five years to the day since the Huskies won their first championship (over Tennessee, naturally), and Connecticut would mark the anniversary with a performance to remember. There was little doubt that this had been the Huskies' year, and aside from a one-point loss to the Vols, Connecticut had outscored its opponents by an average of 30.6 points per game. But few expected the 71–52 pasting that UConn administered to coach Pat Summitt's team.

Tennessee's troubles began during the morning shootaround when it lost junior guard Kristen (Ace) Clement to a badly sprained ankle. Clement was in so much pain and screaming so loudly that Summitt had to ask her to calm down because she was "scar-

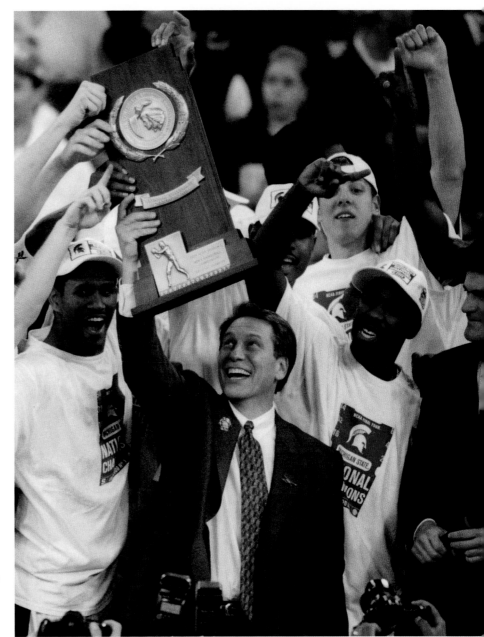

ing the team." The Huskies tied their own championship-game record by forcing 26 turnovers. They blocked 11 shots (a title game–record nine by Kelly Schumacher) and held All-Americas Tamika Catchings and Semeka Randall to a combined 22 points. "No question about it, they were awesome," said Summitt. "They schooled us."

So the 1999–2000 college basketball season will be remembered for the team that schooled its opponents and for the players who decided to stay in school. The men's regular season may have left us shaking our heads, but Michigan State and the UConn women did their best to redeem it.

Eyes on the Prize: With plenty of help from Cleaves (right), Izzo (center) led the Spartans to a 26–7 regular-season record, the Big Ten title, a top seed in the national tournament and college basketball's ultimate reward, the NCAA championship trophy.

PHOTO GALLERY

Read the Fine Print: Nick Collison of Kansas kept a close watch on the ball as he tried to corral a rebound in front of teammate Drew Gooden (0) and Iowa State's Marcus Fizer (5) during the Jayhawks' 64–62 home loss to the Cyclones on February 16.

Down and Out: The expressions of Tennessee coach Pat Summitt (left) and Vols All-America forward Tamika Catchings told the story of the women's NCAA championship game in Philadelphia as Tennessee was routed 71–52 by Connecticut, which won its second national title.

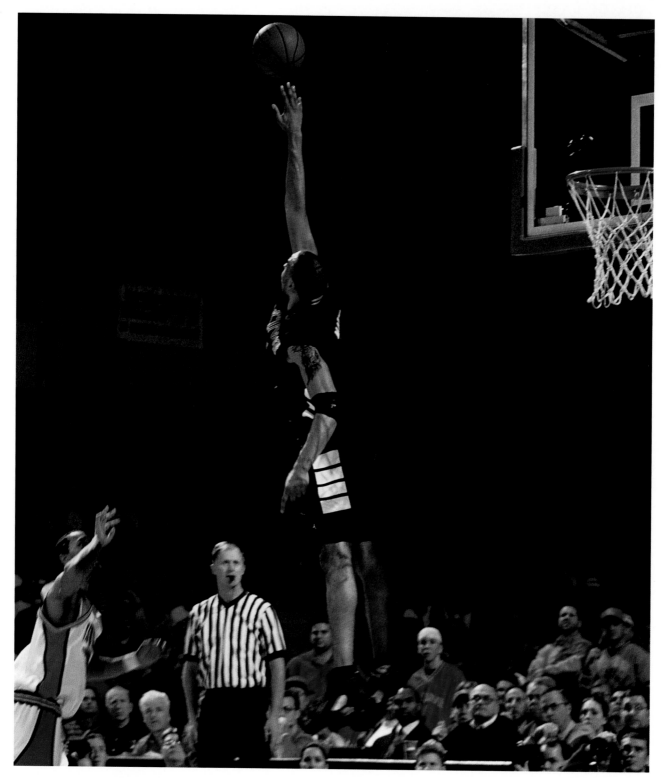

No one in college basketball was better at blocking or altering an opponent's shot than the majestic Kenyon Martin of Cincinnati, who recovered from a broken leg in the Conference USA tournament to become the No. 1 pick in the 2000 NBA draft.

Leap of Faith: Florida sophomore Mike Miller (13), who decided to take his chances in the NBA draft after the school year, soared to the hoop over Butler's Mike Marshall during the Gators' 69–68 OT win in the NCAAs.

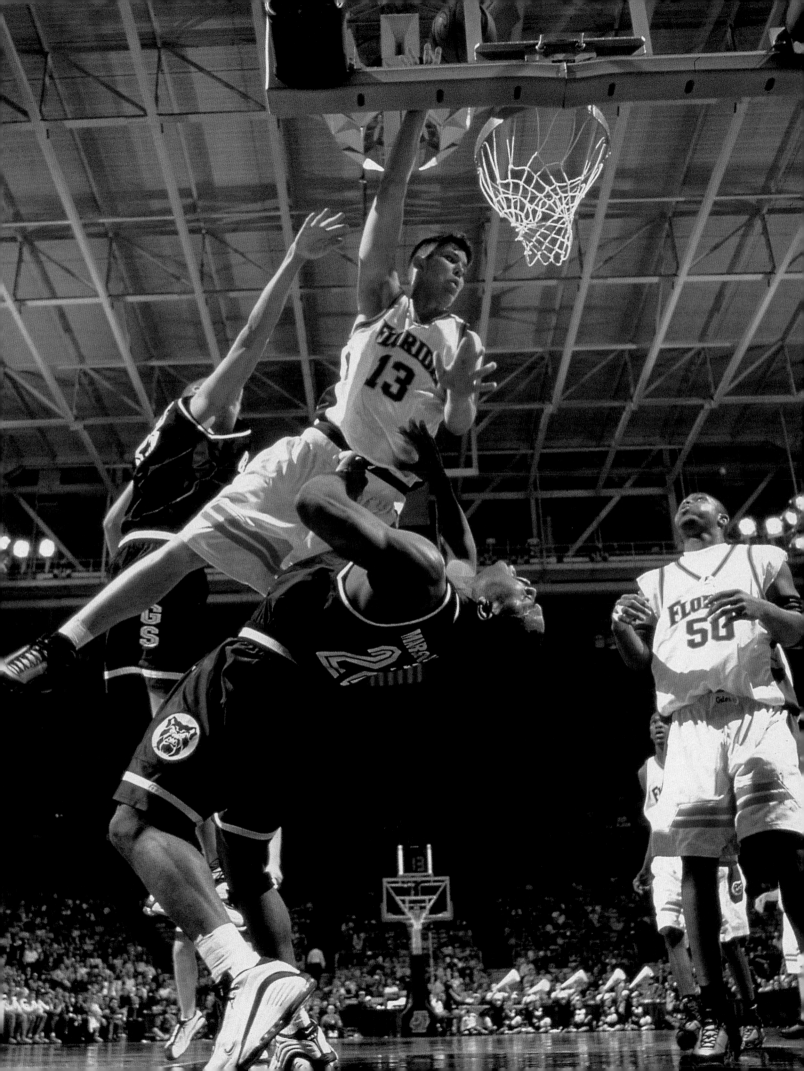

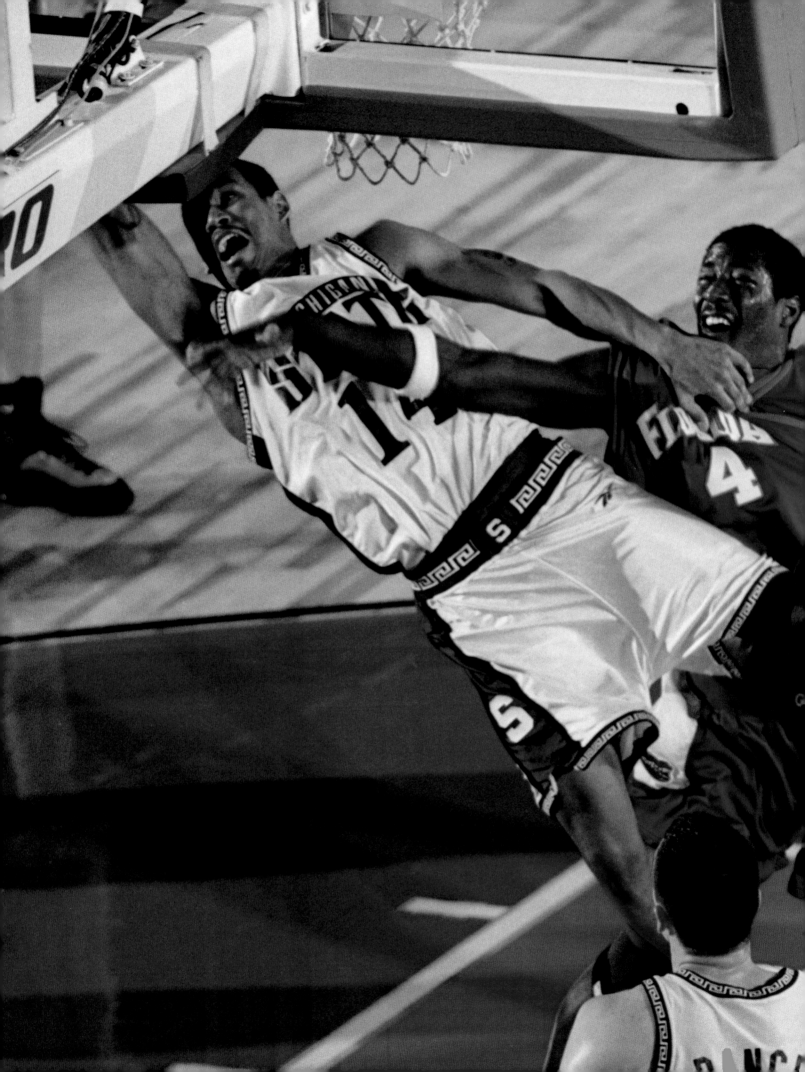

Michigan State's Charlie Bell (14), who scored nine points, grabbed eight rebounds and made five assists in the game, battled Florida's Donnnell Harvey (4) under the boards during the Spartans' 89–76 victory in the national championship game in Indianapolis. Bell was one of several Spartans who rose to the occasion when their leader, senior point guard Mateen Cleaves, went down with a sprained ankle.

PROFILES

KENYON MARTIN

Frustrated pivotmen around the country would have enjoyed the lovers' spat that took place on Jan. 28, 2000, between Cincinnati center Kenyon Martin (below) and his fiancée, Fatimah Conley. The subject at hand—or rather, on Martin's right pectoral—was his most recent tattoo, BAD ASS YELLOW BOY, which comes from a song by a rap group called (we're not making this up) UNLV. Kenyon was explaining how BAD ASS represents his basketball image and how YELLOW BOY is the term used for light-skinned blacks, like Martin, back home in Dallas. That's when Fatimah finally broke in.

"I'm sorry," she said, "but I hate it."

"Well, I like it," replied Kenyon. "That's why I got it."

"But it totally puts negative connotations on you!"

"Don't nobody see it, so what's the problem?"

"When you're in a game and you pull your jersey up and beat your chest after you do something good, people see it."

"How many times have I done that?"

"Once is enough!"

On and on the domestic comedy went—Martin would all but bellow, "To the moon, Alice!"—until it became clear that no matter how many turnarounds the most prolific scorer on the nation's top college basketball team put up, every one of them would be majestically swatted away by Conley, a chemistry major who stands no taller than 5' 4".

Well, it's time somebody turned the tables. ...

A 6' 8½", 230-pound senior, Martin is best described not as a center or a forward but rather, in the tradition of Manuel Noriega, as a Cincinnati strongman. After all, his dunks are not dunks. They're detonations. He doesn't just block shots. He often catches them. More than any other player in the nation, Martin visibly frightens opposing players. ...

Tales of Martin's blocks are legion on the banks of the Ohio. Take last season, when he swatted the shot of Xavier's Lloyd Price out of bounds ... over the opposite baseline. Or this season when, against Gonzaga, Martin appeared out of nowhere for a two-handed denial of Axel Dench's breakaway dunk attempt. Says Bearcats senior forward Ryan Fletcher, "If you're coming down on a two-on-one break against Ken and you pump-fake before passing, he's the only player I've ever seen who's quick enough to contest your shot, land and then step over and block the other guy's shot."

Additionally, Martin has morphed into a dangerous scorer only a year after Cincinnati coach Bob Huggins chastised him for taking just 7.5 shots a game.

Martin's long-term growth as a college player—an anachronism in these impatient times—has almost perfectly echoed his slow but sure maturation off the court. Born in Saginaw, Mich., he was raised in Dallas's rough-and-tumble Oak Cliff neighborhood by the two most important women in his life: his mother, Lydia, and his older sister by almost four years, Tamara. (The last time Kenyon saw his father, former New Mexico basketball player Paul Roby, was when Kenyon was seven.) "Tamara has always been like a father for me," says Kenyon. It was Tamara, after all, who took the call from a concerned teacher during Kenyon's junior year at Dallas's Bryan Adams High. "He was being a butt in math class, so I came to school and started whaling on him in the hall," she says. "He's 6' 7" and I'm 5' 5", but he sat there and listened to me, and we never had any more problems out of him." ...

Three years later, Lydia and Tamara's efforts are paying off, and Kenyon says he's set to graduate with a major in criminal justice and a minor in psychology.

Then there's the violin. Though he's no Itzhak Perlman, Martin played a mean fiddle in middle school, and (the cat's out of the bag) Conley plans on giving him a violin for Valentine's Day.

So here's our advice, Fatimah. Give your man a break. As the Bearcats' victims will tell you, the tattoo's correct, after all.

—Grant Wahl
excerpted from SI, Feb. 7, 2000

Martin missed the NCAAs with a broken leg, and the Bearcats lost in the second round to Tulsa. Martin recovered from his injury in time to become the No. 1 pick in the 2000 NBA draft, going to the New Jersey Nets.
—Ed.

BOB KNIGHT

It was a flip remark, tossed off for reasons unclear even after the extraordinary events of the weekend had played out. Maybe he meant to be a provocateur. Perhaps he was indulging in nothing more than a moment of youthful bravado, trying to impress four buddies who had gone with him to Assembly Hall on the Indiana campus in the early afternoon of Sept. 8 to buy football tickets. In any case, when Kent Harvey, a twitchy 19-year-old freshman, spotted the Hoosiers' basketball coach, he said, "Hey, what's up, Knight?"

Harvey and his friends say Bob Knight (right) grabbed Harvey by the arm, dragged him aside and, according to one member of their party, said, "Show me some f------ respect. I'm older than you." Knight says he lightly touched Harvey on the arm, never used profanity and was only trying to teach a lesson in "manners and civility" that any adult might offer.

But Knight had long ago turned in his adult card. He once told an arena full of people that his critics could "kiss my ass." He threw a potted plant against a framed picture in the athletic department, causing a secretary to be hit by flying glass. He verbally and physically intimidated and harassed players, colleagues, referees and strangers. After a university investigation brought on by a videotape that surfaced last spring of Knight's hand thrust to the jugular of former player Neil Reed, Indiana president Myles Brand warned Knight that a new "zero-tolerance policy" would subject him to immediate dismissal if he were to slip up again. So on Sept. 10, in announcing that Knight had been fired, Brand insisted that it really wasn't his decision to end Knight's tenure in Bloomington after 29 years, but Knight's.

"It was the ethical and moral thing to do, to give him one last chance [in May]," Brand said. "The fact is that having given Coach Knight one last opportunity, he failed to take advantage of it." Indeed, during the Sept. 10 press conference Brand sounded at times like an apostle of some new math that requires an accumulation of missteps to breach a threshold of zero tolerance. Since he had last assembled the press in Indianapolis on May 15, there had been "many instances," Brand said, in which Knight had been "defiant and hostile" and otherwise demonstrated that he had "no desire … to live within the guidelines."…

If Knight had any chance of surviving despite all these

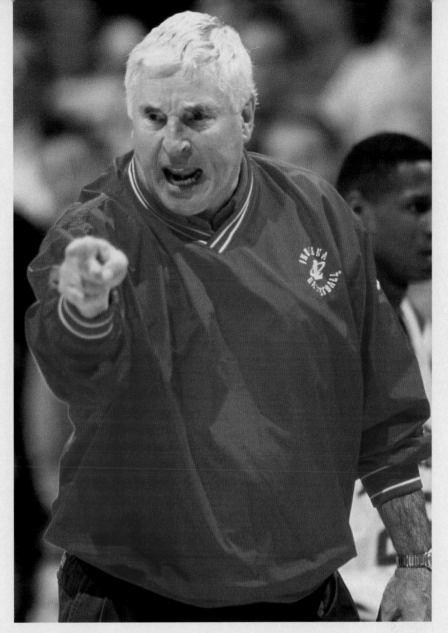

episodes, that possibility disappeared on Friday, Sept. 8, when he blindsided the administration by holding a press conference to offer his version of the encounter with Harvey. At 10:30 p.m. Brand phoned Knight at home and discovered that Knight had booked a fishing trip to Canada for the following morning. Brand made it clear that this wasn't the time to be leaving town. Knight went anyhow, committing one last transgression that Brand described as "gross insubordination."…

Brand cut a very different figure from the man who seemed so wishy-washy while announcing in the spring of 2000 that Knight would stay. This time he often sounded like a disappointed parent who adopts a tone of "this hurts me more than it will hurt you." But if Brand seemed to be diminishing the importance of the Harvey incident as he listed Knight's transgressions, he may have been doing so to take the onus off a suddenly vulnerable student on his campus. "This young man has been caught up in events well beyond his own personal responsibility," Brand said.

Many Bloomingtonians were unwilling to spare Harvey the blame for Knight's exit. Of all the undergraduates who might have crossed Knight's path, Harvey turned out to have a uniquely troublesome pedigree. He's a stepson of Mark Shaw, a Bloom-

BOB KNIGHT

continued from previous page

ington author, lawyer and radio personality who had regularly criticized Knight on a talk show until deciding to give up the program in July because, he said, his stepsons—Kent Harvey is a triplet—were about to enroll at Indiana.

Shaw says he and Harvey wanted only an apology from Knight, not his head. But after the Sunday, Sept. 10, announcement, an estimated 4,000 students marched on Brand's campus residence, Bryan House. Though much of the crowd was as festive as it was angry, alternating chants of "We want beer!" with "F--- Kent Harvey!" the protesters burned the president in effigy on his own lawn while police in riot gear looked on. Meanwhile Harvey was receiving death threats, and his home phone number and class schedule were posted on a pro-Knight Web site. As of Sunday he was no longer on campus and had been offered police protection. …

On Sunday evening Knight returned from Canada and met with his players in an emotional session at Assembly Hall. They were still in a state of shock, and several spoke of transferring. But … it appeared that Indiana could probably avoid mass defections if the school retained assistants Mike Davis and John Treloar, which Doninger says he is considering. … Late Sunday night, outside Assembly Hall, Knight used a bullhorn to thank a crowd of students for their support and promised to hold a rally this week to give his side of things. (Knight did not respond to SI's request for an interview for this story.)

"This is a sad day," Doninger told SI on Sunday. "After Myles made his decision in May and I reflected on it, I realized it was Solomonic to give a guy who had done a lot of good things one last chance. But the atmosphere hadn't changed, even after Myles had gone out of his way—and been much maligned for it—to give Bob another chance. I genuinely hoped it would work. Myles did too. That's why he's so disappointed that it didn't."

Normally we applaud constancy of character. We're suspicious of the protean man who sways with each situation. And in large part Knight owed his success to an unbending nature. His doctrinaire approach as a coach won him many games, even if the victories came less regularly as the years wore on and the world around him changed and he didn't. But Knight was unbending in every other sphere of his life as well, from demanding that his players go to class to acting any way he chose as long as he believed he was in the right. Brand actually expected him to adopt qualities he has never had—the very qualities that in a twist made last week's drama appear to be lifted from the Greek canon. Knight had the hubris to try to teach a freshman last week something he had never learned himself. …

—Alexander Wolff
excerpted from SI, Sept. 18, 2000

Knight's former assistant, Davis, was hired as interim coach on Sept. 12. Kent Harvey transferred from Indiana. —Ed.

MARCUS FIZER

It's not easy to keep track of all the highs and lows that junior forward Marcus Fizer (5) has experienced since arriving at Iowa State, but one need look no further than the Cyclones' last two meetings with Iowa to see the distance between Fizer's North and South poles. During last season's game Fizer was whistled for a technical foul early in the second half after he shoved Hawkeyes forward Jacob Jaacks. Iowa State coach Larry Eustachy benched Fizer for the final 15:15, and Fizer finished with two points, his career low, in a 74–54 loss. Contrast that with the December 1999 game against Iowa, in which Fizer had 16 points and seven rebounds in a 79–66 win and took it upon himself to upbraid a teammate for wearing a hat to the pregame meal in violation of team rules. "Last year," says Eustachy, "Marcus would have been the one wearing the hat."

If the shortest distance between those two points is a straight line, then Fizer took the scenic route. Though he was the Big 12's freshman of the year in 1997–98 and led the league in scoring in '98–99 with 18.0 points per game, the 6' 8", 265-pound Fizer too often accrued his numbers at the Cyclones' expense. As a sophomore he shot 36.8% or worse from the field in 11 games, and Iowa State went 1–10 in those games as it finished ninth in the conference with a 6–10 record. In the 1999–2000 season, through Jan. 16, Fizer's field goal percentage was up to 66.0 (seventh in the nation), and so was his scoring average, to 21.0 points. As a result the Cyclones were 15–2 and appeared poised to make the NCAA tournament for the first time in three years. "My freshman and sophomore years I was just going through the motions," says Fizer, who also leads Iowa State in rebounding, with 7.4 per

game. "Now I know what it is to be a true leader, to have the whole team riding on your shoulders."

A former McDonald's All-America from Arcadia, La., Fizer faced a difficult transition at the end of his freshman year when Tim Floyd, the coach who had recruited him to Iowa State, left to take over the Chicago Bulls and was replaced by Eustachy, who had been at Utah State. "When I introduced myself to Marcus," says Eustachy, "he was very distant, like I was going to have to do things his way." Eustachy threw Fizer out of the weight room during the preseason last year for slacking off, and at a practice early this season he made the entire team do extra running because he didn't like Fizer's body language. The two appear to be more simpatico of late, however. Moments after the win over Iowa, Fizer jumped on the scorer's table and held up a sign that read LARRY EUSTACHY NO. 1.

Fizer's attitude adjustment can only boost him further in the eyes of pro scouts. His increased maturity couldn't have come at a better time. Fizer has a two-year-old son, Aamondae, who lives with Fizer's relatives in Louisiana, and a one-year-old daughter, Arae, who lives with her mother in Virginia. In September '99 Fizer got engaged to girlfriend Anysha Ticer, with whom he lives in Ames. "I worry all the time," Fizer says. "My family is the most important thing to me." That's yet another sign that he's growing in the right direction.

—Seth Davis
excerpted from SI, Jan. 24, 2000

Fizer led Iowa State to the quarterfinals of the NCAAs and was the fourth pick in the 2000 NBA draft, going to Chicago. —Ed.

2000 NCAA Basketball Men's Division I Tournament

NATIONAL CHAMPIONSHIP: MICHIGAN ST 89 — FLORIDA 76

WEST / MIDWEST (Left side)

1st Round → 2nd Round → Regionals

WEST:
- 1 Arizona 26–6 / 16 Jackson St 17–15 → Arizona 71–47
- 8 Wisconsin 18–13 / 9 Fresno St 24–9 → Wisconsin 66–56 → Wisconsin 66–59
- 5 Texas 23–8 / 12 Indiana St 22–9 → Texas 77–61
- 4 Louisiana St 26–5 / 13 SE Missouri St 24–6 → Louisiana St 64–61 → Louisiana St 72–67 → Wisconsin 61–48
- 6 Purdue 21–9 / 11 Dayton 22–8 → Purdue 62–61
- 3 Oklahoma 26–6 / 14 Winthrop 21–8 → Oklahoma 74–50 → Purdue 66–62
- 7 Louisville 19–11 / 10 Gonzaga 24–8 → Gonzaga 77–66
- 2 St. John's 24–7 / 15 Northern Ariz. 20–10 → St. John's 61–56 → Gonzaga 82–76 → Purdue 75–66 → Wisconsin 64–60

MIDWEST:
- 1 Michigan St 26–7 / 16 Valparaiso 19–12 → Michigan St 65–38
- 8 Utah 22–8 / 9 St. Louis 19–13 → Utah 48–45 → Michigan St 73–61
- 5 Kentucky 22–9 / 12 St. Bonaventure 21–9 → Kentucky 85–80 (2OT)
- 4 Syracuse 24–5 / 13 Samford 21–10 → Syracuse 79–65 → Syracuse 52–50 → Michigan St 75–58
- 6 UCLA 19–11 / 11 Ball St 22–8 → UCLA 65–57
- 3 Maryland 24–9 / 14 Iona 20–10 → Maryland 74–59 → UCLA 105–70
- 7 Auburn 23–9 / 10 Creighton 23–9 → Auburn 72–69
- 2 Iowa St 29–4 / 15 C. Conn. St 25–5 → Iowa St 88–78 → Iowa St 79–60 → Iowa St 80–56 → Michigan St 75–64

Regional final (West vs Midwest): Michigan St 53–41
Semifinal vs South side: Florida 71–59

EAST / SOUTH (Right side)

1st Round → 2nd Round → Regionals

EAST:
- 1 Duke 27–4 / 16 Lamar 15–15 → Duke 82–55
- 8 Kansas 23–9 / 9 DePaul 21–11 → Kansas 81–77 (OT) → Duke 69–64
- 5 Florida 24–7 / 12 Butler 23–7 → Florida 69–68 (OT)
- 4 Illinois 21–9 / 13 Pennsylvania 21–7 → Illinois 68–58 → Florida 93–76 → Florida 87–78
- 6 Indiana 20–8 / 11 Pepperdine 24–8 → Pepperdine 77–57
- 3 Oklahoma St 24–6 / 14 Hofstra 24–6 → Oklahoma St 86–66 → Oklahoma St 75–67
- 7 Oregon 22–7 / 10 Seton Hall 20–9 → Seton Hall 72–71 (OT)
- 2 Temple 26–5 / 15 Lafayette 24–6 → Temple 73–47 → Seton Hall 67–65 (OT) → Oklahoma St 68–66 → Florida 77–65

SOUTH:
- 1 Stanford 26–3 / 16 S Carolina St 20–13 → Stanford 84–65
- 8 N Carolina 18–13 / 9 Missouri 18–12 → N Carolina 84–70 → N Carolina 60–53
- 5 Connecticut 24–9 / 12 Utah St 28–5 → Connecticut 75–67
- 4 Tennessee 24–6 / 13 LA-Lafayette 25–8 → Tennessee 63–58 → Tennessee 65–51 → N Carolina 74–69
- 6 Miami (FL) 21–10 / 11 Arkansas 19–14 → Miami (FL) 75–71
- 3 Ohio St 22–6 / 14 Appalachian St 23–8 → Ohio St 87–61 → Miami (FL) 75–62
- 7 Tulsa 29–4 / 10 UNLV 23–7 → Tulsa 89–62
- 2 Cincinnati 28–3 / 15 NC-Wilmington 18–12 → Cincinnati 64–47 → Tulsa 69–61 → Tulsa 80–71 → N Carolina 59–55

2000 NCAA Basketball Women's Division I Tournament

NATIONAL CHAMPIONSHIP: CONNECTICUT 89 — TENNESSEE 52

WEST / MIDWEST (Left side)

WEST:
- 1 Connecticut 30–1 / 16 Hampton 16–14 → Connecticut 116–45
- 8 Drake 23–6 / 9 Clemson 18–11 → Clemson 64–50 → Connecticut 83–45
- 5 Oklahoma 23–7 / 12 Brigham Young 22–8 → Oklahoma 86–81
- 4 Purdue 22–7 / 13 Dartmouth 20–7 → Purdue 70–66 → Oklahoma 76–74 → Connecticut 102–80
- 6 Xavier 26–4 / 11 S.F. Austin 27–3 → S.F. Austin 73–72
- 3 Louisiana St 22–6 / 14 Liberty 22–8 → Louisiana St 77–54 → Louisiana St 57–45
- 7 Marquette 22–9 / 10 West Kentucky 21–9 → West. Kentucky 68–65
- 2 Duke 26–5 / 15 Campbell 22–8 → Duke 71–42 → Duke 90–70 → Louisiana St 79–66 → Connecticut 86–71

MIDWEST:
- 1 Louisiana Tech 28–2 / 16 Alcorn St 22–8 → Louisiana St 95–93
- 8 Kansas 20–9 / 9 Vanderbilt 20–12 → Vanderbilt 71–69 (2OT) → Louisiana Tech 66–65
- 5 N Carolina St 20–8 / 12 SMU 21–8 → SMU 64–63
- 4 Old Dominion 27–4 / 13 WI-Green Bay 21–8 → Old Dominion 94–85 → Old Dominion 96–76 → Louisiana Tech 86–74
- 6 Illinois 22–9 / 11 Utah 23–7 → Illinois 75–58
- 3 Iowa St 25–5 / 14 St. Francis (PA) 23–7 → Iowa St 92–63 → Iowa St 79–68
- 7 Auburn 21–7 / 10 SW Missouri 23–8 → Auburn 78–74
- 2 Penn St 26–4 / 15 Youngstown St 22–8 → Penn St 83–63 → Penn St 75–69 → Penn St 66–65 → Penn St 86–65

Regional final (West vs Midwest): Connecticut 89–67
Semifinal vs East/South side: Tennessee 64–54

EAST / SOUTH (Right side)

EAST:
- 1 Tennessee 28–3 / 16 Furman 20–10 → Tennessee 90–38
- 8 Arizona 24–6 / 9 Kent 25–5 → Arizona 73–61 → Tennessee 75–60
- 5 Boston College 25–8 / 12 Nebraska 18–12 → Boston College 93–76
- 4 Virginia 23–8 / 13 Pepperdine 21–9 → Virginia 74–62 → Virginia 74–70 → Tennessee 77–56
- 6 Tulane 26–4 / 11 Vermont 25–5 → Tulane 65–60
- 3 Texas Tech 25–4 / 14 Tenn. Tech 24–8 → Texas Tech 83–54 → Texas Tech 76–59
- 7 George Wash. 25–5 / 10 UCLA 18–10 → Geo. Washington 79–72
- 2 Notre Dame 25–4 / 15 San Diego 17–12 → Notre Dame 87–61 → Notre Dame 95–60 → Texas Tech 69–65 → Tennessee 57–44

SOUTH:
- 1 Georgia 29–3 / 16 Montana 22–7 → Georgia 74–46
- 8 Michigan 22–7 / 9 Stanford 20–8 → Stanford 81–74 → Georgia 83–64
- 5 N Carolina 18–12 / 12 Maine 20–10 → N Carolina 62–57
- 4 UC-SB 30–3 / 13 Rice 21–9 → Rice 67–64 → N Carolina 83–50 → Georgia 83–57
- 6 Oregon 23–7 / 11 UAB 19–12 → AL-Birmingham 80–79 (OT)
- 3 Mississippi St 23–7 / 14 St. Peter's 23–7 → Mississippi St 94–60 → AL-Birmingham 78–72
- 7 Texas 21–12 / 10 St. Joseph's 24–5 → St. Joseph's 69–48
- 2 Rutgers 22–7 / 15 Holy Cross 23–6 → Rutgers 91–70 → Rutgers 59–39 → Rutgers 60–45 → Rutgers 59–51

64

NCAA Championship Game Box Score

MICHIGAN ST 89

MICHIGAN ST	MIN	FG M–A	FT M–A	REB O–T	A	PF	TP
Hutson	23	2–4	2–2	0–1	3	4	6
Peterson	32	7–14	4–6	1–2	5	3	21
Granger	34	7–11	2–2	2–9	1	2	19
Cleaves	33	7–11	1–1	0–2	4	1	18
Bell	33	3–6	2–3	3–8	5	2	9
Richardson	15	4–7	1–2	1–2	0	1	9
Anagonye	11	0–0	0–0	2–3	0	0	0
Chappell	6	2–4	0–0	1–1	0	4	5
Ballinger	6	1–1	0–0	0–0	0	2	2
Thomas	4	0–0	0–0	1–1	1	1	0
Smith	1	0–0	0–0	0–0	0	0	0
Cherry	1	0–0	0–0	0–0	0	0	0
Ishbia	1	0–1	0–0	0–0	0	0	0
Totals	200	33–59	12–16	11–29	19	20	89

Percentages: FG—.559, FT—.750. 3-pt goals: 11–22, .500 (Peterson 3–8, Granger 3–5, Cleaves 3–4, Bell 1–2, Chappell 1–3). Team rebounds: 3. Blocked shots: 1 (Anagonye). Turnovers: 14 (Peterson 3, Anagonye 2, Bell 2, Cleaves 2, Granger 2, Chappell, Hutson, Thomas). Steals: 5 (Bell 2, Chappell, Peterson, Richardson).

FLORIDA 76

FLORIDA	MIN	FG M–A	FT M–A	REB O–T	A	PF	TP
Wright	29	5–8	3–5	4–10	4	4	13
Miller	31	2–5	5–6	1–2	2	0	10
Haslem	28	10–12	7–7	2–2	0	4	27
Dupay	15	0–4	0–0	0–0	1	2	0
Hamilton	14	0–1	0–0	0–0	0	1	0
Nelson	26	4–10	0–0	1–4	3	1	11
Bonner	7	0–3	0–0	1–3	0	1	0
Weaks	22	1–3	0–0	1–1	1	2	3
Harvey	16	3–11	3–4	4–6	0	2	9
Parker	12	1–3	0–0	0–0	2	2	3
Totals	200	26–60	18–22	14–29	13	19	76

Percentages: FG—.433, FT—.818. 3-pt goals: 6–18, .333 (Wright 0–1, Miller 1–2, Dupay 0–2, Hamilton 0–1, Nelson 3–6, Bonner 0–2, Weaks 1–1, Parker 1–3). Team rebounds: 1. Blocked shots: 2 (Haslem, Harvey). Turnovers: 13 (Haslem 3, Nelson 3, Harvey 2, Miller 2, Parker, Weaks, Wright). Steals: 5 (Nelson 2, Weaks 2, Wright).

Halftime: Michigan St 43, Florida 32. A: 43,116.
Officials: Burr, Boudreaux, Hall.

Final AP Top 25

Poll taken before NCAA Tournament.

1. Duke	27–4	5. Temple	26–5	9. St John's	24–7	13. Florida	24–7	17. Maryland	24–9	21. Illinois 21–9
2. Michigan St	26–7	6. Iowa St	29–4	10. Louisiana St	26–5	14. Oklahoma St	24–6	18. Tulsa	29–4	22. Indiana 20–8
3. Stanford	26–3	7. Cincinnati	28–3	11. Tennessee	24–6	15. Texas	23–8	19. Kentucky	22–9	23. Miami (FL) 21–10
4. Arizona	26–6	8. Ohio St	22–6	12. Oklahoma	26–6	16. Syracuse	24–5	20. Connecticut	24–9	24. Auburn 23–9
										25. Purdue 21–9

NCAA Men's Division I Individual Leaders*

SCORING

	CLASS	GP	FIELD GOALS FGA	FG	PCT	3-PT FG FGA	FG	FREE THROWS FTA	FT	PCT	REB	PTS	AVG
Courtney Alexander, Fresno St	Sr	27	564	252	44.7	175	58	137	107	78.1	128	669	24.8
SirValiant Brown, Geo. Washington	Fr	30	668	222	33.2	277	73	273	221	81.0	100	738	24.6
Ronnie McCollum, Centenary	Jr	28	577	226	39.2	258	92	153	123	80.4	103	667	23.8
Eddie House, Arizona St	Sr	32	623	263	42.2	200	73	164	137	83.5	175	736	23.0
Harold Arceneaux, Weber St	Sr	28	416	213	51.2	103	38	226	180	79.6	207	644	23.0
Rashad Phillips, Detroit	Sr	32	513	226	44.1	252	102	208	181	87.0	96	735	23.0
Demond Stewart, Niagara	Jr	29	515	217	42.1	164	55	244	176	72.1	195	665	22.9
Marcus Fizer, Iowa St	Jr	37	562	327	58.2	42	15	239	175	73.2	285	844	22.8
Craig Claxton, Hofstra	Sr	31	538	253	47.0	134	51	195	149	76.4	168	706	22.8
Troy Murphy, Notre Dame	So	37	557	274	49.2	92	30	323	261	80.8	380	839	22.7

FIELD-GOAL PERCENTAGE

	CLASS	GP	FGA	FG	PCT
Brendan Haywood, N Carolina	Jr	36	274	191	69.7
John Whorton, Kent	Sr	31	250	159	63.6
Joel Przybilla, Minnesota	So	21	199	122	61.3
Stromile Swift, Louisiana St	So	34	342	208	60.8
Patrick Chambers, AR-Pine Bluff	Sr	27	287	174	60.6
Melvin Ely, Fresno St	Jr	31	297	180	60.6

FREE-THROW PERCENTAGE

	CLASS	GP	FGA	FT	PCT
Clay McKnight, Pacific	Sr	24	78	74	94.9
Troy Bell, Boston College	Fr	27	180	161	89.4
Lee Nosse, Middle Tennessee St	Jr	28	93	83	89.2
Khalid El-Amin, Connecticut	Jr	35	120	107	89.2
Brad Buddenborg, Oakland	So	28	120	107	89.2
Joe Crispin, Penn St	Jr	35	203	181	89.2

REBOUNDS

	CLASS	GP	REB	AVG
Darren Phillip, Fairfield	Sr	29	405	14.0
Josh Sankes, Holy Cross	Jr	28	334	11.9
Larry Abney, Fresno St	Sr	34	402	11.8
Shaun Stonerook, Ohio	Sr	33	387	11.7
Jarrett Stephens (Penn St)	Sr	35	368	10.5

ASSISTS

	CLASS	GP	REB	AVG
Mark Dickel, UNLV	Sr	31	280	9.0
Doug Gottlieb, Oklahoma St	Sr	34	293	8.6
Chico Fletcher, Arkansas St	Sr	28	232	8.3
Brandon Granville, Southern Cal	So	30	248	8.3
Ed Cota, N Carolina	Sr	35	284	8.1

THREE-POINT FIELD-GOAL PERCENTAGE

	CLASS	GP	FGA	FG	PCT
Jonathan Whitworth, Middle Tennessee	Jr	28	99	50	50.5
Jason Thornton, Central Florida	So	32	190	94	49.5
Aki Palmer, Colorado St	Fr	30	143	70	49.0
Pete Conway, Montana St	Fr	29	90	44	48.9
Stephen Brown, Idaho St	Sr	27	133	65	48.9

THREE-POINT FIELD-GOALS MADE PER GAME

	CLASS	GP	FG	AVG
Brian Merriweather, TX-Pan Am	Jr	28	114	4.1
Josh Heard, Tennessee Tech	Sr	28	112	4.0
Tevis Stukes, Baylor	Sr	29	100	3.45
Two tied at 3.43.				

BLOCKED SHOTS

	CLASS	GP	BS	AVG
Ken Johnson, Ohio St	Sr	30	161	5.4
Wojciech Myrda, Louisiana-Monroe	So	28	144	5.1
Loren Woods, Arizona	Jr	26	102	3.9
Joel Przybilla, Minnesota	So	21	81	3.9
Sitapha Savane, Navy	Sr	29	111	3.8

STEALS

	CLASS	GP	FG	AVG
Carl Williams, Liberty	Sr	28	107	3.8
Rick Mickens, Central Connecticut	Sr	26	93	3.6
Pepe Sanchez, Temple	Jr	25	85	3.4
Fred House, Southern Utah	Jr	29	98	3.4
Eric Coley, Tulsa	Sr	37	123	3.3
Tim Winn, St. Bonaventure	Sr	31	103	3.3

*Includes games played in tournaments.

Up-and-Down Under

Despite a sparkling city, genial hosts and spectacular athletes, the Sydney Games were not without their problems ■ Hank Hersch

Launching her quest to become the first woman to win five gold medals in a single Olympics, Marion Jones (3357) blitzed the field in the 100-meter dash in Sydney, winning in 10.75. Ekaterini Thanou of Greece (2005) finished second in 11.12.

He was little more than a 6' 2", 289-pound obstacle for flashlit cameras and binocular-covered eyes at the opening ceremonies of the 2000 Summer Olympics. The 110,000 people at Stadium Australia had come to glimpse greatness, and as the U.S. contingent paraded around the track, the spectators' enhanced vision zoomed from track star Marion Jones to cyclist Lance Armstrong to Dream Team swingman Vince Carter.

Obstructing their view was a huge and obscure figure (crew cut, chubby cheeks, doughy frame) from a distant and obscure locale (a 250-acre dairy farm in Afton, Wyo.), who would be competing in an ancient and obscure sport (Greco-Roman wrestling). But those who gathered in Sydney on Sept. 15 might have paid more attention to Rulon Gardner had they known that in 12 days he would face one of the most intimidating and dominant competitors in the 104-year history of the modern Games.

That legendary athlete was one of the primary objects of many fans' star searches, and he was not difficult to spot. The menacing, mysterious and massive Alexander Karelin carried the flag for Russia, and his credentials as a front man were impossible to dispute. He was 33, had won three Olympic gold medals and was undefeated in international matches during the past 14 years. Steeled

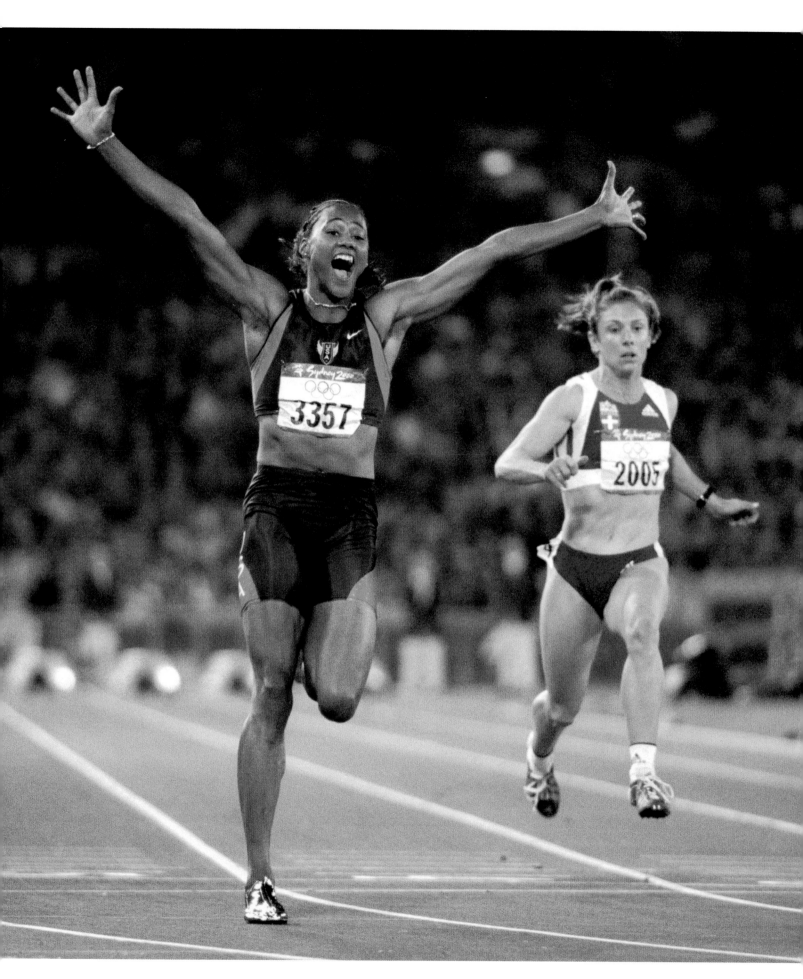

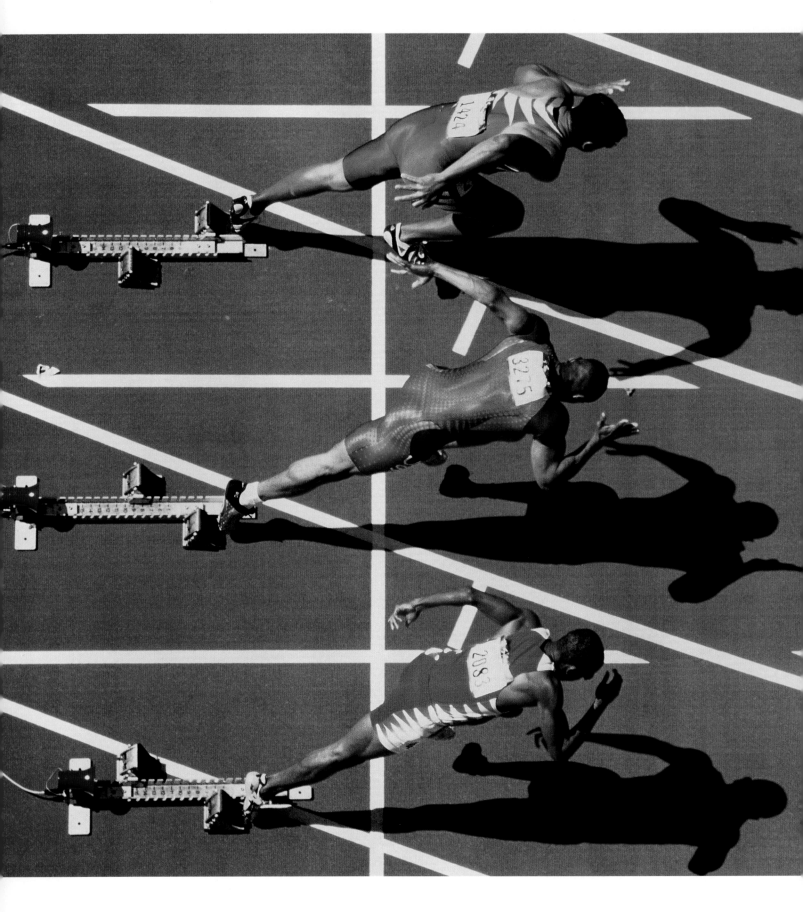

by life in frigid Siberia, the chiseled, 6' 4", 290-pound Karelin was capable of picking up his superheavyweight opponents, hoisting them over his shoulder and driving them headfirst into the mat. That maneuver, the reverse lift, inspired enough fear of lifelong injury that some of Karelin's opponents would allow themselves to be pinned rather than suffer it.

"You consider this ancient sport and this monumental man who's had a perfect career," said retired U.S. wrestler Jeff Blatnick, who lost to Karelin in 1987, "and the only thing you can say is that he's what Hercules was to the ancient Greeks."

Gardner had tangled with Karelin in 1997, only four years after the American switched from freestyle wrestling to Greco-Roman. En route to a (literally) crushing 5–0 loss, Gardner was reverse-lifted three times. "I landed so hard," he said, "that the backs of my heels almost came around and touched my head."

So it was that Henry Kissinger, at the behest of IOC president Juan Antonio Samaranch, was on hand at the Sydney Convention Exhibition Centre as Samaranch presented the gold medal after the superheavyweight finals. Not even such skilled diplomats as Samaranch and Kissinger could disguise the motivation behind their choice of venue: Karelin, a member of the Russian parliament, was aiming for his unprecedented fourth Greco-Roman gold; Gardner, a former Nebraska Cornhusker, had as his most distinguished finish a fifth in the 1997 world championships. Early in the second period Gardner took a 1–0 lead when Karelin made the mistake of breaking a hold. No matter. Surely the great Karelin would find a way to snatch the victory.

Growing up, Gardner rose between 4 a.m. and 5 a.m. to heave bales of hay, lug 50-pound irrigation pipes and move stubborn half-ton cows. He had, for all his puffiness, a resolve to match Karelin's: Like the cows on his family's farm, he was not easily budged. No matter what Karelin tried, Gardner held firm, and the score remained 1–0. As the final seconds ticked away, the huge Russian lowered his head in resignation, defeated at last in what could well be his final match.

No, the binoculars at Stadium Australia, no matter how acute, had no way of appreciating Gardner and what he might accomplish. Nor could they have seen a dire threat to American basketball hegemony in the Lithuanian men's team, a group that, in the semifinals, was only a missed three-pointer away from dropping the Dreamers, who

went on to win gold. Nor could they have perceived in Norwegian substitute Dagny Mellgran a doubly-gilded performance: Mellgran scored a golden goal in sudden-death overtime of the gold medal match to defeat the reigning world and Olympic champion U.S. women's soccer team.

Indeed, there were dozens of athletes who emerged from the anonymity of the opening ceremonies to greatness by the Games' close. Ben Sheets was a 22-year-old righthanded pitcher toiling for the Milwaukee Brewers' Triple-A affiliate before the Olympics. After the Games he was a hero who had shut out mighty Cuba 4–0 to deliver the Americans the baseball gold medal. Konstadinos Kederis, 27, was mostly unknown outside of Greece before Sydney 2000. After becoming the first Greek man in 104 years—104!—to win a gold medal in track, he is a possible torchbearer for the 2004 Games in Athens. Kederis emerged from obscurity to blitz the 200-meter field and win in 20.09.

Australia's 400-meter runner Cathy Freeman was well known before the Games, and she won the gold in her event, but few could have predicted that the host Aussies would reap a glittering medal count of 58. For a nation of 18 million, that total far exceeded the per capita output of the U.S. (97), Russia (88) and China (59).

Starting with 17-year-old Aussie swimmer Ian Thorpe's brilliant anchor leg to edge the United States for gold in the men's 4 x 100 freestyle relay (an event in which the Americans had never been beaten at the Olympics or the worlds), the 2000 Olympics were rife with astounding performances. Unfortunately they were also marred by astounding mismanagement and, in some cases, outright scandal.

The women's all-around gymnastics finals were irrevocably tainted when officials set the vault too low at the start of that event. The favorite in the all-around, Svetlana Khorkina of Russia, attempted a difficult $1\frac{1}{2}$ forward twist with a half turn on the vault. She landed on her knees, receiving a 9.343 that destroyed any hope of a medal. But shortly after her attempt it was discovered that the vault had been set at the wrong height: five centimeters low. The athletes who had taken their turns before the height was readjusted were given a chance to try again, but Khorkina was too unnerved to bother. After winning a gold in the uneven parallel bars three days later she said, "It will help me to forget that day, which will remain very, very far from me, somewhere perhaps near the North Pole."

Which, judging by the U.S. TV ratings, might as

Maurice Greene (opposite, middle) sprang out of the blocks with Tenia Teiti of the Cook Islands (top) and John Herman Muray of Indonesia (bottom) to start their first-round 100-meter heat in Sydney. Greene would take the heat in 10.31 and win the gold medal the following day, clocking 9.87 in the final to edge silver medalist Ato Boldon of Trinidad and Tobago, who finished in 9.99.

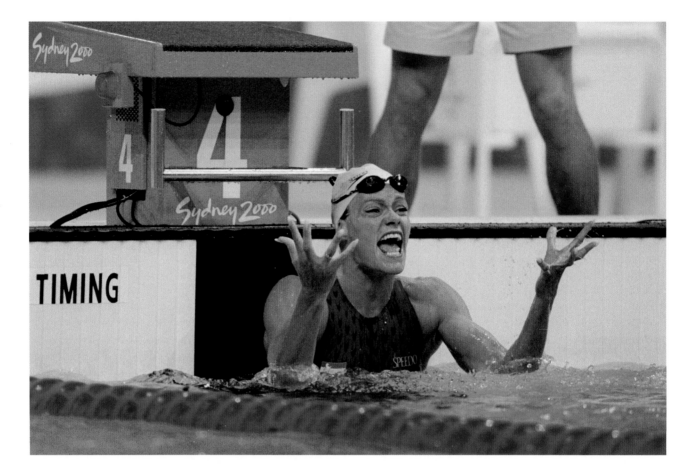

High Point for the Lowlands: The Netherlands' Inge de Bruijn (above) stood out in an impressive field at the Sydney Olympic swimming competition, winning three gold medals and setting three world records, including a 56.61 in the 100-meter butterfly final.

well have been where the 2000 Games were held. Because Sydney is 15 time zones ahead of the West Coast and 18 ahead of the East, no events of significance took place in U.S. prime time. NBC, which paid $705 million for the rights to the Olympics, decided to show nothing live, and its nightly five-hour package was heavily edited and larded with features. Bad reviews of the predigested coverage only drove ratings further down. NBC Sports president Dick Ebersol had promised a 16.1 rating, but the Games fell well short (8.9). Despite being the most-watched program almost every night for two weeks, the Games were perceived as a flop on the tube. Witness a headline in the satirical paper *The Onion*: IOC: MANY VIEWERS MAY BE USING OLYMPICS-ENHANCING DRUGS.

Drugs—performance-enhancing ones—were the source of the Sydney Games' greatest controversy. Romanian gymnast Andreea Raducan was stripped of the all-around gold medal because a banned ingredient, which she insisted came from her team doctor-prescribed cold medicine, showed up in her blood. Four other athletes lost medals for more egregious abuses, such as nandrolone, stanozlol and furosemide. A Romanian hammer thrower

was escorted off the track as she was about to compete. And 41 would-be Olympians—27 of them from China, which has hopes of hosting the 2008 Games—were caught cheating before they could reach Sydney.

Worse, though, was the shadow that the suspicion of drug use cast over exceptional performances. Even the great Jones was not immune. When it leaked out that her husband, shot-putter C.J. Hunter, had tested positive four times over the summer, some wondered if she was using as well. Jones won a remarkable three golds and two bronzes in Sydney, despite the distractions caused by the revelations about her husband, and—as she has throughout her career—tested negative.

The news concerning Hunter, who did not compete because of a knee injury, led to accusations from the IOC that USA Track & Field was covering up doping among its athletes, with 15 positive tests undisclosed. "The Sydney Games," wrote the national newspaper, *The Australian*, "are in danger of being remembered as the Drugs Olympics."

But in the end, the misdeeds and mismeasurements of a few, no matter how flagrant, could not indelibly tarnish the 2000 Games, particularly for

those who saw them untaped and unedited in sparkling Sydney. Watching athletes compete under the enormous pressure of the world's gaze makes for a grand spectacle, and no moment packed as much drama as the final of the women's 400-meter run. The home crowd had come to see the favorite, Freeman—Our Cathy—a world champion of Aboriginal descent who had lit the Olympic flame at the opening ceremonies. "There has been no single occasion," wrote *The Sydney Morning Herald*, "when more has been expected of an Australian sportsperson."

With a nation beseeching her, Freeman charged to the finish in 49.11 seconds, outpacing three women who ran personal bests. Michael Johnson, her male counterpart from the U.S., would also live up to his status as a favorite, cruising to an unprecedented second straight 400 title, in 43.84.

For the American women's softball team, the journey was not so easy. The defending champions came to Sydney with a 110-game winning streak, but in round-robin play they hit the first three-game losing skid in their history. Ace righthander Lisa Fernandez felt especially snakebitten, fanning 25 batters in $12^{2}/_3$ innings against Australia, only to surrender a decisive two-run homer. Following that bitter defeat, the players gathered in the shower, in uniform, for a "voodoo cleansing," Fernandez said. "We scrubbed off the evil spirit that was on us." It must have worked: Fernandez blanked the Aussies for 10 innings in the semifinal, then three-hit Japan for a 2–1 victory in the gold medal game.

Such clutch performances had come to be expected of some Olympians, like men's gymnast Alexei Nemov of Russia, 24, who won not only the all-around gold but also four medals on the individual apparatus, boosting his career total to 12. Under the steady hand of five-time Olympic point guard Teresa Edwards—and with the superb inside play of Lisa Leslie—the U.S. women's basketball team went 6–0, flooring the Aussies 76–54 for the gold medal. Cuba's Felix Savon dominated the heavyweight boxing division for his third straight Games, equaling his countryman Teofilo Stevenson's legacy of excellence. And after deciding to retire in 1996 and soon thereafter discovering he had diabetes, 38-year-old Steven Redgrave of Britain won the coxless-fours rowing gold medal for the fifth gold of his unsurpassed career.

Each of those competitors deserved the full NBC up-close-and-personal treatment, with the jump cuts and the soft-focus. Perhaps none of them,

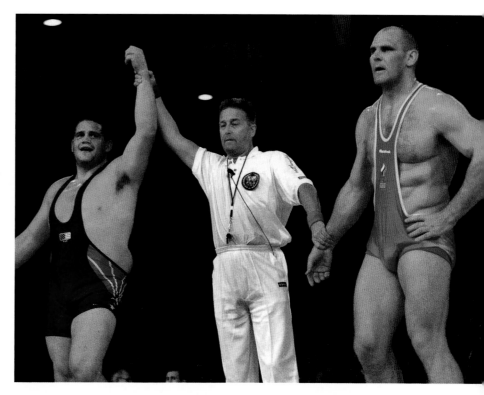

though, had quite as good a story line as Laura Wilkinson, a 22-year-old platform diver from The Woodlands, Texas. Six months before the Games, Wilkinson broke three toes on her right foot. Still, she practiced her push-offs, standing in her cast on the platform for six hours a day. She entered the final day of the platform competition in fifth place, 60 points behind the leader. On her fourth dive, an inward $2^1/_2$ somersault that put extreme pressure on her newly healed bones, Wilkinson tried to banish her fears of hitting her head on the tower by thinking of Hilary Grivich, a teammate who had died in a car crash two years earlier. Wilkinson nailed the dive and then watched the competition unravel around her. With a perfectly executed reverse $2^1/_2$ somersault with a half twist, she won the gold medal on her final dive. The victory made Wilkinson the first American woman since Lesley Bush in 1964 to win gold in the platform.

And then, of course, there was Gardner, who after his upset of Karelin was feted in Sydney and toasted across the U.S. Gardner would turn out to be the perfect symbol for an upside-down summer Down Under, because in the closing ceremonies he was front-and-center in everyone's view, and no one sought to look past him for a brighter star. He was carrying the American flag, and everyone knew who he was.

It was difficult to tell who was more stunned when the decision was announced in the heavyweight gold medal match in Greco-Roman wrestling: the triumphant Rulon Gardner of the U.S. or the dejected Alexander Karelin of Russia, who suffered his first loss in 14 years of international competition and saw his quest for a fourth straight gold in the event fall short.

PHOTO GALLERY

Tag Team: Anthony Ervin (top) and Gary Hall Jr. (bottom), both of the U.S., touched the wall at the same instant in the men's 50-meter freestyle in Sydney. Both men clocked 21.98, and they shared the gold medal.

Australia's teenage swimming sensation Ian Thorpe (opposite, top) won the 400-meter freestyle in a sizzling world record of 3:40.59, finished second in the 200 and won two relay gold medals.

Synchronized diving made its debut in Sydney as Austria's Anja Richter-Libiseller and Marion Reiff (right) finished fourth in the women's 10-meter platform. Li Na and Sang Zue of China won gold in the event.

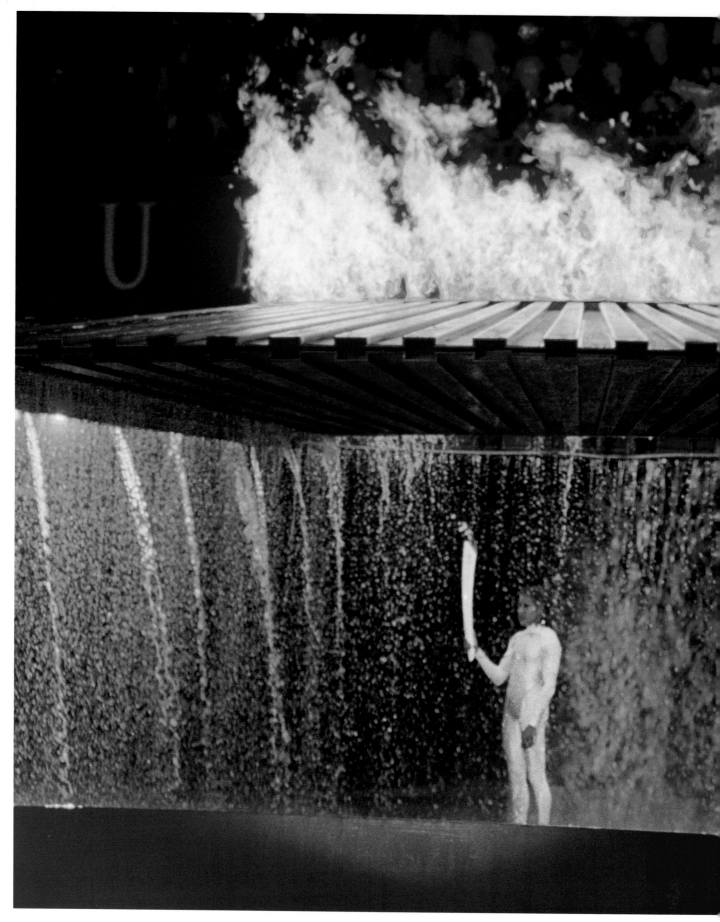

Let the Games Begin: Cathy Freeman, Australia's world champion 400-meter runner of Aboriginal descent, lit the Olympic torch in Sydney. With her entire nation watching closely, she would go on to win the gold medal in the 400, clocking 49.11 to outpace Lorraine Graham of Jamaica, who finished second in 49.58.

PROFILES

RULON GARDNER

Take one look at the Russian, Alexander Karelin (menacing, muscular, mysterious) and his American opponent, Rulon Gardner (crew-cutted, chubby-cheeked, cream-pie-soft), and the outcome of this gold medal Greco-Roman heavyweight match seems foreordained. The celebrated Karelin, 15 pounds at birth, hardened by a boyhood spent hauling logs and rowing on the frigid lakes of his native Siberia, his mind molded by doses of Dostoyevsky, surely will annihilate the unknown Gardner, an athlete, yes, but one no doubt with a background of TV watching, Nintendo playing and Whopper consuming. Karelin, 33, is on the downside of a career that has put him among the Olympic gods, but when he finally loses—if he ever loses—it will be to some hungry Hungarian, some massive Moldavian or maybe Bulgaria's Sergei Mourieko, a.k.a Baby Karelin, widely considered the second-best superheavyweight at the Sydney Games. But it won't be to this Gardner (right)....

The match begins, and it is, like most superheavy bouts, a tugging and pulling contest, but any second the 6' 4", 290-pound Karelin, who last lost in 1986, is expected to lock both arms around Gardner's midsection, hoist him over his shoulder in a move known as a reverse lift and launch the American so that he lands on his pumpkin head. That's what Karelin did to Gardner three times in 1997, when during their only previous meeting Karelin drubbed him 5–0, a margin of victory comparable to 10–0 in baseball.

This time, however, Gardner repeatedly repels Karelin and then takes a 1–0 lead early in the second period when Karelin makes a small, rare mistake.... Concern begins to appear on

Karelin's chiseled face as the match goes into overtime (mandatory when neither wrestler has scored at least three points), and soon something more telling appears: fatigue. Karelin's eyes narrow, his mouth hangs open. At every break in the action he puts his hands on his hips and gasps for oxygen.

Then, with five seconds left in the overtime, Karelin simply bows his head in resignation. Gardner remains crouched in the center of the mat, wary of a ruse, but the match is over. Karelin has lost to a man whose most impressive credential is a fifth-place finish in the 1997 worlds. Karelin looks dazed as the referee holds up Gardner's hand. In a few minutes Karelin will stand on the podium and hear the national anthem of a country other than his own, something that has never happened to him.

A Russian journalist pounds the press table over and over, lowers his head and puts his hands over his eyes. How could it have happened? How could the Greco-Roman world have turned so topsy-turvy that, within an hour, the great Karelin will be ripping the medal off his neck "as if it were a black mark, not an Olympic silver," as one Russian newspaper will put it the next day? ... Well, consider this: It turns out that where Gardner came from and where Karelin came from aren't so different after all.

On the 250-acre dairy farm in Afton, Wyo., where Reed and Virginia Gardner raised their nine children, things were so quiet in the evening that as teenagers Rulon and his older brother Reynold got so they could recognize which friend was approaching by the sound of his car. The

friends dropped by, in twos and threes, asking if the brothers wanted to abandon their chores for a drive into town. The answer was always no. There was usually something else to be done around the farm, and, anyway, beer drinking and carrying on weren't options for the Gardner kids. They were Mormons.

Life in the Star Valley in western Wyoming was hard. Maybe not as hard as life in Siberia, but damn hard. For nine months a year Rulon rose between 4 and 5 a.m. to complete his chores before school, and it was worse in the summer because there was no leaving the farm for classes or after-school sports. Rulon got it coming and going.... At school Rulon was called Fatso and was chided for coming to school with muck stains on his shoes. He rarely struck out at his tormentors, and his round face, innocent as an unshucked ear of corn, was usually bathed in a smile. Still, the insults toughened him, made him a little hard inside.

In 1979, when Rulon was eight, the Gardners had a terrible year. The Fatso jokes were plentiful, the milking barn burned down, a side business of Reed's (selling livestock feed) was failing, and Rulon's 14-year-old brother, Ronald, died of aplastic anemia. The Gardners had to borrow $150,000 to rebuild the barn, and life became even harder—hand-me-downs and simple meals and no vehicles except those needed to get around the farm. "It was hard on everybody," Reed says. "Maybe it made us tougher in the long run." ...

Reynold gave an explanation the day after Rulon's monumental victory: "It's the law of the harvest. You plant the seed, you water the seed, you fertilize the seed and you weed the seed. If you do those things, and only if you do them, you will harvest."

Reynold stared at his brother, who was signing autographs and letting tourists fondle his gold medal. "Only a few people know how hard Rulon worked and where he came from," said Reynold. "Rulon knows the law of the harvest."

—Jack McCallum
excerpted from SI, Oct. 9, 2000

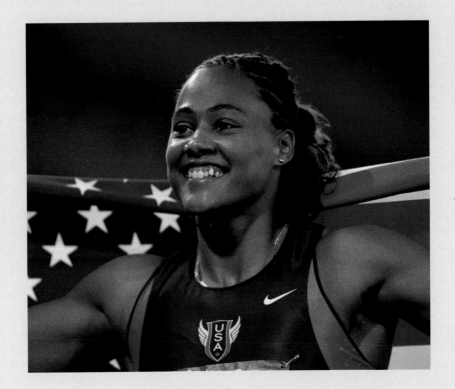

MARION JONES

Word got out quietly in the spring of 1998. Marion Jones's agent, Charley Wells, sidled up to a writer doing a feature on Jones and said, "You know, we're going for five gold medals in Sydney." At the 1997 world championships Jones had won the 100 meters, stunning track insiders with the swiftness of her return to form after three years of concentrating on basketball at North Carolina. It was assumed that come Sydney, the versatile Jones (above) would try to match the performances of Jesse Owens in '36 and Carl Lewis in '84 by winning gold medals in the 100, 200, long jump and 4 x 100 relay. That assumption was wrong. "We're going for the four-by-400 too," Wells said.

No woman has attempted to win five track and field gold medals at one Olympics. In 1948 Fanny Blankers-Koen won four, and 40 years later Florence Griffith Joyner nearly won four but fell just short on the anchor leg of the 4 x 400 (file this away). Five golds is the career record for a female U.S. Olympian, and Jones proposes to equal it in a span of nine days. Some very talented people were, and remain, amazed at the breadth of her ambition. "Why go for all five now?" asks Michael Johnson, who won two golds in the 1996 Games. "She's an amazing athlete, but why not get the 100, 200 and four-by-one now, and then come back in 2004 and get the 400, long jump and four-by-four?"

Why not? "Because that's not her, not even close," says Curtis Frye, Jones's sprint coach during her dalliances with track at

MARION JONES

continued from previous page

North Carolina. "Marion Jones is a genius, and you don't restrict genius, you applaud it."

This is a fair admonition. At 24, Jones is the second-fastest woman in history at 100 and 200 meters (behind Flo-Jo), a dangerous—if inconsistent—long jumper and a voracious competitor. "The girl is nasty, period," says Maurice Greene, the men's world-record holder in the 100.

As soon as Jones began speaking about winning five golds, she became the hot topic of pre-Olympic buzz Her image suffered slightly when she went to the '99 world championships in Seville seeking four gold medals (she didn't participate in the 4 x 400) in a Sydney dry run but got just one gold, finishing third in the long jump, injuring her back in the 200 and dropping out of the 4 x 100 relay. She flew home without speaking to reporters, creating the impression that she was immature and that her handlers—including her 300-pound husband, world shot put champion C.J. Hunter—were overmatched by the demands of her celebrity.

Nike, with which Jones has a seven-figure endorsement contract, then did something for her that it had never done for an athlete of her stature. It arranged for her to be represented by a public relations firm, Bragman Nyman Cafarelli of Beverly Hills. The Swoosh People didn't want any more bad press for this smart, attractive female whom they viewed as nearly limitless in her potential to sell their goods. Together, the shoe company and the p.r. agency have managed Jones's time and polished her image, taking full advantage of her telegenic appeal.

All that is left is for Jones to win five events. Can she? You bet. Will she? Consider: Including qualifying, she has to run 10 races and long jump as many as nine times. On Sept. 27 she has to run two heats of the 200 and qualify in the long jump. On Sept. 30 she has to run two relay finals less than two hours apart. Cool Sydney evenings will help, but fatigue will be a factor

In the end the difference between success and failure for Jones will probably be infinitesimal: a centimeter in the long jump, .1 of a second in the four-by-four or the 200. A lesson to consider: When she was a college freshman, running spring track with a basketball body, Jones injured an ankle walking her bike down a set of stadium steps. Frye figured she was out of the NCAA meet, but Jones startled him by limping to a sixth-place finish in the 200 and a second in the long jump. Afterward Jones's mother, Marion Toler, approached Frye and told him, "Never underestimate Miss Jones."

The warning still stands, and that's no hype.

—Tim Layden
excerpted from SI, Sept. 11, 2000

Jones won five medals in Sydney, but two of them were bronze. She won gold in the 100, the 200 and the 4 x 400-meter relay, and finished third in both the long jump and the 4 x 100 relay.—Ed.

LAURA WILKINSON

Laura Wilkinson emerged from the Olympic Aquatic Centre after the semifinals of the 10-meter platform diving on Sunday afternoon, carrying the burden of fifth place and a doorstop-sized book under her arm.

"Good reading?" a reporter asked.

"Harry Potter," Wilkinson said. "The fourth one—*The Goblet of Fire*."

This is what literary folk call foreshadowing, because seven hours later, Wilkinson (right) not only performed gold-medal-winning dives but en route to victory also spun a tale worthy of Potter. This wasn't merely a story of the first gold medal in platform diving by an American woman since Lesley Bush in 1964. It was a fantasy writ large featuring Chinese giants and Quidditch-like swoops and Muggles who didn't believe anyone who broke three bones while in training for these Games could shock the diving world.

Mostly, it was the story of a very humble, very brave hero who hails from The Woodlands, Texas, and who had earned eight national diving titles while at the University of Texas. "This is the Olympics," said Wilkinson's coach, Ken Armstrong. "Magical things happen all the time."

The plot was simple enough. On March 8, Wilkinson broke the middle three bones in her right foot in a freak accident: She banged it on a piece of plywood equipment that she uses for dry-land training. The next day Armstrong rapped on her apartment door at 6 a.m. and announced that he didn't care if her leg needed to be amputated because she'd worked too hard not to be an Olympian. Wilkinson eschewed surgery, which would have kept her off the diving board for several weeks. Instead, she practiced six hours a day with various types of casts, mounting the platform and visualizing going through her takeoffs and come-outs for every dive on her list. After the cast was removed 10 weeks later, Wilkinson was diving again, practicing her somersaults and twists and refreshing muscle memory. In June she won the Olympic trials. "The broken foot

was a godsend," said Armstrong, her coach at The Woodlands Diving Club outside Houston. "I had never seen that sense of urgency in her."

The 22-year-old Wilkinson projects preternatural calm. Before her dives in Sydney she was the only Olympic 10-meter performer to acknowledge with a smile her family and friends cheering lustily in the stands. Her beaming face was an open book. Of course, her mettle would be sorely tested, but she grabbed the lead on the third of her five dives in the final, a reverse $2\,^1/_2$ somersault that's in her diving wheelhouse—she had four 9.5s—while the heavily favored Chinese, Li Na and Sang Xue, inexplicably did world-class belly flops. Then Wilkinson stole the competition on the fourth dive, the most difficult one for her, an inward $2\,^1/_2$ somersault she had butchered in the prelims. Just before she mounted the 40 steps of the tower, Armstrong impulsively blurted, "Do it for Hilary."

Hilary Grivich, Wilkinson's former club teammate and friend, died in a car accident in 1997. The inspired Wilkinson, as always, recited Philippians 4:13—*I can do all things through Christ, who strengthens me*—and then nailed her dive, scoring all 8.5s and 9s.

She held off Li by only 1.74 points, a remarkable conclusion to *Laura Wilkinson and the Medal of Gold.*

—Michael Farber
SI, Oct. 2, 2000

2000 Summer Games

TRACK AND FIELD
Men

100 METERS
1.	Maurice Green, United States	9.87
2.	Ato Boldon, Trinidad and Tobago	9.99
3.	Obadele Thomoson, Barbados	10.04

200 METERS
1.	Konstadinos Kederis, Greece	20.09
2.	Darren Campbell, Great Britain	20.14
3.	Ato Boldon, Trinidad and Tobago	20.20

400 METERS
1.	Michael Johnson, United States	43.84
2.	Alvin Harrison, United States	44.40
3.	Gregory Haughton, Jamaica	44.70

800 METERS
1.	Nils Schumann, Germany	1:45.08
2.	Wilson Kipketer, Denmark	1:45.14
3.	Aissa Djabir Said-Guerni, Algeria	1:45.16

1,500 METERS
1.	Noah Ngeny, Kenya	3:32.07 OR
2.	Hicham El Guerrouj, Morocco	3:32.32
3.	Bernard Lagat, Kenya	3:32.44

5,000 METERS
1.	Millon Wolde, Ethiopia	13:35.49
2.	Ali Saidi-Sief, Algeria	13:36.20
3.	Brahim Lahlafi, Morocco	13:36.47

10,000 METERS
1.	Haile Gebrselassie, Ethiopia	27:18.20
2.	Paul Tergat, Kenya	27:18.29
3.	Assefa Mezgebu, Ethiopia	27:19.75

MARATHON
1.	Gezenghe Abera, Ethiopia	2:10:11
2.	Eric Wainaina, Kenya	2:10:31
3.	Tesfaye Tola, Ethiopia	2:11:10

110-METER HURDLES
1.	Anier Garcia, Cuba	13.00
2.	Terrence Trammell, United States	13.16
3.	Mark Crear, United States	13.22

400-METER HURDLES
1.	Angelo Taylor, United States	47.50
2.	Hadi Souan Somalyi, Saudi Arabia	47.53
3.	Llewelyn Herbert, South Africa	47.81

3,000-METER STEEPLECHASE
1.	Reuben Kosgei, Kenya	8:21.43
2.	Wilson Boit Kipketer, Kenya	8:21.77
3.	Ali Ezzine, Morocco	8:22.15

4 x 100-METER RELAY
1.	United States: (Jon Drummond Bernard Williams III, Brian Lewis, Maurice Greene)	37.61
2.	Brazil	37.90
3.	Cuba	38.04

4 x 400-METER RELAY
1.	United States: (Alvin Harrison, Antonio Pettigrew, Calvin Harrison, Michael Johnson)	2:56.35
2.	Nigeria	2:58.68
3.	Jamaica	2:58.78

20-KILOMETER WALK
1.	Robert Korzeniowski, Poland	1:18:59
2.	Noe Hernandez, Mexico	1:19:03
3.	Vladimir Andreyev. Russia	1:19:27

50-KILOMETER WALK
1.	Robert Korzeniowski, Poland	3:42:22
2.	Aigars Fadejevs, Latvia	3:43:40
3.	Joel Sanchez, Mexico	3:44:36

TRACK AND FIELD (CONT.)
Men

HIGH JUMP
1.	Sergey Kliugin, Russia	7 ft 8¼ in
2.	Javier Sotomayor, Cuba	7 ft 7¼ in
3.	Abderrahmane Hammad, Algeria	7 ft 7¼ in

POLE VAULT
1.	Nick Hysong, United States	19 ft 4¼ in
2.	Lawrence Johnson, United States	19 ft 4¼ in
3.	Maksim Tarasov, Russia	19 ft 4¼ in

LONG JUMP
1.	Ivan Pedroso, Cuba	28 ft¾ in
2.	Jai Taurima, Australia	27 ft 10¼ in
3.	Roman Schurenko, Ukraine	27 ft 3¼ in

TRIPLE JUMP
1.	Jonathan Edwards, Great Britain	58 ft 1¼ in
2.	Yoel Garcia, Cuba	57 ft 3¾ in
3.	Denis Kapustin, Russia	57 ft 3½ in

SHOT PUT
1.	Arsi Harju, Finland	69 ft 10¼ in
2.	Adam Nelson, United States	69 ft 7 in
3.	John Godina, United States	69 ft 6¾ in

DISCUS THROW
1.	Virgilijus Alekna, Lithuania	227 ft 4 in
2.	Lars Riedel, Germany	224 ft 9 in
3.	Frantz Kruger, South Africa	223 ft 8 in

HAMMER THROW
1.	Szymon Ziolkowski, Poland	262 ft 6 in
2.	Nicola Vizzoni, Italy	261 ft 3 in
3.	Igor Astapkovich, Belarus	259 ft 8½ in

JAVELIN
1.	Jan Zelezny, Czech Republic	295 ft 9½ in
2.	Steve Backley, Great Britain	294 ft 9½ in
3.	Sergey Makarov, Russia	290 ft 10½ in

DECATHLON
		PTS
1.	Erki Nool, Estonia	8641
2.	Roman Seberle, Czech Republic	8606
3.	Chris Huffins, United States	8595

Women

100 METERS
1.	Marion Jones, United States	10.75
2.	Ekaterini Thanou, Greece	11.12
3.	Tanya Lawrence, Jamaica	11.18

200 METERS
1.	Marion Jones, United States	21.84
2.	P. Davis-Thompson, Bahamas	22.27
3.	Susanthika Jayasinghe, Sri Lanka	22.28

400 METERS
1.	Cathy Freeman, Australia	49.11
2.	Lorraine Graham, Jamaica	49.58
3.	Katharine Merry, Great Britain	49.72

800 METERS
1.	Maria Mutola, Mozambique	1:56.15
2.	Stephanie Graf, Austria	1:56.64
3.	Kelly Holmes, Great Britain	1:56.80

1,500 METERS
1.	Nouria Merah-Benida, Algeria	4:05.10
2.	Violeta Szekely, Romania	4:05.15
3.	Gabriela Szabo, Romania	4:05.27

5,000 METERS
1.	Gabriela Szabo, Romania	14:40.79 OR
2.	Sonia O'Sullivan, Ireland	14:41.02
3.	Gete Wami, Ethiopia	14:42.23

10,000 METERS
1.	Derartu Tulu, Ethiopia	30:17.49 OR
2.	Gete Wami, Ethiopia	30:22.48
3.	Fernanda Ribeiro, Portugal	30:22.88

TRACK AND FIELD (CONT.)
Women

MARATHON
1.	Naoko Takahashi, Japan	2:23:14 OR
2	Lidia Simon, Romania	2:23:22
3.	Joyce Chepchumba, Kenya	2:24:45

100-METER HURDLES
1.	Olga Shishigina, Kazakhstan	12.65
2.	Glory Alozie, Nigeria	12.68
3.	Melissa Morrison, United States	12.76

400-METER HURDLES
1.	Irina Privalova, Russia	53.02
2.	Deon Hemmings, Jamaica	53.45
3.	Nouza Bidouane, Morocco	53.57

4 x 100-METER RELAY
1.	Bahamas (S. Fynes, C. Sturrup, P. Davis-Thompson, D. Ferguson)	41.95
2.	Jamaica	42.13
3.	United States	42.20

4 x 400-METER RELAY
1.	United States (Jearl Miles-Clark, Monique Hennagan, Marion Jones, La Tasha Colander-Richardson)	3:22.62
2.	Jamaica	3:23.25
3.	Russia	3:23.46

20-KILOMETER WALK
1.	Wang Liping, China	1:29.05
2.	Kiersti Plaetzer, Norway	1:29.33
3.	Maria Vasco, Spain	1:30.23

HIGH JUMP
1.	Yelena Yelesina, Russia	6 ft 7 in
2.	Hestrie Cloete, S Africa	6 ft 7 in
3.	Kajsa Bergqvist, Sweden	6 ft 7 in

POLE VAULT
1.	Stacy Dragila, United States	15 ft 1 in OR
2.	Tatiana Grigorieva, Australia	14 ft 11 in
3.	Vala Flosadottir, Iceland	14 ft 9 in

LONG JUMP
1.	Heike Drechsler, Germany	22 ft 11¼ in
2.	Fiona May, Italy	22 ft 8½ in
3.	Marion Jones, United States	22 ft 8½ in

TRIPLE JUMP
1.	Tereza Marinova, Bulgaria	49 ft 10½ in
2.	Tatyana Lebedeva, Russia	49 ft 2½ in
3.	Olena Hovorova, Ukraine	49 ft 1 in

SHOT PUT
1	Yanina Korolchik, Belarus	67 ft 5½ in
2.	Laris Peleshenko, Russia	65 ft 4¼ in
3.	Astrid Kumbernuss, Germany	64 ft 4½ in

DISCUS THROW
1.	Ellina Zvereva, Belarus	224 ft 5 in
2.	Anastasia Kelesidou, Greece	215 ft 7 in
3.	Irina Yatchenko, Belarus	213 ft 11 in

JAVELIN
1.	Trine Hattestad, Norway	226 ft ½ in OR
2.	Mirella Maniani-Tzelili, Greece	221 ft 5½ in
3.	Osleidys Menendez, Cuba	217 ft 1 in

HEPTATHLON
		PTS
1.	Denise Lewis, Great Britain	6584
2.	Yelena Prokhorova, Russia	6531
3.	Natalya Sazanovich, Belarus	6527

HAMMER THROW
1.	Kamila Skolimowska, Russia	233 ft 5 in OR
2.	Olga Kuzenkova, Russia	228 ft 11 in
3.	Kirsten Muenchow, Germany	227 ft 3 in

Note: OR=Olympic record. WR=world record.
EOR=equals Olympic record. EWR=equals world record.

BASEBALL
1. United States
2. Cuba
3. S Korea

BASKETBALL
Men
Final: United States 85,
 France 75
 Lithuania (3rd)
United States: Shareef Abdur-Rahim, Ray Allen, Vin Baker, Vince Carter, Kevin Garnett, Tim Hardaway, Allan Houston, Jason Kidd, Antonio McDyess, Alonzo Mourning, Gary Payton, Steve Smith

Women
Final: United States 76,
 Australia 54
 Brazil (3rd)
United States: Ruthie Bolton-Holifield, Teresa Edwards, Yolanda Griffith, Chamique Holdsclaw, Lisa Leslie, Nikki McCray, Delisha Milton, Katie Smith Dawn Staley, Sheryl Swoopes, Natalie Williams, Kara Wolters

GYMNASTICS
Men

ALL-AROUND	PTS
1. Alexei Nemov, Russia	58.474
2. Wei Yang, China	58.361
3. O. Beresh, Ukraine	58.212

HORIZONTAL BAR	PTS
1. Alexei Nemov, Russia	9.787
2. Benjamin Varonian, France	9.787
3. Joo-hyung Lee, S Korea	9.775

PARALLEL BARS	PTS
1. Xiaopeng Li, China	9.825
2. Joo-hyung Lee, S Korea	9.812
3. Alexei Nemov, Russia	9.800

VAULT	PTS
1. Gervasio Deferr, Spain	9.712
2. Alexei Bondarenko, Russia	9.587
3. Leszsk Blanik, Poland	9.475

POMMEL HORSE	PTS
1. Marius Urzica, Romania	9.862
2. Eric Poujade, France	9.825
3. Alexei Nemov, Russia	9.800

RINGS	PTS
1. Szilveszter Csollany, Hungary	9.850
2. Dimosthenis Tampakos, Kasak.	9.762
2. Iordan Iovtchev, Bulgaria	9.737

FLOOR EXERCISE	PTS
1. Igors Vihrovs, Latvia	9.812
2. Alexei Nemov, Russia	9.800
3. Iordan Iovtchev, Bulgaria	9.787

TEAM COMBINED EXERCISES	PTS
1. China	231.919
2. Ukraine	230.306
3. Russia	230.019

Women

ALL-AROUND	PTS
1. Simona Amanar, Romania	38.642
2. Maria Olaru, Romania	38.581
3. Xuan Li, China	38.418

GYMNASTICS *(CONT.)*
Women

VAULT	PTS
1. Yelena Zamolodtchikova, Russia	9.731
2. Andreea Raducan, Romania	9.693
3. Yekaterina Lobazniouk, Russia	9.674

UNEVEN BARS	PTS
1. Svetlana Khorkina, Russia	9.862
2. Ling Jie, China	9.837
2. Yang Yun, China	9.787

BALANCE BEAM	PTS
1. Li Xuan, China	9.825
2. Yekaterina Lobazniouk, Russia	9.787
3. Yelena Prodounova, Russia	9.775

FLOOR EXERCISE	PTS
1. Y. Zamolodtchikova, Russia	9.850
2. Svetlana Khorkina, Russia	9.812
3. Simona Amanar, Romania	9.712

TEAM COMBINED EXERCISES	PTS
1. Romania	154.608
2. Russia	154.403
3. China	154.008

RHYTHMIC ALL-AROUND	PTS
1. Yulia Barsukova, Russia	39.632
2. Yulia Raskina, Belarus	39.548
3. Alina Kabaeva, Russia	39.466

RHYTHMIC TEAM EXERCISES	PTS
1. Russia	39.500
2. Belarus	39.500
3. Greece	39.283

SWIMMING
Men

50-METER FREESTYLE	
1. Gary Hall Jr, United States	21.98
1. Anthony Ervin, United States	21.98
3. Pieter van den Hoogenband, Netherlands	22.03

100-METER FREESTYLE	
1. P. van den Hoogenband, Neth.	48.30
2. Alexander Popov, Russia	48.69
3. Gary Hall Jr, United States	48.73

200-METER FREESTYLE	
1. P. van den Hoogenband, 1:45.35 EWR Netherlands	
2. Ian Thorpe, Australia	1:45.83
3. Massimiliano Rosolino, Italy	1:46.65

400-METER FREESTYLE	
1. Ian Thorpe, Australia	3:40.59 WR
2. Massimiliano Rosolino, Italy	3:43.50
3. Klete Keller, United States	3:47.00

1,500-METER FREESTYLE	
1. Grant Hackett, Australia	14:48.33
2. Kieren Perkins Australia	14:53.59
3. Chris Thompson, U.S.	14:56.81

100-METER BACKSTROKE	
1. Lenny Krayzelburg, U.S.	53.72 OR
2. Matthew Welsh, Australia	54.07
3. Stev Theloke, Germany	54.82

200-METER BACKSTROKE	
1. Lenny Krayzelburg, U.S.	1:56.76 OR
2. Aaron Piersol, United States	1:57.35
3. Matthew Welsh, Australia	1:59.59

100-METER BREASTSTROKE	
1. Domenico Fioravanti, Italy	1:00.46 OR
2. Ed Moses, United States	1:00.73
3. Roman Sloudnov, Russia	1:00.91

SWIMMING *(CONT.)*
Men

200-METER BREASTSTROKE	
1. Domenico Fioravanti, Italy	2:10.87
2. Terence Parkin, S Africa	2:12.50
3. Davide Rummolo, Italy	2:12.73

100-METER BUTTERFLY	
1. Lars Froelander, Sweden	52.00
2. Michael Klim, Australia	52.18
3. Geoff Huegill, Australia	52.22

200-METER BUTTERFLY	
1. Tom Malchow, U.S.	1:55.35 OR
2. Denys Sylant'yev, Ukraine	1:55.76
3. Justin Norris, Australia	1:56.17

200-METER INDIVIDUAL MEDLEY	
1. M. Rosolino, Italy	1:58.98 OR
2. Tom Dolan, United States	1:59.77
3. Tom Wilkens, United States	2:00.87

400-METER INDIVIDUAL MEDLEY	
1. Tom Dolan, United States	4:11.76 WR
2. Eric Vendt, United States	4:14.23
3. Curtis Myden, Canada	4:15.33

4 x 100-METER MEDLEY RELAY	
1. United States	3:34.84 WR
(Lenny Krayzelburg,Ed Moses, Ian Crocker, Gary Hall Jr)	
2. Australia	3:35.27
3. Germany	3:35.88

4 x 100-METER FREESTYLE RELAY	
1. Australia	3:13.67 WR
(Ian Thorpe, Michael Klim, Ashley Callus, Chris Fydler)	
2. United States	3:13.86
3. Brazil	3:17.40

4 x 200-METER FREESTYLE RELAY	
1. Australia	7:07.05 WR
(Ian Thorpe, Michael Klim, William Kirby, Todd Pearson)	
2. United States	7:12.64
3. Netherlands	7:12.70

Women

50-METER FREESTYLE	
1. Inge de Bruijn, Netherlands	24.32
2. Therese Alshammar, Sweden	24.51
3. Dara Torres, United States	24.63

100-METER FREESTYLE	
1. Inge de Bruijn, Netherlands	53.83
2. Therese Alshammar, Sweden	54.33
3. Dara Torres, United States	54.43

200-METER FREESTYLE	
1. Susie O'Neill, Australia	1:58.24
2. Martina Moravcova, Slovakia	1:58.32
3. Claudia Poll Ahrens, Costa Rica	1:58.81

400-METER FREESTYLE	
1. Brooke Bennett, U.S.	4:05.80
2. Diana Munz, United States	4:07.07
3. Claudia Poll Ahrens, Costa Rica	4:07.83

800-METER FREESTYLE	
1. Brooke Bennett, U.S.	8:19.67 OR
2. Yana Klochkova, Ukraine	8:22.66
3. Kaitlin Sandeno, U.S.	8:24.29

100-METER BACKSTROKE	
1. Diana I. Mocanu, Rom.	1:00.21 OR
2. Mai Nakamura, Japan	1:00.55
3. Nina Zhivanevskaya, Spain	1:00.89

SWIMMING *(CONT.)*
Women

200-METER BACKSTROKE	
1. Diana I. Mocanu, Romania	2:08.16
2. Roxana Maracineanu, France	2:10.25
3. Miki Nakao, Japan	2:11.05

100-METER BREASTSTROKE	
1. Megan Quann, United States	1:07.05
2. Leisel Jones, Australia	1:07.49
3. Penny Heyns, South Africa	1:07.55

200-METER BREASTSTROKE	
1. Agnes Kovacs, Hungary	2:24.35
2. Kristy Kowal, United States	2:24.56
3. Amanda Beard, United States	2:25.35

100-METER BUTTERFLY	
1. Inge de Bruijn, Netherlands	56.61 WR
2. Martina Moravcova, Slovakia	57.97
3. Dara Torres, United States	58.20

200-METER BUTTERFLY	
1. Misty Hyman, U.S.	2:05.88 OR
2. Susie O'Neill, Australia	2:06.58
3. Petria Thomas, Australia	2:07.12

200-METER INDIVIDUAL MEDLEY	
1. Yana Klochkova, Ukraine	2:10.68 OR
2. Beatrice N. Caslaru, Romania	2:12.57
3. Cristina Teuscher, U.S.	2:13.32

400-METER INDIVIDUAL MEDLEY	
1. Yana Klochkova, Ukraine	4:33.59 WR
2. Yasuko Tajima, Japan	4:35.90
3. Beatrice N. Caslaru, Romania	4:37.18

4 x 100-METER MEDLEY RELAY	
1. United States	3:58.30 WR
(BJ Bedford,Megan Quann, Jenny ThompsonDara Torres)	
2. Australia	4:01.59
3. Japan	4:04.16

4 x 100-METER FREESTYLE RELAY	
1. United States	3:36.61 WR
(Jenny Thompson,Courtney Shealy, Dara Torres,A. Van Dyken)	
2. Netherlands	3:39.83
3. Sweden	3:40.30

4 x 200-METER FREESTYLE RELAY	
1. United States	7:57.80 OR
(Samantha Arsenault,Diana Munz, Lindsay Benko,Jenny Thompson)	
2. Australia	7:58.52
3. Germany	7:58.64

Note: OR=Olympic Record. WR=World Record. EOR=Equals Olympic Record. EWR=Equals World Record.

Power Struggles

While France reaffirmed its dominance in
Europe, the mighty were overthrown in
Major League Soccer ■ B. J. Schecter

Two years after he
scored twice in the
final to lead France to
the World Cup title
over Brazil, Zidane
(opposite) guided Les
Bleus to glory in
Europe, dictating play
in the midfield during
France's 2–1 victory
against Italy in the
championship game.

Say this for the French: They certainly have a flair
for the dramatic. Two years after winning the
1998 World Cup, Les Bleus established themselves
as one of the best teams of all time by winning the
European championship. It was the first time a
team had followed a World Cup triumph with a
European title, and the French did it in style, ral-
lying to beat Italy in overtime in an electrifying
final. *C'est magnifique!*

The French won the World Cup in '98 without a
true goal scorer, and some critics wrote off the title
as an aberration, more a product of home field ad-
vantage (the Cup was held in France) than daz-
zling soccer. But in Euro 2000, France had goal
scorers to spare: Thierry Henry, only 20 years old
during the World Cup, had blossomed into a
world-class striker for English club Arsenal, and he
was joined by Paris St. Germain star Nicholas
Anelka, Christophe Dugarry (Bordeaux), David
Trezeguet (Juventus) and Sylvain Wiltord (Arse-
nal). All of which meant that each time out, France
kept three deadly, first-rate finishers on its bench.

Despite the added firepower up top, France, as
it had in '98, still revolved around crafty mid-
fielder Zinedine Zidane, the 1998 FIFA World
Player of the Year. "When we don't know what to
do," said defender Bixente Lizarazu, "we just give
it to Zizou, and he works something out." With
Zidane pulling the strings, France was the class of

Arguably the best player in U.S. history, Ramos (above) retired from the national team after helping it to a crucial victory over Barbados in November; he planned to continue playing for the revitalized MetroStars.

the tournament, playing imaginative, stylish and, above all, attacking soccer. The dream final would have been France versus the Netherlands, another team with the players and the panache to emphasize offense in such a pressure-packed tournament. But because the Dutch missed five penalty kicks in the semifinals (two of them in regulation time!), what we got was France versus Italy, which defeated the Netherlands in a shootout following a scoreless draw. Not that France-Italy was without its own appeal, to be sure. The Italians are masters of the defensive, counterattacking game and would provide a perfect foil for France's flair for offense. Indeed, for the majority of the final the Azzurri had the upper hand.

The Italians scored in the 56th minute when Marco Delvecchio redirected a beautiful cross from Gianluca Pessotto into the top of the net. Striker Alessandro Del Piero had two golden chances to increase Italy's lead, but he shot wide in the 59th minute and right into the arms of French keeper Fabien Barthez in the 85th. Still, Italy led 1–0 heading into the final minute of stoppage time, and with victory imminent its subs rose from the bench and saluted their fans behind them.

The celebration, it turned out, was premature. With fewer than 20 seconds remaining, Les Bleus got a miracle as second-half substitute Wiltord, in traffic and from a tough angle, punched in the tying goal to send the game into overtime. A golden goal would settle the championship. "Everybody thought we were dead," said Henry. "With the French team, it's never over."

Deflated by the last-gasp equalizer, Italy went down to defeat 13 minutes into extra time. Trezeguet, another substitute, took a feed from Robert Pires, who'd made a nice move to get free on the left, and one-timed it into the top of the net. France's thrilling 2–1 victory provided a fitting close to one of the most exciting and highest

scoring (85 goals in 31 games) European championships in history. It also carved out a special place in history for Les Bleus, one shared by multiple World Cup winners Brazil, Germany and Italy. "We're even stronger than we were at the World Cup," said Zidane. "We've had two years to mature, and we have several talented strikers now."

Said dejected Italy coach Dino Zoff, "When you feel victory is in your hands and it slips away, it takes a lot of your spirit. But it was a great effort. I'm really sorry, but this is soccer." Del Piero, who missed those two chances to increase the Azzurri's lead, said, "Regret is to say too little. I feel guilty." Only seconds from victory, Italy was left to lament what might have been.

In the United States, Major League Soccer made several giant strides toward what could be a bright domestic future for the sport. Led by new commissioner Don Garber, the league lured some well-known players into its ranks and significantly improved its level of play. In May, MLS paid a record $4 million transfer fee for speedy striker Luis (el Matador) Hernandez, Mexico's leading scorer in the '98 World Cup. Hernandez joined Bulgaria's legendary Hristo Stoitchkov (Chicago) and former superstar Lothar Matthäus of Germany (New York/New Jersey) in the ranks of MLS's quality foreign signings. The league also proved it could develop domestic talent as the U.S. Olympic team, stocked with young MLS stars, made history by advancing to the semifinals in Sydney. No previous U.S. team had made it out of the first round in the Olympics.

The 2000 regular season was a topsy-turvy version of the previous year. Defending champs D.C. United went from first to worst, missing the playoffs for the first time in the league's five-year history, while 1999's cellar dwellers, the New York/New Jersey MetroStars and the Kansas City Wizards, made the opposite journey, winning division titles a year after finishing dead last.

With midfielder Tab Ramos back in form after an ACL injury, and with help from the improvised dispersal draft, which MLS held as part of the deal that brought Hernandez to the Galaxy, the MetroStars played some of the most exciting soccer in the league. While L.A. got Hernandez from the Mexican league, the MetroStars got Clint Mathis and midfielder Roy Myers from L.A. Mathis, a promising U.S. striker, came via the dispersal draft, and Myers, of Costa Rica, came in a trade because L.A. needed to unload one foreign player so that the addition of Hernandez would

not put them over the limit of four per team. Confused yet? Well, then look at it this way: The league knew it could ill afford to have a doormat in the soccer-savvy, media-saturated New York area, and now it no longer does.

Indeed, the MetroStars were good enough to survive the distraction caused by the aging Matthäus, who was a disruptive influence almost from the moment the league acquired him, loudly complaining about front-office changes and the quality of the Metros' play. He finally meshed with the team in the stretch run, after it had established its winning ways in his absence. (He missed a month of the season to play for Germany in Euro 2000.) But even with the legendary Matthäus in its back line, the Metros forte was offense. Forwards Adolfo Valencia and Mathis each scored 16 goals, and Mathis set an MLS record against Dallas on Aug. 26 when he exploded for five goals.

Kansas City displayed a different kind of mastery in August, turning in a remarkable nine shutouts in 12 games. A significant reason behind the Wizards' defensive dominance was former national team goalkeeper Tony Meola, who routinely made spectacular saves and finished the regular season with a league-leading 16 shutouts.

Chicago won the league's toughest division, the Central, with arguably the league's most talented roster. In addition to Stoitchkov, the Fire had Polish international Peter Nowak and U.S. national teamers Chris Armas, Ante Razov and Josh Wolff at its disposal. Thanks to the dynamic duo of midfielder Carlos Valderrama and striker Mamadou Diallo, who led the league in scoring with 26 goals in 28 games, Tampa Bay finished a close second to the Fire. But the Mutiny crumbled at crunch time, getting swept out of the first round by Los Angeles. The MetroStars dispatched Dallas in their first-round meeting while New England extended Chicago to three games, only to be blown out 6–0 in the finale.

Kansas City crept through the playoffs at a steady pace, edging sub-.500 Colorado in three games in the first round, and needing more than that to nip Los Angeles in the semis: After tying

the series at four points apiece with a 1–0 win in Game 3, the Wizards won it with a goal in the 20-minute, sudden-death mini-game that decided the series. Kansas City's bruising striker Miklos Molnar of Denmark scored both goals. That was the Wizards' formula all season long: Get an early goal from Molnar and then protect the slim lead with staunch defense and superb goalkeeping. Not particularly sexy, perhaps, but very effective: The Wizards got an 11th-minute goal from Molnar in the championship game against Chicago—which edged the MetroStars in a hardfought, physical semifinal—and made it stand up for a 1–0 victory and the MLS title. Meola, who made several huge saves, including point-blank stops on Dema Kovalenko and Wolff, was a no-brainer choice for MVP of the game. He might not have room on his mantle for the award, though, as he'll have to squeeze it in next to his Goalkeeper of the Year, Comeback Player of the Year and regular-season MVP trophies.

While Hernandez and Matthäus sputtered in Los Angeles and New York, respectively, Major League Soccer's other marquee signing, Stoitchkov (8), sparkled in Chicago, leading the Fire to MLS Cup 2000 in Washington, D.C., where it fell 1–0 to Chris Henderson (19) and the Kansas City Wizards.

PHOTO GALLERY

France's Christophe Dugarry (above, left) battled Fabio Cannavaro of Italy (above, right) for a head ball during the European Championship on July 2 in Rotterdam. France scored a late goal to tie the game and send it in to extra time, then netted a golden goal to claim the title and become the first team to follow a World Cup triumph ('98) with a European crown.

Cobi Jones (right, white uniform) scored two goals and had an assist in a June 3 friendly against South Africa, leading the U.S. to a 4–0 victory in Washington, D.C. But that tune-up game would be the high-water mark of 2000 for Jones, whose play faltered when the U.S. began qualifying for the 2002 World Cup in July.

Earthquake Alert: The Fire's Chris Armas (14) and Ante Razov (9) closed down San Jose midfielder Mauricio Solis (23) in a June 24 game in San Jose. After a 31st-minute goal by Chicago's Dema Kovalenko, Solis and the Earthquakes rallied, scoring an equalizer in stoppage time. Rookie Ian Russell netted the 92nd-minute goal off a corner kick, collecting Richard Mulrooney's cross and burying it for the first goal of his MLS career.

PROFILES

LANDON DONOVAN

Since he began playing soccer in Redlands, Calif., in 1987, Landon Donovan has loved taking the field at night. "Day games are less exciting—people come to them thinking about what they'll be doing afterward," the 18-year-old striker says, "but night games are events, like concerts. I always get pumped up to play them." The days have been long and hard for Donovan since February '99 when he signed a four-year, $400,000 contract with Bayer Leverkusen, the premier club in Germany's Bundesliga. Leverkusen assigned him to its developmental *regionalliga* squad, which plays in small stadiums in the hinterlands. Under constant pressure to perform, targeted because of his big salary, 9,000 miles from home, the kid who might become the U.S.'s first great goal scorer had struggled.

In March 2000, however, Donovan (right) finally found his footing. Fittingly, the breakthrough came at night, in a midweek *regionalliga* match against Essen. Though it was a home game for Leverkusen, it took place at a stadium in nearby Cologne; Leverkusen's field lacks the facilities to contain Essen's supporters, the rabid Red Bulls, who must be funneled into an enclosure to prevent violence. Twenty-five minutes into the game Donovan shunted his defender aside, stretched out a leg and tapped a teammate's weak shot home. Three minutes later, on a two-on-one breakaway, he volleyed a pass into the corner of the net from 15 yards out. Then, with a minute left in the first half, Donovan scored his third goal, drilling in a loose ball from near the top of the penalty box to give Bayer a 5–1 lead; they won 5–2. "Some games you can do no wrong," Donovan says. "I just kept shooting." In the papers the next day soccer writers compared Donovan to Leverkusen's famed scorer Ulf Kristen. …

Donovan describes the Essen game as a "coming of age," one that validated his decision to leave home and endure the hardships of adjusting to life in industrial Leverkusen. It scarcely helped that he was shuttling between Leverkusen and various international tournaments to play for the U.S. under-17 team. But those hassles had their rewards. In November, Donovan received the Golden Ball, given to the outstanding player at the under-17 world championship in New Zealand, capping a youth career that included 35 goals and 16 assists in 41 international games.

A chasm yawns, however, between being the world's best 17-year-old striker and just holding your own against veteran professionals. …

Donovan…rose rapidly through Southern California's youth soccer system. At 17 he was not only playing for the U.S. under-23 team but also scoring regularly. He returned to the U.S. on Sunday to play with the under-23 team in an Olympic qualifying tournament. "We've never had such a highly touted young attacking player," says Bruce Arena, coach of the national team. "A lot of people are saying Landon's the savior of American soccer, and I'd love to say he's the real thing, the answer to our problems. But there's no direct correlation between success in the under-17s and at the senior level. Plus, I think all those expectations can be a huge burden."

The questions about Donovan involve only the sport's intan-

gibles. In speed and agility tests he eclipses elite players years older than he is, and his ball handling technique is world-class. ... At 16 Donovan started hearing from clubs in England and Germany. "We seldom offer a young foreign player such a contract," says Michael Reschke of Bayer Leverkusen, "but in 21 years working with young players, I've rarely seen such strong potential.''...

Within Leverkusen's soccer combine, people characterize the sport as a "hard business." The Bayer Leverkusen uniforms have the word ASPIRIN printed across their chests, in homage to the parent company's best-known product. Players are awarded bonuses for games started, goals scored and wins; fines are levied for even minor infractions. Few players on the *regionalliga* team have lucrative contracts like Donovan's, so those extra payouts matter. The competition for starting slots often rages so intensely that practice injuries are commonplace. With mantralike similarity the Leverkusen bosses point out that Donovan is competing against grown men with families to feed. Donovan's getting the same message from his father. "I always try to drill into him that it's not a club team anymore," Tim Donovan says. "Everyone's playing for money, and he's trying to take away someone's job. Landon says, 'I know, I know,' but I think it was hard for a 17-year-old to grasp.''...

Emotionally it would have been far easier for Donovan to play for a team in Major League Soccer, but ... he describes bypassing MLS as a no-brainer. The U.S. league is a fledgling business; the Bundesliga is the central focus of an entire country's sporting passion. "Here we get 8,000 people watching third-division games," says [fellow American and Leverkusen teammate John] Thorrington.

Nevertheless, Donovan still struggles to get settled in Germany. Less than a week after his hat trick against Essen he told Hermann he felt worn-out and homesick. The team had a bye weekend coming up, and other players were planning visits home. Leverkusen shelled out for a plane ticket, and the next day Donovan touched down in Southern California. There's more than just expatriate blues at play here. The strain Donovan is under is enormous, especially for a kid whose lifelong friends are giddily preparing for prom night. "I wanted to chill out and see my family," Donovan says. "I wanted to spend time just doing whatever I wanted, not having a schedule. There have been times in Germany, like when I wasn't playing, that I wanted to go home the next day. But when I'm playing well, I can't imagine why I would ever leave."

—Marc Spiegler
excerpted from SI, April 17, 2000

CHRIS ARMAS

Club and country. They're the magnetic poles of a soccer player's world, a constant source of divided loyalty—paycheck versus patriotism—that makes futbol unique among the major sports. Imagine that Derek Jeter had to leave the New York Yankees for a couple of days to play in a real World Series, for the U.S. ... Such was the scenario last week facing Chris Armas, the most indispensable player for both the Chicago Fire and the U.S. national soccer team.

Over five days, club and country converged for an American player as never before. On Wednesday, Oct. 11, the U.S. met Costa Rica in Columbus, Ohio, needing a victory to clinch a berth in the final round of qualifying for the 2002 World Cup. Then on Sunday in Washington, D.C., the Fire took on the Kansas City Wizards in MLS Cup 2000 to decide the champion of U.S. professional soccer.

But this soccer weenie's fantasy also turned out to be an exhausting odyssey for Armas. His task last week? Run a combined 14 miles in two defensive struggles, in two cities, four days apart—with a knee injury that makes grown men cry. Floored by a vicious tackle in a World Cup qualifier against Barbados in August, Armas was still nursing a grade-two sprain of his left MCL that had caused him to miss the Olympics and a month of the MLS season. Whenever the ligament flares up—from kicking the ground accidentally or from cutting too abruptly—it feels "like needles all over the inside of your knee," Armas says.

To appreciate Armas's manifold talents is, first, to understand what he's not. He is not the savior of American soccer, and he is not the electric goal scorer the U.S. has craved for years. Yet Armas's skills are no less important. He is, in soccer parlance, a ball winner—"a little thief running around the midfield," says Chicago's Jesse Marsch. ... Armas, 28, is the first American who can be mentioned in the same breath as Manchester United's Roy Keane, the gold standard for defensive midfielders. "Chris is the guy who does the dirty work, who disrupts everything

CHRIS ARMAS

continued from previous page

the other team does," says Fire striker Ante Razov. ...

We pick up Armas's journey in Columbus, home of the best soccer stadium in the country.

WEDNESDAY, OCT. 11
He almost didn't come. Armas (right) had aggravated his knee injury during the Fire's semifinal victory over the New York/New Jersey MetroStars on the previous Friday. That night, when he couldn't bend or straighten his leg without feeling pain, he thought, Am I going to miss the qualifier *and* MLS Cup? After all this work? Armas made the trip anyway, though four hours before game time he's still nervous, unsure that he can last the entire match. "I'm shooting for 90 minutes," he says. "Anything less, and that means I'm feeling some pain."

Armas holds on for the full 90, but the U.S. struggles. The team is missing six starters because of injury or suspension [and scraps its way to a 0–0 draw]. "Tomorrow night I'll start to feel really sore," Armas says, "and the next morning you start getting pains in your feet and your legs and your back. All of a sudden you're like, My body's killing me."

THURSDAY, OCT. 12
More discouraging news: Armas, his wife, Justine, and teammates Razov and Wolff are stuck at Port Columbus airport for two hours after their United flight to Washington is canceled. ...

FRIDAY, OCT. 13
Sure enough, Armas's first steps out of bed are excruciating. ...

In room 238 Armas lies on a trainer's table, his left knee wrapped with an electric stimulator. "When Chris left last Friday night," Fire trainer Rich Monis says, "we were hoping for selfish reasons that he wouldn't play [for the U.S.]. But as long as he felt O.K., it was up to him."

"How does it feel?" Monis asks, removing the stimulator.

Armas grimaces. "I feel it up *here*," he says, pointing to the inside of his knee. No more therapy for today, though. Armas calls it a night.

SATURDAY, OCT. 14
MLS ... presents its awards to the season's top players, the Best 11, at a gala only 18 hours before kickoff. Armas is a winner for the third straight year, despite having played in only 16 of the Fire's 32 regular-season games. "It's an honor to be chosen, but my goal is to make it a short night," he says while Justine adjusts his tie. "We'll sit down, and my leg will get swollen, and I'll worry about it." ...

SUNDAY, OCT. 15
From the opening sequence of the MLS title game, when Armas springs Peter Nowak free with a header only to have Nowak stumble in front of the goal, the Fire dominates the Wizards in every aspect but one. Scoring. In the 11th minute K.C.'s Chris Klein eludes Armas as he churns up the right side and serves a cross into the penalty box. The ball ricochets off the Fire's Marsch to Wizards striker Miklos Molnar, who pushes home the gift goal.

"Klein poked it by me, and he did well to put it in the box, but we had numbers there," Armas says later, shaking his head. "I was thinking, Be patient. We'll get more chances, score a few goals."

The chances come. The goals do not. The Fire hits the woodwork twice, once when Gutierrez doinks the crossbar from three yards out. Wizards goalkeeper Tony Meola parries another 10 shots, and K.C. raises the silver trophy as the 2000 MLS champion. "So we had a lot of chances? So we dominated? Big deal," Armas says in the crypt-quiet Chicago locker room. "No point in saying what we could have done. We didn't do it. That's reality."

So is this: After surviving one of the most intense weeks in the history of U.S. soccer, Armas still has one more game to play, on Saturday, October 21, in Chicago against the Miami Fusion. It's the final of the U.S. Open Cup, a 154-team knockout competition that included all the MLS clubs plus squads from three other professional and amateur leagues. In other words, the Fire may have lost a championship on Sunday, but it can still finish the season with a big, shiny trophy.

We told you this sport was unlike any other, didn't we?

—Grant Wahl
excerpted from SI, Oct. 23, 2000

TONY MEOLA

It was a historic night for Kansas City Wizards goalkeeper Tony Meola. His team had just clinched a spot in MLS Cup 2000 by beating the Los Angeles Galaxy, the champagne was whizzing through the air like tracer fire in the Wizards' Arrowhead Stadium locker room, and the victors were bouncing together and booming the *Ole! Ole! Ole!* chant that makes soccer celebrations more childish and fun than those of any other sport. But none of that is what made last Friday evening historic. "I actually wore underwear today!" Meola yelled, pumping his blood-stained fist. "I haven't worn underwear since my wedding night! I must have had that pair since the sixth grade!"

Ole! Ole! Ole!

Thus Meola added one more chapter to his growing legend. It's not enough that he set an MLS record with 16 shutouts this season, or that he helped turn the last-place Wizards into the league's winningest team, or that after missing most of 1999 with a torn left ACL, he was set to be honored this week as MLS's 2000 Comeback Player of the Year, Goalkeeper of the Year and (in all likelihood) Most Valuable Player. No, there was one more stunning feat: Meola did all that without wearing any drawers (or, in jockspeak, free balling, as sung to the tune of Tom Petty's "Free Fallin'".)

In aspect and in style, Meola, 31, resembles another Italian-American swashbuckler, Sylvester Stallone, with one small difference: Meola's comeback worked. "He's the only keeper in the league who can win you five to 10 games a season by himself," says teammate Peter Vermes, the MLS Defender of the Year. "Tony can make saves that other guys can't, and he's so good at distribution that he puts us on the counterattack, whereas other goalkeepers look for the safe pass to the back."

"He's so smooth about angles," adds K.C. coach Bob Gansler, whose ties with Meola go back to their days as coach and player on the 1990 World Cup team. "Another thing is his communication with the players around him. Tony used to rip people's heads off. Now he gives them information without castration."

Sure enough, the only snipping that Meola has performed since his star-making turn in the '94 World Cup was the removal of his ponytail. Now married and the father of two, Meola is no longer a "25-year-old punk," as he puts it, and his game has matured too.

Two years after the New York/New Jersey MetroStars traded him to the Wizards, Meola is one of the few people who can say, "Kansas City has opened up a lot of doors for me that might not have opened in New York." He's the only MLS player to have his own weekly TV or radio show, and he has both—a television program called KC Kicks and a radio call-in show, *The Wizards Soccer Hour with Tony Meola*. So thoroughly has Meola seeped into the city's sports culture that the Grand Street Cafe, a tony eatery near the equally tony Country Club Plaza, proudly serves the Tony Shake, a 60% vanilla, 40% chocolate concoction honoring its most famous patron.

About the only comeback that Meola hasn't completed is his return to the national team; he's stuck at No. 3 keeper, behind Kasey Keller—who may be the best player the U.S. has ever produced—and Brad Friedel. It's worth noting, however, that Friedel has mostly ridden the bench at the club level in England for two years, while Meola (below) has been winning MLS honors. "I believe I should be on the national team because I've done everything [U.S. coach] Bruce Arena has asked me to do," Meola says. "He knows anytime he rings my phone, I'll be there."

For now, at least, Meola has a future full of possibility, from playing "another four or five years at this level," he says, to moving to Europe (Italian Serie A team Reggina offered to sign him in August, but Meola says he didn't want to abandon the Wizards) to going into broadcasting after his playing days are done. "Not soccer," he says. "I want to do *SportsCenter*."

Why limit yourself? The same goes for the Wizards, who'll be raising a certain silver trophy after Sunday's MLS Cup against the Chicago Fire at RFK Stadium if Meola can live up to the T-shirt he wears every game, the one with the word goals crossed out. Whether he'll be sporting anything else underneath on his way in and out of the stadium is a different question.

"This was a special occasion, man," he said last week. "Everyone argues about boxers or briefs, but I say neither. I guess it's my own sick little world I live in."

Maybe so, but it's a sick little triumphant world.

—Grant Wahl
SI, Oct. 16, 2000

2000 European Championship

GROUP STANDINGS

Group A

Country	GP	W	L	T	GF	GA	Pts
*Portugal	3	3	0	0	7	2	9
*Romania	3	1	1	1	4	4	4
England	3	1	2	0	5	6	3
Germany	3	0	2	1	1	5	1

Group B

Country	GP	W	L	T	GF	GA	Pts
*Italy	3	3	0	0	6	2	9
*Turkey	3	1	1	1	3	2	4
Belgium	3	1	2	0	2	5	3
Sweden	3	0	2	1	2	4	1

Group C

Country	GP	W	L	T	GF	GA	Pts
*Spain	3	2	1	0	6	5	6
*Yugoslavia	3	1	1	1	7	7	4
Norway	3	1	1	1	1	1	4
Slovenia	3	0	1	2	4	5	2

Group D

Country	GP	W	L	T	GF	GA	Pts
*Netherlands	3	3	0	0	7	2	9
*France	3	2	1	0	7	4	6
Czech Rep.	3	0	2	1	1	6	3
Denmark	3	0	2	1	0	8	0

*Advanced to second round.

Note: In group play, teams are awarded three points for a victory, one for a tie. The top two in each group advance to the quarterfinals.

GROUP PLAY SCORES

Group A
Germany 1, Romania 1
Portugal 3, England 2
Portugal 1, Romania 0
England 1, Germany 0
Romania 3, England 2
Portugal 3, Germany 0

Group B
Belgium 2, Sweden 1
Italy 2, Turkey 1
Italy 2, Belgium 0
Sweden 0, Turkey 0
Turkey 2, Belgium 0
Italy 2, Sweden 1

Group C
Norway 1, Spain 0
Yugoslavia 3, Slovenia 3
Spain 2, Slovenia 1
Yugoslavia 1, Norway 0
Slovenia 0, Norway 0
Spain 4, Yugoslavia 3

Group D
France 3, Denmark 0
Neth. 1, Czech Rep. 0
France 2, Czech Rep. 1
Neth. 3, Denmark 0
Czech Rep. 2, Den. 0
Netherlands 3, France 2

Euro 2000—Quarterfinals

```
Portugal
           Portugal (2-0)
Turkey
                            France (2-1)          Euro 2000 Final                Italy (0-0)*        Italy (2-0)          Italy
France                                               France                                                             Romania
           France (2-1)                              (2-1) ot                                        Netherlands (6-1)  Netherlands
Spain                                                                                                                   Yugoslavia
```

* Italy won penalty-kick shootout 3–1 over the Netherlands in the semifinals.

Major League Soccer

2000 FINAL STANDINGS

Eastern Division

TEAM	WON	LOST	TIED	PTS
NY/NJ (3)	17	12	3	54
New England (7)	13	13	6	45
Miami	12	15	5	41
D.C.	8	18	6	30

Central Division

TEAM	WON	LOST	TIED	PTS
Chicago (2)	17	9	6	57
Tampa Bay (4)	16	12	4	52
Dallas (6)	14	14	4	46
Columbus	11	16	5	38

Western Division

TEAM	WON	LOST	TIED	PTS
Kansas City (1)	16	7	9	57
Los Angeles (5)	14	10	8	50
Colorado (8)	13	15	4	43
San Jose	7	17	8	29

Note: Three points for a win. One point for a tie. Number in parentheses is playoff seed.

Scoring Leaders

PLAYER, TEAM	GP	G	A	PTS
Mamadou Diallo, TB	28	26	4	56
Clint Mathis, NY/NJ	29	16	14	46
Ante Razov, Chicago	24	18	6	42
Diego Serna, Miami	31	16	10	42
Adolfo Valencia, NY/NJ	31	16	9	41

Goals Leaders

PLAYER, TEAM	GP	G
Mamadou Diallo, Tampa Bay	28	26
Ante Razov, Chicago	24	18
Adolfo Valencia, NY/NJ	31	16
Clint Mathis, NY/NJ	29	16
Diego Serna, Miami	31	16

Assists Leaders

PLAYER, TEAM	GP	A
Carlos Valderrama, Tampa Bay	32	26
Steve Ralston, Tampa Bay	30	17
Martin Machon, Miami	24	16
Preki, Kansas City	31	15
Peter Nowak, Chicago	28	14
Clint Mathis, NY/NJ	29	14

Goals-Against-Average Leaders

PLAYER, TEAM	GAA
Tony Meola, Kansas City	0.92
Kevin Hartman, Los Angeles	1.00
Zach Thornton, Chicago	1.28
Joe Cannon, San Jose	1.49
Scott Garlick, Tampa Bay	1.53

2000 Playoffs

```
Kansas City
              Kansas City (6-1)
Colorado
                                 Kansas City (5-4)     Kansas City        Chicago (6-3)     Chicago (6-3)     Chicago
Tampa Bay                                              (1-0)                                                 New England
              Los Angeles (6-0)                                                             NY/NJ (6-0)      Dallas
Los Angeles                                                                                                 NY/NJ
```

Note: Except for the final, which was a single game, scores in parentheses are points earned (three for a win, one for a tie) in a three-game series, the winner being the first team to accumulate five.

MLS Cup 2000

WASHINGTON, D.C., OCTOBER 15, 2000

Chicago	0	0	—0
Kansas City	1	0	—1

Goals: Molnar (Klein) 11.

Chicago—Thornton, Brown, Bocanegra, Bonseu, Nowak (Kubik 83), Gutierrez (Beasley 70), Armas, Marsch (Wolff 59), Kovalenko, Stoitchkov, Razov.
Kansas City—Meola, Klein (Gomez 89), Garcia, Vermes, Prideaux, Preki (Okafor 74), McKeon, Zavagnin, Henderson, Johnston, Molnar.
Att: 39,159.

International Competition

1999–2000 U.S. MEN'S NATIONAL TEAM RESULTS

DATE	OPPONENT	SITE	RESULT	U.S. GOALS
Nov 17, 1999	Morocco	Marrakech	1–2 L	Wynalda
Jan 16, 2000	Iran	Los Angeles	1–1 T	Armas
Jan 29	Chile	Coquimbo, Chile	2–1 W	Lewis, Jones
Feb 12	Haiti*	Miami	3–0 W	Kirovski, Wynalda, Jones
Feb 16	Peru*	Miami	1–0 W	Jones
Feb 19	Colombia*	Miami	2–2 T•	McBride, Armas
March 12	Tunisia	Birmingham, AL	1–1 T	Olsen
April 26	Russia	Moscow	2–0 L	—
June 3	South Africa#	Washington, D.C.	4–0 W	Jones (2), Reyna, Stewart
June 6	Ireland#	Foxboro, MA	1–1 T	Razov
June 11	Mexico#	East Rutherford, NJ	3–0 W	McBride, Hejduk, Razov
July 16	Guatemala†	Mazatanengo, Guat.	1–1 T	Razov
July 23	Costa Rica†	San Jose, Costa Rica	1–2 L	Stewart
Aug 16	Barbados†	Foxboro, MA	7–0 W	Pope, McBride, Moore (2), O'Brien Ramos, Stewart
Sept 3	Guatemala†	Washington, D.C.	1–0 W	McBride
Oct 11	Costa Rica†	Columbus, OH	0–0 T	—
Nov 15	Barbados†	Waterford, St. Michael, Barbados	4–0 W	Mathis, Stewart, Jones, Razov

*CONCACAF Gold Cup. # U.S. Cup 2000. †Qualifying for 2002 World Cup. • Colombia won penalty-kick shootout.
Record in full internationals from Nov 17, 1999, through Nov 15, 2000: 8-3-6.

2000 U.S. WOMEN'S NATIONAL TEAM RESULTS

DATE	OPPONENT	SITE	RESULT	U.S. GOALS
Jan 7	Czech Republic	Melbourne	8–1 W	Mascaro (2), Kester (2), Bush, Serlenga, Welsh, Zepeda
Jan 10	Sweden	Melbourne	0–0 T	—
Jan 13	Australia	Adelaide, Australia	3–1 W	Kester, Slaton, Wagner
Feb 6	Norway	Ft. Lauderdale, FL	2–3 L	Hamm, Lilly
Feb 9	Norway	Ft. Lauderdale, FL	1–2 L	Welsh
March 12	Portugal	Silves, Portugal	7–0 W	Parlow (3), MacMillan, Fawcett, Venturini, Foudy
March 14	Denmark	Faro, Portugal	2–1 W	Fair, MacMillan
March 16	Sweden	Lagos, Portugal	1–0 W	Hamm
March 18	Norway	Loulé, Portugal	1–0 W	Chastain
April 5	Iceland	Davidson, NC	8–0 W	Welsh (3), Wagner, Pearce (2), Hamm, Lilly
April 8	Iceland	Charlotte, NC	0–0 T	—
May 5	Mexico	Portland, OR	8–0 W	MacMillan (2), Lilly, Serlenga, Milbrett, Hamm, Fair, Welsh
May 7	Canada	Portland, OR	4–0 W	Foudy, Parlow, Milbrett, Welsh
May 31	China	Canberra, Australia	0–1 L	—
June 2	Canada	Sydney	9–1 W	Milbrett (3), MacMillan, Parlow (3), Fair (2)
June 4	New Zealand	Sydney	5–0 W	Welsh (2), Parlow (3)
June 8	Japan	Newcastle, Australia	4–1 W	Parlow, MacMillan, Chastain, Wagner
June 11	Australia	Newcastle, Australia	1–0 W	MacMillan
June 23	Trinidad & Tobago	Hershey, PA	11–0 W	Parlow (3), Fair (2), Milbrett, Hamm (2), MacMillan, Whalen (2)
June 25	Costa Rica	Louisville, KY	8–0 W	Serlenga (3), Welsh (2), MacMillan, Bush, Whalen
June 27	Brazil	Foxboro, MA	0–0 T	—
July 1	Canada	Louisville, KY	4–1 W	MacMillan (2), Milbrett, Hamm
July 3	Brazil	Foxboro, MA	1–0 W	Milbrett
July 7	Italy	Central Islip, NY	4–1 W	Wagner, Whalen, Bush, Putz
July 16	Norway	Osnabrück, Germany	1–0 W	Milbrett
July 19	China	Göttingen, Germany	1–1 T	Hamm
July 22	Germany	Braunschweig, Germany	1–0 W	Foudy
July 27	Norway	Tromsø, Norway	1–1 T	Serlenga
July 30	Norway	Oslo	1–2 L	Parlow
Aug 13	Russia	Annapolis, MD	7–1 W	Milbrett (2), Foudy, Hamm, Parlow (2), Akers
Aug 15	Russia	College Park, MD	1–1 T	Fawcett
Aug 20	Canada	Kansas City, MO	1–1 T	Lilly
Sept 1	Brazil	San Jose, CA	4–0 W	Foudy, Fawcett, Hamm (2)
Sept 14	Norway*	Melbourne	2–0 W	Milbrett, Hamm
Sept 17	China*	Melbourne	1–1 T	Foudy
Sept 20	Nigeria*	Melbourne	3–1 W	Chastain, Lilly, MacMillan
Sept 24	Brazil*	Canberra, Australia	1–0 W	Hamm
Sept 28	Norway*	Sydney	2–3 L	Milbrett (2)

Record from Jan 7 through Sept 28: 25-5-8. *2000 Sydney Olympic Games.

95

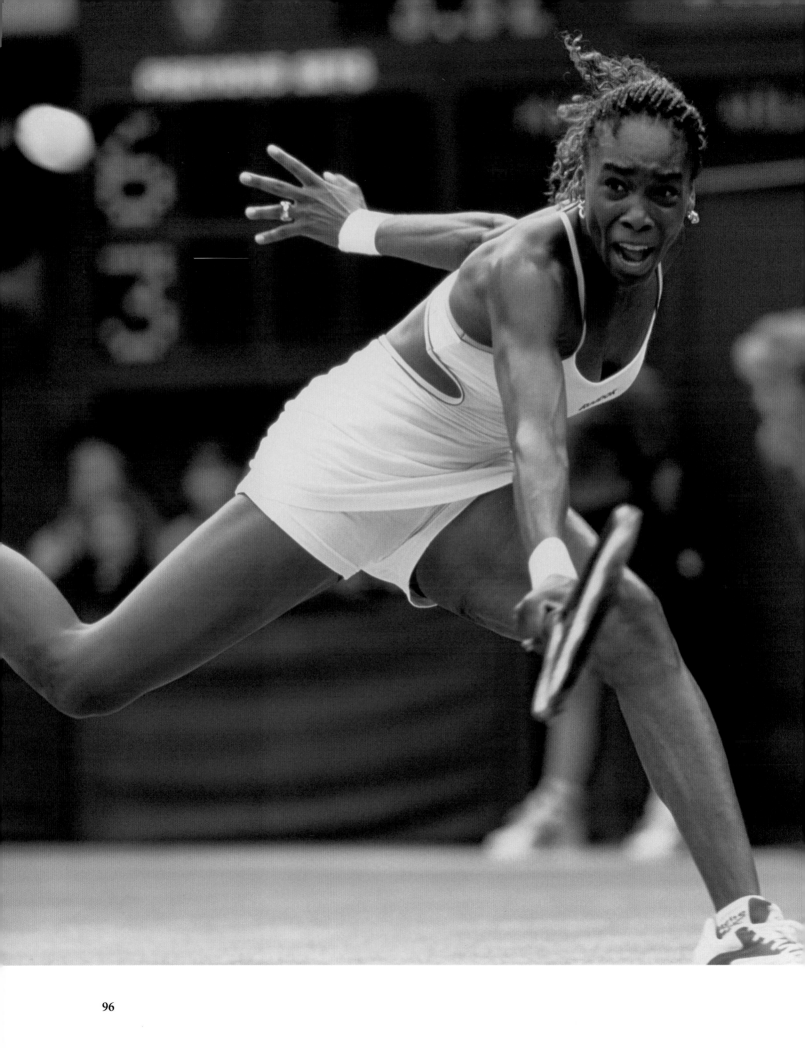

Sister Act

With exciting rivalries, superb play and the irrepressible Williams sisters, the women's tour stole the spotlight in 2000 ■ B.J. Schecter

The game of tennis is changing—players are getting stronger, faster, their games more powerful—and nowhere is the shift more profound than in the women's game. No longer taking a backseat to the men, the women are producing what is arguably a more exciting brand of tennis. They're more pleasing to watch (and we're not talking about Anna Kournikova); they play the game with an intensity and vigor absent from most of the men's games; and they've generated rivalries that produce epic matches.

Richard Williams, the outspoken and outlandish father of stars Venus and Serena, was right about at least one thing: His daughters are responsible for redefining the women's game. After taking six months off, Venus finished the year as the best player in women's tennis, winning Wimbledon, the U.S. Open and an Olympic gold medal. Her power, quickness and astonishing range proved more than most of her opponents could handle, but Venus's ascent almost never happened.

She began 2000 battling tendinitis in both her wrists. The nagging soreness wouldn't relent and finally forced her out of the Australian Open in January, whereupon she disappeared from the game. At the Ericsson Open in March, her father said that he had advised Venus to retire. While Venus never followed that advice, she acknowledged that during the first part of the year she

stayed at her home in Palm Beach Gardens, Fla., and hardly practiced. "It was great," she said. "Serena and my mom would be gone on the tour, and me and Daddy were on the couch watching *Zorro* at midnight. I'd fall asleep and wake up disoriented, and my dad would put me into bed. I'd been there so long, it was strange finally leaving home. No more *Zorro*."

Venus rejoined the tour in time for the French Open, where she advanced to the quarterfinals, losing to Arantxa Sánchez Vicario. Venus came to Wimbledon with no grass-court preparation but nonetheless used the fabled venue as the launchpad for a 32-match winning streak that would stretch into September and encompass two Grand Slam titles and a gold medal in Sydney. One of her Wimbledon victims was her sister, Serena. Though the sisters downplayed the possible matchup, the press couldn't help looking ahead to the enticing prospect of the semifinals, where, if they kept winning, Venus and Serena were slated to meet. After Venus disposed of Martina Hingis in the quarters, it happened, marking the first time sisters had ever met in the semis of a Grand Slam.

Serena was in better form at the time, having lost only 13 games in her previous five matches, but she completely fell apart against her older sister on Centre Court. Leading 4–2 in the second set (she'd lost the first), Serena dropped 10 straight points to

Venus (opposite) and her sister, Serena, took the WTA by storm in 2000, winning six of seven tournaments in late summer. Among the triumphs were Venus's wins at Wimbledon, the U.S. Open and the Olympics in Sydney, and Serena's victory at the Estyle.com Classic in Los Angeles.

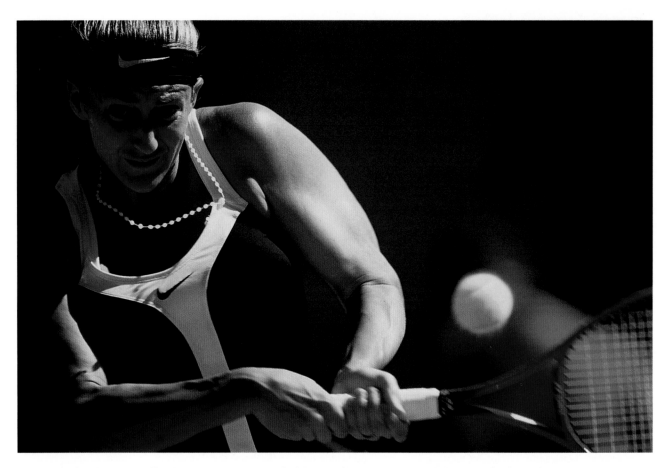

The locals were delighted to see Mary Pierce (above), who was raised in the U.S. but holds French citizenship, lift the winner's trophy at Roland Garros after she defeated Conchita Martinez 6–2, 7–5 in the final of the French Open.

allow Venus to regain control of the match. Some observers made the insulting suggestion that the Williams sisters were fixing the outcome. They weren't. After Venus beat her sister, she was somber and consoled Serena at the net. "Let's get out of here," Venus told Serena. "It was terrible," Venus would say later. "Serena believed she was going to win Wimbledon. We both believed [we were going to win]. For either one of us to lose was terrible."

For nearly a year Venus had stewed over the fact that her younger sister had won a Slam (the 1999 U.S. Open) before she did. And in the final, with her first major title there for the taking, Venus was nervous and erratic. But so was defending champion Lindsay Davenport. In a match plagued by double faults and unforced errors, the elder Williams sister seized her opportunity. After championship point in her 6–3, 7–6 victory, the crowd erupted and Venus jumped up and down in jubilation. Her father held up handmade signs (one of which said IT'S VENUS'S PARTY AND NO ONE WAS INVITED!) and later stepped out on top of the NBC broadcast booth and did some celebrating of his own. "We thought the roof was coming down," said commentator Chris Evert.

With her remarkable performance in the U.S. Open two months later, Venus brought the curtain, if not the roof, down on a spectacular season. Though she didn't quite have her "A" game in the early rounds, she showed a will to win that must have intimidated her opponents; they knew that whether or not she was on her game, Venus wasn't going down without a fight.

The draw was such that if the Williams sisters were to meet, it would be in the final, and it seemed like that was all people talked about, including the players. "Everyone was expecting an all-Williams final," said Davenport. "Martina and I had a little talk and didn't want that to happen." Davenport made sure it didn't, and her comments, which she made after she defeated Serena 6–4, 6–2 in the quarterfinals, sparked a few days' worth of controversy.

But clearly, it's only a matter of time before the Williamses meet in a Grand Slam final. In the '99 U.S. Open, they were a match away from doing so, but Hingis beat Venus in a semifinal slugfest. This year Hingis and Venus met again in the semis, and another heavyweight bout unfolded, a 4–6, 6–3, 7–5 thriller that was easily the match of the year.

Hingis had Williams on the ropes for much of the match but couldn't put her away. After they split the first two sets, Hingis led 5–3 in the third. She had just won an astounding 29-stroke rally to go ahead 15–30 and was two points away from the final. Richard Williams, unable to stand the pressure bearing down on his daughter, left the stadium. The next point, a 21-stroke gem, turned on a lob by Venus. Instead of slamming home a winner, Hingis overcautiously returned a gettable ball, and Williams ripped a backhand past her to even the game at 30. Williams won that game and the next three to seal the victory.

She won the final in similar fashion. Two points away from going up 5–1 in the first set, Davenport dumped an easy volley and hit a routine backhand into the net. Williams came back to win that game and took control of the match for a 6–4, 7–5 victory. Her triumph meant that a Williams had won three of the last four Grand Slams. "Straight out of Compton! And Watts too!" Richard Williams yelled to the crowd after Venus's win.

The more buttoned-down Pete Sampras didn't have to shout to be noticed in 2000. With his victory at Wimbledon, he surpassed Roy Emerson as the player with the most career Grand Slams (13). He had missed chances to break the record at both the Australian Open, where he lost to Andre Agassi in the semifinals, and at the French, where he made his usual early exit, losing in the second round. Setting the record at hallowed Wimbledon, where he had won six times, would be special for Sampras, but it almost didn't happen.

Following his first-round match at the All England Club, Sampras experienced a flareup of tendinitis in his left shin. The pain was severe enough to keep him out of practice until the day before the final. An extra smattering of rain delays aided Sampras's recovery, but he later admitted that had it been any other tournament he probably would have withdrawn.

Somehow, though, Sampras battled his way to the final. True, he never faced a player ranked higher than No. 12, but it was nevertheless a gritty performance. As was his play against Patrick Rafter in the final, the start of which was delayed by more than an hour due to rain. During the match there were two more rain delays lasting a combined two hours. Sampras kept his focus through it all, and, leading two sets to one and up 5–2 in the fourth set, he realized it was his moment and began to cry. "It all hit me that I was going to win, and it hit me hard," Sampras said later. "It was going to happen: the moment I've dreamed about."

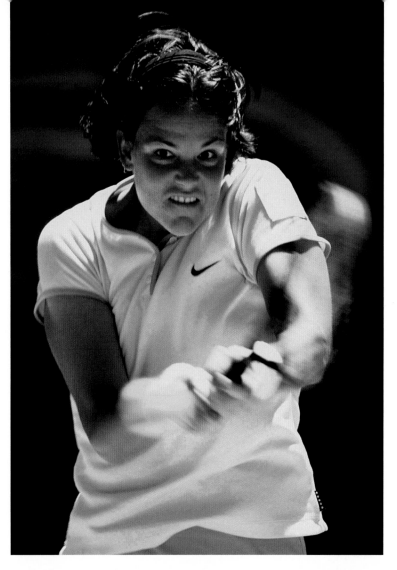

The moment arrived at 8:56 p.m., London time, when Sampras put away championship point. As he approached the net, his eyes began to well up. He made his way to the grandstand, where he embraced his parents, who were there to witness their son in a Grand Slam final for the first time since the 1992 U.S. Open. He turned to his fiancée, Bridget Wilson, to whom he proposed before coming to Wimbledon, and Tom Gullikson, the twin brother of his deceased coach Tim, and lost it. "You get older, and other things are more important than tennis," Sampras said. "It is important to me that they were here, that they were part of it, because those are the memories you'll have when you're done."

It was perhaps appropriate that Sampras should look to the future after his record 13th Grand Slam title, because in the next Grand Slam final, the U.S. Open, he came face to face with it in the person of Marat Safin, a 6' 4", 20-year-old Russian with a booming serve and teen-idol good looks. Safin blanked Sampras 6–4, 6–3, 6–3. "It reminded me of when I was 19 and steamrolled over Andre," said Sampras, alluding to his win over Agassi in the '90 Open final. And look what *he* went on to accomplish.

Davenport (above), who defeated Hingis 6–1, 7–5 to take the Australian Open in January, reached the finals of both Wimbledon and the U.S. Open, only to lose to the indomitable Venus in each event.

PHOTO GALLERY

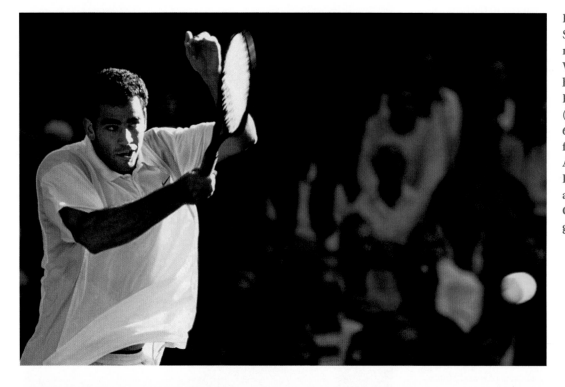

Baker's Dozen: Sampras (left) made history at Wimbledon when he defeated Patrick Rafter 6–7 (10–12), 7–6 (7–5) 6–4, 6–2 in the final to surpass Australia's Roy Emerson as the alltime leader in Grand Slam singles titles with 13.

Swiss Miss: Hingis (left) did not win a Grand Slam event in 2000, but she reached the final of the Australian Open and the semis of the U.S. Open, where she fell to Venus Williams in the match of the year, a 4–6, 6–3, 7–5 thriller.

At the Australian Open, Agassi (right) bellied up to his sixth career Grand Slam title and exposed a firm resolve along the way, outlasting Sampras in a grueling semifinal before defeating Yevgeny Kafelnikov 3–6, 6–3, 6–2, 6–4 in the final.

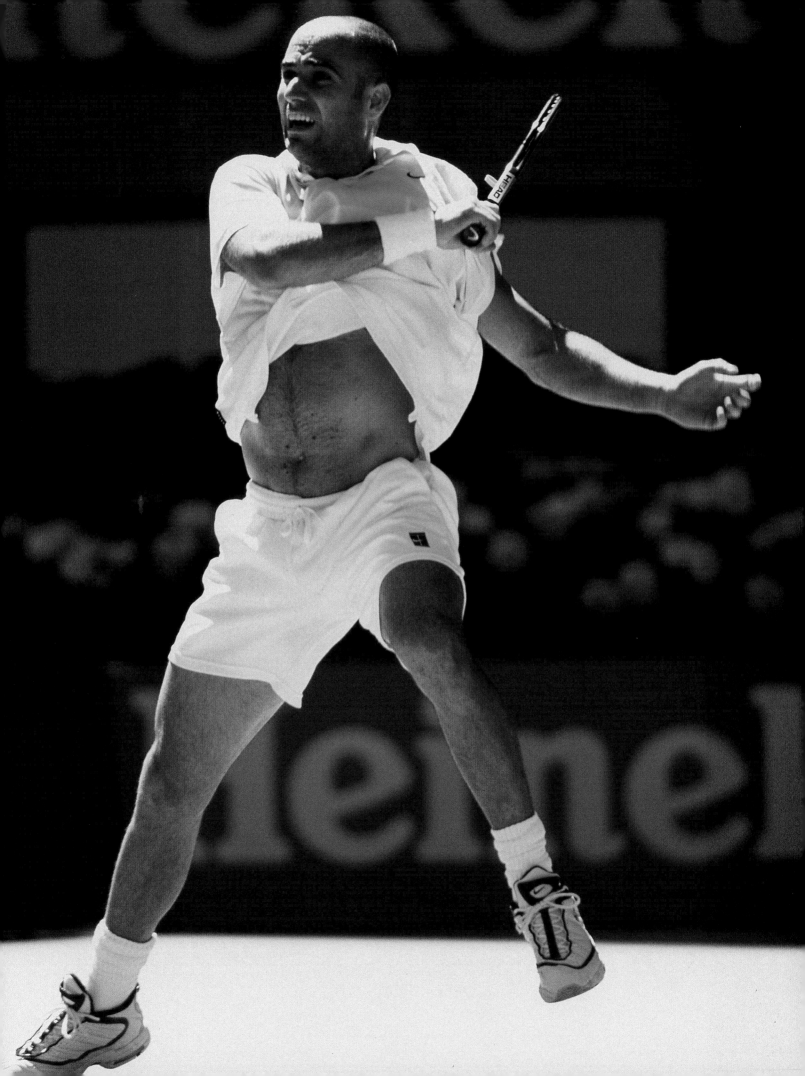

With his 6–4, 6–3, 6–3 pasting of Pete Sampras in the U.S. Open final, 20-year-old Marat Safin of Russia (left, facing camera) served notice that the future of tennis may well belong to him. After a disappointing first-round loss to Fabrice Santoro of France at the Sydney Olympics, Safin went on to win two more tournaments, including the Paris Indoor, and reach the semifinals of the season-ending Masters Cup. He finished 2000 ranked second in the world.

PROFILES

PETE SAMPRAS

All day the gloom had come and gone, bringing rain delays and the threat of a washout, but now it was settling in for good: darkness falling over Wimbledon's Centre Court. The rich whiteness of the tennis shoes, the net-cord tape, the shirts and shorts and even the court's chalk lines had begun to dissolve into the dusk. It was 8:55 p.m. Pete Sampras (opposite) and the crowd of 13,812 and the NBC executives in America and everyone who had flights booked and families waiting needed just one more break. One more break to keep the match from spilling into Monday. One more break for Sampras to bury Australia's Patrick Rafter and serve for history. Everyone kept glancing at the sky. Could Sampras get it in time? He had Rafter pinned against a wall—a two-sets-to-one lead and up 4–2, 40–15 with Rafter down to his second serve—but everything depended on this moment.

Rafter unloaded his most valued weapon, a vicious serve kicking 91 mph to Sampras's backhand. Sampras took it high, muscling the ball along the ad-court sideline, too far for the charging Rafter to reach. The place stayed silent an instant longer, then erupted in a whirl of noise. The two men walked to their chairs. Rafter knew. Everyone knew. It was over. Sampras was about to serve for his record-breaking 13th Grand Slam singles championship, a seventh Wimbledon title, and neither night nor Sampras's sore left leg nor the spirit of Slam record holder Roy Emerson could stop him. Both men sat. Sampras felt tears coming to his eyes, two weeks of stress and a decade's worth of labor coming to a boil. "It all hit me that I was going to win, and it hit me hard," Sampras said later. "It was going to happen: the moment I've dreamed about."

The clock ticked to 8:56 p.m. Chair umpire Mike Morrissey called out the most important word of the 2000 Wimbledon championships. "Time," he said.

For that is what Sunday's final, and the entire tournament, came down to: time, and Sampras's race against it. Time, and the need to hold off its ravages until he could secure his most lasting achievement. Time, and the way it changes a man's perspective. On Sunday all the faces of Sampras's life came together. His parents, Sam and Georgia, the first ones to put a racket in his hand, had flown from their home in Palos Verdes Estates, Calif., to see Sampras play a Grand Slam final for the first time since the 1992 U.S. Open. Sampras's fiancée, Bridgette Wilson, to whom he had proposed the night before leaving for England in June, was there, as was his best friend, John Black; his agent, Jeff Schwartz; and his coach, Paul Annacone. Even the face of his most influential coach, the deceased Tim Gullikson, made it, in the person of Tim's twin brother, Tom. "Timmy would've been proud," Tom would tell him.

Sampras wanted them all around him, win or lose, because at 28 he knows what he didn't know when he won his first Grand

Slam event at 19: "You get older, and other things are more important than tennis," he said. "It was important to me that they were here, that they were part of it, because those are the memories you'll have when you're done."

Time is closing in. Sampras knows that, because he'll celebrate another birthday next month, and the past year has been a battle against his body. A herniated disk in his back knocked him out of the 1999 U.S. Open and left him unable to walk for days. A torn hip flexor cost him an epic semifinal against Andre Agassi at the 2000 Australian Open. Tendinitis in Sampras's left shin hit after his first-round Wimbledon match two weeks ago and left him unable to practice until the day before the final. Had this been any other tournament, Sampras said following the final, he would have pulled out. He said he considered defaulting after the second round. But always, dangling before him, was the most alluring draw he had seen—before Sunday's match with the 12th-seeded Rafter, the highest-ranked player Sampras faced was No. 56, Jan-Michael Gambill—played on grass courts, where points are short and his serve is its most dominating. Emerson's record was there for the taking. Who could say when Sampras would get another chance like this?

For two weeks his confidence had been shot. He submitted his shin to acupuncture, massage, icing, anti-inflammatories, painkillers. He underwent hours of daily treatment and entered every match "completely out of sorts," he said. "The racket didn't feel good in my hand." On Sunday the rain made things worse, delaying the start of the final by an hour, then causing two mid-match delays lasting a total of nearly three hours. When Rafter, who won the first set, went up 4–1 in the second-set tiebreaker, Sampras thought he was going to lose. But then Rafter crumbled in a flurry of unforced errors, and he admitted afterward, "I knew I was screwed."

Sampras took the breaker, and the match was even. Rafter's nerve and serve never recovered, and Sampras's stayed as strong as ever. When he came out to serve at 5–2 in the fourth set, a series of flashbulb explosions began in the now dark stands. Two quick serves and a backhand volley later, Sampras stood poised at championship point. His final serve bombed in at 122 mph. Rafter had no chance. "It's the most difficult Slam I've ever won," Sampras said after the 6–7, 7–6, 6–4, 6–2 victory, and "the most satisfying."

Sampras raised his arms. He shook hands with Rafter, put down his racket, took a step, bent over at the service line and began to cry. He is the greatest men's champion Wimbledon has seen. His serve-and-volley game and shy demeanor have always been the perfect fit for the All England Club but never more so than on Sunday. Sampras prides himself on being a throwback, and in a stadium with no light stanchions, on a day when rain made critics again call for a retractable roof, Sampras and Cen-

tre Court created a surreal and quaint tableau. There was Sampras, clambering up the thick, wide steps to hug his father and mother in the stands. The couple, who hid from cameramen all day, looked panicked when they were approached by reporters. They had told their son that they loved him and that they were proud, and that was enough. Sam Sampras would not be dancing on the roof of any broadcast booth. "He won't be putting up any signs, either," Sampras said. "He doesn't quite enjoy the attention like Mr. Williams."...

When Sampras finished with his parents, he walked down the stairs to accept his trophy. Sampras declared his love for his parents, his fiancée and Wimbledon in the on-court miked interview he did before the crowd. He walked around the edge of the court holding up the cup, and flashbulbs popped like fireworks in the evening air. The scene had the quality of something that might have happened long ago, captured in black and white. It was 9:12 p.m. Sampras began walking toward the tunnel, and people refused to stop applauding. Women in flowered dresses slapped their hands on the concrete walls. Men pounded their umbrella points onto the cold stone floor. Sampras held the trophy. Into darkness and history he disappeared.

—S.L. Price,
excerpted from SI, July 17, 2000

VENUS WILLIAMS

The contrast [between Sam Sampras, father of Wimbledon men's champ Pete, and Richard Williams, father of Wimbledon women's champ Venus] … couldn't have been starker. The action on Sunday gave every nod to the past, but the day before, Wimbledon had seen the unpredictable future. While Venus Williams's father, Richard, held up his hand-lettered signs (I NEED AN ICE-COLD COCA COLA and IT'S VENUS'S PARTY AND NO ONE WAS INVITED!, among others), she rolled to her first Grand Slam singles title with a 6–3, 7–6 win over defending champion Lindsay Davenport. The match lacked drama and featured a nerve-racking display of double faults and unforced errors by both women, but Venus's achievement was unassailable: By taking out No. 1 Martina Hingis, her sister, Serena, and Davenport en route to the title, the 20-year-old Williams finally made good on the promise she showed in having bulled her way to the 1997 U.S. Open final. After erasing Davenport last Saturday, Williams laughed and leaped about the grass, and her father stepped out on top of the NBC booth and started jumping too. "We thought the roof was coming down," said commentator Chris Evert.

It was like nothing Wimbledon had seen, but then very little the Williams clan did this fortnight went according to form. Venus had hardly been expected to win; she had played just nine matches all year and only recently returned from a curious fade. Her 18-year-old sister's victory at the '99 U.S. Open—and her first loss to Serena three weeks later—left Venus "worried about myself," she said late last Saturday evening. "I was like, Venus, you've got to start coming through at some point. You have to cross that line."

But recurring tendinitis in both wrists knocked her out of the Australian Open. Months passed without news, and then Richard arrived at Miami's Ericsson Open in March and declared that he was

VENUS WILLIAMS

continued from previous page

advising Venus to retire. She stayed home in Palm Beach Gardens, Fla., watching tennis but practicing little. ...

She lost weakly to Arantxa Sánchez Vicario in the quarterfinals of the French Open in May and came to Wimbledon two weeks before the tournament with no grass-court preparation. Still, in her one week home between the two Slam events, Venus (right, with her U.S. Open trophy) bought a gown to wear at Wimbledon's Champions' Ball. Aside from her family, she was the only one who knew she was on the verge of a breakthrough. "She hadn't gotten past a top player in a Grand Slam," Davenport said after the quarterfinals. "She never beat anybody." Last week, though, Venus cracked the game's elite with her 6–3, 4–6, 6–4 quarterfinal win over Hingis that left the top-ranked player shaken. "Someone else probably deserves to be Number 1," Hingis said. Richard Williams has long said his daughters would eventually battle for that spot, and that day seems inevitable. After beating Hingis, Venus looked into the stands and pointed to her father, who pointed back at her, and the two jumped up and down. Serena, sitting next to him, seemed delighted. But when her father tried to hug her, she patted him halfheartedly. Serena had also bought a gown for the Wimbledon ball. Now she would have to play her older sister in the semifinal for a chance at the dance.

It seemed that Serena should win—she had dropped only 13 games in her previous five matches. Sampras, Andre Agassi and Martina Navratilova picked her to beat Venus. But ... Serena looked like a different player, shaky and tentative, and [blew a 4–2 lead in the second set]....

When Serena smacked a double fault on match point, she stopped, held her head in her hand in disbelief, then all but staggered to meet Venus at the net. Venus never clenched a fist or smiled. Stone-faced, she put her arm around her sister

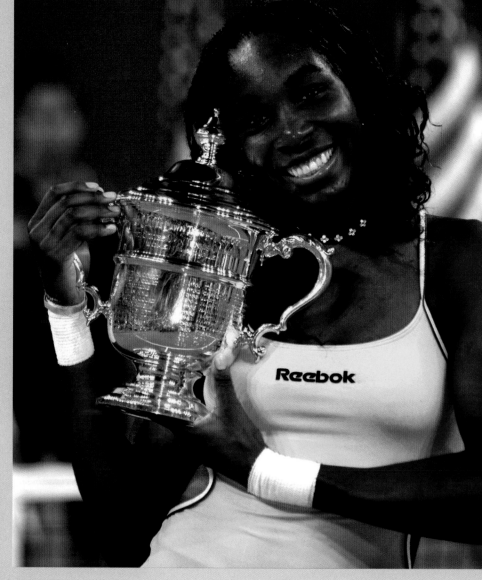

and said, "Let's get out of here." She had never been sadder in winning. "It was terrible," Venus said. "No fun, to say the least. Serena believed she was going to win Wimbledon. We both believed [we were going to win]. For either of us to lose was terrible."

But when Venus was victorious on Saturday, becoming the first African-American to win the tournament since Arthur Ashe in 1975 and the first black woman since Althea Gibson in 1958, there was only joy. Venus climbed up to the family box, and the sisters put their heads together and whispered happily. "She was wearing my shirt, which I hadn't seen for years," said Venus, who teamed with Serena on Monday to win the doubles title. "I wear her pants, which I will not give back. We love each other."

—S.L. Price,
excerpted from SI, July 17, 2000

MARAT SAFIN

HELP WANTED: Tempestuous Top 5 tennis player seeks full-time coach to accompany him on circuit. Experience preferred. Must be able to moonlight as sports psychologist. Flexible hours. Competitive $ $.

If you're interested in the above position, fax your résumé and references to the ATP Tour, attention: Marat Safin. The 20-year-old Russian, currently the No. 4 player in the world, may be tearing up the tennis circuit, but since April he has been unable to retain a full-time coach, relying instead on an assortment of temps. "I'm starting to take it personally," Safin says of the unfilled position. "Maybe nobody loves me."

That's hardly the case—and not just because Safin's walk-into-a-net-post-gorgeous girlfriend, Silvia, is usually on his arm when he's not on the court. As

Pete Sampras and Andre Agassi, now 29 and 30 respectively, enter their sunset years and gradually relinquish the baton, Safin (below) is emerging as the leading young light in men's tennis. The centerpiece of the ATP Tour's cheeky NEW BALLS PLEASE ad campaign, which tacitly acknowledges that the sport is desperate for a transfusion, Safin is a star for the new millennium. He's tall, dark and handsome; he speaks three languages (Russian, Spanish and English in descending order of fluency); and he's disarmingly candid. Not surprisingly, he's fast becoming a fan favorite. Playing in the RCA Championships in Indianapolis in mid-August, Safin was mobbed for autographs and photos at every turn. "I only sign for beautiful girls," he joked before obliging Hoosiers of all shapes and sizes. …

The proprietor of a 133-mph serve and unmatched all-court skills, Safin has won three tournaments and more than $1.2 million in prize money in 2000. Though he has never advanced beyond the quarterfinals of a Grand Slam event, his stamina and heat-seeking baseline missiles place him on the shortlist of viable contenders to win the wide-open U.S. Open, which commences on Aug. 28.

Regardless of how he fares at Flushing Meadows, the consensus on tour is that Safin is a future No. 1. "He's only 20, he's a big, strong guy, and he's got all the tools," Sampras said after Safin defeated him en route to winning last month's Toronto Masters Series event. "Being Number 1 and staying there is a whole new ball game, but he's got the potential to do that." …

Such benedictions would have been unthinkable earlier this year, when Safin played so poorly and with such little passion that he contemplated retirement. In the first round of the Australian Open, he lost to little-known Grant Stafford of South Africa after an effort so desultory that he was docked $2,000 for tanking. … By late April, Safin had won only five matches in 12 tournaments. "Confidence is so funny," he says, pointing to his head. "It's not coming, not coming, not coming, and you say, 'I have no chance of beating anybody.' You just have to hope it returns. When it does, then you feel no one should beat you." …

Safin plays a high-risk style of tennis, sizing up the lines and wasting little time massaging a point. When he's on, he plays breathtakingly well, blending power with style and grace. In his first match in Indianapolis, against Israel's Harel Levy, Safin offered a tasting menu of his skills, smoking winners from the baseline, pounding aces and knocking off clever stab volleys.

Yet when his radar is off a bit, the results can be disastrous. Earlier this month in Cincinnati, for instance, he overhit relentlessly and lost in straight sets to France's Fabrice Santoro, a markedly inferior player. "Sometimes he's out of control," [coach Alexander] Volkov says of Safin. "In that match I thought he was going to have a heart attack."

When Safin is having a rough day, he often takes out his frustrations on his Head graphite rackets. He claims that last year he cracked 48 of his implements, and he is on a similar pace this year. Fortunately for Safin, the ATP Tour has relaxed its rules on racket abuse, on the grounds that it promotes "color" among the players. "That's the way it should be," Safin says. "I'm not like [the preternaturally poised] Stefan Edberg; I'm not a robot. I'm an individual who gets mad. If I break a racket, who does it really hurt?" …

But if Safin's temper is of the hair-trigger variety, he is equally quick with a one-liner. After Safin outlasted Sampras in Toronto, a reporter congratulated him on having played an excellent tiebreaker in the third set. "For you, maybe it was good," Safin responded. "For me, I lost 10 years of my life."

In mid-August he was asked if he had designs on emulating [Anna] Kournikova and emigrating soon to the U.S. "Oh, so you want me to kill myself?" responded Safin, who recently bought an apartment in Monte Carlo. "They don't even let me drink a beer in this country."

Then there's the matter of that coaching vacancy. "I can't understand it," Safin says with mock earnestness. "You get to spend 24 hours a day around me. That should be hard to resist, shouldn't it?"

—L. Jon Wertheim,
excerpted from SI, Aug. 28, 2000

2000 Grand Slam Champions

AUSTRALIAN OPEN
Men's Singles

WINNER	FINALIST	SCORE
QUARTERFINALS		
Andre Agassi (1)	Hicham Arazi	6–4, 6–4, 6–2
Yevgeny Kafelnikov (2)	Younes El Aynaoui	6–0, 6–3, 7–6 (7–4)
Pete Sampras (3)	Chris Woodruff	7–5, 6–3, 6–3
Magnus Norman (12)	Nicolas Kiefer (4)	3–6, 6–3, 6–1, 7–6 (7–4)
SEMIFINALS		
Andre Agassi	Pete Sampras	6–4, 3–6, 6–7 (0–7), 7–6 (7–5), 6–1
Yevgeny Kafelnikov	Magnus Norman	6–1, 6–2, 6–4
FINAL		
Andre Agassi	Yevgeny Kafelnikov	3–6, 6–3, 6–2, 6–4

Women's Singles

WINNER	FINALIST	SCORE
QUARTERFINALS		
Martina Hingis (1)	Arantxa Sánchez Vicario (13)	6–1, 6–1
Lindsay Davenport (2)	Julie Halard-Decugis (9)	6–1, 6–2
Jennifer Capriati	Ai Sugiyama	6–0, 6–2
Conchita Martinez (10)	Elena Likhovtseva (16)	6–3, 4–6, 9–7
SEMIFINALS		
Martina Hingis	Conchita Martinez	6–3, 6–2
Lindsay Davenport	Jennifer Capriati	6–2, 7–6 (7–4)
FINAL		
Lindsay Davenport	Martina Hingis	6–1, 7–5

Note: Seedings in parentheses.

FRENCH OPEN
Men's Singles

WINNER	FINALIST	SCORE
QUARTERFINALS		
Magnus Norman (3)	Marat Safin (12)	6–4, 6–3, 4–6, 7–5
Gustavo Kuerten (5)	Yevgeny Kafelnikov (4)	6–3, 3–6, 4–6, 6–4, 6–2
Juan Carlos Ferrero (16)	Alex Corretja (10)	6–4, 6–4, 6–2
Franco Squillari	Albert Costa	6–4, 6–4, 2–6, 6–4
SEMIFINALS		
Magnus Norman	Franco Squillari	6–1, 6–4, 6–3
Gustavo Kuerten	Juan Carlos Ferrero	7–5, 4–6, 2–6, 6–4, 6–3
FINAL		
Gustavo Kuerten	Magnus Norman	6–2, 6–3, 2–6, 7–6, (8–6)

Women's Singles

WINNER	FINALIST	SCORE
QUARTERFINALS		
Martina Hingis (1)	Chanda Rubin	6–1, 6–3
Mary Pierce (6)	Monica Seles (3)	6–4, 3–6, 6–4
Arantxa Sánchez Vicario (8)	Venus Williams (4)	6–0, 1–6, 6–2
Conchita Martinez (5)	Marta Marrero	7–6 (7–5), 6–1
SEMIFINALS		
Mary Pierce	Martina Hingis	6–4, 5–7, 6–2
Conchita Martinez	Arantxa Sánchez Vicario	6–1, 6–2
FINAL		
Mary Pierce	Conchita Martinez	6–2, 7–5

Note: Seedings in parentheses.

WIMBLEDON
Men's Singles

WINNER	FINALIST	SCORE
QUARTERFINALS		
Pete Sampras (1)	Jan-Michael Gambill	6–4, 6–7 (4–7), 6–4, 6–4
Andre Agassi (2)	Mark Philippoussis (10)	7–6 (7–4), 6–3, 6–4
Patrick Rafter (12)	Alexander Popp	6–3, 6–2, 7–6 (7–1)
Vladimir Voltchkov	Byron Black	7–6 (7–2), 7–6 (7–2), 6–4
SEMIFINALS		
Pete Sampras	Vladimir Voltchkov	7–6 (7–4), 6–2, 6–4
Patrick Rafter	Andre Agassi	7–5, 4–6, 7–5, 4–6, 6–3
FINAL		
Pete Sampras	Patrick Rafter	6–7 (10–12), 7–6 (7–5), 6–4, 6–2

Women's Singles

WINNER	FINALIST	SCORE
QUARTERFINALS		
Venus Williams (5)	Martina Hingis (1)	6–3, 4–6, 6–4
Lindsay Davenport (2)	Monica Seles (6)	6–7 (4–7), 6–4, 6–0
Serena Williams (8)	Lisa Raymond	6–2, 6–0
Jelena Dokic	Magui Serna	6–3, 6–2
SEMIFINALS		
Lindsay Davenport	Jelena Dokic	6–4, 6–2
Venus Williams	Serena Williams	6–2, 7–6 (7–3)
FINAL		
Venus Williams	Lindsay Davenport	6–3, 7–6 (7–3)

Note: Seedings in parentheses.

U.S. OPEN
Men's Singles

WINNER	FINALIST	SCORE
QUARTERFINALS		
Pete Sampras (4)	Richard Krajicek	4–6, 7–6 (8–6), 6–4, 6–2
Lleyton Hewitt (9)	Arnaud Clement	6–2, 6–4, 6–3
Marat Safin (6)	Nicolas Kiefer (14)	7–5, 4–6, 7–6 (7–5), 6–3
Todd Martin	Thomas Johansson	6–4, 6–4, 3–6, 7–5
SEMIFINALS		
Pete Sampras	Lleyton Hewitt	7–6 (9–7), 6–4, 7–6 (7–5)
Marat Safin	Todd Martin	6–3, 7–6 (7–4), 7–6 (7–1)
FINAL		
Marat Safin	Pete Sampras	6–4, 6–3, 6–3

Women's Singles

WINNER	FINALIST	SCORE
QUARTERFINALS		
Martina Hingis (1)	Monica Seles (6)	6–0, 7–5
Venus Williams (3)	Nathalie Tauziat (8)	6–4, 1–6, 6–1
Lindsay Davenport (2)	Serena Williams (5)	6–4, 6–2
Elena Dementieva	Anke Huber (10)	6–1, 3–6, 6–3
SEMIFINALS		
Lindsay Davenport	Elena Dementieva	6–2, 7–6 (7–5)
Venus Williams	Martina Hingis	4–6, 6–3, 7–5
FINAL		
Venus Williams	Lindsay Davenport	6–4, 7–5

Note: Seedings in parentheses.

Major Tournament Results

MEN'S TOUR

DATE	TOURNAMENT	SITE	WINNER	FINALIST	SCORE
Jan 3–9	Qatar Open	Doha, Qatar	Fabrice Santoro	Rainer Schuttler	3–6, 6–3, 6–2
Jan 17–30	Australian Open	Melbourne	Andre Agassi	Yevgeny Kafelnikov	3–6, 6–3, 6–2, 6–4
Feb 7–13	Marseille Open	Marseille, France	Marc Rosset	Roger Federer	2–6, 6–3, 7–6 (7–5)
Feb 7–13	Dubai Open	Dubai, UAE	Nicolas Kiefer	Juan-Carlos Ferrero	7–5, 4–6, 6–3
Feb 14–20	ABN/Amro	Rotterdam,	Cedric Pioline	Tim Henman	6–7 (3–7), 6–4, 7–6 (7–4)

Major Tournament Results

MEN'S TOUR

DATE	TOURNAMENT	SITE	WINNER	FINALIST	SCORE
Feb 14–20	Kroger St. Jude	Memphis	Magnus Larsson	Byron Black	6–2, 1–6, 6–3
Feb 21–27	AXA Cup	London	Marc Rosset	Yevgeny Kafelnikov	6–4, 6–4
Mar 13–19	Champions Cup	Indian Wells, California	Alex Corretja	Thomas Enqvist	6–4, 6–4, 6–3
Mar 23–Apr 2	Ericcson Open	Miami	Pete Sampras	Gustavo Kuerten	6–1, 6–7 (2–7), 7–6 (7–5), 7–6 (10–8)
Apr 10–16	Estoril Open	Estoril, Portugal	Carlos Moya	Francisco Clavet	6–3, 6–2
Apr 17–23	Monte Carlo Open	Monte Carlo	Cedric Pioline	Dominik Hrbaty	6–4, 7–6 (7–3), 7–6 (8–6)
Apr 24–30	Open Seat Godo	Barcelona	Marat Safin	Juan Carlos Ferrero	6–3, 6–3, 6–4
May 1–7	BMW Open	Munich	Franco Squillari	Tommy Haas	6–4, 6–4
May 8–14	Italian Open	Rome	Magnus Norman	Gustavo Kuerten	6–3, 4–6, 6–4, 6–4
May 15–21	German Open	Hamburg	Gustavo Kuerten	Marat Safin	6–4, 5–7, 6–4, 5–7, 7–6 (7–3)
May 29–June 11	French Open	Paris	Gustavo Kuerten	Magnus Norman	6–2, 6–3, 2–6, 7–6 (8–6)
June 12–18	Gerry Weber Open	Halle, Germany	David Prinosil	Richard Krajicek	6–3, 6–2
June 19–25	Heineken Trophy	'S-Hertogenbosch Netherlands	Patrick Rafter	Nicolas Escude	6–1, 6–3
June 26–July 9	Wimbledon	Wimbledon	Pete Sampras	Patrick Rafter	6–7 (10–12), 7–6 (7–5), 6–4, 6–2
July 10–16	Gstaad Open	Gstaad, Switzerland	Alex Corretja	Mariano Puerta	6–1, 6–3
July 17–23	Mercedes Cup	Stuttgart, Germany	Franco Squillari	Gaston Gaudio	6–2, 3–6, 4–6, 6–4, 6–2
July 24–30	Generali Open	Kitzbuhel, Austria	Alex Corretja	Emilio Alvarez	6–3, 6–1, 3–0 retired
July 31–Aug 6	Canadian Open	Toronto	Marat Safin	Harel Levy	6–2, 6–3
Aug 7–13	ATP Championship	Cincinnati	Thomas Enqvist	Tim Henman	7–6 (7–5), 6–4
Aug 14–20	RCA Championships	Indianapolis	Gustavo Kuerten	Marat Safin	3–6, 7–6 (7–2), 7–6 (7–2)
Aug 14–20	Legg Mason Classic	Washington, D.C.	Alex Corretja	Andre Agassi	6–2, 6–3
Aug 28–Sept 10	U.S. Open	New York City	Marat Safin	Pete Sampras	6–4, 6–3, 6–3
Sept 11–17	President's Cup	Tashkent, Uzbekistan	Marat Safin	Davide Sanguinetti	6–3, 6–4
Oct 2–8	Salem Open	Hong Kong	Nicolas Kiefer	Mark Philippoussis	7–6 (7–4), 2–6, 6–2
Oct 9–15	CA Tennis Trophy	Vienna	Tim Henman	Tommy Haas	6–4, 6–4, 6–4
Oct 16–22	The Toulouse Open	Toulouse, France	Alex Corretja	Carlos Moya	6–3, 6–2
Oct 16–22	Heineken Open	Shanghai, China	Magnus Norman	Sjeng Schalken	6–4, 4–6, 6–3
Oct 23–29	Kremlin Cup	Moscow	Yevgeny Kafelnikov	David Prinosil	6–2, 7–5
Oct 23–29	Swiss Indoors	Basel, Switzerland	Thomas Enqvist	Roger Federer	6–2, 4–6, 7–6 (7–4), 1–6, 6–1
Oct 30–Nov 5	Tennis Masters Series	Stuttgart	Wayne Ferreira	Lleyton Hewitt	7–6 (8–6), 3–6, 6–7 (7–5), 7–6 (7–2), 6–2
Nov 6–12	Grand Prix de Tennis	Lyon	Arnaud Clement	Patrick Rafter	7–6 (7-2), 7–6 (7–5)
Nov 6–12	St. Petersburg Open	St. Petersburg, Russia	Marat Safin	Dominik Hrbaty	2–6, 6–4, 6–4
Nov 13–19	Tennis Masters Series	Paris	Marat Safin	Mark Philippoussis	3–6, 7–6 (9–7), 6–4, 3–6, 7–6 (10–8)
Nov 20–26	Stockholm Open	Stockholm	Thomas Johansson	Yevgeny Kafelnikov	6–2, 6–4, 6–4
Nov 20–26	Samsung Open	Brighton, England	Tim Henman	Dominik Hrbaty	6–2, 6–2
Nov 27–Dec 3	Tennis Masters Cup	Lisbon	Gustavo Kuerten	Andre Agassi	6–4, 6–4, 6–46

WOMEN'S TOUR

DATE	TOURNAMENT	SITE	WINNER	FINALIST	SCORE
Jan 10–16	Sydney International	Sydney	A. Mauresmo	L. Davenport	6–1, 7–5
Jan 17–30	Australian Open	Melbourne	L. Davenport	Martina Hingis	6–1, 7–5
Jan 31–Feb 6	Pan Pacific Open	Tokyo	Martina Hingis	Sandrine Testud	6–3, 7–5
Feb 7–13	Open Gaz de France	Paris	Nathalie Tauziat	Serena Williams	7–5, 6–2
Feb 14–20	Faber Grand Prix	Hannover, Germany	Serena Williams	D. Chladkova	6–1, 6–1
Mar 10–18	Tennis Masters Series	Indian Wells, California	L. Davenport	Martina Hingis	4–6, 6–4, 6–0
Mar 23–Apr 2	Ericsson Open	Miami	Martina Hingis	L. Davenport	6–3, 6–2
Apr 10–16	Bausch & Lomb Championships	Amelia Island, Florida	Monica Seles	Conchita Martinez	6–2, 6–3
Apr 17–23	Family Circle Cup	Hilton Head, S Carolina	Mary Pierce	A. Sánchez Vicario	6–1, 6–0
May 1–7	Betty Barclay Cup	Hamburg	Martina Hingis	A. Sánchez Vicario	6–3, 6–3
May 8–14	German Open	Berlin	C. Martinez	Amanda Coetzer	6–1, 6–2
May 15–21	Tennis Masters Series	Rome	Monica Seles	A. Mauresmo	6–2, 7–6 (7–4)
May 22–27	Int'l de Strasbourg	Strasbourg, France	Silvija Talaja	Rita Kuti Kis	7–5, 4–6, 6–3
May 29–June 11	French Open	Paris	Mary Pierce	Conchita Martinez	6–2, 7–5
June 19–25	Direct Line Champ'ships	Eastbourne, England	Julie Halard-Decugis	Dominique Van Roost	7–6 (7–4), 6–4
June 26–July 9	Wimbledon	Wimbledon	Venus Williams	L. Davenport	6–3, 7–6 (7–3)
July 24–30	Bank of the West	Stanford	Venus Williams	L. Davenport	6–1, 6–4
July 31–Aug 6	Acura Classic	San Diego	Venus Williams	Monica Seles	6–0, 6–7 (3–7), 6–3
Aug 7–13	Estyle.com Classic	Los Angeles	Serena Williams	L. Davenport	4–6, 6–4, 7–6 (7–1)
Aug 14–20	du Maurier Open	Montreal	Martina Hingis	Serena Williams	0–6, 6–3, 3–0 ret.
Aug 21–27	Pilot Pen Int'l	New Haven, CT	Venus Williams	Monica Seles	6–2, 6–4
Aug 28–Sept 10	U.S. Open	New York City	Venus Williams	Lindsay Davenport	6–4, 7–5
Sept 25–Oct 1	Seat Open	Luxembourg	Jennifer Capriati	Magdalena Maleeva	4–6, 6–1, 6–4
Oct 2–8	Princess Cup	Tokyo	Serena Williams	Julie Halard-Decugis	7–5, 6–1
Oct 2–8	Porsche Tennis Grand Prix	Filderstadt, Germany	Martina Hingis	Kim Clijsters	6–0, 6–3
Oct 9–15	Swisscom Challenge	Zurich	Martina Hingis	Lindsay Davenport	6–4, 4–6, 7–5
Oct 9–15	Japan Open	Tokyo	Juli Halard-Decugis	Amy Frazier	5–7, 7–5, 6–4
Oct 16–22	Generali Ladies Open	Linz, Austria	Lindsay Davenport	Venus Williams	6–4, 3–6, 6–2
Oct 16–22	Heineken Open	Shanghai, China	Meghann Shaughnessy	Iroda Tulyaganova	7–6 (7–2), 7–5
Oct 23–29	Ladies Kremlin Cup	Moscow	Martina Hingis	Anna Kournikova	6–3, 6–1
Oct 23–29	Slovak Indoor	Bratislava, Slovakia	Daniella Bedanova	Miriam Oremans	6–1, 5–7, 6–3
Oct 30–Nov 5	Sparkassen Cup	Liepzig, Germany	Kim Clijsters	Elena Likhovtseva	7–6 (8–6), 4–6, 6–4
Oct 30–Nov 5	Bell Challenge	Quebec City	Chanda Rubin	Jennifer Capriati	6–4, 6–2
Nov 6–12	Advanta Championships	Philadelphia	Lindsay Davenport	Martina Hingis	7–6 (9–7), 6–4
Nov 6–12	Wismilak International	Kuala Lumpur, Malaysia	Henrieta Nagyova	Iva Majoli	6–4, 6–2
Nov 13–19	Chase Championships	New York City	Martina Hingis	Monica Seles	6–7 (7–5), 6–4, 6–4

Burning Bright

Every golf story in 2000—and there were some notable ones—took a backseat to the history-making Tiger Woods ■ Marty Burns

At the PGA Championship in August, Woods (opposite) withstood a 66-66-66 finish by unsung Bob May to reach a three-hole sudden-death playoff, which he won to claim his third major championship of 2000. Woods won nine of the 20 tournaments he entered.

As a young boy Tiger Woods dreamed of one day dominating pro golf the way his hero Jack Nicklaus did. At age 10 Tiger even taped a list of the Golden Bear's records to the headboard of his bed, a reminder of his goals each night before he lay down to sleep.

Funny how innocent the dreams of children can be. For in 2000 the grown-up Woods outdistanced the competition on the PGA tour by a wider margin than he could have ever imagined, eclipsing the glorious feats of Nicklaus and anybody else who ever played the game. In fact, were he not so good at avoiding bunkers, one might even say Woods turned the sport into his own personal sandbox.

In just his fourth full pro season Woods won the U.S. Open, the British Open and the PGA Championship to join Ben Hogan ('53) as the only players in history to win three majors in a single year. Along the way he became, at age 24, the youngest player to complete the career Grand Slam, the record holder for low score in all four majors and arguably the world's most recognizable sports figure. His spectacular season drew immense galleries and TV ratings, landed him on the cover of TIME and earned him a record $100 million endorsement deal with Nike. No other story in golf—the tributes to the late Payne Stewart, Vijay Singh's impressive win at the Masters or Karrie Webb's ascendancy as the dominant woman player—came close.

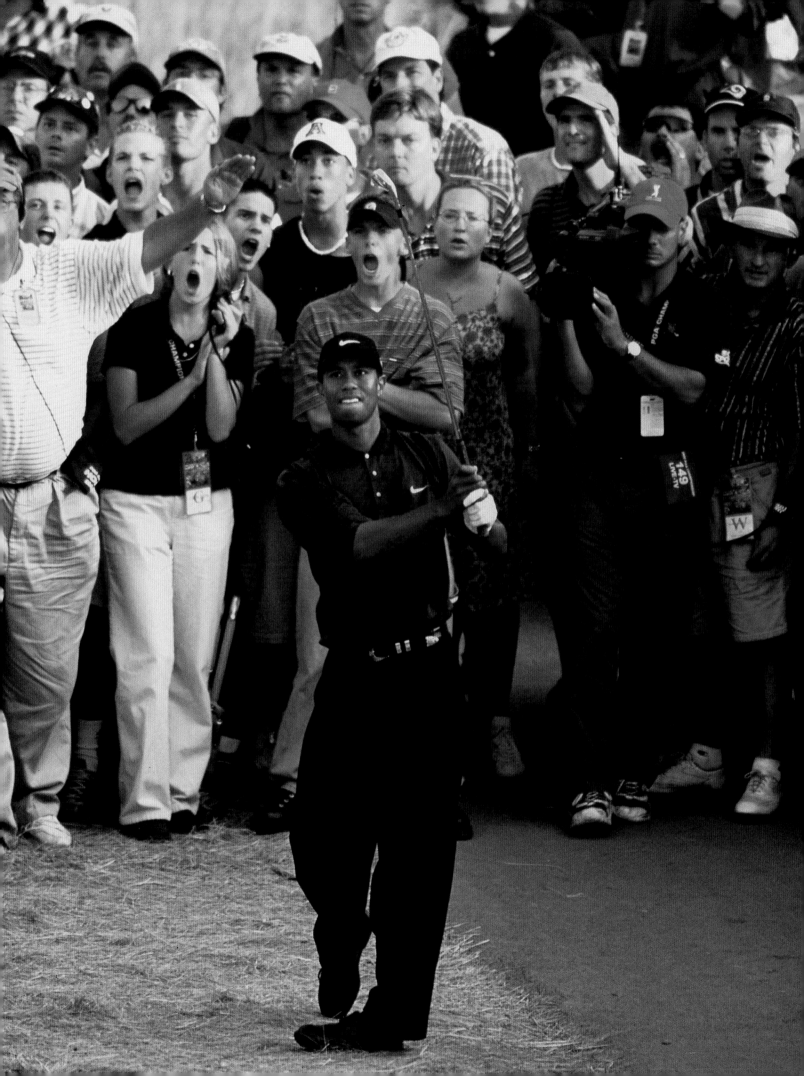

It wasn't only that Woods won so often in 2000, it was also the thoroughly convincing way in which he won. In his three major victories he made the game look as easy as he did bouncing that golf ball on the blade of his wedge in his well-known TV commercial.

Consider:

• He won the U.S. Open (at Pebble Beach) by 15 strokes, shattering the record for a major championship set by Old Tom Morris in the 1862 British Open. He also became the first player to win a U.S. Open in double digits below par (12 under).

• He became the youngest golfer to achieve the career Grand Slam (Nicklaus was 26 when he accomplished the feat in 1966) with an eight-stroke victory in the British Open. His 19-under-par 269 at St. Andrews set a record for lowest score in relation to par at a major.

• His triumph at the PGA Championship, at Valhalla, was his second straight PGA title and his fourth major in five tries. His 18-under 270 was the lowest score in relation to par in PGA history and left him with the distinction of holding the scoring record in all four major championships.

Through September Woods had won nine of the 17 PGA Tour events he entered in 2000, earning a record $8.3 million in prize money and leaving everyone else to play for second place. Indeed, Ernie Els endured five runner-up finishes, four to Woods, in a season that otherwise might have merited the player of the year award. "[Tiger's] the best who ever played," veteran pro Mark Calcavecchia said after the British Open, summing up the feelings of most of his fellow Tour pros. "And he's 24."

The Year of the Tiger began in Hawaii at the Mercedes Championships, the season's first event, when he finished eagle-birdie-birdie and defeated Els in a playoff. A month later he rallied from seven shots down with seven holes to play to win the Pebble Beach National Pro-Am. It was Woods's sixth consecutive PGA Tour victory, the longest such streak in 52 years.

Though an opening-round 75 cost him any shot at adding a second Masters green jacket to his collection this year (he still rallied to finish fifth, six strokes behind Singh), Woods bounced back in historic fashion at the U.S. Open. In perhaps the most dominating four-round performance ever, Woods never three-putted en route to a 65-69-71-67. His stone-cold determination to win was so fierce he skipped a ceremony the day before the tournament honoring the late Stewart, the '99

Open champ who had died eight months earlier in a plane crash. "I felt going [to the ceremony] would be more of a deterrent for me during the tournament, because I don't want to be thinking about it," said Woods, who played a practice round instead.

His steely focus carried over to the British Open, where he put on a sizzling display of power and precision to card rounds of 67-66-67-69 without benefit of a single eagle. His consistency was mind-boggling. Despite thick rough and 112 bunkers on the Old Course, he never once hit the ball into the sand.

In a dramatic finale to his astounding summer, Woods outdueled Bob May in a three-hole playoff to become the first repeat PGA champion since Denny Shute in 1937. Unlike his U.S. and British Open victories, however, Woods had to sweat this one out. The unheralded May, whose only career victory had come on the European tour, matched Tiger shot for shot, birdie for birdie. "Probably one of the greatest duels I've ever had in my life," said Woods, who merely birdied the last two holes of regulation to force the tie and then won the playoff with a 20-foot birdie putt on the 16th hole and a shot out of a greenside bunker to within two feet of the cup on the 18th.

It was breathtaking shots like those, which Woods made appear almost routine in 2000, that captured the public's fascination and elevated Tiger to an early entry in golf's pantheon. As Michael Jordan did in basketball, Woods offered even casual fans a chance to see something they had never seen before. Even Woods's boyhood idol, Nicklaus, who likely played in his final British and U.S. Opens in 2000, was amazed. "I kept saying, 'I can't understand why we don't have anybody else playing that well,' " said Nicklaus. "I am more understanding now. He's that much better."

Indeed, Tiger had turned the game into mere child's play.

In any other year, Els (above), who finished runner-up in five tournaments—four of which were won by Woods—would have been player of the year.

Webb (opposite) celebrated her victory in the Takefuji Classic in Hawaii in March, one of seven tournaments, two of them majors, that she won in a season that approached Woods's historic year for brilliance.

PHOTO GALLERY

Tiger Woods (opposite) blasted out of the tall grass at the season-opening Mercedes Championships in Hawaii, where he set the tone for the year to come: Finishing eagle-birdie-birdie, Woods tied the luckless Ernie Els with a 16-under-par 276, then won in a playoff.

Paul Azinger (below), who won the Sony Open in January for his first victory since being diagnosed with cancer in 1993, chipped out of a stream at the Masters. Though he didn't shine at Augusta, Azinger made 2000 his best year since '93, finishing 12th at the U.S. Open and seventh at the British Open.

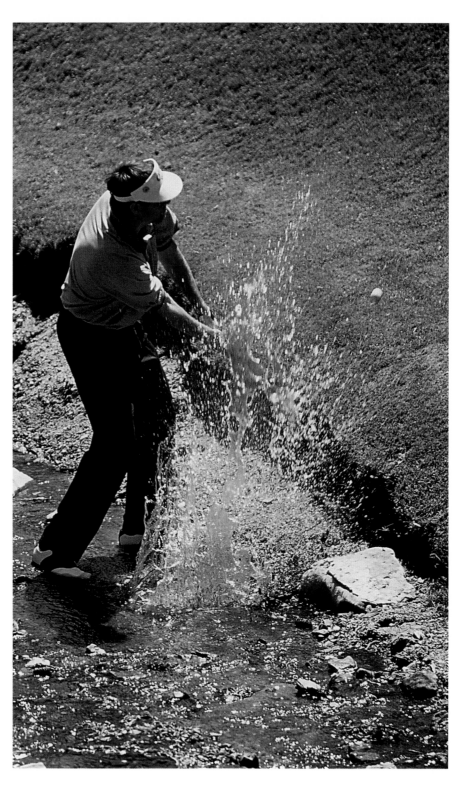

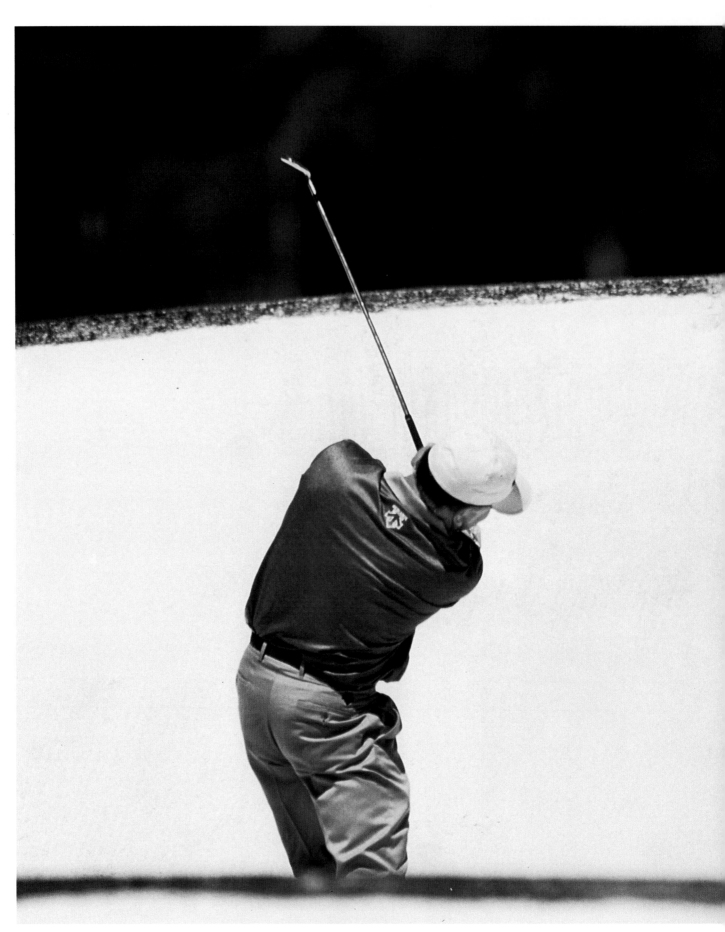

Mark O'Meara blasted out of a sand trap at Augusta, where he shot 75–75 and failed to make the cut. At year's end, O'Meara was still searching for his first victory since 1998, when he won both the Masters and the British Open.

PROFILES

JULI INKSTER

"I don't think I give myself enough credit," Juli Inkster (right) said following her victory at the 2000 McDonald's LPGA Championship in June, and she knows that others have sold her short, too. Inkster had the poor timing to arrive on the scene in the early '80s, during the heyday of glamour girls such as Nancy Lopez and Jan Stephenson, and she had rather stubbornly begun to play her best golf in the late '90s, just in time to get overshadowed by Karrie Webb. Over that span Inkster—who turned 40 in June—has quietly turned into a player for the ages. With her successful defense at the McDonald's, she has now super-sized her résumé to include six major championships, as many as any active player. In fact, only a celestial fivesome can claim more majors than Inkster: Patty Berg (15), Mickey Wright (13), Louise Suggs (11), Babe Zaharias (10) and Betsy Rawls (8). ...

Like Mark O'Meara before her, Inkster in 1999 reinvented herself as a late-blooming superstar, winning five tournaments, including the U.S. Women's Open, and kicking down the door to the Hall of Fame. O'Meara, like a lot of other golfers who reach the pinnacle late in life, was content to cash in and check out, but in 2000 Inkster has come back better than ever. Despite having played in only 10 events coming into the LPGA Championship, she had a victory (her 23rd), three seconds and a pair of thirds. ...

What makes Inkster's game so timeless is not any new-school pyrotechnics but the kind of golf that never goes out of style—eerily consistent ball striking, steady putting and a knack for never beating herself. She was thoroughly tested at this LPGA Championship by a setup that would have done the USGA proud. Last year Inkster scorched the DuPont Country Club in Wilmington, Del., to the tune of 16 under, a stroke shy

of the tournament record. A new superintendent was brought in, and DuPont suddenly grew some fangs in the form of gnarly, four-inch rough and greens that were as hard as granite countertops. Par was a good score, which is why Inkster didn't panic after opening 72–69 (one under on the 6,408-yard par-71 layout). That left her in a three-way tie for ninth, five back of Laura Davies, who had been nearly flawless in overpowering what she calls her favorite course on tour. Inkster knew that DuPont would be even more difficult on the weekend, but she figured she would play better. Having teed it up in only two events since mid-May, she was struggling to find the rhythm and timing on her unorthodox but highly effective swing.

For a 40th birthday, Saturday was as pleasant a day as could be hoped for. Inkster finally found her swing, hitting 17 greens and shooting a 65, the low round of the week. Afterward she was presented with a cake and a huge bou-

quet of balloons and was serenaded by the fans around the 18th green. The icing was that Inkster, at seven under, had moved into a tie for the lead with Wendy Ward, a 27-year-old Texan. ... Ward has idolized Inkster since Ward reached the LPGA tour in 1996, and they now share a coach (Mike McGetrick), along with frequent practice rounds. Of Inkster's surge up the leader board, Ward said, "We expect Juli to do things like that. She's probably the most competitive person you'll meet out here."

Inkster so dotes on her two daughters that this spring she took six weeks off in large part to coach 10-year-old Hayley's basketball team. Beneath the soccer mom veneer, though, is a cutthroat closer: Heading into Wilmington, she had turned her last five third-round leads into victories.

Sunday brought a stiff, swirling wind and ballooning scores. Inkster played the front nine in one over, making the turn tied with Ward and Nancy Scranton. ...

With [Karrie] Webb [who shot a final-round 73 to drop to ninth] out of the picture, the rest of the contenders were left to duke it out on the back nine, and what followed was not exactly an infomercial for the quality of play on the LPGA tour. The top four players heading into the final round collectively shot 13 over par on the back side on Sunday. …

Inkster, by virtue of four straight pars on the back nine, was three strokes up but, proving that Sunday's dispiriting play was contagious, promptly clanged two approach shots off the same tree on the par-4 14th hole. That led to a double bogey that sliced her lead to one, over Ward and Stefania Croce, a 30-year-old Italian journeywoman who was already in the clubhouse, having shot a 68, which tied for the low round of the day.

Nothing had changed when the final twosome reached the 72nd hole. Ward missed the fairway, missed the green and then missed a 15-footer for par, dooming herself to a lifetime of nightmares featuring an oscillating ball. Inkster's shot out of a greenside bunker ended up within eight feet of the pin, leaving herself a putt for par and the victory. Improbably, she blew the putt, and Croce, a charming character heretofore known mostly for the Continental flair of her wardrobe, was suddenly in a major championship playoff. The ending was predictable—Inkster made two textbook pars, biding her time until Croce cracked. Croce complied by flying the green of the second playoff hole and failing to get up and down.

An exhausted Inkster talked about her latest major statement. "It means a lot to me to prove to myself that I'm still one of the top players," she said. "It's in my blood. I love to compete."

As for the larger implications of her sixth major, Inkster said, "Maybe when I'm in my rocking chair at age 41, I'll have more thoughts on that." It would be nice if the recognition she richly deserves were to come so soon. Failing that, Inkster will simply continue to win important tournaments, just as she always has.

—Alan Shipnuck
excerpted from SI, July 3, 2000

TIGER WOODS

It's a strange job, traipsing about, typing sports. You forget how to tingle. Your Amaze-o-Meter gets stuck on empty. A comeback to win the Super Bowl? *Yawn, scribble.* A 9.9 to win the gold? *Scribble, yawn.* Almost 220 mph on that last lap? *Yawn, yawn.*

Then along comes Tiger Woods, and a job becomes a privilege. I would pogo from Bangor to Birmingham to see Woods play. I would wear spike heels, a see-through muumuu and RuPaul's curlers if it were the only way through the gate. I ought to buy my dad a box of cigars for having me the year that he did.

We're lucky. All of us. We're alive when the single most dominating athlete in 70 years is at his jaw-dropping best. Bathe in it. Wallow in it. Savor it. Take notes. Get video. Save newspapers. Your grandkids will want details.

Michael Jordan? This guy is better. Jordan had teammates. Woods is out there by himself. Jordan beat guys one-on-one, one-on-two. Woods won last week's unforgettable PGA Championship at Valhalla one-on-149. What's more, Woods never got cheap calls from refs.

Woods is pureeing everybody, everywhere, every way—from miles ahead and from two behind, as he was on Sunday with 12 holes to play. How many guys are good enough to

TIGER WOODS

continued from previous page

win a major playing off cart paths on the last two holes? He thumps great players, and he survives the guy pulling gold monkeys out of his ear. Staring into the biggest upset since Colts-Jets, he snuffed out a toy pit bull named Bob May with a mile of must-make putts. All he did was birdie eight of 13 holes, including the first playoff hole. You can't Buster Douglas Tiger Woods. He stuffs every Cinderella back into the pumpkin.

Woods is the most amazing performer I've ever seen, and I've seen Ali, Gretzky, Jordan, Montana and Nicklaus. What Woods is doing is so hard it's like climbing Everest in flip-flops. Performing heart transplants in oven mitts. The four major championships have been played 344 times, and Woods now holds or shares the scoring record in all four of them? That's *sick*.

Woods's adjusted scoring average this year is 67.86, which would be a record by about a mile if it holds up for the rest of the season. Before Woods put up his 68.43 last year, only Greg Norman (68.81) in 1994 and Nick Price (68.98) in '97 had broken 69. Since the PGA Tour came up with the adjusted scoring average in 1988, the largest margin of victory—other than Woods's .74 last year—was Norman's .58 of a stroke. This year Woods figures to lead by 1.53 strokes. That's, what, 163% better than the Shark's margin?

You're sick of hearing about Tiger Woods. You're going to hear more. He has more than twice as much jing as the next guy on the PGA Tour money list. He has more than triple the points of the next guy on the U.S. Ryder Cup list. He has more than twice as many points as the next guy in the World Golf Ranking. Muhammad Ali was great, but was he twice as great as Joe Frazier?

The grumps in the press tent keep trying to find a buzzkill in all this. *Hey, Nicklaus had to beat Gary Player and Tom Watson.* Hey, if Woods didn't exist, wouldn't Ernie Els be Player by now? Might not David Duval have a chance to be Watson? Brilliant careers are going around stuck on Woods's golf spikes.

What do you have to shoot to win here? Stuart Appleby was asked last Thursday. "Tiger Woods," he said.

Go see this kid while you're breathing. Three straight majors? Not done in 47 years. Four of the last five majors? Not done, ever. Now he's leaning on the doorbell of something nobody thought would ever be done: the Grand Slam. Oh, yes, it is. If Woods wins the Masters in April 2001, that *is* the Grand Slam. It's not the *continuous* Slam or the *asterisk* Slam, just the Grand Slam. He says so. I say so. Hell, sportswriters invented it; sportswriters make the rules. And don't give me Bobby Jones. Beating three guys named Nigel and two sheep at the British Amateur doesn't even compute.

Woods and Jack Nicklaus were walking down the first fairway at the 2000 PGA, their ears ringing from the roars. "Man, it's loud," Nicklaus said to Woods. "Thank God, I'm done playing. Now you get to deal with this the rest of your career."

As well he should.

—Rick Reilly
SI, Aug. 28, 2000

KARRIE WEBB

For four hours, anyway, Karrie Webb had the stage to herself. At the very moment Tiger Woods was slipping off the 18th green at St. Andrews to sign his historic British Open scorecard, Webb was walking to the 1st tee of an eight-year-old golf course built on a former cattle ranch on the outskirts of suburban Chicago. She was hoping to make some history of her own, hoping to win her first U.S. Open. In the locker room at the Merit Club, a half dozen LPGA players looked at a television, its giant screen filled with thousands of overseas golf revelers occupying every cranny and nook around golf's most celebrated green. Thousands of spectators were at the sprawling Merit Club, too, but there was no frenzy. Everybody knew what Webb was about to do: firmly establish herself, in the words of Nancy Lopez, "as the Tiger Woods of women's golf."

Their similarities are uncanny. Webb is 25 and lives in Florida. Woods is 24 and lives in Florida. Both won Rookie of the Year awards in 1996 and Player of the Year awards in 1999. Both have swings that are wide and powerful, rooted in classical moves but utterly modern. Both have a remarkable capacity for work and a healthy ability to get away from the game. Both know how to peak. It's their ultimate weapon. Woods has won each of the four men's professional major championships. Webb has won three of the four for women.

On July 16, 2000, she won the 55th U.S. Women's Open by *five* shots—that's still considered a lot in any tournament Tiger's not entered in, by the way—over Meg Mallon and Cristie Kerr, who turned pro at 18 and is starting to come into her own at age 22. …

The week began inauspiciously for Webb. Her inaugural tee shot in Thursday morning's first round was a pull-hook that finished in the rough, 10 yards in back of a spindly tree just wide enough to block her route to the green. … [She eventually] two-putted for a bogey. Not the start she had in mind. But after the round, she revealed why she is a golfing

genius and why she does not need the services of a sports psychologist. "You have to remember that you have 71 holes to go," she said. "If you lose your patience on the first hole, you might as well go back to the clubhouse and get a flight home." …

Few people thought the timing of the women's 2000 U.S. Open, opposite a British Open at St. Andrews, was ideal. …

[But] you couldn't really engage Webb in a conversation about the venue or the timing of the event or even Tiger. She had other things on her mind, like winning. She opened with a 69, three under par and one behind Mallon, and was still a stroke behind her after both women shot par in the second round. On Saturday, Webb closed the deal, or so it seemed. She shot a businesslike 68, four under par, without doing anything spectacular. Mallon, much beloved and befreckled, shot a 73, and she trailed Webb by four. Nobody else was really in the picture.

Around the clubhouse and in the parking lot, Webb's competitors talked about Webb in a way that brought to mind Tiger's competitors talking about Tiger. Mallon, winner of the 1991 U.S. Open, focused on Webb's ability to "smell blood and go in for the kill." …

Webb was praised widely, and you had the feeling the players, without knowing it, were trying to keep pace with the praise Woods was receiving at St. Andrews. "She's the most competitive person out here," said Beth Daniel, one of Webb's close friends. "If you go out to dinner, she'll try to beat you back to the hotel, like it's a race."

And then an odd thing happened on Sunday. Webb came out nervous, unsure about her club selections, tentative with her putts. Through six holes, she was one over for the day and Mallon was even, and the margin was three strokes. On the 7th hole, a downhill, cross-breeze par-3 playing at 155 yards, Webb struggled to settle on a club, hemmed and hawed about starting a backswing and finally pulled her tee ball into the water. She made a double bogey. Mallon made a par, and the difference was one shot.

Then came the smelling of blood and the making of a kill. Webb played the remaining 11 holes in nine pars and two birdies, and Mallon, tripping on her balky putter, was never again in range. "I had to remember," Webb said later, "that I was still leading."

She closed with a birdie, reaching the par-5 18th with two prodigious whacks, and finished with a 73. …

Webb's name goes on a trophy along with those of Patty Berg, Babe Didrikson Zaharias, Betsy Rawls, Mickey Wright, Betsy King and Annika Sorenstam. Webb won last year's du Maurier Classic and this year's Nabisco Championship, and now needs only the McDonald's LPGA Championship to complete a career Grand Slam. Her victory at the Merit Club gives her enough points to qualify automatically for the LPGA Hall of Fame. All she needs is the requisite number of years on tour—10. She's halfway there. Getting into the Hall of Fame has been a life's dream for Webb. "Everything from now on is a bonus for me," she said. …

In victory Webb showed her subtle wit and indomitable competitiveness, too. Late on Sunday afternoon, somebody reminded her that Woods needed six attempts to win the U.S. Open and that Webb had needed only five. She smiled, licked her right index finger and made a notch mark in the air. That's how she does her best public speaking: with actions.

In Port St. Lucie, Fla., Mickey Wright did just what the TV executives hoped the rest of the country would do. She watched Tiger in the morning, mesmerized, and Karrie in the afternoon, deeply impressed. Wright won four U.S. Opens, the same number as Betsy Rawls. Nobody has won more. "She could break that record," Wright said. "From everything I've seen, she certainly could."

One down, four more to go. Things that used to seem ridiculous no longer do. The old marks in golf are reachable again. It's a brand new day.

—Michael Bamberger
excerpted from SI, July 31, 2000

Men's Majors

THE MASTERS
Augusta National GC (par 72; 6,985 yds); Augusta, April 6–9

PLAYER	SCORE	EARNINGS ($)
Vijay Singh	72-67-70-69—278	828,000
Ernie Els	72-67-74-68—281	496,800
David Duval	73-65-74-70—282	266,800
Loren Roberts	73-69-71-69—282	266,800
Tiger Woods	75-72-68-69—284	184,000
Tom Lehman	69-72-75-69—285	165,600
Phil Mickelson	71-68-76-71—286	143,367
Davis Love III	75-72-68-71—286	143,367
Carlos Franco	79-68-70-69—286	143,367
Hal Sutton	72-75-71-69—287	124,200
Nick Price	74-69-73-72—288	105,800
Fred Couples	76-72-70-70—288	105,800
Greg Norman	80-68-70-70—288	105,800
Dennis Paulson	68-76-73-72—289	80,500
John Huston	77-69-72-71—289	80,500
Jim Furyk	73-74-71-71—289	80,500
Chris Perry	73-75-72-69—289	80,500
Jeff Sluman	73-69-77-71—290	69,000
Steve Stricker	70-73-75-73—291	53,820
Bob Estes	72-71-77-71—291	53,820
Padraig Harrington	76-69-75-71—291	53,820
Glen Day	79-67-74-71—291	53,820
Jean Van de Velde	76-70-75-70—291	53,820
Colin Montgomerie	76-69-77-69—291	53,820

U.S. OPEN
Pebble Beach Golf Links Course (par 71; 6,828 yds); Pebble Beach, CA, June 15–18

PLAYER	SCORE	EARNINGS ($)
Tiger Woods	65-69-71-67—272	800,000
Miguel Angel Jiménez	66-74-76-71—287	391,150
Ernie Els	74-73-68-72—287	391,150
John Huston	67-75-76-70—288	212,779
Lee Westwood	71-71-76-71—289	162,526
Padraig Harrington	73-71-72-73—289	162,526

U.S. OPEN (CONT.)

PLAYER	SCORE	EARNINGS ($)
Nick Faldo	69-74-76-71—290	137,203
Loren Roberts	68-78-73-72—291	112,766
David Duval	75-71-74-71—291	112,766
Stewart Cink	77-72-72-70—291	112,766
Vijay Singh	70-73-80-68—291	112,766
Paul Azinger	71-73-79-69—292	86,223
Retief Goosen	77-72-72-71—292	86,223
Michael Campbell	71-77-71-73—292	86,223
José María Olazábal	70-71-76-75—292	86,223
Fred Couples	70-75-75-73—293	65,214
Phil Mickelson	71-73-73-76—293	65,214
Mike Weir	76-72-76-69—293	65,214
Scott Hoch	73-76-75-69—293	65,214
Justin Leonard	73-73-75-72—293	65,214
David Toms	73-76-72-72—293	65,214

BRITISH OPEN
Old Course (par 72; 7,115 yds); St. Andrews, Scotland, July 20–23

PLAYER	SCORE	EARNINGS ($)
Tiger Woods	67-66-67-69—269	759,150
Thomas Bjorn	69-69-68-71—277	371,984
Ernie Els	66-72-70-69—277	371,984
Tom Lehman	68-70-70-70—278	197,379
David Toms	69-67-71-71—278	197,379
Fred Couples	70-68-72-69—279	151,830
Paul Azinger	69-72-72-67—280	100,587
Pierre Fulke	69-72-70-69—280	100,587
Loren Roberts	69-68-70-73—280	100,587
Darren Clarke	70-69-68-73—280	100,587
David Duval	70-70-66-75—281	56,346
Mark McNulty	69-72-70-70—281	56,346
Davis Love III	74-66-74-67—281	56,346
Vijay Singh	70-70-73-68—281	56,346
Stuart Appleby	73-74-68-70—281	56,346
Bob May	72-72-66-71—281	56,346
Bernhard Langer	74-70-66-71—281	56,346

BRITISH OPEN (CONT.)

PLAYER	SCORE	EARNINGS ($)
Phil Mickelson	72-66-71-72—281	56,346
Dennis Paulson	68-71-69-73—281	56,346
Notah Begay	69-73-69-71—282	38,717
Padraig Harrington	68-72-70-72—282	38,717
Steve Pate	73-70-71-68—282	38,717
Paul McGinley	69-72-71-70—282	38,717
Bob Estes	72-69-70-71—282	38,717
Steve Flesch	67-70-71-74—282	38,717

PGA CHAMPIONSHIP
Valhalla GC (par 72; 7,167 yds), Louisville, August 17–20

PLAYER	SCORE	EARNINGS ($)
Tiger Woods†	66-67-70-67—270	900,000
Bob May	72-66-66-66—270	540,000
Thomas Bjorn	72-68-67-68—275	340,000
José María Olazábal	76-68-63-69—276	198,667
Stuart Appleby	70-69-68-69—276	198,667
Greg Chalmers	71-69-66-70—276	198,667
Franklin Langham	72-71-65-69—277	157,000
Notah Begay	72-66-70-70—278	145,000
Scott Dunlap	66-68-70-75—279	112,500
Davis Love III	68-69-72-70—279	112,500
Phil Mickelson	70-70-69-70—279	112,500
Fred Funk	69-68-74-68—279	112,500
Darren Clarke	68-72-72-67—279	112,500
Michael Clark II	73-70-67-70—280	77,500
Chris DiMarco	73-70-69-68—280	77,500
Lee Westwood	72-72-69-67—280	77,500
Stewart Cink	72-71-70-67—280	77,500
Tom Kite	70-72-69-70—281	56,200
Robert Allenby	73-71-68-69—281	56,200
Angel Cabrera	72-71-71-67—281	56,200
J.P. Hayes	69-68-68-76—281	56,200
Lee Janzen	76-70-70-65—281	56,200

† Won three-hole playoff.

Men's Tour Results

2000 PGA TOUR EVENTS

TOURNAMENT	FINAL ROUND	WINNER	SCORE/ UNDER PAR	EARNINGS ($)
Mercedes Championships	Jan 9	Tiger Woods	276/–16	522,000
Sony Open	Jan 16	Paul Azinger	261/–19	522,000
Bob Hope Classic	Jan 23	Jesper Parnevik	331/–27	540,000
Phoenix Open	Jan 30	Tom Lehman	270/–14	576,000
Pebble Beach National Pro-Am	Feb 7	Tiger Woods	273/–15	720,000
Buick Invitational	Feb 13	Phil Mickelson	270/–18	540,000
Nissan Open	Feb 20	Kirk Triplett	272/–12	558,000
Tucson Open	Feb 27	Jim Carter	269/–19	540,000
Match Play Championship	Feb 27	Darren Clarke	4 & 3	1,000,000
Doral-Ryder Open	Mar 5	Jim Furyk	265/–23	540,000
Honda Classic	Mar 12	Dudley Hart	269/–19	522,000
Bay Hill Invitational	Mar 19	Tiger Woods	270/–18	540,000
The Players Championship	Mar 27	Hal Sutton	278/–10	1,080,000
BellSouth Classic#	Apr 2	Phil Mickelson*	205/–11	504,000
The Masters	Apr 9	Vijay Singh	278/–10	828,000
MCI Classic	Apr 16	Stewart Cink	270/–14	540,000
Greater Greensboro Classic	Apr 23	Hal Sutton	274/–14	540,000
Houston Open	Apr 30	Robert Allenby*	275/–13	504,000
Compaq Classic	May 7	Carlos Franco*	270/–18	612,000
Byron Nelson Classic	May 14	Jesper Parnevik*	269/–11	720,000
The Colonial	May 21	Phil Mickelson	268/–12	594,000
The Memorial	May 28	Tiger Woods	269/–19	558,000
Kemper Open	June 4	Tom Scherrer	271/–13	540,000
Buick Classic	June 11	Dennis Paulson*	276/–8	540,000
U.S. Open	June 18	Tiger Woods	272/–12	800,000
St. Jude Classic	June 25	Notah Begay	271/–13	540,000

2000 PGA TOUR EVENTS (CONT.)

TOURNAMENT	FINAL ROUND	WINNER	SCORE/ UNDER PAR	EARNINGS ($)
Greater Hartford Open	July 2	Notah Begay	260/–20	504,000
Western Open	July 9	Robert Allenby*	274/–14	540,000
Greater Milwaukee Open	July 16	Loren Roberts	260/–24	450,000
British Open	July 23	Tiger Woods	269/–19	759,150
B.C. Open	July 23	Brad Faxon	270/–18	360,000
John Deere Classic	July 31	Michael Clark*	265/–19	468,000
Qwest International	Aug 6	Ernie Els	487‡	630,000
Buick Open	Aug 13	Rocco Mediate	268/–20	486,000
PGA Championship	Aug 20	Tiger Woods*	270/–18	900,000
World Golf Championships/ NEC Invit.	Aug 27	Tiger Woods	259/–21	1,000,000
Reno-Tahoe Open	Aug 27	Scott Verplank*	275/–13	540,000
Air Canada Championship	Sep 3	Rory Sabbatini	268/–16	540,000
Canadian Open	Sep 10	Tiger Woods	266/–22	594,000
SEI Pennsylvania Classic	Sep 17	Chris DiMarco	270/–14	576,000
Texas Open	Sept 24	Justin Leonard	261/–19	468,000
Buick Challenge	Oct 1	David Duval	269/–19	414,000
Michelob Championship	Oct 8	David Toms*	271/–13	540,000
Invensys Classic	Oct 15	Billy Andrade	332/–28	765,000
Tampa Bay Classic	Oct 22	John Huston	271/–13	432,000
National Car Rental Classic	Oct 29	Duffy Waldorf	262/–26	540,000
The Tour Championship	Nov 5	Phil Mickelson	267/–10	900,000
World Golf Championships/AMEX	Nov 12	Mike Weir	277/–11	1,000,000
Williams World Challenge**	Dec 3	Davis Love III	266/–22	1,000,000

* Won sudden-death playoff. # Tournament shortened by rain. ‡ Revised Stableford scoring.
** Not an official event.

Women's Majors

NABISCO CHAMPIONSHIP
Mission Hills CC; Rancho Mirage, CA
(par 72; 6,520 yds) March 23–26

PLAYER	SCORE	EARNINGS ($)
Karrie Webb	67-70-67-70—274	187,500
Dottie Pepper	68-72-72-72—284	116,366
Meg Mallon	75-70-73-67—285	84,916
Cathy Johnston-Forbes	74-71-71-70—286	59,755
Michele Redman	73-73-69-71—286	59,755
Helen Dobson	73-74-72-68—287	40,570
Chris Johnson	73-68-73-73—287	40,570
Rosie Jones	74-71-74-69—288	31,135
Kim Saiki	72-77-68-71—288	31,135
Jenny Lidback	75-72-74-68—289	24,170
Wendy Doolan	73-73-69-74—289	24,170
Pat Hurst	72-72-70-75—289	24,170
A.S. Wongluekiet*	75-71-68-75—289	—
Kristi Albers	77-71-72-70—290	20,845
Se Ri Pak	73-71-77-70—291	18,957
Janice Moodie	74-72-70-75—291	18,957

LPGA CHAMPIONSHIP
DuPont Country Club; Wilmington, DE
(par 71; 6,408 yds) June 22–25

PLAYER	SCORE	EARNINGS ($)
Juli Inkster†	72-69-65-75—281	210,000
Stefania Croce	72-67-74-68—281	130,330
Se Ri Pak	73-69-69-71—282	76,319
Nancy Scranton	72-70-67-73—282	76,319
Wendy Ward	69-69-68-76—282	76,319
Heather Bowie	74-70-70-69—283	42,503
Laura Davies	70-66-75-72—283	42,503
Jane Crafter	72-69-69-73—283	42,503
Akiko Fukushima	71-72-71-70—284	29,839
Karrie Webb	72-70-69-73—284	29,839

LPGA CHAMPIONSHIP (CONT.)

PLAYER	SCORE	EARNINGS ($)
Jan Stephenson	70-69-69-76—284	29,839
Kelly Robbins	72-72-73-68—285	21,885
Amy Fruhwirth	74-71-70-70—285	21,885
Leta Lindley	71-73-71-70—285	21,885
Annika Sorenstam	70-73-70-72—285	21,885
Mi Hyun Kim	70-73-70-72—285	21,885
Dawn Coe-Jones	71-73-72-70—286	16,602
Meg Mallon	72-73-69-72—286	16,602
Jane Geddes	66-74-73-73—286	16,602
Pat Hurst	71-70-71-74—286	16,602
Wendy Doolan	69-71-71-75—286	16,602

†Won on second playoff hole.

U.S. WOMEN'S OPEN
Merit Club; Libertyville, IL
(par 72; 6,540 yds) July 20–23

PLAYER	SCORE	EARNINGS ($)
Karrie Webb	69-72-68-73—282	500,000
Cristie Kerr	72-71-74-70—287	240,228
Meg Mallon	68-72-73-74—287	240,228
Rosie Jones	73-71-72-72—288	120,119
Mi Hyun Kim	74-72-70-72—288	120,119
Grace Park	74-72-73-70—289	90,458
Kelli Kuehne	71-74-73-71—289	90,458
Beth Daniel	71-74-72-73—290	79,345
Annika Sorenstam	73-75-73-70—291	67,369
Kelly Robbins	74-73-71-73—291	67,369
Laura Davies	73-71-72-75—291	67,369
Jennifer Rosales	75-75-69-73—292	55,355
Pat Hurst	73-72-72-75—292	55,355
Dorothy Delasin	76-68-72-76—292	55,355
Se Ri Pak	74-75-75-69—293	47,846
Kellee Booth	70-78-75-70—293	47,846

U.S. WOMEN'S OPEN (CONT.)

PLAYER	SCORE	EARNINGS ($)
Janice Moodie	73-77-75-69—294	40,586
Kathryn Marshall	72-72-77-73—294	40,586
Shani Waugh	69-75-73-77—294	40,586
Lorie Kane	71-74-72-77—294	40,586

DU MAURIER CLASSIC
Royal Ottawa GC; Aylmer, Quebec
(par 72; 6,403 yds) August 10–13

PLAYER	SCORE	EARNINGS ($)
Meg Mallon	73-68-72-69—282	180,000
Rosie Jones	74-70-71-68—283	111,711
Annika Sorenstam	69-69-72-74—284	81,519
Diana D'Alessio	67-73-73-72—285	63,404
Juli Inkster	72-68-74-72—286	46,797
Lorie Kane	72-67-71-76—286	46,797
Becky Iverson	74-74-71-70—289	30,192
Karrie Webb	71-72-76-70—289	30,192
Se Ri Pak	69-76-72-72—289	30,192
Laura Philo	71-69-77-72—289	30,192
Kim Williams	71-75-72-72—290	22,986
Carin Koch	72-73-74-72—291	21,174
Jane Crafter	74-71-75-72—292	18,758
Mhairi McKay	70-73-75-74—292	18,758
Kristi Albers	69-74-75-74—292	18,758
Rachel Hetherington	72-73-75-73—293	16,041
Trish Johnson	72-72-70-79—293	16,041
Leslie Spalding	71-76-75-72—294	13,928
Dana Dormann	72-73-77-72—294	13,928
Kelli Kuehne	72-73-76-73—294	13,928
Brandie Burton	78-70-72-74—294	13,928
Leigh Ann Mills	70-75-74-75—294	13,928

* Amateur.

Women's Tour Results

2000 LPGA TOUR EVENTS

TOURNAMENT	FINAL ROUND	WINNER	SCORE/ UNDER PAR	($) EARNINGS
LPGA Office Depot	Jan 16	Karrie Webb	281/–7	112,500
Naples LPGA Memorial	Jan 23	Nancy Scranton*	275/–13	127,500
L. A. Women's Championship	Feb 13	Laura Davies	211/–5	112,500
Hawaiian Ladies Open	Feb 19	Betsy King	204/–12	97,500
Australian Ladies Masters	Feb 27	Karrie Webb	274/–14	112,500
Takefuji Classic	Mar 4	Karrie Webb*	207/–9	120,000
Welch's/Circle K Championship	Mar 12	Annika Sorenstam*	269/–19	105,000
Standard Register PING	Mar 19	Charlotta Sorenstam	276/–12	127,500
Nabisco Championship	Mar 26	Karrie Webb	274/–15	187,500
Longs Drugs Challenge	Apr 16	Juli Inkster	275/–13	105,000
Chick-fil-A Championship	Apr 30	Sophie Gustafson	206/–10	135,000
Philips Invitational	May 7	Laura Davies	275/–5	127,500
Electrolux Championship	May 14	Pat Hurst	275/–13	120,000
Firstar LPGA Classic	May 21	Annika Sorenstam	197/–19	97,500
Corning Classic	May 28	Betsy King*	276/–12	120,000
Kathy Ireland Greens.com	June 4	Grace Park	274/–14	112,500
Rochester International	June 11	Meg Mallon	280/–8	150,000
Evian Masters	June 17	Annika Sorenstam*	276/–12	270,000
LPGA Championship	June 25	Juli Inkster*	281/–3	210,000

2000 LPGA TOUR EVENTS (CONT.)

TOURNAMENT	FINAL ROUND	WINNER	SCORE/ UNDER PAR	($) EARNINGS
ShopRite Classic	July 2	Janice Moodie	203/–10	165,000
Jamie Farr Kroger Classic	July 9	Annika Sorenstam*	274/–10	150,000
Big Apple Classic	July 16	Annika Sorenstam	206/–7	135,000
U.S. Women's Open	July 23	Karrie Webb	282/–6	500,000
Giant Eagle LPGA Classic	July 30	Dorothy Delasin*	205/–11	150,000
Michelob Light Classic	Aug 6	Lorie Kane	205/–11	120,000
du Maurier Classic	Aug 13	Meg Mallon	282/–6	180,000
Women's British Open	Aug 20	Sophie Gustafson	282/–10	178,800
Oldsmobile Classic	Aug 27	Karrie Webb	265/–13	112,500
Rail Classic	Sep 3	Laurel Kean	198/–18	135,000
Betsy King Classic	Sep 10	Michele Redman	202/–14	120,000
Safeway LPGA Championship	Sept 24	Mi Hyun Kim*	215/–1	120,000
New Albany Golf Classic	Oct 1	Lorie Kane*	277/–11	150,000
Samsung World Championship	Oct 15	Juli Inkster	274/–14	152,000
AFLAC Champions	Oct 22	Karrie Webb*	273/–15	122,000
Mizuno Classic	Nov 5	Lorie Kane*	204/–12	127,500
Arch Tour Championship	Nov 19	Dottie Pepper	279/–9	215,000

* Won sudden-death playoff.

PGA Tour Final 2000 Money Leaders

NAME	EVENTS	BEST FINISH	SCORING AVERAGE*	EARNINGS ($)
Tiger Woods	20	1 (9)	67.79	9,188,321
Phil Mickelson	23	1 (4)	69.25	4,746,457
Ernie Els	20	1 (1)	69.31	3,469,405
Hal Sutton	25	1 (2)	70.12	3,061,444
Vijay Singh	26	1 (1)	70.01	2,573,835
Mike Weir	28	1 (1)	70.36	2,547,829
David Duval	19	1 (1)	69.41	2,462,846
Jesper Parnevik	20	1 (2)	69.94	2,413,345
Davis Love III	25	2 (3)	69.90	2,337,765
Stewart Cink	27	1 (1)	69.79	2,169,727

*Adjusted for average score of field in each tournament entered.

LPGA Tour Final 2000 Money Leaders

NAME	EVENTS	BEST FINISH	SCORING AVERAGE	EARNINGS ($)
Karrie Webb	21	1 (7)	69.91	1,865,053
Annika Sorenstam	21	1 (5)	70.45	1,333,448
Meg Mallon	25	1 (2)	70.99	1,123,735
Juli Inkster	18	1 (3)	70.69	957,705
Pat Hurst	25	1 (1)	70.93	831,311
Mi Hyun Kim	27	1 (1)	71.13	825,720
Lorie Kane	28	1 (3)	71.39	758,689
Rosie Jones	24	2 (2)	71.21	614,804
Dottie Pepper	18	1 (1)	70.77	571,695
Michele Redman	27	1 (1)	71.62	566,444

Express Train

The Yankee dynasty made only one stop as it zipped past the Mets in the first Subway Series in 44 years ■ Mark Bechtel

When the broken bat of Piazza (opposite, 31)— whom Clemens (22) had beaned in a July interleague game— skittered toward the mound at the start of Game 2, the Yankee righthander lost his cool, creating an incident that would overshadow the brilliant pitching performance he delivered afterward.

It had been 44 years since New York had a World Series all to itself, so Gothamites were more than ready to hype the Mets-Yankees Subway Series as a latter day Civil War, an event of national import that would pit brother against brother. "I was growing up in New York in the '40s and '50s, when the Dodgers and Giants played all the time, and that was wild," Yankees manager Joe Torre said. "I have a feeling that this city is not going to be the same for the next 10 days, and maybe for some time after that. I hope it's going to be a good Series. I hope it's clean. I hope that people behave themselves, because it's going to split a few families up, I think."

As it turned out, the fans behaved famously. The players were a different story. Roger Clemens, possessor of a sizable surly streak, sparked one of the odder imbroglios in Series history when he threw a spiky piece of wood, *Buffy the Vampire Slayer*–style, in the direction of Mike Piazza. He was part Bob Feller, part Sarah Michelle Gellar. It was an improbable turn of events in what was an improbable matchup, not because the Mets were making their first Fall Classic appearance since 1986, but because the two-time defending champs had made it back to the Series.

It was not a good regular season for the established powers. Last year's AL Central champs, the Cleveland Indians, missed the playoffs. So did the

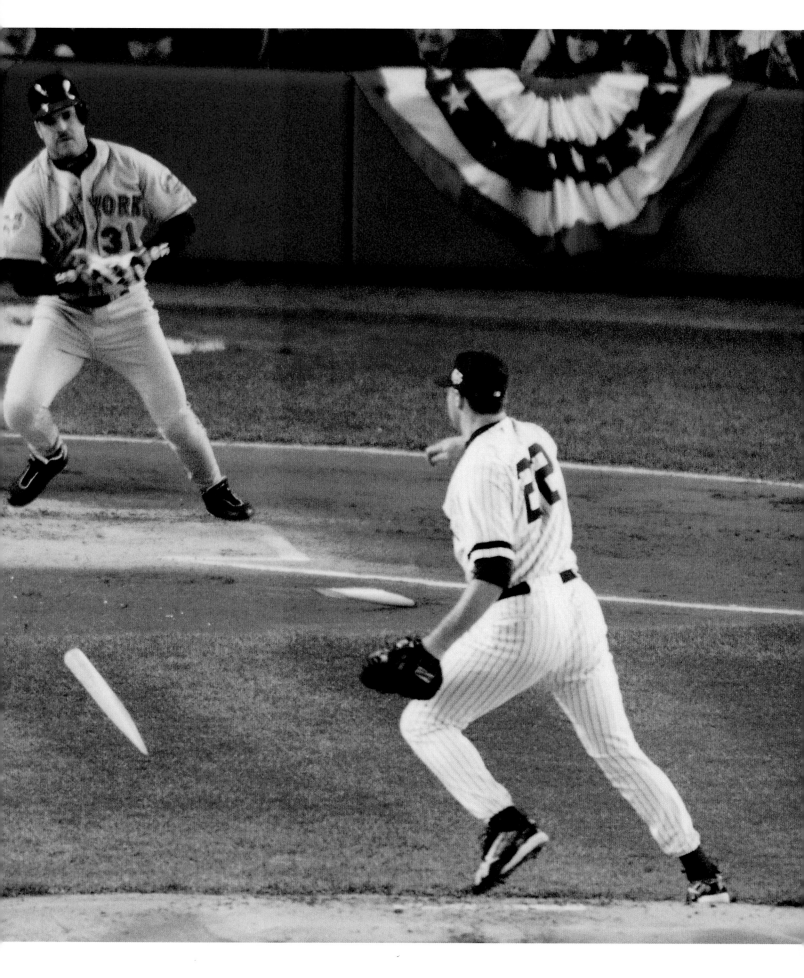

Go Figure: One of baseball's superstars, Griffey Jr. (above, 30) left Seattle for his hometown of Cincinnati, only to see the Reds' fortunes sink while Seattle won the AL West and advanced to the ALCS against the Yankees.

defending West champs, the Texas Rangers, who finished last in the division. The Yankees were the only team to return to the postseason from the American League, and they limped their way in. New York clinched the AL East on the same day it was beaten 13–2 by the Orioles, and the Yankees entered the playoffs on a seven-game losing streak, during which they were outscored 68–15 by lightweights Detroit, Tampa Bay and Baltimore.

So who were the new faces hogging most of the good times? Well, in the American League, it took a supercomputer, some slide rules and a team of MIT graduates to figure out the playoff scenarios as the AL West pennant and the wild-card race came down to the wire. Oakland, with a roster chock-full of kids, seized the AL West crown on the final day of the season, while Seattle, which not only missed the playoffs in '99 but also traded its star, Ken Griffey Jr., to the Reds before this season, took the wild card. And the White Sox—written off as quitters in 1997 when they dumped proven veterans for prospects while still in con-

tention in late July—dominated the Central, a division the Indians had won five years running.

The Tribe ran into all sorts of injury problems in 2000. Their pitching staff was decimated, and they ended up using a Major League–record 32 hurlers. Their best player, rightfielder Manny Ramirez, missed 44 games with an assortment of maladies, and the team went 22–22 without him. That opened the door for the White Sox, who got a dominating first-half performance from the heretofore underachieving pitcher James Baldwin, and plenty of pop from designated hitter Frank Thomas, who batted .328, belted 43 homers and drove in 143 runs. Chicago took first place on April 19 and never let go.

The division may have been out of reach early, but the Indians battled through their injuries to contend for the wild card. Even though a series of rainouts forced them to play nine games in six days in September—including one each against the White Sox and the Twins on the same day— Cleveland was still running neck-and-neck-and-neck with Oakland and Seattle as the season's final

weekend approached. The rainout of a September game between the A's and the Devil Rays threw a giant monkey wrench into the race. Heading into the last weekend, Oakland was a half game behind the Mariners in the West and 1 ¹/₂ ahead of the Indians in the wild-card race.

Not only were there several scenarios in which two of the three teams would have to play a one-game playoff the day after the season ended, but there was also the possibility that Oakland would have to travel to Tampa on Oct. 2 to make up the rained-out game with the Devil Rays after the regular season ended. Further, there was the chance that following the makeup game, the A's still could be tied for either the division or the wild card. That would require—you guessed it—another one-game playoff.

Players didn't know which was worse: the pressure of a playoff race or the headache of trying to figure out the playoff race. "A lot of the guys in this room don't have the college education necessary to follow all that," said A's first baseman Jason Giambi, scanning the Oakland clubhouse. "Sometimes ignorance is bliss."

So is having a player like AL MVP Giambi, who had a September to remember, hitting .400 with 13 homers and 32 RBIs while racking up a slugging percentage over .800. But more important was his presence in the clubhouse. On most nights the A's fielded a lineup in which seven of the nine players had less than five years of big-league experience, and Giambi was their unquestioned leader. Seemingly impervious to pressure, the youthful A's went 22–7 in the season's final month, and when the complicated playoff picture finally came into focus, they needed a victory against Texas on Oct. 1 to win the West. They delivered a 3–0 gem.

Indeed, all of the teams involved in the race took care of business when it mattered most. The Indians swept Toronto over the final weekend of the season, beating 20-game winner David Wells in the finale, a development that put the pressure squarely on the Mariners, who played later that afternoon against the Angels. A loss would have put Seattle in a playoff against the Indians to determine the AL wild-card team. A win and they were in. The M's delivered a 5–2 comeback victory.

While those three teams provided drama and generally reminded fans of what is so great about baseball, the sport's reigning champs were putting on an amazing display of ineptitude. Father Time seemed to be getting the better of the Bronx Bombers as 37-year-old David Cone went 4–14

with a 6.91 ERA; 34-year-old Scott Brosius hit a meager .230; and who-knows-how-old-but-older-than-he-says Orlando Hernández went 12–13. Things were so bad that journeyman Glenallen Hill was New York's best player for part of the summer. When they finally sewed up the East, thanks to a Boston loss to Tampa Bay, the Yankees sat disinterestedly around the clubhouse until manager Joe Torre told them to celebrate what they had done over the course of the season and hit the champagne.

The stalwarts of '99 struggled in the National League as well. The Astros, fresh from a 97-win season in the frumpy yet spacious Astrodome, lost 90 games in their new, state-of-the-art bandbox, Enron Field. The small-market Reds, who as scrappy underdogs fought their way to within one game of the playoffs last year, added arguably the game's greatest player, Griffey Jr., and then finished 10 games out of first in the Central. Hailed as a genius in '99, Cincinnati manager Jack McKeon was dumped at the end of 2000.

Arizona, which essentially bought a division title in '99, added fireballer Curt Schilling for the stretch run in 2000 but never seriously challenged for a playoff spot. The Diamondbacks were replaced in the postseason by San Francisco, which won the NL West in its first season in Pac Bell

Despite missing 44 games because of injuries, Ramirez (above) belted 38 homers and drove in 122 runs for Cleveland while batting .351. He also became a free agent after the season, signing with Boston for eight years and $160 million.

Park, a beautiful stadium abutting the Bay. Second baseman Jeff Kent (.334, 33 home runs, 125 RBIs), who won the NL MVP award, and leftfielder Barry Bonds (.306, career-high 49 homers, 106 RBIs) led the way for the Giants.

Replacing the Astros atop the NL Central were the Cardinals, who used some clever acquisitions to run away with the division. In an era in which franchises rely increasingly on free agency rather than trades to build teams, St. Louis G.M. Walt Jocketty pulled off one great preseason swap after another. Without giving up much of anything, he bolstered his pitching staff with Darryl Kile, Pat Hentgen and Dave Veres. Kile, who had lost 30 games in two years with Colorado, won 20 games for St. Louis and lowered his ERA by 2.70. Hentgen won 15 games for the Cards, and Veres saved 29.

Jocketty also picked up second baseman Fernando Viña, which allowed him to trade prospect Adam Kennedy along with suddenly expendable starter Kent Bottenfield to Anaheim for centerfielder Jim Edmonds. Edmonds, who'd become unhappy in Anaheim, smacked 42 homers for St. Louis. And when Mark McGwire went down with a bad knee, Jocketty made a deadline deal for veteran Will Clark, who hit .345 with 12 homers in two months with the team.

McGwire's injury limited him to 89 games, yet he still hit 32 homers. But the home run race, which was close once again, suffered in Big Mac's absence and failed to capture fans' imaginations, though Sammy Sosa did belt 50—the third year in a row he reached that milestone. Instead of being captivated by a home run derby, fans caught .400 fever, as Colorado first baseman Todd Helton flirted with the lofty batting-average barrier before a .267 September dropped him to .372.

In the end, the only run at history that was successful was the Yankees'. No team since the 1972–74 A's had won three consecutive world championships, and the Bronx Bombers' trifecta was even tougher to pull off than Oakland's had been. It came in the free-agent era, when holding a team together is all but impossible. The Yankees are, of course, something of an exception. You can call New York owner George Steinbrenner many things, but cheap is not one of them. The Yankees have the fiscal wherewithal to keep their vital cogs in place—and to acquire spare parts as needed—but it seemed like other forces were aligned against them. Pitching coach Mel Stottlemyre left the team in September after undergoing cancer treatment. Darryl Strawberry, who provided such a spark in

the '99 playoffs, couldn't stay out of trouble with the law, and was suspended for the year after testing positive for cocaine. Second baseman Chuck Knoblauch's throwing woes bordered on the clinical. Shane Spencer, a hot bat off the bench the past two years, blew out his knee. Veteran Paul O'Neill could barely run come October.

Say what you want about the amount of money they spent, but the Yanks' 26th World Series win might have been their most impressive, as evidenced by the increasingly emotional state of their usually stoic boss, Torre, as his team clawed through the postseason. The gritty A's almost sent them packing in the Division Series, forcing them to a fifth game. In the ALCS they met the Mariners, who had swept the White Sox in their first-round meeting. Seattle stymied the New York bats for long stretches at a time, but when the Yankees got their offense on track, it was deadly. A seven-run eighth inning won Game 2 for the Yanks, and they wrapped up the series with a six-run inning in Game 6.

In the National League the Braves' vaunted pitching rotation got shellacked by the Cardinals, who swept Atlanta without the game's greatest slugger, McGwire. St. Louis hammered Greg Maddux and lit up Tom Glavine, and the mighty Braves were gone. In the other first-round series, another slugger staged a vanishing act: Barry Bonds was MIA as the Giants bowed out to the Mets in four games. The Mets found a gem in minor-league callup Timo Perez, who replaced the injured Derek Bell in right field and stroked clutch hit after clutch hit. In the NLCS, the Mets rolled over the Cardinals, with Mike Hampton twirling a three-hit shutout in Game 5 to clinch.

That set up the Subway Series, which very nearly lived up to the leviathan hype it generated. The Yankees took Game 1 when Mets closer Armando Benitez failed to hold a 3–2 lead in the bottom of the ninth. Benitez was the one player who made Mets fans nervous. He'd blown more than half of the postseason save opportunities of his career, many of them on home runs. The Yankees closer, Mariano Rivera, on the other hand, was on his way to a postseason record for consecutive scoreless innings, a run that stretched back to 1997. Benitez allowed the Yankees to tie the game on a Knoblauch sacrifice fly, and the Bombers won it in the 12th on a base hit by Jose Vizcaino.

As dramatic as the opener was, Game 2 devolved into the realm of the ridiculous before half an in-

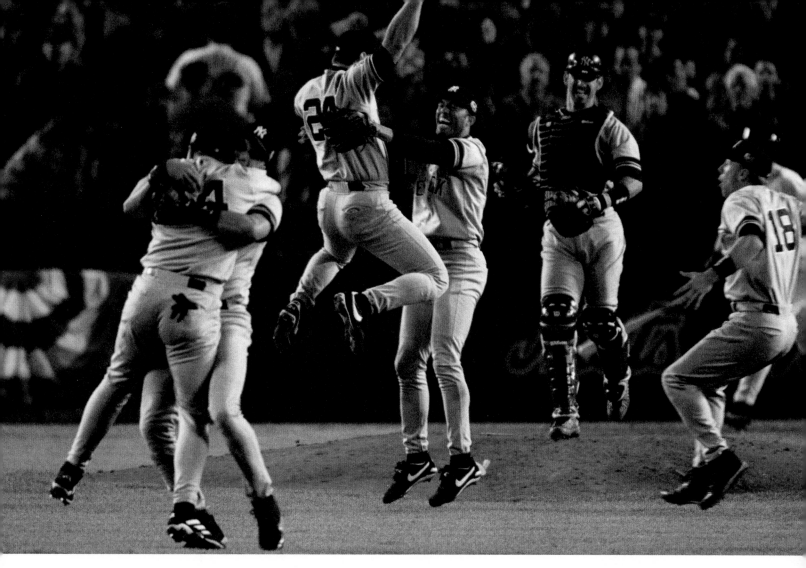

ning was in the books. The Mets were wondering which Clemens would show up: the one the A's roughed up in the Division Series or the one who handcuffed the Mariners with a one-hit, 15-strike-out performance in the ALCS. They got the latter, but not without a bizarre prelude. In the top of the first, Clemens faced Piazza, whom he had infamously beaned during a July interleague meeting. As Yankee Stadium throbbed with the tension of not only a World Series but also the subplot between Piazza and Clemens (Piazza had publicly criticized Clemens in July), Clemens whipped a fastball that Piazza fought off, breaking his bat into three pieces. The largest piece, the jagged barrel head, skittered toward Clemens, who picked it up and—inexplicably—threw it across the first base line directly in front of Piazza, who was running out the foul ball. The broken bat missed Piazza, but both benches cleared and Piazza immediately strolled toward Clemens, asking what in God's name the pitcher was doing.

No punches were thrown, and Clemens settled down to two-hit the Mets for eight innings. After the game, Clemens offered excuses for the incident that were more ridiculous than the act itself.

He claimed he thought the bat was actually the ball, which begs the question of why he would throw the ball in the direction of the runner. He also said he never saw Piazza, which seemed unlikely at best. Clemens was fined $50,000 the next day, and fans almost forgot the way he dominated Mets hitters. The Yankees took a 6–0 lead into the ninth before the Mets hit two homers to close to 6–5, the final score.

Two nights later, the Mets finally solved the Yankees, winning 4–2 on Benny Agbayani's eighth inning tie-breaking single. But Jeter hit Bobby Jones's first pitch of Game 4 for a homer, and the Yanks held on for a 3–2 win. They returned to their clubhouse to discover that a main had broken, flooding the locker room with water. The next night, the Yankees flooded it with champagne, as second baseman Luis Sojo, whom New York picked up from the Pirates in August, came through with the game-winning base hit off a valiant but exhausted Al Leiter in the ninth. The Yankees bore Torre aloft on their shoulders, and he shed a few tears along the way.

"You never get tired of it," he said later. "It never gets old."

Rivera (center) induced a long fly ball to centerfield from Piazza for the last out of Game 5 and the Series, touching off a jubilant—and lately annual—Yankee celebration. Bombers Tino Martinez (24), Luis Sojo, Derek Jeter (left, embracing) and Scott Brosius (18) joined in the fun.

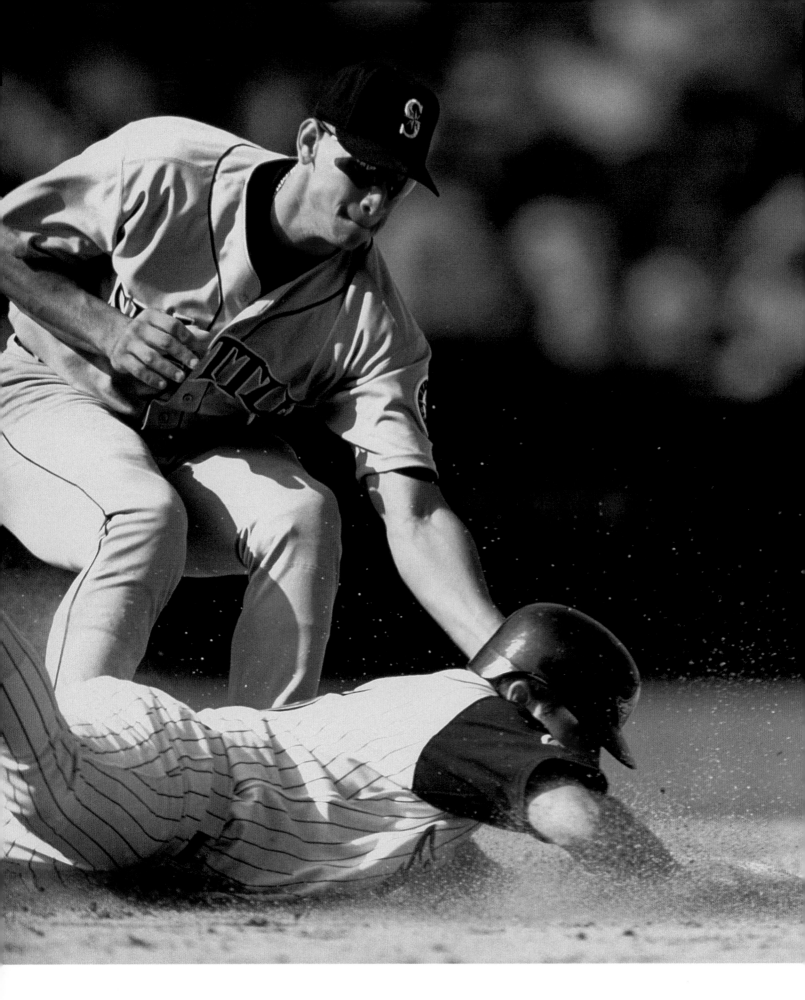

PHOTO GALLERY

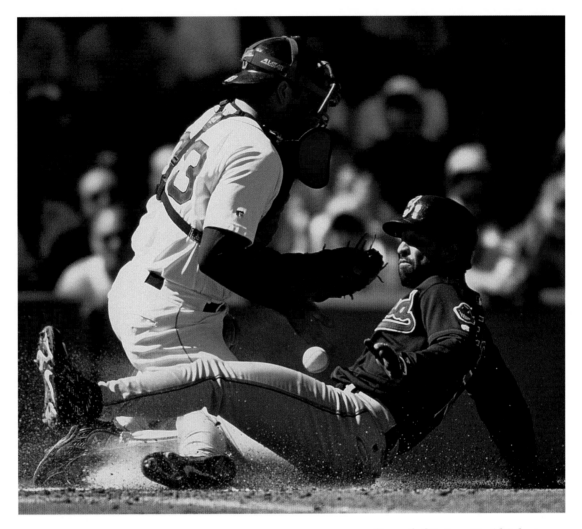

Reversal of Fortune: David Roberts (above) scored the sixth run of a seven-run first inning for Cleveland when Red Sox catcher Jason Varitek couldn't hold on to the throw from leftfield. The Sox would have the last word in the Sept. 21 game, though, rallying for a 9–8 win.

Seattle's 26-year-old shortstop, Alex Rodriguez, made a tag at second versus Anaheim in September (left), and a heist in Texas in December: He signed with the Rangers for 10 years and $252 million, sports' richest contract.

Beltin' Blue Jay: Toronto's Carlos Delgado (above) flirted with the Triple Crown in 2000: In August he was batting .364 with 39 homers and 124 RBIs. He cooled off in September but still finished with a .344 average, 41 home runs and 137 RBIs, among the top 5 in the AL in each category. Toronto signed him to a long-term deal after the season.

Robbin' Robin: Fans may have prevented Mets third baseman Robin Ventura from reaching this foul ball (right), but no one could stop New York from seizing its first NL pennant since 1986. The Mets won 94 games to make the play-offs as a wild-card team, then knocked off San Francisco and St. Louis to reach the World Series.

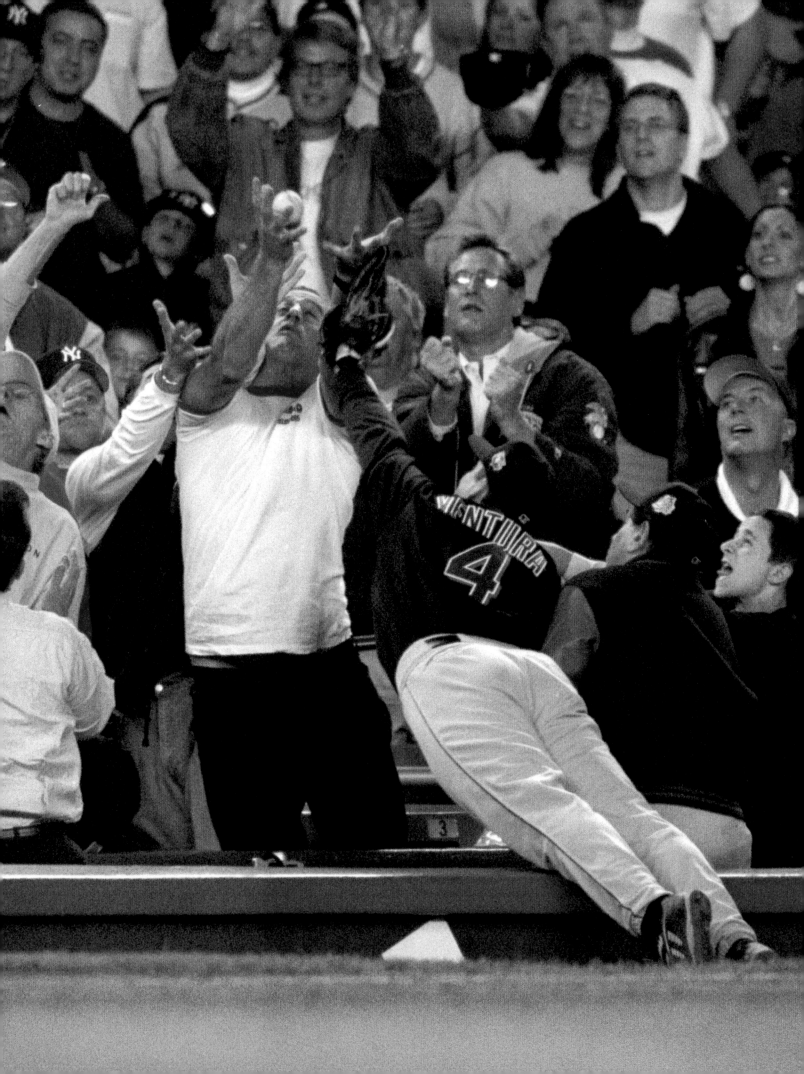

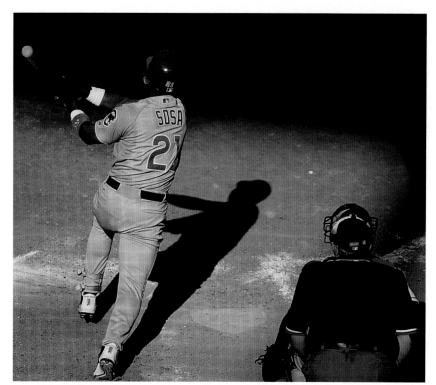

Sammy Sosa (left, 21) didn't exactly return to the shadows in 2000 after his 66- and 63-home-run seasons of the previous two years, but he did cool off a bit, belting 50 round-trippers for the hapless Chicago Cubs, who went 65–97.

Some Fan: Bay Area resident Rickie Navrette (right, catching ball), who displayed his allegiance on his jersey, nevertheless prevented San Francisco outfielder Barry Bonds from robbing an opponent of a home run.

Helping His Own Cause: Padres pitcher Adam Eaton beat a throw from centerfield and scored San Diego's seventh run past Chicago catcher Jeff Reed (below) in the Padres' 8–6 victory over the Cubs on Aug. 6.

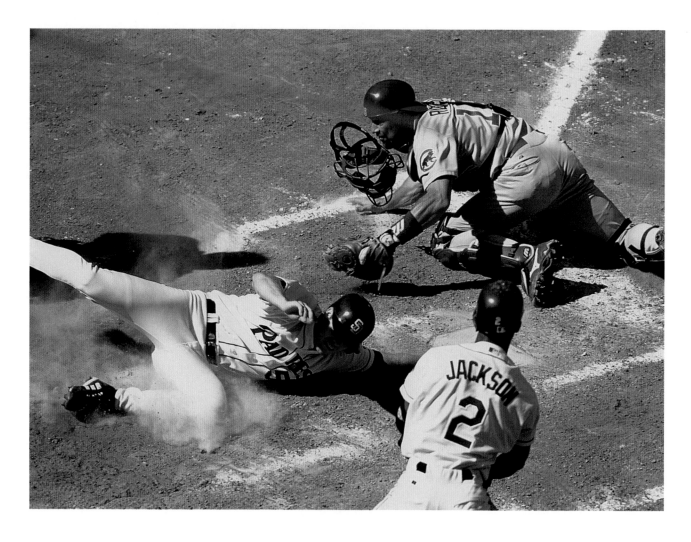

PROFILES

TODD HELTON

The beer in his hand and the bereaved expression on his face give Todd Helton (opposite) the appearance of a man at a wake, which, in a way, he is. Helton, the Colorado Rockies first baseman and the hottest batter in the major leagues during April and May, is sitting in front of his locker in the Coors Field clubhouse, his feet propped up on a black suitcase full of dirty laundry from a recent road trip. To hear Helton tell it, the suitcase might as well be a casket containing his timing and mechanics. Poor Todd has just gone hitless for the third straight game against the Chicago Cubs, during which his batting average has sunk from a league-leading .418 to a banjo-hitting .388. "It's like they're throwing 120 miles per hour every time I go to the plate," he laments. "I'm just not seeing the ball."

So clueless and adrift was Helton that he had only nine hits (including a pair of home runs) in his next 12 at bats in a three-game series against the Pittsburgh Pirates in late May, nudging his average to .415 and reclaiming the major league batting lead. On May 27, Helton's solo homer in the ninth, a 413-foot shot to right off Pirates lefty reliever Jason Christiansen, gave the Rockies a 7–6 win. "You've got to make quality pitches, or he'll beat you," says Cubs catcher Joe Girardi, "and he may beat you anyway. Look at his numbers"— which also included 15 homers, 47 RBIs and a .793 slugging percentage—"those are Little League numbers." …

How many guys in the Show have played quarterback in the Southeastern Conference? Before signing with the Rockies, who drafted him eighth overall

in 1995 and gave him an $892,000 signing bonus, Helton spent three years on Rocky Top, playing two sports at Tennessee. In football, as a junior he started three games in '94, throwing for 110 yards and a touchdown in the Vols' 41–23 victory over Georgia in Athens. Then he suffered a partially torn right medial collateral ligament against Mississippi State. When Helton went down, onto the field to replace him jogged a gangly freshman with a big upside—a kid by the name of Manning. For all practical purposes, the injury and Manning's arrival gave Helton the final push toward a career in baseball. "I got along with Peyton great," says Helton, a lefty who smiles as easily as he hits to the opposite field. "We still talk once in a while." You could say things have worked out for both of them.

You see the quarterback in Helton as he charges a bunt and throws to second. "He makes that throw like he's making a jump pass over the middle," says Cubs manager Don Baylor, who skippered the Rockies from 1993 through '98. You see it also in Helton's obsession with videotape. Ever since his first full major league season, in '98, when he hit .315 with 25 homers and 97 RBIs, he has reviewed his every at bat, scribbling observations in a notebook. "I started doing it to learn more about the pitchers," he says. "But I ended up learning twice as much about myself. I'd say, 'Jeez, I've made 15 outs in the last four days rolling over the ball'— patterns I wouldn't have picked up on if I hadn't written them down." …

It's this laserlike focus that has enabled Todd to methodically erase one question mark after another during his brief pro

career. A player once thought to lack power, he hit 60 homers over his first two full big league seasons. Coddled as a rookie by Baylor, who kept him out of the lineup against tough lefties, Helton through May 28 was batting .400 against southpaws this year. Dogged by poor starts in 1998 and '99, Helton['s overall average] … was approaching the neighborhood of .400. "If he keeps improving at this rate," says Rockies righty reliever Jerry Dipoto, "we're going to have another Roy Hobbs on our hands."

Truth is, Helton resembles Robert Redford less than he does character actor Bill Paxton, who played the sadistic older brother Chet in *Weird Science* (and who uttered in that role the timeless line, "You're stewed, buttwad!"). While it may look natural, Helton's sweet swing is the product of years of practice. Most nights during grade school, junior high and high school, after finishing his homework, he would hit balls into a net in the family garage under the watchful eye of his father, Jerry, who had jerry-rigged a tee from the hose of an old washing machine. …

Tennessee baseball coach Rod Delmonico recalls the day during walk-on tryouts that Helton, a freshman, grabbed a bat and started driving ball after ball out of the park. Says Delmonico, "Our equipment manager, who was feeding the pitching machine, came to me all excited and said, 'Did you see that guy hit? He was pretty good!' "

He was better than good. Following a brilliant college career in which, in addition to playing first base, he served as the Vols' closer—"He was the best pitcher I've ever coached," says Delmonico—

Helton signed with Colorado and reported to the Class A Asheville (N.C.) Tourists. The transition from college to the pros proved tougher than he'd expected. Helton had never been a pull hitter, but the short porch in right at Asheville's McCormick Field beckoned like a siren. "I tried to hit it every time," says Helton.

Instead, he hit .254, with one home run and countless ground balls to second. The Rockies' roving hitting instructor at the time was Clint Hurdle, who dubbed Helton's unhappy first pro season "The Summer of 4 to 3." …

Rejuvenated by an off-season in Maui, where he played some baseball and more golf, Helton returned to the mainland and tore up the minors for two years, hitting .352 in 99 games at Triple A Colorado Springs in 1997 before being called up to the Rockies to finish the season. …

When you get a chance, watch Helton when he's on deck. He stands a few steps beyond the circle, insinuating himself into the pitcher's field of vision while boring holes in the poor fellow with his stare. All this may not be necessary. He's already on the pitcher's mind. "You come to Colorado, the first guy you talk about is Todd Helton," says Cubs righthander Kerry Wood. "We try to stay down in the zone and not give him anything to hit."

"By the same token," adds Cubs righty Jon Lieber, "you don't want to get behind in the count, because that makes him a much better hitter."

Either way, you're stewed.

—Austin Murphy
excerpted from SI, June 5, 2000

DEREK JETER

"Where are my parents? Where are my parents?"

In and out of spikes, New York Yankees shortstop Derek Jeter (opposite) moves like silk billowed by a breeze. Goodness flows all around him. He's perpetually light on his feet, even as bedlam spills like the champagne in and around the dank hallways of Shea Stadium early last Friday in the afterglow of—goodness!—the Yankees' fourth world championship in Jeter's five full seasons in the big leagues. At 26, he has already been enriched with a lifetime's heaping portion of success. ...

"Where are my parents? Find out where they are," he says to a Yankees security official, who squawks into his radio to another official.

Every time Derek plays a baseball game attended by his parents, Charles and Dorothy of Kalamazoo, Mich., he must know where they are seated. Before the first ball is put into play, he catches their gaze and gives them a wave of his hand. He must know where they are after the game, too. On this night, before the Yankees' 4–2 Game 5 victory that clinched the World Series, Jeter found them in their distant seats high above third base. Afterward, in the madness, he cannot locate them. Then the radio answers, "Right by me. On the field."

Jeter skips along the creaky wooden runway that leads through the darkness under Shea's field-level seats to the dugout. To no one in particular he says aloud with a sigh, "Oh, man. If we'd lost this, I was moving out of town. Gone!" He bolts up the dugout steps, where he finds his parents standing on the warning track. He gives them each a kiss and a long, tight hug.

"MVP! MVP!" A large knot of fans behind the Yankees dugout begins serenading him with the latest of his many honorifics. Jeter had at least one crucial hit or play in each of the Yankees' four wins in their defeat of their crosstown rivals, the Mets, earning himself the World Series MVP award. It will make a nice bookend to his All-Star Game MVP award. No other player has ever won both awards in the same season. ...

After showering, Jeter puts on a silvery gray, windowpane suit with a gray silk T-shirt underneath. The man is impervious to wrinkles. ...

Once upon a time there was a man named DiMaggio who played baseball with such graceful ease that people swore they'd never see his like again. DiMaggio was, above all, a winner. His Yankees—and, yes, the New York teams from 1936 to '41, the Clipper's first six seasons in the major leagues, were known as DiMaggio's Yankees—won 598 games, approaching 100 a year, and failed to win the World Series only once.

It's in DiMaggio's footsteps that Jeter walks proudly and gracefully. The rare modern player who has never tried creatine or yearned for muscle mass, the 6' 3", 195-pound Jeter has the smooth carriage and angular build of a baseball player from DiMaggio's era. Jeter, above all, is a winner too. His Yankees—and, yes, this dynasty will go down as Jeter's Yankees—have won 487 games, approaching 100 a year, and have failed to win the World Series only once. ...

"I met him a couple of times when he came out to the Stadium," Jeter says of DiMaggio, "but I never had a conversation with him. I shook his hand, said hello, but I was too much in awe to talk to him."

Now Jeter is DiMaggio's worthy heir, in style and in numbers. In regular-season and World Series play, DiMaggio scored 625 runs through his fifth full season. Jeter scored 623. DiMaggio had 994 hits. Jeter had 1,034. DiMaggio played in 19 World Series games over his first five seasons; his Yankees went 16–3. Jeter played in 19 World Series games, too; his Yankees went 16–3. Jeter hit for a higher World Series batting average (.342) than did DiMaggio (.304), while producing more of New York's offense than Joltin' Joe: From 1936 to '39, DiMaggio scored or drove in 21 of the Yankees' 113 runs in the World Series, or 19%; from 1996 through 2000, Jeter was responsible for 22 of New York's 85 Series runs, or 26%.

Through five seasons the ring count is all even. Jeter keeps his rings locked away at his home in Tampa. Once after each season he will take them out to study them. "Each one tells a different story, like chapters in a book," he says. "Starting in November, when you begin to work out, through October, you devote a whole year to do one thing: to win. That's all that matters. This is the way I've always looked at it: If you're going to play at all, you're out to win. Baseball, board games, playing along with *Jeopardy!* with my friends. I hate to lose."

Jeter seemed destined for greatness. He shares a birthday (June 26) with Abner Doubleday, the mythical inventor of baseball. On the day the Yankees' front office gathered to talk about its top pick of the 1992 draft, Jeter's name came up, and one of those present said, "Jeter? Isn't he going to Michigan?" There was a moment of silence. Then Dick Groch, the scout who signed Jeter, said, "No. He's going to Cooperstown." Says Reggie Jackson, the original Mr. October, "In big games, the action slows down for him where it speeds up for others. I've told him, 'I'll trade my past for your future.' "...

Two nights [after the Yankees clinched the Series], Jeter rested his feet on an ottoman in his small, modestly furnished apartment on the East

Side of Manhattan. His ironing board and iron stood at the ready by his dining table. He had slept past noon the past two days and left his apartment only for dinners, once in the Bronx with friends and this night in midtown with his parents. On Sunday he would eat downtown at a team party arranged by Torre. On Monday, after his fourth

victory parade through lower Broadway, he was booked to do Letterman.

"No doubt, this team ranks up there with any team of all time," Jeter says. "You can come up with teams that had better players or hit more home runs or scored more runs. But the name of the game is winning. I can't see any team being better."

Outside, 11 floors below the drawn blinds, life after the Subway Series pulsed on. The usual cacophonous symphony of car horns and tire screeches continued. Nothing had changed. This winner wasn't going anywhere. More than ever, this is his town. More than ever, this is his team. —Tom Verducci
excerpted from SI, Nov. 6, 2000

DAVID WELLS

David Wells is fat. Not phat. Fat. He is not a work in progress, not a lug trying to shed some pounds, not a Weight Watchers washout. Over the past 13 years, since Wells (opposite) broke in as a reliever with the Toronto Blue Jays, players and trainers and managers and general managers and owners have spent time—too much time—trying to convince themselves and the rest of the world that Wells was a fat guy in search of a skinny body. Nothing could be further from the truth. Wells is a fat guy who is content being fat, and if he is in search of anything, it is a beer. ... Everything about Wells is fat. The three likenesses of family members tattooed on his upper body are fat. The dark-brown goatee that could comfortably house a family of six robins is fat. His fingers and toes, his ears and nose, his forehead and chin(s) are fat. Even his voice sounds fat, the words spewing forth in a husky tone, with a fleshiness to them.

Blue Jays general manager Gord Ash, a mountain of a man himself, is one of those who wasted his time. During Wells's first stint with Toronto, from 1987 through '92, Ash, the assistant G.M. for four of those years, was part of the effort to whittle away at the 6' 4" Wells, wishfully listed at 225 pounds. What's more, the Blue Jays condemned the pitcher's other conspicuous characteristics: his love of Metallica CDs played at ear-melting volume, a devotion to multiple brews, a sharp tongue and a Firestarter temper. "We did everything we could to control Boomer" says Ash, who, fed up with Wells's antics and in-

consistent performance, helped the team reach its decision to release him in March 1993. "We learned the hard way: The worst way to control him is to try and control him."

Wells was 7–9 with a 5.40 ERA in his final season as a badgered Blue Jay. The next year, playing in Detroit for laid-back, do-what-ya-wanna-do manager Sparky Anderson, Wells became, with an 11–9 record and 4.19 ERA, one of the Tigers' top starters. Two seasons later he was an All-Star. Three seasons after that, in 1998, he was the ace of the New York Yankees, throwing a perfect game, going 18–4 with a 3.49 ERA, winning two Championship Series games and one more in the World Series, going Manhattan barhopping with the honeys and kickin' it on Letterman's love seat. "We made mistakes with Boomer," says Ash. "They won't be made twice."

That has become Ash's mantra, what with the out-of-nowhere Blue Jays riding Wells's 14–2 record, 3.41 ERA and league-high four complete games to the top of the American League East. In fact, Ash has spent nearly 17 months repeating it, ever since that awkward day of Feb. 18, 1999, when Toronto traded righthander Roger Clemens to the Yankees and received young second baseman Homer Bush, lefthanded reliever Graeme Lloyd and a Fritos-ingesting Babe Ruth fanatic (now wishfully listed at 235) who loved to wear pinstripes and who greeted the news of the trade not with tears or smiles but with a look of disgust. Shortly after the deal was made,

when he was able to contact Wells, Ash assured the lefthander that times and attitudes had changed in Toronto, that these were open-minded days for the Blue Jays. In other words, be the ace of our staff—and consume all the [beer] and Ho Hos you'd like.

"All I ask is that you respect me as a pitcher," Wells says now. "All the other stuff doesn't mean s---." ...

Pitching in 1999 with a chronically sore back and for a chronically mediocre team, Wells went 17–10 and led the American League in complete games (seven) and innings pitched (231 $^2/_3$).

Since the beginning of the 1999 season, his 31 wins are the second most in baseball, trailing only Boston Red Sox righthander Pedro Martinez's 32. "More than anybody I know, I love this game," says the 37-year-old Wells. "I take a lot of pride in what I do and what we do as a team. People make a big deal out of success. I feel like you're supposed to succeed. It's what you're paid for."

"You need people who hate to lose, and he despises losing," says Toronto manager Jim Fregosi. "Just look at his durability. Whether he's in pain or not, he wants to pitch."

Unlike Martinez, who can retire batters with the sheer viciousness of his repertoire, Wells relies on smarts, instinct and, most of all, location. While his fastball, which used to top out at 95 mph, usually stays around 90, Wells mixes his pitches (two- and four-seam fastballs, a slider and an off-the-table curve) with all the predictability of a slot machine. …

Although Wells is pitching better than ever, the 2001 season could be his last. He's in the first season of a two-year, $16 million extension, which also contains incentive bonuses and includes a

team option at $7.75 million for 2002. If the club doesn't pick it up, says Wells, he'll retire as, of all things, a Blue Jay. Somewhere, Dave Lemanczyk is smiling.

"I don't think Boomer wants to be Orel Hershiser," says Ash, referring to the 41-year-old righthander whom the Dodgers recently released after a run of three miserable starts. "He wants to go out in style. His dream exit would be to pitch a no-hitter and just keep on walking and never turn back. That's the Boomer Wells I know."

—Jeff Pearlman
excerpted from SI, July 10, 2000

Final Standings

National League

EASTERN DIVISION

Team	Won	Lost	Pct	GB	Home	Away
Atlanta	95	67	.586	—	51–30	44–37
†New York	94	68	.580	1	55–26	39–42
Florida	79	82	.491	15½	43–38	36–44
Montreal	67	95	.414	28	37–44	30–51
Philadelphia	65	97	.401	30	34–47	31–50

CENTRAL DIVISION

Team	Won	Lost	Pct	GB	Home	Away
St. Louis	95	67	.586	—	50–31	45–36
Cincinnati	85	77	.525	10	43–38	42–39
Milwaukee	73	89	.451	22	42–39	31–50
Houston	72	90	.444	23	39–42	33–48
Pittsburgh	69	93	.426	26	37–44	32–49
Chicago	65	97	.401	30	38–43	27–54

WESTERN DIVISION

Team	Won	Lost	Pct	GB	Home	Away
San Francisco	97	65	.599	—	55–26	42–39
Los Angeles	86	76	.531	11	44–37	42–39
Arizona	85	77	.525	12	47–34	38–43
Colorado	82	80	.506	15	48–33	34–47
San Diego	76	86	.469	21	41–40	35–46

†Wild-card team.

American League

EASTERN DIVISION

Team	Won	Lost	Pct	GB	Home	Away
New York	87	74	.540	—	44–36	43–38
Boston	85	77	.525	2½	42–39	43–38
Toronto	83	79	.512	4½	45–36	38–43
Baltimore	74	88	.457	13½	44–37	30–51
Tampa Bay	69	92	.429	18	36–44	33–48

CENTRAL DIVISION

Team	Won	Lost	Pct	GB	Home	Away
Chicago	95	67	.586	—	46–35	49–32
Cleveland	90	72	.556	5	48–33	42–39
Detroit	79	83	.488	16	43–38	36–45
Kansas City	77	85	.475	18	42–39	35–46
Minnesota	69	93	.426	26	36–45	33–48

WESTERN DIVISION

Team	Won	Lost	Pct	GB	Home	Away
Oakland	91	70	.565	—	47–34	44–36
†Seattle	91	71	.562	½	47–34	44–37
Anaheim	82	80	.506	9½	46–35	36–45
Texas	71	91	.438	20½	42–39	29–52

†Wild-card team.

2000 Individual Leaders

NATIONAL LEAGUE BATTING

Batting Average

Todd Helton, Col	.372
Moises Alou, Hou	.355
Vladimir Guerrero, Mtl	.345
Jeffrey Hammonds, Col	.335
Jeff Kent, SF	.334
Luis Castillo, Fla	.334
Jose Vidro, Mtl	.330
Jeff Cirillo, Col	.326
Gary Sheffield, LA	.325
Edgardo Alfonzo, NY	.324

Hits

Todd Helton, Col	216
Jose Vidro, Mtl	200
Andruw Jones, Atl	199
Vladimir Guerrero, Mtl	197
Jeff Kent, SF	196
Jeff Cirillo, Col	195
Sammy Sosa, Chi	193
Luis Gonzalez, Ariz	192
Neifi Perez, Col	187
Jason Kendall, Pitt	185

Doubles

Todd Helton, Col	59
Jeff Cirillo, Col	53
Jose Vidro, Mtl	51
Luis Gonzalez, Ariz	47
Shawn Green, LA	44

Triples

Tony Womack, Ariz	14
Neifi Perez, Col	11
Vladimir Guerrero, Mtl	11
Bobby Abreu, Phil	10
Tom Goodwin, LA	9
Ron Belliard, Mil	9

Home Runs

Sammy Sosa, Chi	50
Barry Bonds, SF	49
Jeff Bagwell, Hou	47
Richard Hidalgo, Hou	44
Vladimir Guerrero, Mtl	44
Gary Sheffield, LA	43
Todd Helton, Col	42
Jim Edmonds, StL	42
Ken Griffey, Cin	40
Mike Piazza, NY	38

Runs Scored

Jeff Bagwell, Hou	152
Todd Helton, Col	138
Barry Bonds, SF	129
Jim Edmonds, StL	129
Andruw Jones, Atl	122
Richard Hidalgo, Hou	118
Chipper Jones, Atl	118
Jeff Kent, SF	114
Jason Kendall, Pitt	112
Brian Giles, Pitt	111

Total Bases

Todd Helton, Col	405
Sammy Sosa, Chi	383
Vladimir Guerrero, Mtl	379
Jeff Bagwell, Hou	363
Richard Hidalgo, Hou	355
Andruw Jones, Atl	355

Stolen Bases

Luis Castillo, Fla	62
Tom Goodwin, LA	55
Eric Young, Chi	54
Tony Womack, Ariz	45
Rafael Furcal, Atl	40

Runs Batted In

Todd Helton, Col	147
Sammy Sosa, Chi	138
Jeff Bagwell, Hou	132
Jeff Kent, SF	125
Vladimir Guerrero, Mtl	123
Brian Giles, Pitt	123
Richard Hidalgo, Hou	122
Preston Wilson, Fla	121
Ken Griffey, Cinn	118
Jeff Cirillo, Col	115

Slugging Percentage

Todd Helton, Col	.698
Barry Bonds, SF	.688
Vladimir Guerrero, Mtl	.664
Gary Sheffield, LA	.643
Richard Hidalgo, Hou	.636

On-Base Percentage

Todd Helton, Col	.463
Barry Bonds, SF	.440
Gary Sheffield, LA	.438
Brian Giles, Pitt	.432
Edgardo Alfonzo, NY	.425

Bases On Balls

Barry Bonds, SF	117
Brian Giles, Pitt	114
Jeff Bagwell, Hou	107
Todd Helton, Col	103
Jim Edmonds, StL	103

NATIONAL LEAGUE PITCHING

Earned Run Average

Kevin Brown, LA	2.58
Randy Johnson, Ariz	2.64
Jeff D'Amico, Mil	2.66
Greg Maddux, Atl	3.00
Mike Hampton, NY	3.14
Al Leiter, NY	3.20
Chan Ho Park, LA	3.27
Tom Glavine, Atl	3.40
Rick Ankiel, StL	3.50
Robert Person, Phil	3.63

Saves

Antonio Alfonseca, Fla	45
Trevor Hoffman, SD	43
Robb Nen, SF	41
Armando Benitez, NY	41
Danny Graves, Cinn	30
Dave Veres, StL	29
Rick Aguilera, Chi	29
Jeff Shaw, LA	27
Jose Jimenez, Col	24
John Rocker, Atl	24

Wins

Tom Glavine, Atl	21
Darryl Kile, StL	20
Randy Johnson, Ariz	19
Greg Maddux, Atl	19
Chan Ho Park, LA	18
Scott Elarton, Hou	17
Livan Hernandez, SF	17
Al Leiter, NY	16
Garrett Stephenson, StL	16
Mike Hampton, NY	15

Games Pitched

Steve Kline, Mtl	83
Scott Sullivan, Cin	79
Mike Myers, Col	78
Turk Wendell, NY	77
Armando Benitez, NY	76
Felix Rodriguez, SF	76

Innings Pitched

Jon Lieber, Chi	251
Greg Maddux, Atl	249⅓
Randy Johnson, Ariz	248⅔
Tom Glavine, Atl	241
Livan Hernandez, SF	240

Strikeouts

Randy Johnson, Ariz	347
Chan Ho Park, LA	217
Kevin Brown, LA	216
Ryan Dempster, Fla	209
Al Leiter, NY	200
Javier Vazquez, Mtl	196
Rick Ankiel, StL	194
Pedro Astacio, Col	193
Jon Lieber, Chi	192
Darryl Kile, StL	192

Complete Games

Curt Schilling, Ariz	8
Randy Johnson, Ariz	8
Greg Maddux, Atl	6
Jon Lieber, Chi	6
Three tied with five.	

Shutouts

Greg Maddux, Atl	3
Randy Johnson, Ariz	3
Six tied with two.	

2000 Individual Leaders *(Cont.)*

AMERICAN LEAGUE BATTING

Batting Average

Nomar Garciaparra, Bos	.372
Darin Erstad, Ana	.355
Manny Ramirez, Clev	.351
Carlos Delgado, Tor	.344
Derek Jeter, NY	.339
David Segui, Clev	.334
Jason Giambi, Oak	.333
Mike Sweeney, KC	.333
Frank Thomas, Chi	.328
Johnny Damon, KC	.327

Hits

Darin Erstad, Ana	240
Johnny Damon, KC	214
Mike Sweeney, KC	206
Derek Jeter, NY	201
Nomar Garciaparra, Bos	197
Carlos Delgado, Tor	196
Jermaine Dye, KC	193
David Segui, Clev	192
Frank Thomas, Chi	191
Roberto Alomar, Clev	189

Doubles

Carlos Delgado, Tor	57
Nomar Garciaparra, Bos	51
Deivi Cruz, Det	46
John Olerud, Sea	45
Bobby Higginson, Det	44
Matt Lawton, Minn	44
Frank Thomas, Chi	44
Three tied with 41.	

Triples

Cristian Guzman, Minn	20
Adam Kennedy, Ana	11
Al Martin, Sea	10
Johnny Damon, KC	10
Ray Durham, Chi	9

Home Runs

Troy Glaus, Ana	47
Frank Thomas, Chi	43
Jason Giambi, Oak	43
Carlos Delgado, Tor	41
David Justice, NY	41
Tony Batista, Tor	41
Alex Rodriguez, Sea	41
Rafael Palmeiro, Tex	39
Manny Ramirez, Clev	38
Edgar Martinez, Sea	37

Runs Scored

Johnny Damon, KC	136
Alex Rodriguez, Sea	134
Ray Durham, Chi	121
Darin Erstad, Ana	121
Troy Glaus, Ana	120
Derek Jeter, NY	119
Frank Thomas, Chi	115
Carlos Delgado, Tor	115
Roberto Alomar, Clev	111
Tim Salmon, Ana	108

Total Bases

Carlos Delgado, Tor	378
Darin Erstad, Ana	366
Frank Thomas, Chi	364
Troy Glaus, Ana	340
Jermaine Dye, KC	337

Stolen Bases

Johnny Damon, KC	46
Roberto Alomar, Clev	39
Delino DeShields, Balt	37
Rickey Henderson, Sea	36
Kenny Lofton, Clev	30
Mark McLemore, Sea	30

Runs Batted In

Edgar Martinez, Sea	145
Mike Sweeney, KC	144
Frank Thomas, Chi	143
Jason Giambi, Oak	137
Carlos Delgado, Tor	137
Alex Rodriguez, Sea	132
Magglio Ordonez, Chi	126
Manny Ramirez, Clev	122
Bernie Williams, NY	121
Rafael Palmeiro, Tex	120

Slugging Percentage

Manny Ramirez, Clev	.697
Carlos Delgado, Tor	.664
Jason Giambi, Oak	.647
Frank Thomas, Chi	.625
Alex Rodriguez, Sea	.606

On-Base Percentage

Jason Giambi, Oak	.476
Carlos Delgado, Tor	.470
Manny Ramirez, Clev	.457
Frank Thomas, Chi	.436
Nomar Garciaparra, Bos	.434

Bases On Balls

Jason Giambi, Oak	137
Carlos Delgado, Tor	123
Jim Thome, Clev	118
Frank Thomas, Chi	112
Troy Glaus, Ana	112

AMERICAN LEAGUE PITCHING

Earned Run Average

Pedro Martinez, Bos	1.74
Roger Clemens, NY	3.70
Mike Mussina, Balt	3.79
Mike Sirotka, Chi	3.79
Bartolo Colon, Clev	3.88
David Wells, NY	4.11
Gil Heredia, Oak	4.12
Albie Lopez, TB	4.13
Tim Hudson, Oak	4.14
Chuck Finley, Clev	4.17

Saves

Todd Jones, Det	42
Derek Lowe, Bos	42
Kazuhiro Sasaki, Sea	37
Mariano Rivera, NY	36
John Wetteland, Tex	34
Keith Foulke, Chi	34
Jason Isringhausen, Oak	33
Billy Koch, Tor	33
Roberto Hernandez, TB	32
Troy Percival, Ana	32

Wins

David Wells, Tor	20
Tim Hudson, Oak	20
Andy Pettitte, NY	19
Pedro Martinez, Bos	18
Aaron Sele, Sea	17
Chuck Finley, Clev	16
Dave Burba, Clev	16
Rick Helling, Tex	16
Denny Neagle, NY	15
Bartolo Colon, Clev	15

Games Pitched

Kelly Wunsch, Chi	83
Mike Venafro, Tex	77
Mark Guthrie, Minn	76
Bob Wells, Minn	76
Mike Trombley, Balt	75

Innings Pitched

Mike Mussina, Balt	237⅔
David Wells, Tor	229⅔
Kenny Rogers, Tex	227⅓
Brad Radke, Minn	226⅔
Sidney Ponson, Balt	222

Strikeouts

Pedro Martinez, Bos	284
Bartolo Colon, Clev	212
Mike Mussina, Balt	210
Chuck Finley, Clev	189
Roger Clemens, NY	188
Hideo Nomo, Det	181
Dave Burba, Clev	180
Tim Hudson, Oak	169
David Wells, Tor	166
Eric Milton, Minn	160

Complete Games

David Wells, Tor	9
Pedro Martinez, Bos	7
Mike Mussina, Balt	6
Sidney Ponson, Balt	6
Brad Radke, Minn	4
Albie Lopez, TB	4

Shutouts

Pedro Martinez, Bos	4
Aaron Sele, Sea	2
Tim Hudson, Oak	2
Seven tied with one.	

2000 Playoffs

NATIONAL LEAGUE DIVISIONAL PLAYOFFS

Oct 3	Atlanta 5 at St. Louis 7	Oct 4	NY 1 at San Francisco 5	
Oct 5	Atlanta 4 at St. Louis 10	Oct 5	NY 5 at San Francisco 4 (10 inn.)	
Oct 7	St. Louis 7 at Atlanta 1	Oct 7	San Francisco 2 at NY 3 (13 inn.)	
(St. Louis won series 3–0)		Oct 8	San Francisco 0 at NY 4	
		(New York won series 3–1)		

NATIONAL LEAGUE CHAMPIONSHIP SERIES

Oct 11	New York 6 at St. Louis 2	Oct 15	St. Louis 6 at New York 10
Oct 12	New York 6 at St. Louis 5	Oct 16	St. Louis 0 at New York 7
Oct 14	St. Louis 8 at New York 2	**(New York won series 4–1)**	

AMERICAN LEAGUE DIVISIONAL PLAYOFFS

Oct 3	Seattle 7 at Chicago 4	Oct 3	New York 3 at Oakland 5	
Oct 4	Seattle 5 at Chicago 2	Oct 4	New York 4 at Oakland 0	
Oct 6	Chicago 1 at Seattle 2	Oct 6	Oakland 2 at New York 4	
(Seattle won series 3–0)		Oct 7	Oakland 11 at New York 1	
		Oct 8	New York 7 at Oakland 5	
		(New York won series 3–2)		

AMERICAN LEAGUE CHAMPIONSHIP SERIES

Oct 10	Seattle 2 at New York 0	Oct 15	New York 2 at Seattle 6
Oct 11	Seattle 1 at New York 7	Oct 17	Seattle 7 at New York 9
Oct 13	New York 8 at Seattle 2	**(New York won series 4–2)**	
Oct 14	New York 5 at Seattle 0		

2000 World Series

Game 1

New York (N)	0 0 0 0 0 0 3 0 0 0 0—3
New York (A)	0 0 0 0 0 2 0 0 1 0 0 1—4

WP—Stanton. **LP**—Wendell.
LOB—NYM 8, NYY 15. **2B**—NYM: Agbayani, Zeile, Abbott; NYY: Justice, Posada. **Sac**—NYM: Bordick. **SF**—NYY: Knoblauch. **CS**—NYM: Piazza; NYY: Knoblauch. **GIDP**—NYY: O'Neill.
T—4:51. **A**—55,913.

Game 2

New York (N)	0 0 0 0 0 0 0 5—5
New York (A)	2 1 0 0 1 0 1 1 x—6

WP—Clemens. **LP**—Hampton.
E—NYM: Payton, Bordick, Perez; NYY: Clemens. **LOB**—NYM 4, NYY 12. **2B**—NYM: Martinez, Jeter 2, O'Neill. **HR**—NYM: Piazza, Payton; NY: Brosius. **SF**—NYY: Brosius. **CS**—NYY: Vizcaino.
T—3:30. **A**—56,059.

Game 3

New York (A)	0 0 1 1 0 0 0 0 0—2
New York (N)	0 1 0 0 0 1 0 2 x—4

WP—Franco. **LP**—Hernandez. **SV**—Benitez.
LOB—NYY 10, NYM 8. **2B**—NYY: O'Neill, Justice; NYM: Ventura, Piazza, Zeile, Agbayani. **3B**—NYY: O'Neill. **HR**—NYM: Ventura. **Sac**—NYY: Hernandez; NYM: Reed. **SF**—NYM: Trammell.
T—3:39. **A**—55,299.

Game 4

New York (A)	1 1 1 0 0 0 0 0 0—3
New York (N)	0 0 2 0 0 0 0 0 0—2

WP—Nelson. **LP**—Jones. **SV**—Rivera.
E—NYM: Trammell. **LOB**—NYY 9, NYM 6. **3B**—NYY: O'Neill, Jeter. **HR**—NYY: Jeter; NYM: Piazza. **SF**—NYY: Brosius. **SB**—NYY: Sojo. **GIDP**—NYY: O'Neill.
T—3:20. **A**—55,290.

Game 5

New York (A)	0 1 0 0 0 1 0 0 2—4
New York (N)	0 2 0 0 0 0 0 0 0—2

WP—Stanton. **LP**—Leiter. **SV**—Rivera.
E—NYY: Pettitte; NYM: Payton. **LOB**—NYY 6, NYM 10. **2B**—NYM: Piazza. **HR**—NYY: Williams, Jeter. **Sac**—NYM: Leiter.
T—3:32. **A**—55,292.

Oklahoma!

The wins came sweeping down the plain for the surprising Sooners, who defied the skeptics and won the national title ■ B.J. Schecter

Some danced, some cried and others glided around the turf of Pro Player Stadium in a state of jubilation. Oklahoma senior quarterback Josh Heupel wasn't sure what to do. He was mobbed by teammates, coaches and fans, and when he looked up at the scoreboard, which read OKLAHOMA 13, FLORIDA STATE 2, he could hardly believe it.

Indeed, much of Oklahoma's perfect 2000 season, which was capped off by an improbable win over the heavily favored Seminoles in the Orange Bowl for the national title, was scarcely within the realm of belief. That Florida State had reached the BCS national championship for the third consecutive year was no surprise, but Oklahoma's presence in the game was like your country cousin crashing the cotillion. At the beginning of the season the Sooners weren't even considered contenders. After finishing 7–5 in 1999, Oklahoma began the year ranked No. 19. But with one impressive victory after another the Sooners slowly crept onto the nation's radar screen. First it was a 63–14 pasting of Texas, then a 41–31 win over Kansas State, followed by an impressive 31–14 win over then–No. 1 Nebraska, and finally a 27–24 triumph over Kansas State again in the Big 12 championship game.

Yet with each victory, Oklahoma seemed to win as many critics as converts. Even after the Sooners finished the regular season as the nation's only undefeated team in Division I-A, they weren't

With Oklahoma clinging to a 6–0 lead early in the fourth quarter, the Seminoles missed their best chance of the game when receiver Morgan (87), who had beaten Sooner defensive back Derrick Strait (2), couldn't hold on to Weinke's pass in the end zone.

Oklahoma running back Quentin Griffin (22), who gained 40 yards on 11 carries in the game, scampered 10 yards for the touchdown that put the Sooners up 13–0 in the fourth quarter of the Orange Bowl.

shown much respect. Most observers believed Florida State would walk all over Oklahoma in the Orange Bowl. The pregame line had the Seminoles favored by 11. None of this mattered to coach Bob Stoops and his troops. "People aren't at practice every day," said Stoops. "They don't see what I see. I don't pay much attention to what people who don't know what they're talking about say or think. If the oddsmakers determined our fate, we'd be 7–4."

In the week leading up to the national championship game, all Oklahoma heard was how it didn't have the athletes to keep up with Florida State. Stoops and his players listened to the analysis and nodded their heads. Florida State was loaded with talent, they agreed, but it wasn't as if Oklahoma was stocked with Division I-AA players. "I've heard all this talk about how fast Florida State is," Stoops said the day before the game. "But I've never heard people describe our guys as slow."

Publicly, Stoops said nothing as the experts pumped up Florida State and downplayed the talent and desire of his team. Privately, he stewed. A starting safety at Iowa from 1979 to '82 and a two-time All–Big Ten selection, the 40-year-old Stoops knows something about overachieving. When he was a Hawkeye, there were many players who had more talent than he did, but few had his heart. Four days before the game, Stoops was quietly confident as his team finished practice.

"We've been incredibly focused all week and believe me, we'll be ready," he said. "I'm very confident we'll win the game. We've been ready all year and trust me, we'll be ready for the challenge."

Stoops came to Oklahoma—2000 was his second season with the Sooners—with an impressive coaching résumé. Most people are lucky to find one mentor, but Stoops had three: former Iowa coach Hayden Fry, Kansas State coach Bill Snyder and Florida coach Steve Spurrier. In 1996, Stoops

made a name for himself as Spurrier's defensive coordinator, helping the Gators win the national title. Against Florida State in the Sugar Bowl that season, Stoops assembled an airtight defensive game plan and the Gators held the Seminoles to 19 points below their regular-season scoring average, routing them 52–20.

After watching this year's Florida State team on film, Stoops was quick to remind his staff that the Seminoles' offensive scheme in 2000—potent though it was—was essentially the same as it had been in 1996. "It's amazing," said one member of the Oklahoma coaching staff two days before the game. "In four years they've hardly changed a thing."

The task of neutralizing this year's model of the souped-up Seminole O—which featured Heisman Trophy–winning quarterback Chris Weinke, a 28-year-old senior—fell to Stoop's younger brother, Mike, the Sooners' co–defensive coordinator. The Seminoles came in averaging 549.0 yards per game, and Weinke could read coverages like pop-up books. Mike Stoops knew he would have to disguise his defensive schemes.

Even without their leading receiver, Marvin (Snoop) Minnis, who was academically ineligible for the game, the Seminoles felt they could pick apart the Oklahoma secondary. As FSU coach Bobby Bowden told his staff early in the year: "We may never have an offense this good again. We have an outstanding quarterback, two good running backs, big-play receivers and the best offensive line we've ever had."

Indeed, after an Oct. 7 loss to Miami, Florida State looked like a pro team for the remainder of the season, moving the ball and scoring at will. But against a stifling Oklahoma defense, "The train just kept coming off the tracks," Weinke would say later.

Mike Stoops decided to use five or six defensive backs against Weinke. But in order for this strategy to work, the Sooners had to be able to stop the run and disguise their coverages. They did both, holding Florida State to 27 yards on the ground and confusing Weinke all night. Nickleback Ontei Jones would start several yards off the line of scrimmage and sprint back into coverage just before the ball was snapped. Free safety J.T. Thatcher would line up as a linebacker on one play and a safety on the next. He'd blitz one play and fake a blitz on the next.

Oklahoma's actual coverages and sets were the same ones they had used all year, but they *looked* different. With Florida State's running game held

in check, its play-calling became predictable, and even a no-huddle offense couldn't improve the results. "It seemed like they had radar," said Seminoles receiver Atrews Bell. "Everything we tried they were ready for."

Still, Oklahoma wasn't exactly running roughshod over the Florida State defense. The Sooners led 3–0 at the half and took a 6–0 lead into the fourth quarter. It appeared as if the Seminoles would take a 7–6 lead when Robert Morgan dived for a catchable pass in the end zone. But Morgan, like many of Weinke's receivers all night, couldn't hold on to the ball.

The Sooner defense effectively put the game away late in the fourth quarter when linebacker Rocky Calmus knocked the ball out of Weinke's grasp as the quarterback scrambled out of the pocket. Sooner defensive back Roy Williams recov-

ered the fumble at the Florida State 15. Two plays later Quentin Griffin scored the game's only touchdown on a 10-yard run, giving Oklahoma a 13–0 lead. Florida State's only points would come on a safety with 55 seconds remaining in the game.

For Heupel it was a fitting end to a circuitous college career which began in his hometown of Aberdeen, S.Dak., and made stops at Weber State and Snow Junior College before settling in Norman in 1999. Steady and never flashy, Heupel always found a way to get the job done. He passed for only 214 yards in the Orange Bowl, but he made very few mistakes, and his team came out on top.

The game was a bit of a grudge match for Heupel. Though he never publicly admitted it, Heupel was deeply disappointed that he didn't win the Heisman Trophy. He was a close runner-up, but

Miami's James Jackson (21) gained 62 yards in the Sugar Bowl against Florida but left the game in the second quarter with a sprained foot. His replacement, Clinton Portis, rushed for 97 yards to help the Hurricanes to a 37–20 victory and a second-place finish in the polls with an 11–1 record.

Cornerback Roc Alexander (3) and Washington, which defeated national runner-up Miami 34–29 on Sept. 9, knocked off quarterback Drew Brees (above, center) and Purdue in the Rose Bowl 34–24. The Huskies finished the season at 11–1 and placed third in the final polls.

the award went to Weinke, his flashier counterpart at Florida State, who passed for 4,167 yards and threw 33 touchdown passes in 2000. If Heupel was looking for revenge, he certainly got it when his Sooners defied almost everyone's expectations in the Orange Bowl. After the game, Heupel and Patrick McClung, a minister from Norman who had been Heupel's spiritual guide all season, knelt at midfield and gave thanks. Heupel's tears mixed with the rain, which had started to fall in sheets into an emptying Pro Player Stadium.

By season's end many college football fans would have given thanks if the convoluted Bowl Championship Series had ceased to exist. To be sure, Oklahoma's impressive victory over Florida State left no doubt as to who was the best team in the nation, but the BCS system created a simmering pot of controversy before the major bowls kicked off. Everyone agreed that the Sooners, as the only undefeated team in the nation, deserved to be in the championship game. But many observers be-

lieved their opponent should have been second-ranked Miami, which beat Florida State 27–24 in October. Others thought 10–1 Washington, which beat Miami in September, deserved a shot at the title. Then there were 10–1 Oregon State and 10–1 Virginia Tech making their claims. Virginia Tech's only loss came against Miami, in a game the Hokies started without superstar quarterback Michael Vick, who was hurt. Prior to the season, Vick was the odds-on favorite to win the Heisman Trophy, and he probably would have done so if an ankle injury hadn't limited him in four games. A sophomore, Vick declared himself eligible for the NFL draft soon after the season ended.

If Florida State had beaten Oklahoma, Miami would have been crowned co–national champion. The Hurricanes took care of their business by beating Florida 37–20 in the Sugar Bowl. The victory capped a remarkable turnaround for Miami, which had been a power in the late '80s and early '90s but had fallen hard from '92 to '98. The Miami pro-

gram was rife with unseemly incidents off the field, and in 1995 its administration admitted that 57 of its players had received fraudulent Pell Grants. Later that year the NCAA penalized the Hurricanes in a variety of ways; the most serious was the loss of 31 scholarships over three years.

Butch Davis took over as head coach just before Miami was saddled with the sanctions. He quickly cleaned up shop and threw players off the team who wouldn't adhere to his rules. In 1999, the Hurricanes were 9–4 and ranked 15th in the final national polls; this year, they had a legitimate gripe when they weren't invited to the national title game.

Another team that worked its way up from ground zero was Oregon State. Interestingly enough, the Beavers' coach was former Miami man Dennis Erickson, who had been with the Hurricanes during the Pell Grant scandal. When Erickson came to Corvallis from the Seattle Seahawks in 1999, Oregon State had just a set an NCAA record with its 28th consecutive losing season. In Erickson's first year the Beavers went 7–5, and in 2000 they went 11–1. If anyone doubted that the Beavers were for real they needed to look no further than Oregon State's 41–9 trouncing of Notre Dame in the Fiesta Bowl.

As impressive as the coaching jobs by Stoops, Davis and Erickson were, nobody engineered a turnaround as remarkable as second-year South Carolina coach Lou Holtz. In 1999, Holtz inherited a Gamecocks program in disarray, and during his first season one thing after another went wrong. South Carolina failed to win a single game. The Gamecocks entered the 2000 season with the longest losing streak in Division I-A, 21 games. Ending that run of ignominy was the first order of business, which the Gamecocks dispatched in their opener, routing New Mexico State 31–0. South Carolina would win seven of its first eight games before losing three straight to Tennessee, Florida and Clemson. But the Gamecocks ended the season back on the winning side of the ledger, beating Ohio State 24–7 in the Outback Bowl to finish 8–4.

That defeat turned out to be John Cooper's last as coach of Ohio State. It didn't matter that Cooper had won 72% of his games in 13 seasons in Columbus. His Buckeyes had trouble in big games, as evidenced by their 2-10-1 record against Michigan, and he never seemed to win over Ohio State's fans.

By season's end, coaches at some of the biggest programs in the land had received pink slips. Notre Dame coach Bob Davie kept his job, but coaches at Alabama, Georgia, Arizona, Arizona State, USC, Missouri, Maryland, North Carolina and Oklahoma State were shown the door. The pressure and the stakes at big-time programs showed no sign of decreasing. One wonders what effect coaches like Stoops, Erickson, Davis and Holtz will have. They showed that it is possible to turn things around in a couple of seasons, and may have inadvertently fueled the increasingly widespread produce-now-or-get-fired mentality.

Whatever his effect on the relationship between coaches and athletic directors, Stoops has a lot to teach his peers. When he took over in 1999 the Sooners were a laughingstock. They hadn't had a winning season or won a bowl game since 1993. From the start, Stoops embraced Oklahoma's tradition, inviting legendary former coach Barry Switzer and former star linebacker Brian Bosworth to be part of the program. Stoops wanted his players to believe that putting on the Oklahoma uniform was a privilege. The players bought every word, and the result was an improbable national championship.

"Our players recognize that the history of Oklahoma is about winning national championships," Stoops said. Yes, the history, the present and by all indications, the future.

Heupel (14) connected on 25 of 39 passes for 214 yards in the Orange Bowl, but the only numbers he and the Sooners and their fans cared about could be read on the scoreboard at the final whistle.

149

PHOTO GALLERY

Miami defensive
back Al Blades
went high while
his teammate
Dan Morgan
went low to stop
Virginia Tech
running back
Andre Kendrick (4)
on Nov. 4.
Miami won the
game 41–21,
handing the
Hokies their only
loss of the season.

Eager Beaver:
Oregon State
quarterback
Jonathan Smith
(above) prepared
to take a snap dur-
ing the Beavers'
23–13 home win
against Oregon in
the annual "Civil
War" game.
Oregon State fin-
ished the season
11–1 and ranked
fourth in
the AP poll.

151

Oh, McCoo: Penn State running back Eric McCoo (8) stretched out for extra yardage during the Nittany Lions' 22–20 victory over Purdue on Sept. 30. The defeat of the 13th-ranked Boilermakers was the highlight of Penn State's dismal 5–7 season.

South Carolina running back Derek Watson (22) lost his helmet when he ran into Alabama linebacker Victor Ellis (9), and the Gamecocks lost their first game of the season after four victories when they collided with the Crimson Tide on Sept. 30 in Columbia, S.C., and fell, 27–17.

Wildcat Strike: Kansas State defenders Chris Johnson (36) and Monty Beisel (44) overwhelmed Iowa quarterback Scott Mullen during the Wildcats' 27–7 rout in the season-opening Eddie Robinson Classic on Aug. 26 in Kansas City, Mo.

Acrobatic Aggie: Texas A&M's Robert Ferguson (6) sailed over Oklahoma defensive back Roy Williams after making a reception in the fourth quarter of the Aggies' 35–31 home loss to the Sooners on Nov. 11. Oklahoma rallied from a 14-point, fourth-quarter deficit to win the game and keep its national championship hopes alive. Ferguson made eight catches for 105 yards and one score.

PROFILES

LaDainian Tomlinson

The people of Fort Worth have never seen anything quite like the 2000 election campaign. Television, Internet, public appearances, endorsements, old-fashioned billboards—it's an onslaught that won't stop. On a balmy afternoon in late October, TCU tailback and Heisman Trophy candidate LaDainian Tomlinson (opposite) walked past a parked SUV decorated with a purple LT FOR HEISMAN bumper sticker, complete with website address. "There are so many of these," he said, tapping the van's back window with his index finger, "that I've started to notice the cars that *don't* have one."

Two days later Tomlinson ran for 200 yards on 41 carries in a 37–0 victory over Rice. That performance enabled the 5' 11", 220-pound senior from Waco to remain the leading rusher in the nation (184.7 yards per game) and 7–0 TCU to win its 12th consecutive game over two seasons, the longest streak in the nation. The ninth-ranked Horned Frogs have ascended from the ashes of a 1–10 season in 1997. . . .

At the center of all this mojo is Tomlinson, whose Heisman run has been imbued with significance that goes far beyond football. Tomlinson runs not only to win the Heisman and earn TCU a long-shot BCS bowl invitation, but also to help the Frogs hold on to miracle-working coach Dennis Franchione; to push the university toward its goal of national academic prominence; to educate the schoolchildren of the Dallas–Fort Worth metroplex about the value of good teachers; and, on a personal level, to please the mother who raised him and the father who deserted him. "It's a lot to think about, so I just try not to think about it," says Tomlinson.

Instead, he simply performs as well as any running back in the country. In 1999, as a junior, Tomlinson led the nation with 1,850 yards rushing and broke the NCAA single-game record with a ridiculous 406 yards on 43 carries against UTEP. In August 2000, when Franchione presented Tomlinson with his plaque for winning the NCAA rushing title, LT gave it to his offensive linemen, who hung it in their meeting room. "How often is your best player your best teammate?" asks senior offensive tackle David Bobo.

This season Tomlinson is on pace to rush for 2,032 yards—not bad for a guy who didn't play tailback in high school until his senior year and who, in his first two years at TCU, ran for a total of only 1,255 yards. On Sept. 16 he shredded the defense of Big Ten contender Northwestern for 243 yards on 39 carries, and three weeks later he beat up Hawaii for 294 yards and four touchdowns on 49 carries. Tomlinson attracts more attention than free shrimp yet hasn't been held to fewer than 119 yards in a game this fall. Talk about targets: In the second half of a rainy 17–3 TCU victory over Tulsa on Oct. 21, a linebacker yelled at Tomlinson, "We're going to tear your ACL."

Most opponents, though, are more respectful of this quick, durable yardage machine who plays much larger than his listed size. "He's real quick and real hard to tackle," says Hawaii linebacker Chris Brown. "He's got strong legs, and he's elusive." Rice linebacker Jeff Vanover says Tomlinson is "just as strong" as Michigan tailback Anthony (A-Train) Thomas but has "more finesse."

NFL personnel people are less certain. Tomlinson "is not a big-time inside runner," says Ted Sundquist, the Denver Broncos' director of college scouting. Tom Donahoe, the Pittsburgh Steelers' director of football operations, will say only, "I think he'll play in the league and be a good back. I'm eager to see him in a bowl and in the all-star games."

What Donahoe and his NFL colleagues will see is a back who looks squat but stands only an inch under six feet, bench-presses 450 pounds and runs the 40, according to Franchione, in 4.37, not the 4.5 that NFL scouts have estimated from videotape. And if Tomlinson has not been a strong inside runner, he's fast becoming one, according to Northwestern defensive coordinator Jerry Brown. "That was the big difference between Tomlinson last year and this year," says Brown. "He was outstanding running inside [on Sept. 16]. He ran inside on us with power and evasiveness."

None of this makes LT a Heisman favorite. Purdue's Drew Brees, Oklahoma's Josh Heupel and Florida State's Chris Weinke play tougher schedules on larger stages. Yet Tomlinson has justified the campaign that began last winter, when TCU assistant sports information director Trey Carmichael proposed to Franchione that the school aggressively market LT to a public that might otherwise never get to know a running back from the Western Athletic Conference. Franchione agreed, and so, reluctantly, did Tomlinson. The machinery was set in motion.

Word of the plan reached university chancellor Michael Ferrari, who saw an opportunity to expose the country not only to a TCU football player but also to the university as a whole. Ferrari wants to raise TCU's national profile closer to those of schools such as Northwestern and Vanderbilt. . . . "Why not bring together the university's goals with LaDainian's goals, even if some risk is involved?"

Risk? You bet. TCU was a longtime member of the now defunct Southwestern Conference, a league that for many years defined regional passion for college football but in the 1980s also plumbed new depths of scandal in the game. In 1986 TCU was placed on probation by the NCAA for numerous major violations, and it spent the ensuing decade trying to distance itself from the athletic zeal that caused its problems. . . .

Yet TCU has jumped in with both cleats. A five-person campus committee was formed to handle the "LT for 2000" campaign,

and Ferrari approved the solicitation of private donations to fund the endeavor. Approximately 40 donors contributed just over $90,000, prompting scattered charges in the media that TCU is trying to buy the Heisman Trophy—which would be the school's first since Davey O'Brien won it in 1938. In fact, the school is trying to buy much more.

A glitzy Web site (www.LTfor2000.com) was established for Tomlinson, and he made a five-minute videotape entitled *Teachers Are the Real Heroes* that was distributed to more than 300 Dallas–Fort Worth–area schools. This fall Tomlinson has spoken at four of those schools. On Oct. 17 he addressed fourth-, fifth- and sixth-graders at Souder Elementary in Everman, Texas. The first-, second- and third-graders were so disappointed at missing out that they stood in two long lines in the hallway outside the school cafeteria and cheered Tomlinson as he left, nearly reducing him to tears. In TCU classrooms, meanwhile, Tomlinson carries a 2.4 GPA. He is 20 hours short of graduating with a major in psychology and a minor in TV/radio, and he hopes to earn his degree by December 2001. Ferrari, therefore, is quite at peace with his marriage of athlete and marketing strategy, history be damned.

"I'm very comfortable with it," he says. "My comfort rests a great deal with the quality of the people involved."

—Tim Layden
excerpted from SI, Nov. 6, 2000

157

CHRIS WEINKE

The jokes won't cease, because a 28-year-old college football player is simply too inviting a target to leave alone, even if similar quips about him have been circulating for the past three years. Only a couple of weeks ago Florida State's aged quarterback Chris Weinke (right) was on the phone with former Seminoles teammate Kevin Long, a three-year NFL veteran who's the starting center for the Tennessee Titans. "Don't worry about your age, because lots of 28-year-olds are still going to school," Long reassured Weinke. "It's just that most of them are doctors."

As Weinke moved within 128 yards last week of eclipsing the ACC career record of 9,614 passing yards set by Duke's Ben Bennett in 1983, Bennett shrugged off the inevitable. "If somebody has to break my record, I'm glad it's a guy who graduated from high school in the same year I did," said Bennett, a 38-year-old assistant coach at Duke who, in fact, graduated from high school in '80, 10 years before Weinke.

Somewhere, rim shots echo. . . .

It's hard to lay off a guy who enrolled at Florida State in August 1990, with the same freshman class as seven-year NBA point guard Charlie Ward; who made enough money in a six-year minor league baseball career before returning to Tallahassee in '97 that nobody questions how he can afford to drive a 2000 Ford Expedition; who holds such sway over his youngest teammates that when freshman quarterback Chris Rix talks about Weinke, he sounds nothing short of reverential.

Weinke, meanwhile, is laughing all the way through a brilliant senior regular season that concludes on Nov. 18 in Tallahassee when the No. 3–ranked Seminoles host No. 4 Florida. After passing for a routine 324 yards and five touchdowns in a 35–6 victory over Wake Forest on Nov. 11, Weinke has thrown for 30 TDs in 11 games, tops in the nation, with nine interceptions. . . .

Despite missing those six years of football while playing baseball, despite a neck injury that nearly ended his career two years ago and despite the many fans and even teammates who view him as a curiosity—the Old Guy—Weinke has carved out one of the best college quarterback careers in history. . . .

"I believe I'm a confident person, and I thrive on people telling me I can't do something," said Weinke two days before the rout of Wake Forest, "but I never imagined all the things that have happened to me. Starting quarterback at Florida State? Win a national championship? Maybe win another one? Hear my name mentioned for the Heisman Trophy? None of it sinks in." [Weinke won the Heisman.]

In 1999 Weinke threw for 3,103 yards and 25 touchdowns in leading the Seminoles to a wire-to-wire No. 1 ranking. After he passed for 329 yards and four touch-

The 6' 5" Weinke needed improvement in two aspects of quarterbacking: short passes and foot quickness. He improved the former with countless repetitions and the latter by dropping his weight from 245 to 228 pounds and spending long summer hours doing agility drills in a deep sandpit. His NFL future will hinge on winter tryouts, but there seems far less uncertainty now than a year ago. . . .

Weinke has seized control of a good [FSU] team and made it his own. When Duke attacked him with blitzes that the Blue Devils hadn't shown on tape, he changed both the routes his receivers were running and all of Florida State's audible hand signals right there on the field. When Clemson had the Seminoles backed up on their own two-yard line in the first quarter, Weinke called a play-action bomb to Minnis and barked to his blockers in the huddle, "Give me some time, and this is a touchdown." They did, and it was. . . .

In the fall of 1990, Weinke was the prized freshman recruit in what coach Bobby Bowden still calls "the most talented group of quarterbacks we've ever had here." The group included senior Casey Weldon, junior Brad Johnson and fellow freshman Ward, who was behind Weinke in early workouts. Weinke stayed only five days before signing a contract with the Toronto Blue Jays that included a $375,000 bonus. . . .

Weinke was playing first base for the Double A Knoxville Smokies in the summer of 1994, when Michael Jordan of the Birmingham Bulls got his first pro hit, a single bounced up the middle. It's one of Weinke's fondest memories that, before each of the eight games that Knoxville played against the Bulls that summer, MJ would mix with the Smokies' players around the batting cage. . . .

After the 1996 season, the Blue Jays asked Weinke, a light hitter with a decent glove, to move to catcher, which would

have forced him to drop back to Class A. "Starting over," Weinke says. It was a frightening thought for a 24-year-old, six-year veteran. . . .

In a story that has become part of the Weinke legend, Bowden had told Weinke when he left in 1990 that he could have his scholarship anytime he wanted it. "I didn't really expect him to come back," says Bowden. Yet in late fall of '96, Weinke decided that he wanted the scholarship. . . .

As a freshman Weinke was a mess. "He was out of shape, he had no touch on the ball, his footwork was horrible," says [FSU offensive coordinator Mark] Richt. "I told him, 'You might never play here, you know?' "

In the spring of 1998, Weinke was listed as second on the depth chart, behind Dan Kendra, but when Kendra blew out his right knee in spring practice, Weinke was elevated to starter. He threw for 2,487 yards and 19 touchdowns in 10 games . . . before suffering his neck injury in a Nov. 7 win over Virginia. . . .

He accompanied his teammates to the January 1999 Fiesta Bowl but suffered blinding headaches caused by leaking spinal fluid. One day in Phoenix he tried to pick up a football, but his arm and hand were so weak that the ball dropped to the ground. "That scared me," he says. It would be nearly eight months before he was tackled again.

That's all in the past now, a chapter in one of the longest player biographies in college football history. [Weinke is] standing in his family room. The walls are decorated with miniature football helmets, and outside the door, in the backyard, empty beer kegs are swimming in huge plastic ice buckets, the detritus of Saturday-night postgame parties. It's a good life for an old man. "Even if I had the chance to go back nine years," says Weinke, "I wouldn't change anything."

—Tim Layden
excerpted from SI, Nov. 20, 2000

downs in the 46–29 Sugar Bowl victory over Virginia Tech that gave his team the national title, it seemed certain that, at 27, he would enter the NFL draft. Yet he heard that he would probably be picked no higher than the third round, so he stayed put. "I felt the scouts might have been right," says Weinke, who will graduate in December with a degree in sports management and a 3.4 average. "I felt I could make myself a better quarterback.". . .

JOSH HEUPEL

Rent a car [in December] at the Aberdeen (S.Dak.) Regional Airport, and you're likely to be handed what looks like an extension cord. "It's a block heater, for the battery," the Hertz agent told a recent visitor. "If it gets colder than 15 below tonight—and it's supposed to—plug it in."

People in this part of the country must be tougher than people elsewhere, otherwise they'd have left by now. Oklahoma quarterback Josh Heupel's father, Ken, has always called the Dakotas home. (Josh's mother, Cindy, relocated from Oregon after marrying Ken in 1976.) "This is just a little Alberta Clipper," said Gene Brownell of the bitter cold blanketing the Great Plains in early December. Brownell is the athletic director at Aberdeen Central High. His office is down the hall from that of Cindy, who's both the school's principal and the mother of its most famous alumnus.

Early in the morning of June 13, 1988, Cindy, then 33, woke up with a terrible headache. Within hours she could not walk or talk. She was hospitalized and then flown to Minneapolis. For reasons unknown to her doctors—she neither smoked nor drank and was in great shape—a blood clot had formed on the right side of her brain. "I didn't have a real strong chance of surviving," she says. After surgery at the University of Minnesota, and three months of therapy and rehabilitation, she was back at work as an assistant principal.

Since then Cindy hasn't had any further troubles with clotting—but she hasn't exactly led a cosseted existence. For each of the Sooners home games over the past two seasons, she has driven the 1,890-mile round trip from Aberdeen to Norman, Okla. She leaves after work on Friday and travels through the night, arriving around 5 a.m. She hits the road again by five on Sunday morning to be home by evening.

In his third year as head football coach at Aberdeen's Northern State University, a Division II school with an enrollment of 3,000, Ken makes it to fewer of Josh's games. Earlier this month he returned a phone call from the recruiting trail. He was in Rochester, Minn. How cold was it? "Four degrees—short-sleeves weather," he said, joking (we think). Josh says he started sitting in on his father's meetings and film sessions "as soon as I was old enough to shut up, and that was pretty early." Says Ken, who at the time was an assistant coach at Aberdeen Central (he would move to Northern State in 1987), "He was four or five. He could've been playing with trucks, but he loved being around the team.". . .

In high school Josh had the good fortune to have a football coach, Steve Svendsen, who was uniquely qualified to harness Josh's gifts as a passer. Svendsen had recently finished a two-year stint as a graduate assistant at Houston, where coach John Jenkins was minting NFL quarterback David Klingler with the run-and-shoot offense. In the second half of the first game of his sophomore season, Josh took over Aberdeen Central's scaled-down run-and-shoot. "He was just a skinny little thing," says Svendsen, now the coach at Rapid City (S.Dak.) Central High, "but he had a great understanding of what we were trying to do. Even then he checked in and out of plays at the line."

Svendsen still has the "goal sheet" that Josh filled out before his senior season. He could think of only 20 goals before someone, perhaps his dad, said, "That's probably plenty, Josh." Heupel's aims included: *40 at or below 4.75* (since arriving at Oklahoma, he's dropped his 40 from 5.06 to 4.75); *Improve long ball* (keep working, Josh); and *Play great in big games* (done that). In an endearing flash of self-awareness he also wrote, as his final goal, *Learn to relax a bit.*

As a senior he was named South Dakota's player of the year. He got feelers from Houston, Minnesota, Wisconsin and Wyoming—"but it seemed I was always

the second or third guy on their list," he says. That led to a three-year detour in Utah.

Approaching Ephraim, Utah, from the north, one can't help noticing the profusion of squat structures on both sides of Route 89. They're turkey shacks. Ephraim, site of Snow College, is also Utah's turkey capital, where the beauty of the surrounding Wasatch Mountains is compromised, alas, by the ever-present funk of turkey leavings. It was in this unlikely setting, sharing an apartment with seven other guys and subsisting on dinners of rice and gravy, that Heupel enjoyed, in his words, "one of the best times of my life."

His Utah interlude had begun at Weber State, in Ogden, in '96. The Wildcats' coach at the time, Dave Arslanian, had never recruited a player out of South Dakota, but he saw one tape of Heupel and called him. (This would become a pattern.) Heupel redshirted his first season at Weber State and then, on the last day of spring practice, tore an ACL. He played in four games the following season, after which he learned that Arslanian was leaving Ogden to coach at Utah State.

Not long after, Heupel announced that he intended to follow Arslanian, but rather than transfer immediately to Utah State, where he would have been required to sit out a season, he enrolled at Snow in January 1998. After winning the Badgers' starting job in the spring, Heupel was told that a former Snow quarterback, Fred Salanoa, had decided to rejoin the team after briefly transferring to Hawaii. Heupel, it was decided, would play the first half of games, Salanoa the second. Cindy remembers Josh trying to break the news gently to Ken: "There's one other thing, Dad. Fred's brother is the offensive coordinator."

No matter. Even splitting time with Salanoa, Heupel flat-out tore opponents up, throwing for 2,308 yards and 28 touchdowns with only five interceptions and earning recognition as a junior college

All-America. This wasn't good news for Arslanian, who expected Heupel to join him at Utah State. "What happened," says Mike Leach, a former Oklahoma assistant and now the coach at Texas Tech, "is that Josh went to Snow and did too well."

In the same week that Heupel finished that season at Snow, Sooners coach Bob Stoops hired Leach to be his offensive coordinator. When he arrived at Oklahoma, Leach discovered that not a soul on campus was capable of running the spread offense he'd been brought in to install. He saw one tape of Heupel and got on the phone.

Heupel's was not the typical recruiting visit. Like two bears in a cave, he and Leach holed up in Leach's office, ordering takeout and watching tape. Strength coach Jerry Schmidt recalls being introduced to Heupel. "He wanted to know how I could help him increase his speed, his quickness on his drops," says Schmidt. "Usually we interview the recruits, but Josh was the one asking the questions."

Heupel broke the news to Arslanian: He was going to Oklahoma. "I was crushed," says Arslanian, who was fired by Utah State after the 1999 season. "I tried to change his mind. Seeing how it's turned out for Josh, I'm thankful he didn't follow me."

In the hard-working, God-fearing community of Norman, Josh, a management major, and his sister, Andrea, an Oklahoma freshman, fit right in. They attend Bible study on Tuesday nights. Two days before Thanksgiving 1999, Josh distributed food baskets to needy families. This season he spearheaded a food drive. (His first words to his father after the Texas Tech game: "How much food did we get?") "I'm happy for Josh that he's set goals and attained them on the football field," says Cindy, "but I'm more impressed by the kind of person he is."

—Austin Murphy
excerpted from SI, Dec. 25, 2000

Final Polls

ASSOCIATED PRESS

		RECORD	PTS	HEAD COACH	SI PRESEASON RANK
1.	Oklahoma (71)	13–0	1775	Bob Stoops	23
2.	Miami (FL)	11–1	1690	Butch Davis	10
3.	Washington	11–1	1634	Rick Neuheisel	13
4.	Oregon St	11–1	1539	Dennis Erickson	35
5.	Florida St	11–2	1488	Bobby Bowden	2
6.	Virginia Tech	11–1	1432	Frank Beamer	12
7.	Oregon	10–2	1299	Mike Belotti	27
8.	Nebraska	10–2	1282	Frank Solich	1
9.	Kansas St	11–3	1258	Bill Snyder	6
10.	Florida	10–3	1128	Steve Spurrier	11
11.	Michigan	9–3	1061	Lloyd Carr	4
12.	Texas	9–3	894	Mack Brown	9
13.	Purdue	8–4	765	Joe Tiller	16
14.	Colorado St	10–2	640	Sonny Lubick	24
15.	Notre Dame	9–3	611	Bob Davie	26
16.	Clemson	9–3	563	Tommy Bowden	8
17.	Georgia Tech	9–3	545	George O'Leary	33
18.	Auburn	9–4	498	Tommy Tuberville	55
19.	S Carolina	8–4	486	Lou Holtz	73
20.	Georgia	8–4	430	Jim Donnan	7
21.	Texas Christian	10–2	406	Dennis Franchione	15
22.	Louisiana St	8–4	340	Nick Saban	47
23.	Wisconsin	9–4	208	Barry Alvarez	5
24.	Mississippi St	8–4	197	Jackie Sherrill	41
25.	Iowa St	9–3	188	Dan McCarney	54

Note: As voted by a panel of 71 sportswriters and broadcasters following bowl games (1st-place votes in parentheses).

USA TODAY/ESPN

		PTS	PREV RANK
1.	Oklahoma (59)	1475	1
2.	Miami (FL)	1404	2
3.	Washington	1336	4
4.	Florida St	1253	3
5.	Oregon St	1245	6
6.	Virginia Tech	1215	5
7.	Nebraska	1099	8
8.	Kansas St	1077	9
9.	Oregon	1009	11
10.	Michigan	901	15
11.	Florida	899	7
12.	Texas	731	12
13.	Purdue	626	14
14.	Clemson	590	13
15.	Colorado St	587	22
16.	Notre Dame	457	10
17.	Georgia	357	24
18.	Texas Christian	341	16
19.	Georgia Tech	335	17
20.	Auburn	325	20
21.	S Carolina	314	—
22.	Mississippi St	272	—
23.	Iowa St	225	—
24.	Wisconsin	220	—
25.	Tennessee	159	21

Note: As voted by a panel of 59 Division I-A head coaches; 25 points for 1st, 24 for 2nd, etc. (1st-place votes in parentheses).

Bowls and Playoffs

NCAA DIVISION I-A BOWL RESULTS

DATE	BOWL	RESULT	PAYOUT/TEAM ($)	ATTENDANCE
12-20-00	Mobile Alabama	Southern Miss 28, TCU 28	750,000	40,300
12-21-00	Las Vegas	UNLV 31, Arkansas 14	800,000	25,868
12-24-00	Oahu	Georgia 37, Virginia 14	750,000	24,187
12-25-00	Aloha	Boston College 31, Arizona St 17	750,000	24,397
12-27-00	Motor City	Marshall 25, Cincinnati 14	750,000	52,911
12-27-00	Galleryfurniture.com	E Carolina 40, Texas Tech 27	750,000	33,899
12-28-00	Humanitarian	Boise St 38, Texas–El Paso 23	750,000	26,203
12-28-00	Music City	W Virginia 49, Mississippi 38	750,000	47,119
12-28-00	Micronpc.com	N Carolina St 38, Minnesota 30	750,000	28,359
12-28-00	Insight.com	Iowa St 37, Pittsburgh 29	750,000	41,813
12-29-00	Liberty	Colorado St 22, Louisville 17	1.25 million	58,302
12-29-00	Sun	Wisconsin 21, UCLA 20	1 million	49,093
12-29-00	Peach	Louisiana St 28, Georgia Tech 14	1.8 million	73,614
12-29-00	Holiday	Oregon 35, Texas 30	1.9 million	63,278
12-30-00	Alamo	Nebraska 66, Northwestern 17	1.2 million	60,028
12-31-00	Silicon Valley	Air Force 37, Fresno St 34	1.2 million	26,542
12-31-00	Independence	Mississippi St 43, Texas A&M 41	1.1 million	36,974
1-1-01	Outback	S Carolina 27, Ohio St 7	2 million	65,229
1-1-01	Cotton	Kansas St 35, Tennessee 21	2.5 million	63,465
1-1-01	Gator	Virginia Tech 41, Clemson 20	1.4 million	68,741
1-1-01	Citrus	Michigan 31, Auburn 28	4 million	66,928
1-1-01	Rose	Washington 34, Purdue 24	13.5 million	94,392
1-1-01	Fiesta	Oregon St 41, Notre Dame 9	13.5 million	75,428
1-2-01	Sugar	Miami (FL) 37, Florida 20	13.5 million	64,407
1-3-01	Orange	Oklahoma 13, Florida St 2	11–13 million	76,835

Awards

HEISMAN MEMORIAL TROPHY

PLAYER, SCHOOL	CLASS	POS	1ST	2ND	3RD	TOTAL
Chris Weinke, Florida St	Sr	QB	369	216	89	1628
Josh Heupel, Oklahoma	Sr	QB	286	290	114	1552
Drew Brees, Purdue	Sr	QB	69	107	198	619
LaDainian Tomlinson, TCU	Sr	RB	47	110	205	566
Damien Anderson, Northwestern	Sr	RB	6	20	43	101
Michael Vick, Virginia Tech	Jr	QB	7	14	34	83
Santana Moss, Miami	Sr	WR	3	9	28	55
Marques Tuiasosopo, Washington	Sr	QB	5	8	10	41
Ken Simonton, Oregon St	Jr	RB	1	5	12	25
Rudi Johnson, Auburn	Jr	RB	3	1	9	20

Note: Former Heisman winners and the media vote, with ballots allowing for three names (3 points for 1st, 2 for 2nd, 1 for 3rd).

OFFENSIVE PLAYERS OF THE YEAR

Maxwell Award (Player)	Drew Brees, Purdue, QB
Associated Press Player of the Year	Josh Heupel, Oklahoma, QB
Walter Camp Player of the Year	Josh Heupel, Oklahoma, QB

OTHER AWARDS

Davey O'Brien Award (QB)	Chris Weinke, Florida St, QB
Doak Walker Award (RB)	LaDainian Tomlinson, TCU, RB
Biletnikoff Award (WR)	Antonio Bryant, Pittsburgh, WR
Vince Lombardi/Rotary Award (Lineman)	Jamal Reynolds, Florida St, DE
Outland Trophy (Interior lineman)	John Henderson, Tennessee, DL
Butkus Award (Linebacker)	Dan Morgan, Miami (FL), LB
Jim Thorpe Award (Defensive back)	Jamar Fletcher, Wisconsin, CB

COACHES' AWARDS

Walter Camp Award	Bob Stoops, Oklahoma
Eddie Robinson Award (Div I-AA)	Joe Glenn, Montana
Bobby Dodd Award	George O'Leary, Georgia Tech
Bear Bryant Award	Bob Stoops, Oklahoma

AFCA Coaches of the Year

Division I-A	Bob Stoops, Oklahoma
Division I-AA	Paul Johnson, Georgia Southern
Division II	Danny Hale, Bloomsburg
Division III	Larry Kehres, Mt. Union

Awards *(Cont.)*

FOOTBALL WRITERS ASSOCIATION OF AMERICA ALL-AMERICA TEAM
Offense

Antonio Bryant, Pittsburgh, So	Wide receiver
Marvin Minnis, Florida St, Sr	Wide receiver
Brian Natkin, Texas–El Paso, Sr	Tight end
Dominic Raiola, Nebraska, Jr	OL
Chris Brown, Georgia Tech, Sr	OL
Steve Hutchinson, Michigan, Sr	OL
Leonard Davis, Texas, Sr	OL
Joaquin Gonzalez, Miami (FL), Jr	OL
Josh Heupel, Oklahoma, Sr	Quarterback
Damien Anderson, Northwestern, Jr	Running back
LaDainian Tomlinson, Texas Christian, Sr	Running back
Jonathan Ruffin, Cincinnati, So	Placekicker
Santana Moss, Miami (FL), Sr	Kick returner

FOOTBALL WRITERS ASSOCIATION OF AMERICA ALL-AMERICA TEAM *(CONT.)*
Defense

Andre Carter, California, Sr	DL
John Henderson, Tennessee, Jr	DL
Jamal Reynolds, Florida St, Sr	DL
Justin Smith, Missouri, Jr	DL
Rocky Calmus, Oklahoma, Jr	Linebacker
Levar Fisher, N Carolina St, Jr	Linebacker
Dan Morgan, Miami (FL), Sr	Linebacker
Jamar Fletcher, Wisconsin, Jr	Defensive back
Edward Reed, Miami (FL), Jr	Defensive back
Lito Sheppard, Florida, So	Defensive back
Dwight Smith, Akron, Sr	Defensive back
Brian Morton, Duke, Sr	Punter

2000 NCAA Individual Leaders (Division I-A)

Scoring

	CLASS	GP	TD	XP	FG	PTS	PTS/GAME
Lee Suggs, Virginia Tech	So	11	28	0	0	168	15.27
LaDainian Tomlinson, Texas Christian	Sr	11	22	0	0	132	12.00
Damien Anderson, Northwestern	Sr	11	22	0	0	132	12.00
Dwone Hicks, Middle Tennessee St	So	11	21	0	0	126	11.45
Eric Crouch, Nebraska	Jr	11	20	0	0	120	10.91
Thomas Hammock, Northern Illinois	So	9	16	0	0	96	10.67
Chester Taylor, Toledo	Sr	11	19	0	0	114	10.36
Ken Simonton, Oregon St	Jr	11	18	0	0	110	10.00
Deonce Whitaker, San Jose St	Sr	10	16	0	0	98	9.80
Kris Stockton, Texas	Sr	11	0	41	22	107	9.73

Field Goals

	CLASS	GP	FGA	FG	PCT	FG/GAME
Jonathan Ruffin, Cincinnati	So	11	29	26	.897	2.36
Dan Nystrom, Minnesota	So	11	34	22	.647	2.00
Kris Stockton, Texas	Sr	11	26	22	.846	2.00
Rhett Gallego, Alabama-Birmingham	So	11	24	19	.792	1.73
Dave Adams, Air Force	Sr	11	24	19	.792	1.73
Dan Stultz, Ohio St	Sr	11	23	19	.826	1.73
Alex Walls, Tennessee	So	11	20	18	.900	1.64
Owen Pochman, Brigham Young	Sr	12	24	19	.792	1.58
Steve Azar, Northern Illinois	Fr	9	15	14	.933	1.56
Jeff Reed, N Carolina	Sr	11	20	16	.800	1.45

Rushing

	CLASS	GP	CAR	YDS	AVG	TD	YDS/GAME
LaDainian Tomlinson, TCU	Jr	11	369	2158	5.85	22	196.18
Damien Anderson, Northwestern	Sr	11	293	1914	6.53	22	174.00
Michael Bennett, Wisconsin	Jr	10	294	1598	5.44	10	159.80
Deonce Whitaker, San Jose St	Sr	10	224	1577	7.04	15	157.70
Anthony Thomas, Michigan	Sr	11	287	1551	5.40	16	141.00
Ken Simonton, Oregon	Jr	11	266	1474	5.54	18	134.00
Chester Taylor, Toledo	Sr	11	250	1470	5.88	18	133.64
Robert Sanford, Western Michigan	Sr	12	293	1571	5.36	18	130.92
Rudi Johnson, Auburn	Jr	12	324	1567	4.84	13	130.58
Ennis Haywood, Iowa St	Jr	10	230	1237	5.38	8	123.70

Receptions per Game

	CLASS	GP	NO.	YDS	TD	R/GAME
James Jordan, Louisiana Tech	Sr	12	109	1003	4	9.08
Tyson Hinshaw, Central Florida	Sr	11	89	1089	13	8.09
Kenny Christian, Eastern Michigan	Jr	10	78	808	3	7.80
Robert Kilow, Arkansas St	Sr	10	72	1002	3	7.20
Brian Robinson, Houston	So	11	79	892	6	7.18

Receiving Yards per Game

	CLASS	GP	NO.	YDS	TD	YDS/GAME
Antonio Bryant, Pittsburgh	So	10	68	1302	11	130.20
Freddie Mitchell, UCLA	Jr	11	68	1314	8	119.45
Marvin Minnis, Florida St	Sr	12	63	1340	11	111.67
Justin McCareins, Northern Illinois	Sr	11	66	1168	10	106.18
Aaron Jones, Utah	Sr	11	63	1159	11	105.36

Passing Efficiency

	CLASS	GP	ATT	COMP	PCT COMP	YDS	YDS/ATT	TD	INT	RATING PTS
Bart Hendricks, Boise St	Sr	11	347	210	60.52	3364	9.69	35	8	170.6
Chris Weinke, Florida St	Sr	12	431	266	61.72	4167	9.67	33	11	163.1
Rex Grossman, Florida	Fr	11	212	131	61.79	1866	8.80	21	7	161.8
Casey Printers, Texas Christian	So	11	176	102	57.95	1584	9.00	16	6	156.7
Ken Dorsey, Miami (FL)	So	11	322	188	58.39	2737	8.50	25	5	152.3
George Godsey, Georgia Tech	Jr	11	349	222	63.61	2906	8.33	23	6	151.9
John Turman, Pittsburgh	Sr	11	233	128	54.94	2135	9.16	18	7	151.4
Rocky Perez, Texas–El Paso	Sr	11	338	200	59.17	2661	7.87	26	6	147.1
Mike Thiessen, Air Force	Sr	11	195	112	57.44	1687	8.65	13	5	147.0
Ryan Schneider, Central Florida	Fr	9	286	177	61.89	2334	8.16	21	11	147.0

Note: Minimum 15 attempts per game.

DIVISION I-A TEAM SINGLE-GAME HIGHS
Rushing And Passing

Rushing and passing plays: 80—Luke McCown, Louisiana Tech, Oct 28 (vs Miami (FL)).

Rushing and passing yards: 527—Chris Weinke, Florida St, Oct 14 (vs Duke).

Rushing plays: 52—Mike Turner, Northern Illinois, Nov 18 (vs Central Michigan).

Net rushing yards: 322—Emmett White, Utah St, Nov 4 (vs New Mexico St).

Passes attempted: 72—Luke McCown, Louisiana Tech, Oct 28 (vs Miami (FL)).

Passes completed: 47—Luke McCown, Louisiana Tech, Oct 21 (vs Auburn).

Passing yards: 536—Chris Weinke, Florida St, Oct 14 (vs Duke).

DIVISION I-A TEAM SINGLE-GAME HIGHS *(CONT.)*
Receiving And Returns

Passes caught: 20—Kenny Christian, Eastern Michigan, Sept 23 (vs Temple).

Receiving yards: 297—Aaron Jones, Utah St, Nov 11 (vs Boise St).

Punt return yards: 168—Keith Stokes, E Carolina, Nov 11 (vs Houston).

Kickoff return yards: 186—Shawn Terry, W Virginia, Nov 24 (vs Pittsburgh).

The Defense Rests

The Ravens' relentless, swarming 'D' delivered a title to Baltimore and a measure of redemption to its star, Ray Lewis ■ Hank Hersch

Starks (22) intercepted Collins in the third quarter and galloped 49 yards to put the Ravens ahead 17–0 and spark the game's most exciting sequence: back-to-back kickoff returns for touchdowns by the Giants' Ron Dixon and the Ravens' Jermaine Lewis. When the dust settled the Ravens led 24–7.

The first led to his indictment on double-homicide charges; the second to his entry into the NFL pantheon. Baltimore Ravens middle linebacker Ray Lewis will be forever defined by the Super Bowls that bracketed the 2000 NFL season, events that offered up a dismayingly ambiguous portrait of the talented player. For his connection to a street brawl following Super Bowl XXXIV in Atlanta during which two men were stabbed to death, Lewis became a murder suspect. He would plead guilty to a lesser charge of obstruction of justice in June and receive one year's probation. For spearheading the Ravens' 34–7 demolition of the New York Giants in Super Bowl XXXV the following year in Tampa, Lewis joined Dick Butkus, Mike Singletary and Jack Lambert in the ranks of the NFL's great middle linebackers. He solidified his status as the hub of what was arguably the best defense in NFL history and was named MVP of the game, after which he said, "The man upstairs tells you, 'I'll never take you through hell without taking you to triumph.' "

Who was Ray Lewis? His identity may have been murky in '99, but in 2000 he was undoubtedly the best player in a league whose stock in trade is violence and intimidation. There was no greater practitioner of those arts than the Baltimore D, which not only set a record for fewest points allowed in a 16-game season (165), but also surrendered a mere

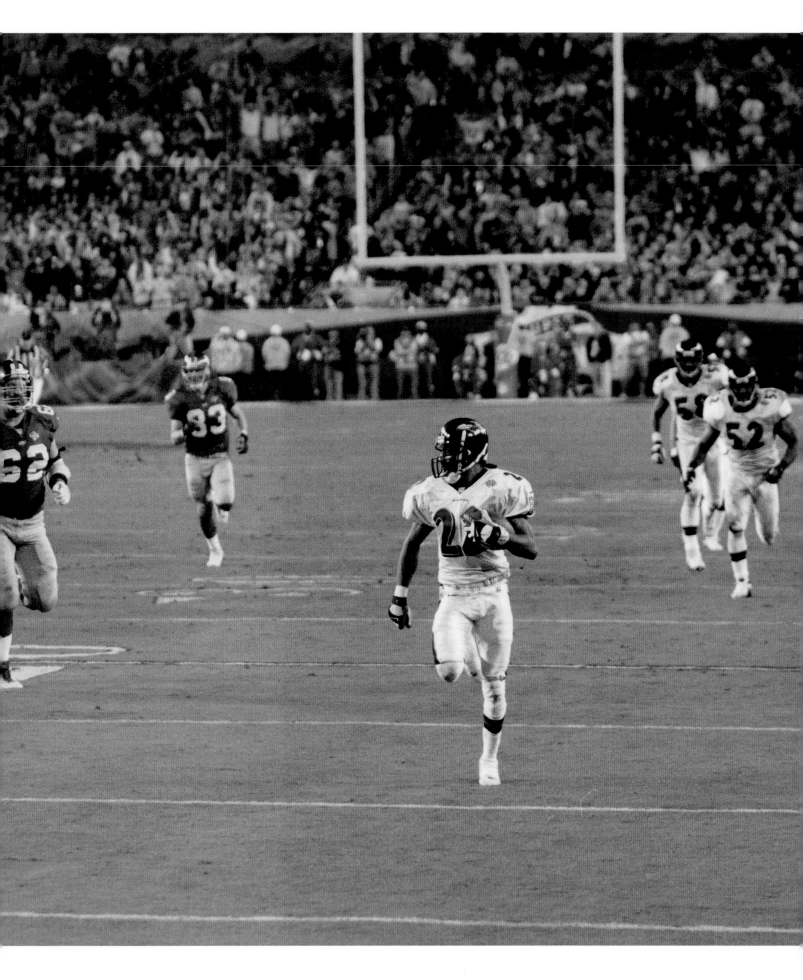

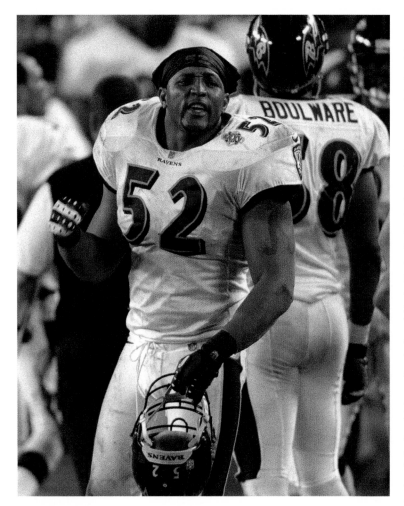

Lewis (52), who won the NFL's Defensive Player of the Year Award after the regular season, was named MVP of the Super Bowl. He made five tackles and knocked down four passes during Baltimore's 34–7 shellacking of the Giants.

16 points in four playoff victories, two of them on the road and one, the Super Bowl, at the neutral site of Tampa Bay's Raymond James Stadium. The 6' 1", 245-pound Lewis, who clogged passing lanes, deflated ballcarriers and generally wreaked havoc from sideline to sideline, was the emotional leader of the Ravens' defense, a unit that was expected to be exceptional and turned out to be one of the best of all time. "Facing our defense is like having 11 billiard balls thrown at you," said Ravens defensive end Rob Burnett. "Eventually, you're going to get hurt and lose your will."

Few observers had predicted that the Ravens would finish the season atop the NFL heap. The buzz at the start of the season had revolved around their neighbors 40 miles to the south, the Washington Redskins. Washington was so stuffed with talent that a Las Vegas book installed them as the 5-to-2 favorite. A year after buying the Redskins for $800 million, 35-year-old Daniel M. Snyder showed no lingering effects of sticker shock, signing two future Hall of Famers in cornerback

Deion Sanders and defensive end Bruce Smith; a former All-Pro safety in Mark Carrier; a pair of pricey backups in quarterback Jeff George and running back Adrian Murrell; and the No. 2 and No. 3 picks in the draft (linebacker LaVar Arrington and tackle Chris Samuels, respectively). "Everyone went shopping this off-season," Sanders said of Snyder's reported $100 million spree. "It's just that Dan's shopping at Versace, and some teams are shopping at Wal-Mart."

That Snydebrennerish approach received its spectacular comeuppance in Week 15, with the Skins clinging to a shot at the playoffs. One week after Snyder had dumped coach Norv Turner for assistant Terry Robiskie, Washington visited archrival Dallas. Cowboys quarterback Troy Aikman left the game after suffering his fourth concussion in 21 games, and an obscure backup named Anthony Wright helped Dallas to a 32–13 blowout. Snyder's profligate spending had yielded a team that put on the most embarrassing show of the season. Gutcheck, please. "I feel bad for Terry," Snyder said. "The players let him down."

It seemed only natural that in a season of unexpected reversals the previous year's Super Bowl teams, a surprising pair at the time, would emerge, along with Washington, as the favorites in 2000—only to be buried in their postseason debuts. The Tennessee Titans, who fell a yard short of forcing overtime at Supe XXXIV in Atlanta, had everything going their way: a back-breaking running back in Eddie George, a game-breaking kick returner in Derrick Mason and a heart-breaking (for their opponents, anyway) knack for succeeding in tight spots. Over a two-year stretch, the Titans were 13–4 in games decided by eight points or fewer. "They hit you in the mouth—they don't finesse you," said Pittsburgh Steelers linebacker Levon Kirkland. "Their mind-set is whatever happens, they will break you down and get the job done."

With a 13–3 record, the league's best, Tennessee held home field advantage throughout the playoffs, and at Adelphia Coliseum that was some advantage: During two seasons in their Nashville stadium the Titans' home record was 15–1. The lone loss came in a 24–23 squeaker to Baltimore on Nov. 12. The Ravens held George to 28 yards on 12 carries in that game, forcing him to fumble twice. Before the AFC Central rivals squared off again in the divisional playoffs, there was a slander-filled discussion about who had the better defense. (Ravens cornerback Chris McAlister said George "folded like a baby" in that Nov. 12 game.)

Tennessee's D was ranked first in the league in total yards surrendered (238.4 per game); Baltimore's gave up a scant 10.3 points per game. The bruising showdown validated those glittering defensive stats. While the Titans yielded only 134 yards to the Baltimore offense, the Ravens gave up only 10 points and won 24–10, thanks to two scores by their vaunted defense, one of them a 50-yard interception return by Lewis.

The reigning champion St. Louis Rams, for their part, were hardly a defensive juggernaut under first-year coach Mike Martz. Offense was not a problem for the Rams, who despite an injury that sidelined quarterback Kurt Warner for five games still led the league in points scored. But like many teams in 2000, the Rams were a lopsided bunch, capable on one side of the ball and inept on the other. They gave up 29 points per game. Indeed, only two teams—New Orleans and Buffalo—finished in the top 10 in both offense and defense.

Sunday to Sunday, wholesale collapses by one unit or the other were almost to be expected. The Denver Broncos returned to the postseason with a high-powered offense overseen by third-year quarterback Brian Griese and running back Mike Anderson, a sixth-round pick out of Utah who rushed for 1,500 yards and was named offensive rookie of the year. But in Week 8, against a usually anemic Cincinnati Bengals attack, the Broncos' D allowed Corey Dillon to ramble for 278 yards, a performance that broke Walter Payton's 23-year-old single-game rushing mark of 275. Before the game, Denver had been second in the league in rushing defense, and Dillon was averaging a mere 52.3 yards per game on the ground.

Nowhere was that sort of imbalance clearer than in the Rams' final two games. In a 26–21 win over the New Orleans Saints that propelled St. Louis into the playoffs, Marshall Faulk, the 2000 MVP, gained a career-high 220 yards and scored three of his single-season-record 26 touchdowns. One week later in the wild-card game, against those same Saints, Faulk gained only 24 yards on 14 carries. The Rams' defense gave up 31 points while

Free-spending Washington's playoff hopes went the way of running back Stephen Davis (48) when he was stopped cold by Dallas defensive lineman Michael Myers during the first quarter of their Dec. 10 game in Irving, Texas. The Cowboys, with little-known backup Wright at quarterback, won the game 32–13, all but eliminating the Redskins from contention.

the offense scored only seven until midway through the fourth quarter. A last-ditch comeback fell short, and the champs bowed, 31–28.

New Orleans, which lost to the Minnesota Vikings 34–16 the following week, was the 2000 up-from-nowhere version of, well, the '99 Rams. A team that had never won a playoff game and was ranked dead last in the league by SI before the season, the Saints were 7–3 when workhorse running back Ricky Williams suffered a broken right ankle that would sideline him the rest of the regular season. The following week against the Raiders, New Orleans quarterback Jeff Blake went down with a season-ending foot injury. But rookie coach Jim Haslett rallied the troops, leaning on a defense spearheaded by tackle La'Roi Glover, the NFL's sack leader with 17, and unveiling 24-year-old quarterback Aaron Brooks, who would guide New Orleans to three wins down the stretch and the NFC West title. "I don't want to overstate this," said Saints general manager Randy Mueller, "but with his ability to beat you with his arm or his legs, Aaron reminds me of John Elway."

A Green Bay Packers backup acquired in the offseason by Mueller, Brooks was one of a handful of young quarterbacks making headlines in and out of the pocket. Just as Elway's draft class of '83 kept the NFL stocked with quality signal-callers for more than a decade, the league may someday look back on 2000 as the coming-out season for its next wave of top QBs. Like Brooks, Philadelphia's second-year

man Donovan McNabb, 24, took a team with a patchwork offense and a tenacious D into the playoffs; he was the Eagles' leading rusher, with 7.3 per.

The 25-year-old Griese, who led the NFL in passing efficiency (102.9), helped make 100-catch receivers of both Ed McCaffrey and Rod Smith. The Indianapolis Colts' Peyton Manning, 24, threw for the most yards (4,413) and tied for the most touchdown passes (33). Manning's favorite target was Marvin Harrison, the league's co-leader in receptions (102). (The Colts had another league leader in second-year running back Edgerrin James, who rushed for 1,709 yards.) San Francisco's Jeff Garcia, a 30-year-old CFL refugee in his first full year as a starter, not only bombed away for 4,278 yards in 2000 but also closed the home season with a memorable finale: In a 17–0 blanking of the Bears, Garcia connected with Jerry Rice on what was probably the legendary receiver's final catch in San Francisco. Rice is 38 years old, and his contract will present salary-cap problems for the Niners in 2001. Garcia also completed 20 passes that day to wideout Terrell Owens, who set a record for receptions in a single game.

But of all the young quarterbacks, no one made larger waves than the 6' 4", 265-pound Daunte Culpepper of Minnesota. The 23-year-old took over the Vikings' already potent offense and tied Manning for the league lead in touchdown passes. He also rushed for seven scores, flashing his 4.42 speed and leveling linebackers who got in his way. Said

14-year veteran Bubby Brister, Culpepper's backup, "I've been around awhile and I can tell you: He's the biggest, strongest, fastest quarterback that ever was."

But in Culpepper's biggest test, the NFC championship game, he was brought down to size by a Giants team peaking at just the right time. After a 31–21 loss to Detroit in Week 12, New York coach Jim Fassel had guaranteed that his teetering team, 7–4 at the time, would make the playoffs. "He was in a no-lose situation, because if we don't get to the playoffs, he gets fired," said defensive tackle Keith Hamilton. "But if he didn't say it, that meant he had some doubts about us." After Fassel's promise, the Giants seized home field advantage with five straight wins, dumped the Eagles 20–10 in the divisional playoffs and then, in one of the most thorough victories in playoff history, wiped out Culpepper and Co. 41–zip to advance to the Super Bowl for the first time since after the 1990 season.

Quarterback Kerry Collins was the catalyst in that victory, completing 28 of 39 passes for 381 yards and five touchdowns—even though he sat out out the fourth quarter. For Collins, it was the the highlight of a six-year career that had been scarred by a DWI arrest, a stint in alcohol rehab, allegations that he used racial slurs and a complete loss of motivation while he was with the Carolina Panthers. "There have been some scary times in my life—good, bad, bizarre," he said. "This part of the story is just as crazy."

In the next chapter, though, Collins would collide head-on with a character whose tale surpassed even his in stretching the limits of plausibility. Ray Lewis flew to Tampa as the NFL's Defensive Player of the Year, but in the days before the Super Bowl the media's interest in him extended to his role in the Atlanta murders. Second-year Ravens coach Brian Billick, in an apparent attempt to draw fire, lashed out at the press for its grilling of Lewis. "We drew a line in the sand with how we wanted to handle things," Billick said, almost smugly. "It was that simple."

Like Fassel, Billick had pushed all the right buttons to get to the Super Bowl, including replacing Tony Banks at quarterback with Tampa Bay Buccaneers castoff Trent Dilfer. With the Ravens' 16–3 victory over the Raiders in the AFC title game in Oakland, Dilfer ran his record in his last 15 starts to 14–1.

The Baltimore offense was never spectacular— during one 21-quarter stretch this season it failed to score a touchdown—but Dilfer knew his role: Avoid interceptions and look for the occasional deadly long pass. He played it perfectly at Ray-

mond James Stadium, completing 12 of 25 passes for 153 yards, with no interceptions and one 38-yard strike to Brandon Stokely that put the Ravens up 7–0 in the first quarter. Collins, under fire and out of rhythm, would endure a waking nightmare, connecting on only 38.5% of his 39 passes and throwing four interceptions, including one that cornerback Duane Starks returned 49 yards for a third-quarter touchdown that made it 17–0.

The Ravens' defense dictated the terms to New York: 152 yards of offense, five turnovers, 2 of 14 third-down conversions. One year after the Rams' futuristic offense had captivated the country, one year after his involvement in a murder trial had cast him as an anti-hero, the Ravens and Lewis had turned the NFL and, to some degree, Lewis's image, upside down. With five tackles and four batted passes, the fiery linebacker was named Super Bowl MVP. "The thing is, the Giants didn't know," Lewis said. "You just don't know until you play us, but our defense is a buzzsaw."

No Sophomore Slump: The Colts' second-year running back Edgerrin James (32) topped his superb rookie season—in which he gained 1,553 yards—by rushing for 1,709 yards on 387 carries in 2000. But Indianapolis, a preseason favorite in the AFC East, struggled to make the playoffs, then lost to Miami 23–17 in the first round.

PHOTO GALLERY

Gathering a perfectly thrown pass from quarterback Mark Brunell, Jacksonville wide receiver Jimmy Smith scored a first-quarter touchdown past the outstretched arms of Baltimore defensive back Duane Starks (above, 22) on Sept. 10. The reception was one of 15 that day for Smith, who scored three touchdowns; but Starks and Baltimore would rally to win the game 39–36.

Rookie running back Jamal Lewis (left) catapulted himself up and over the Denver defense, then stretched to place the ball across the goal line, scoring the Ravens' first touchdown in a 21–3 victory over Denver in their AFC wildcard game in Baltimore on Dec. 31.

Zach Attack: Miami linebacker Zach Thomas (54) sailed toward Raiders running back Randy Jordan in their AFC divisional playoff game in Oakland on Jan. 6, 2001. Thomas, whose legs had been undercut just before the camera shutter snapped, fell well short of Jordan, much like the Dolphins fell well short of the Raiders, losing 27–0.

Uncle! After making a seven-yard reception during Philadelphia's 15–13 loss to the Titans on Dec. 3, Eagles receiver Charles Johnson (81) struggled to free his left foot, which was painfully jammed underneath Tennessee safety Blaine Bishop. Preparing to add to Johnson's misery was Titans linebacker Randall Godfrey (56).

The Rams' Isaac Bruce (below right) glimpsed the world from a new perspective after making a catch against 49ers cornerback Pierson Prioleau on Oct. 29 in San Francisco. Bruce and the Rams, led by backup quarterback Trent Green, outgunned the Niners 34–24.

Battling Birds: Eagles running back Brian Mitchell (30) applied a stiff-arm to the jaw of Cardinals safety Pat Tillman (40), who snatched a fistful of jersey as he tried to make the tackle during Philadelphia's 34–9 rout of Arizona at Veterans Stadium on Nov. 19.

Blocking Broncos: Denver's offensive line cleared space for rookie running back Mike Anderson (38), who took a handoff from bloodied quarterback Brian Griese (14) during the Broncos' 33–24 victory over the Raiders in Oakland on Sept. 17. Anderson rushed for 187 yards in the game.

PROFILES

TRENT DILFER

He got crushed like a beer can at a pregame tailgate, collapsing under 600 pounds of silver-and-black wrath. Curled in the fetal position, ground into the grass by Oakland Raiders defenders William Thomas and Darrell Russell at his own four-yard line—where else did America expect Trent Dilfer (opposite) to be? Yet a tantalizing twist awaited: With the Raider Nation clamoring for his scalp, Dilfer, the Baltimore Ravens' ridiculed quarterback, sprang off the turf and stunningly seized the moment.

Baltimore was locked in a scoreless tie with Oakland early in the second quarter of the AFC Championship Game on Jan. 14, 2001, but Dilfer was, in his own warped way, exulting in the agony. . . .

That's why Dilfer was strangely giddy as the Ravens huddled in their end zone. He told his teammates, "Keep the tempo up and we'll draw them in. They'll blitz again, and then we've got 'em." Turning to veteran tight end Shannon Sharpe, Dilfer added, "I'm just waiting for that matchup we've been looking for. Don't worry, it's coming."

Two plays later Dilfer delivered an off-the-Richter-scale jolt. Facing third-and-18 from the four, the 6' 4", 229-pound Dilfer dropped back five steps, stared down an Oakland blitz and fired the pass of his life. Sharpe, lined up in the right slot in a spread formation called Rocket Right, caught the ball in front of strong safety Marquez Pope at the 12, blew past late-arriving free safety Anthony Dorsett and blasted into the clear. By the time the Raiders caught up to Sharpe, he was in their end zone—and the Ravens were on their way to a 16–3 victory and the franchise's first Super Bowl appearance.

So deal with it, football fans: Trent Dilfer is going to Super Bowl XXXV, and he knows exactly what you're thinking. True, he's riding the coattails of Baltimore's record-setting defense, and, yes,

there are plenty of reasons to wonder whether he's worthy of such good fortune. Dilfer, who signed a one-year free-agent contract with Baltimore in March 2000, concedes that even if the Ravens beat the New York Giants in Tampa, the site of the Super Bowl, he has no idea whether coach Brian Billick will ask him to return in 2001. (Billick is noncommittal on the subject.) Then, without a trace of sarcasm, Dilfer adds, "I want my legacy to be that I was the quarterback of the team that won the Super Bowl in spite of its quarterback.". . .

Appropriately, he'll attempt to [establish that legacy] in Tampa, the city where he made his claim to shame. After the Buccaneers took him with the sixth pick in the 1994 draft, Dilfer, despite going to the Pro Bowl after the '97 season, became known mostly for what he wasn't: neither an especially accurate or mobile passer, nor a man adept at carrying a team. As coach Tony Dungy developed a dominant defense, Dilfer became the somewhat-deserving scapegoat for the Bucs' offensive ineptitude. . . .

On Jan. 14 he completed 9 of 18 passes for 190 yards, with one interception. Take away the 96-yard strike to Sharpe, the longest scoring pass in NFL playoff history, and Dilfer would have had a double-digit yardage day. Such noxious numbers are often cited as evidence of his inferiority, but there's a single statistic he offers as a rebuttal: In his last 15 starts, including four last year with the Bucs, Dilfer is 14–1. "I'll be the first to admit that I've had the luxury of playing with great defenses during that streak," he says, "but I've also been smart enough to do whatever it takes to win those games. . . ."

Late in 1997 Dilfer's detractors never saw the eight painkilling shots he had injected into his badly sprained right ankle or the eight Vicodin pills he swal-

lowed daily—all so that he could continue not only to play in games but also to practice. The Bucs were on the verge of their first playoff appearance since '82, and Dilfer wasn't about to desert his teammates. He made 70 consecutive starts . . . before Dungy benched him in the seventh game of the '99 season. . . . "It crushed me," he says, "because that streak was my ace in the hole. You could call me a bad athlete, call me a choker, but no matter what, you had to say I was a tough player who was always there for my team.". . .

On Saturday, Jan. 13, as he sat on a bench outside the Ravens' hotel overlooking San Francisco Bay, Dilfer pondered his curious place in the football pantheon. "I'd rather figure out the best way to win football games than be the player of the week, and I really mean that," he said. "There are guys who can do both, but I'm definitely not one of them. I want my genius to be that I was willing to do anything and endure anything to get what I wanted. If I do, it will challenge people to decide if quarterbacks truly are measured by whether they win or lose."

Dilfer pointed across the water to Oakland, where the Raiders and their vaunted history awaited. "I'm so psyched that Jim Plunkett will be at this game," Dilfer said, referring to the man who quarterbacked the Silver and Black to Super Bowl victories after the 1980 and the '83 seasons. "He's the player I think that I'm most like: a huge character guy who struggled early, never quit and could care less if he's mentioned on the list of alltime greats. All he did was win."

Then Dilfer took a deep breath and pointed southward toward Aptos, his hometown 49 miles down the coast. An athletic standout and party animal in high school, Dilfer didn't achieve inner peace until he earned a scholarship to Fresno State and struck up a friendship

with a swimmer named Cassandra Franzman. They went out once as freshmen, and she fell asleep twice on the date. But eventually their shared spiritual growth led to love, marriage and three children, daughters Madeleine (four) and Tori (almost two), and son, Trevin (three).

Trent, a onetime scratch golfer, said he has reduced his life to football and family. "I was lying in bed with Cass four nights ago, totally exhausted, and she was helping me study my plays," Dilfer said. "When I went to turn off the light, she said, 'Look, no matter what happens on Sunday or beyond, I want you to know that no one can work any harder than you do as a football player, a father and a husband.' " He looked at the water, paused for several seconds, then stared down at his Quicksilver jeans. When he looked up again, he was crying. . . .

Dilfer cried even more heartily on Jan. 14 as the final seconds ticked away and teammates offered hugs, thanks and congratulations. The moment belonged to him as much as to anyone, and with the Tampa angle waiting to be pounded into public consciousness, it was his chance to thump his chest and yell, How do you like me now?

There was a time when Dilfer couldn't have resisted such a self-congratulatory setup, but now restraint came easily. . . .

In the Network Associates Coliseum parking lot, three dozen friends and family members were waiting to greet Trent with a robust cheer. Cass met him first, just outside the locker room door, and slapped a bear hug on him that encompassed a decade's worth of emotion. Teammates and well-wishers converged to get a piece of him, but he had no intention of breaking free. For the NFL's most amenable bull's-eye, this was the sweetest hit of all.

—Michael Silver
excerpted from SI, Jan. 22, 2001

DAUNTE CULPEPPER

Go ahead and stare. Everybody else does. Do you think you are the first? Friend, you are only the latest.

Daunte Culpepper, quarterback of the Minnesota Vikings, has just entered the cafeteria at the team's training facility in suburban Minneapolis. You stand to make your greeting and study him with the wariness of one who trusts nothing but his own eyesight. Culpepper, dressed all in black but for a diamond sparkle in each ear, strides over with a hand outstretched. You would be wise to show good manners in the presence of such a person, but your mouth has formed a perfect circle, as if frozen in the act of uttering the inevitable: "This guy plays *quarterback*? Come on!"

This is how it happens. Culpepper walks in, and everyone else disappears as he thrusts them into the shade. . . .

Culpepper (opposite) might be the largest starting quarterback in pro football history, but his size has become little more than a curious aside now that the Vikings, at 10–2, are tied with the Raiders for the best record in the NFL and their second-year quarterback is the most surprising story in the league. (In Dallas on Thanksgiving, Culpepper was 15 of 22 for 205 yards and two touchdowns in the Vikings' 27–15 victory over the Cowboys.)

Perhaps the salient fact about Culpepper's rise to prominence is that only a year ago critics were saying he was a bust. In 1999 he didn't throw a pass in a regular-season game. In the three preseason games in which he appeared he looked baffled as he fumbled an exchange from center, made bad throws and suffered seven sacks that set the Vikings back 53 yards. Except for the six snaps he took in a blowout win against the San Francisco 49ers in Week 8, Culpepper spent the year as a scout-squad player, third on the depth chart behind veterans Randall Cunningham and Jeff George. The label "long-term project," which to the discerning NFL observer might as well mean "wasted pick," was attached to his name. [Minnesota coach Dennis] Green praised Culpepper's development, even while saying that he was two or three years from being ready. . . .

"I never doubted myself last year because I understood what my role was," says Culpepper. "If Coach Green said my role was to run scout squad every day and try to make our defense better, then that was what I was going to do. Don't get me wrong. It was definitely tough at times, but I always knew my day was coming." . . .

No one seems less surprised by Culpepper's performance this season than Culpepper, who with so few starts to his credit already has given thought to his legacy. Asked to describe the future he envisions for himself in the NFL, he doesn't hesitate. "I want to be the best ever," he says. "I don't want to be just somebody who played the game. I hang out with [wideout] Randy [Moss] more than anybody else on the team. We sit around and talk, and it's like, 'When we walk away from foot-

ball, we don't want people ever to forget.' When they mention this game, I want them to say 'Culpepper and Moss,' just like they now say 'Montana and Rice.' "

Culpepper pauses and seems to be considering how his words will appear in print. "I know that's saying a lot," he continues, "but I'm saying it anyway. You've got to set your goals that high. If you don't, why are you playing? The best ever—that's what I'm after." . . .

In high school he competed on the weightlifting team. He was also a highly touted high school basketball player, recruited by some of the best programs in the country, Kentucky's among them. To complete the picture, Culpepper was drafted by the New York Yankees in 1995, when he was 18 years old. . . .

Sherm Lewis, the Vikings' offensive coordinator, who joined the team this year after eight seasons in the same capacity with Green Bay, says that Culpepper, "given time, is going to develop into a great leader. His head is probably swimming a little bit right now from all that's been thrown at him, but he picks up things, and he's very coachable. He sees the field, and he knows when to get rid of the ball." . . .

Born to a 16-year-old incarcerated for armed robbery, Daunte was adopted by a woman named Emma Culpepper when he was a day old and raised in Ocala, Fla. He never knew, never even met his father; practically all he would ever know about the man was that his first name was David. Emma raised 13 other children, but Daunte never doubted her devotion to him. "She was loving and caring, but she was also very strict," he says. "She could lay down the law on me. She was both my mom and my dad."

While some might use such a beginning as an excuse for failure, Culpepper regarded it as an opportunity to prove himself. "I feel I'm blessed, one of the luckiest guys ever," he says. "Maybe if I'd had a dad, he would have messed some stuff up for me. Maybe he would have babied me in certain situations when I didn't need to be babied." Now engaged to marry Kimberly Rhem, the mother of his three children, Culpepper says he "grew up wanting to be a father, the kind I never had."

Heading into the draft, the Vikings needed help on defense, but Green refused to bypass a chance to take Culpepper, even though selecting someone like Jevon Kearse, the pass-rushing prodigy from Florida, seemed to be the obvious move. . . .

After Minnesota's first minicamp that spring, Culpepper received permission from Green to work out for 10 weeks with Moss and Carter at Carter's FAST (Functional Agility Speed Technique) Program in Boca Raton, Fla. The Vikings encourage their young players to participate in off-season training at their practice facility, but Culpepper thought he could get in better shape and hone his skills more quickly in Carter's program. Supervised by a staff of professional trainers, the players worked

out five days a week in a Gold's Gym and on a high school football field, challenging one another's endurance in what Culpepper describes as "the most rigorous training" he's ever done. . . .

Even though those weeks in Florida brought Culpepper and his receivers closer together, Moss and Carter still grew impatient with his youthful mistakes when training camp opened. They rode him hard in practice. Concerned that Moss and Carter were being too rough on the quarterback, Sherm Lewis talked with them about what it would take to help Culpepper have a big year.

"We sat in a classroom," Lewis recalls, "and the meeting lasted five or six minutes—that's all. It wasn't a lecture. We just talked man to man. Nobody in the league knows the passing game better than Cris Carter, but he's also very emotional because he wants to win so badly. The last thing he said to me was, 'You'll have to remind me every once in a while to back off.' "

"Randy and Cris, their passion for the game is just like mine," says Culpepper. "They want to win, and they're willing to give whatever it takes. I don't get mad when they say something negative about me. I try to look at it as being positive. Sometimes I might say something back to them in the same way. I can take it, but I can give it too."

Three weeks after being upbraided by Moss in front of reporters [after a 31–24 win over the Detroit Lions on Oct. 1], Culpepper is back in the team's cafeteria, with yet another victory to celebrate. With what must feel like all the eyes of the world upon him, he announces that he has figured something out. He knows what it will take for him to dominate, for him to be remembered as the best quarterback of all time, not just the biggest. "My goal is to win the Super Bowl," he says. "You know how you do that, don't you?"

When your answer is too slow in coming, Culpepper raises a hand and displays a single finger. "One week at a time. . . ."

—John Ed Bradley
excerpted from SI, Dec. 4, 2000

RAY LEWIS

As they prepared to face the defending AFC champion Tennessee Titans in a divisional playoff clash in Nashville on Jan. 7, the Baltimore Ravens were poised to fly as high as their fearsome middle linebacker Ray Lewis (above) could take them. Lewis has become the most menacing defensive presence on a unit that set a league record for the fewest points allowed—165—in a 16-game season. On Jan. 2, he was named the league's Defensive Player of the Year, receiving 30 of 50 votes from a nationwide panel of media members. (New Orleans Saints defensive tackle La'Roi Glover was a distant second with 11 votes.) Having become the league's most dominant defensive player, the 25-year-old Lewis now plans to chase legends. Excelling at a position defined by Hall of Famers Ray Nitschke, Dick Butkus, Jack Lambert and Mike Singletary, he says he wants to be remembered as "the greatest linebacker ever to play this position."

Doing so won't be easy, no matter how well he plays. To most people, Lewis is known less for his football prowess than as the celebrated defendant in a double-murder case in the spring of 2000 stemming from a deadly brawl outside an Atlanta club in the hours following Super Bowl XXXIV. Though charges against him were dropped in a plea-bargain agreement and his two codefendants were acquitted, Lewis knows his life will never be the same. "It doesn't matter to me what others might say or think," he says. "Really, it's irrelevant. I have too many good people around me, on this

team and in the community, who look at me as a football player first.". . .

In Baltimore, the magnitude of Lewis's presence almost defies description. . . . [The Ravens'] creative defensive schemes are designed around the 6' 1", 245-pound Lewis, whose range, nose for the ball and ferocious tackling style are unsurpassed. Marvin Lewis (no relation), the Ravens' brainy defensive coordinator, asks his linemen—hulking tackles Tony Siragusa and Sam Adams and quick ends [Rob]Burnett and Michael McCrary—to occupy blockers so that his star linebacker can make the play. "The way Marvin designs a lot of his blitzes is that he sort of leaves holes open for tailbacks and invites them to run through," Siragusa says. "That's because he trusts Ray to fill the hole and slam it shut. Our schemes wouldn't work with an average middle linebacker."

The NFL is brimming with superior inside linebackers, and until recently Lewis was regarded as one of a large pack. In addition to future Hall of Famer Junior Seau, who is now listed at outside linebacker by the San Diego Chargers, the stars include Sam Cowart (Buffalo Bills), Zach Thomas (Miami Dolphins), Levon Kirkland (Pittsburgh Steelers) and NFL Defensive Rookie of the Year Brian Urlacher (Chicago Bears), as well as such lesser-known standouts as Jeremiah Trotter (Philadelphia Eagles), John Holecek (Bills) and Micheal Barrow (New York Giants). Now, most NFL insiders agree, Lewis has left even Seau in his wake. "None of those guys can do what Ray can do—run sideline to sideline, cover receivers and play in space," Marvin Lewis says. "He's got everything you want, from a great mental capacity to leadership skills to incredible intensity and athletic ability.". . .

There are numbers to support this assertion. Lewis had a team-high 184

tackles during the regular season as well as three sacks, two interceptions and three fumble recoveries. However, as with so many great players—a Singletary, a Jerry Rice, a Terrell Davis—conventional measurables don't do Lewis justice. You can ignore, for example, that his time in the 40-yard dash is a relatively unimpressive 4.7 seconds. "He anticipates, diagnoses and reacts as quickly as any player I've seen," Ravens coach Brian Billick says. "You could say it's instinctive, but that belies it, because a lot of it is having studied where to go."

Following the '99 season and the off-field drama that ensued, Lewis improved his already strong study habits. He directs his fellow defenders' movements during practice, and it's difficult to fool him on game day. "The way a lot of our fronts are designed, coaches will leave two gaps open and assign Ray to both," says Baltimore cornerback Chris McAlister. "It's like, 'You go right *and* you go left,' depending on which way the play flows. They're relying on him to guess right, and he almost always does."

Lewis's explosiveness makes opposing running backs wince. "When Ray hits a guy, you can hear the air go out of him," Siragusa says. "Before the game, it's hysterical—opposing backs will come over and try to buddy up to him, like that will make him take it easy on them. Then the game starts, and you'll hear everyone calling out '52' and looking around frantically to see where he is.". . .

Lewis doesn't regard any opponent with deference. "The thing is, you don't have to respect anybody, as long as you don't disrespect them," he says. . . .

"I played against Lambert and Singletary," says Baltimore vice president of player personnel Ozzie Newsome, a Hall of Fame tight end, "and Ray has the type of temperament both of those guys had." Newsome made Lewis, who starred at

Miami before entering the 1996 draft following his junior year, the 26th pick in the first round, and the Ravens instantly knew they'd snagged a winner. "He's been the leader since he walked in this building," Marvin Lewis says, "and nobody ever questioned it."

Then, on Feb. 11, 2000, Ray Lewis was indicted on the double-murder charges. Newsome and Billick began making contingency plans to find another middle linebacker through free agency or in the draft. But Lewis showed up in Baltimore and convinced his employers, including owner Art Modell, that he was innocent. The Ravens finally exhaled on June 5 when the murder charges were dropped. Lewis pleaded guilty to a misdemeanor charge of obstruction of justice and was sentenced to one year's probation. "I think the whole ordeal brought us together because everybody was so solidly behind him," Burnett says.

Tight end Shannon Sharpe, who signed with Baltimore in the off-season after a brilliant decade with the Broncos, befriended Lewis during the trial and became his workout partner and confidant. "If he's angry at the system, he takes it out on opponents," Sharpe says. "A lot of people turned their back on him, including guys around the league. I tell him all the time, 'You've got an opportunity to be something special, one of the alltime greats.' "

Lewis knows it, and you can feel his urgency on game day. Watch him just before introductions, and his passion is unmistakable. He gathers his fellow defenders in a huddle, bounces like a pogo stick and intones, "What time is it?"

"Game time!" they yell.

"Are my dogs in the house?" he asks.

"Woof, woof, woof!"

Know this: Everyone in the stadium understands who the big dog is.

—Michael Silver
excerpted from SI, Jan. 8, 2001

2000 NFL Final Standings

AMERICAN FOOTBALL CONFERENCE

Eastern Division

	W	L	T	PCT	PTS	OP
Miami	11	5	0	.688	323	226
†Indianapolis	10	6	0	.625	429	326
NY Jets	9	7	0	.562	321	321
Buffalo	8	8	0	.500	315	350
New England	5	11	0	.312	276	338

Central Division

	W	L	T	PCT	PTS	OP
Tennessee	13	3	0	.812	346	191
†Baltimore	12	4	0	.750	333	165
Pittsburgh	9	7	0	.562	321	255
Jacksonville	7	9	0	.438	367	327
Cincinnati	4	12	0	.250	185	359
Cleveland	3	13	0	.188	161	419

Western Division

	W	L	T	PCT	PTS	OP
Oakland	12	4	0	.750	479	299
†Denver	11	5	0	.688	485	369
Kansas City	7	9	0	.438	355	354
Seattle	6	10	0	.375	320	405
San Diego	1	15	0	.062	269	440

NATIONAL FOOTBALL CONFERENCE

Eastern Division

	W	L	T	PCT	PTS	OP
NY Giants	12	4	0	.750	328	246
†Philadelphia	11	5	0	.688	351	245
Washington	8	8	0	.500	281	269
Dallas	5	11	0	.312	294	361
Arizona	3	13	0	.188	210	443

†Wild-card team.

Central Division

	W	L	T	PCT	PTS	OP
Minnesota	11	5	0	.688	397	371
†Tampa Bay	10	6	0	.625	388	269
Green Bay	9	7	0	.562	353	323
Detroit	9	7	0	.562	307	307
Chicago	5	11	0	.312	216	355

Western Division

	W	L	T	PCT	PTS	OP
New Orleans	10	6	0	.625	354	305
†St. Louis	10	6	0	.625	540	471
Carolina	7	9	0	.438	310	310
San Francisco	6	10	0	.375	388	422
Atlanta	4	12	0	.250	252	413

2000 NFL Individual Leaders

AMERICAN FOOTBALL CONFERENCE

Scoring

TOUCHDOWNS	TD	RUSH	REC	RET	PTS
James, Ind	18	13	5	0	108
George, Tenn	16	14	2	0	96
Smith, Mia	16	14	2	0	96
Anderson, Den	15	15	0	0	90
Harrison, Ind	14	0	14	0	84
Taylor, Jax	14	12	2	0	84
Martin, NYJ	11	9	2	0	66
Brown, Oak	11	0	11	0	66
Alexander, KC	10	0	10	0	60
Wheatley, Oak	10	9	1	0	60

KICKING	PAT	FG	LG	PTS
Stover, Balt	30/30	35/39	51	135
Vanderjagt, Ind	46/46	25/27	48	121
Del Greco, Tenn	37/38	27/33	50	118
Mare, Mia	32/34	28/31	49	116
Janikowski, Oak	46/46	22/32	54	112
Christie, Buff	31/31	26/35	48	109
Brown, Pitt	32/33	25/30	52	107
Vinatieri, NE	25/26	27/33	53	106
Hollis, Jax	33/33	24/26	51	105
Elam, Den	49/49	18/24	51	103

Passing

	ATT	COMP	PCT COMP	YDS	AVG GAIN	TD	PCT TD	INT	PCT INT	LG	RATING PTS
Griese, Den	336	216	64.3	2688	8.00	19	5.7	4	1.2	61	102.9
Manning, Ind	571	357	62.5	4413	7.73	33	5.8	15	2.6	t78	94.7
Gannon, Oak	473	284	60.0	3430	7.25	28	5.9	11	2.3	t84	92.4
Grbac, KC	547	326	59.6	4169	7.62	28	5.1	14	2.6	t81	89.9
Flutie, Buff	231	132	57.1	1700	7.36	8	3.5	3	1.3	52	86.5
Brunell, Jax	512	311	60.7	3640	7.11	20	3.9	14	2.7	t67	84.0
McNair, Tenn	396	248	62.6	2847	7.19	15	3.8	13	3.3	t56	83.2
Johnson, Buff	306	175	57.2	2125	6.94	12	3.9	7	2.3	t74	82.2
Frerotte, Den	232	138	59.5	1776	7.66	9	3.9	8	3.5	44	82.1
Bledsoe, NE	531	312	58.8	3291	6.20	17	3.2	13	2.5	59	77.3

Pass Receiving

RECEPTIONS	NO.	YDS	AVG	LG	TD
Harrison, Ind	102	1413	13.9	t78	14
McCaffrey, Den	101	1317	13.0	61	9
Smith, Den	100	1602	16.0	49	8
Moulds, Buff	94	1326	14.1	52	5
McCardell, Jax	94	1207	12.8	t67	5
Gonzalez, KC	93	1203	12.9	39	9
Smith, Jax	91	1213	13.3	t65	8
Anderson, NYJ	88	853	9.7	41	2
Brown, NE	83	944	11.4	t44	4
Glenn, NE	79	963	12.2	t39	6

Pass Receiving (Cont.)

YARDS	YDS	NO.	AVG	LG	TD
Smith, Den	1602	100	16.0	49	8
Harrison, Ind	1413	102	13.9	t78	14
Alexander, KC	1391	78	17.8	t81	10
Moulds, Buff	1326	94	14.1	52	5
McCaffrey, Den	1317	101	13.0	61	9
Smith, Jax	1213	91	13.3	t65	8
McCardell, Jax	1207	94	12.8	t67	5
Gonzalez, KC	1203	93	12.9	39	9
Brown, Oak	1128	76	14.8	45	11
Glenn, NE	963	79	12.2	t39	6

Rushing

	ATT	YDS	AVG	LG	TD
James, Ind	387	1709	4.4	30	13
George, Tenn	403	1509	3.7	t35	14
Anderson, Den	297	1500	5.1	t80	15
Dillon, Cin	315	1435	4.6	t80	7
Taylor, Jax	292	1399	4.8	71	12
Ja. Lewis, Balt	309	1364	4.4	45	6
Bettis, Pitt	355	1341	3.8	30	8
Watters, Sea	278	1242	4.5	55	7
Martin, NYJ	316	1204	3.8	55	9
Smith, Mia	309	1139	3.7	t68	14

Total Yards from Scrimmage

	TOTAL	RUSH	REC
James, Ind	2303	1709	594
George, Tenn	1962	1509	453
Watters, Sea	1855	1242	613
Martin, NYJ	1712	1204	508
R. Smith, Den	1701	99	1602
Anderson, Den	1669	1500	169
Ja. Lewis, Balt	1660	1364	296
Taylor, Jax	1639	1399	240
Dillon, Cin	1593	1435	158
Bettis, Pitt	1438	1341	97

Interceptions

	NO.	YDS	LG	TD
Walker, Mia	7	80	31	0
Rolle, Tenn	7	140	t81	1
Six tied with six.				

Sacks

Armstrong, Mia	16.5
Taylor, Mia	14.5
Hicks, KC	14.0
Gildon, Pitt	13.5
Pryce, Den	12.0

Punting

	NO.	YDS	AVG	NET AVG	TB	IN 20	LG	BLK	RET	RET YDS
Bennett, SD	92	4248	46.2	36.2	10	23	66	0	51	722
Lechler, Oak	65	2984	45.9	38.0	10	24	69	0	30	279
Gardocki, Clev	108	4919	45.5	37.3	5	25	67	0	69	793
Smith, Ind	65	2906	44.7	36.4	9	20	65	0	28	357
Tupa, NYJ	83	3714	44.7	33.2	15	18	70	0	42	660

Punt Returns

	NO.	YDS	AVG	LG	TD
Je. Lewis, Balt	36	578	16.1	t89	2
Rogers, Sea	26	363	14.0	43	0
Poteat, Pitt	36	467	13.0	54	1
Mason, Tenn	51	662	13.0	t69	1
Brown, NE	39	504	12.9	t66	1

Kickoff Returns

	NO.	YDS	AVG	LG	TD
Mason, Tenn	42	1132	27.0	66	0
Williams, NYJ	21	551	26.2	t97	1
Denson, Mia	20	495	24.8	56	0
Rogers, Sea	66	1629	24.7	t81	1
Dunn, Oak	44	1073	24.4	t88	1

2000 NFL Individual Leaders *(Cont.)*

NATIONAL FOOTBALL CONFERENCE

Scoring

TOUCHDOWNS	TD	RUSH	REC	RET	PTS
Faulk, StL	26	18	8	0	156
Moss, Minn	15	0	15	0	90
Green, GB	13	10	3	0	78
Owens, SF	13	0	13	0	78
Davis, Wash	11	11	0	0	66
Stewart, Det	11	10	1	0	66
Garner, SF	10	7	3	0	60
Smith, Minn	10	7	3	0	60

Seven tied with nine.

KICKING	PAT	FG	LG	PTS
Longwell, GB	32/32	33/37	52	131
Gramatica, TB	42/42	28/34	55	126
Nedney, Car	24/24	34/37	52	126
Akers, Phil	34/36	29/33	51	121
Anderson, Minn	45/45	22/23	49	111
Brien, NO	37/37	23/29	48	106
Seder, Dall	27/27	25/33	48	102
Hanson, Det	29/29	24/31	54	101
Andersen, Atl	23/23	25/31	51	98
Wilkins, StL	38/38	17/17	51	89

Passing

	ATT	COMP	PCT COMP	YDS	AVG GAIN	TD	PCT TD	INT	PCT INT	LG	RATING PTS
Green, StL	240	145	60.4	2063	8.60	16	6.7	5	2.1	64	101.8
Warner, StL	347	235	67.7	3429	9.88	21	6.1	18	5.2	t85	98.3
Culpepper, Minn	474	297	62.6	3937	8.31	33	7.0	16	3.4	t78	98.0
Garcia, SF	561	355	63.2	4278	7.63	31	5.6	10	1.8	t69	97.6
Collins, NYG	529	311	58.7	3610	6.82	22	4.2	13	2.5	59	83.1
Blake, NO	302	184	60.9	2025	6.71	13	4.3	9	3.0	t49	82.7
Beuerlein, Car	533	324	60.7	3730	6.70	19	3.6	18	3.4	54	79.7
Favre, GB	580	338	58.2	3812	6.57	20	3.4	16	2.8	t67	78.0
McNabb, Phil	569	330	57.9	3365	5.91	21	3.7	13	2.3	t70	77.8

Pass Receiving

RECEPTIONS	NO.	YDS	AVG	LG	TD
Muhammad, Car	102	1183	11.6	36	6
Owens, SF	97	1451	15.0	t69	13
Carter, Minn	96	1274	13.3	53	9
Horn, NO	94	1340	14.3	52	8
Bruce, StL	87	1471	16.9	t78	9
Holt, StL	82	1635	19.9	t85	6
Faulk, StL	81	830	10.2	t72	8
Centers, Wash	80	600	7.5	26	3
Toomer, NYG	78	1094	14.0	t54	7
Moss, Minn	77	1437	18.7	t78	15

Pass Receiving *(Cont.)*

YARDS	YDS	NO.	AVG	LG	TD
Holt, StL	1635	82	19.9	t85	6
Bruce, StL	1471	87	16.9	t78	9
Owens, SF	1451	97	15.0	t69	13
Moss, Minn	1437	77	18.7	t78	15
Horn, NO	1340	94	14.3	52	8
Carter, Minn	1274	96	13.3	53	9
Muhammad, Car	1183	102	11.6	36	36
Boston, Ariz	1156	71	16.3	t70	7
Toomer, NYG	1094	78	14.0	t54	7
Schroeder, GB	999	65	15.4	t55	4

Rushing

	ATT	YDS	AVG	LG	TD
R. Smith, Minn	295	1521	5.2	t72	7
Faulk, StL	253	1359	5.4	36	18
Davis, Wash	332	1318	4.0	t50	11
E. Smith, Dall	294	1203	4.1	52	9
Stewart, Det	339	1184	3.5	34	10
Green, GB	263	1175	4.5	t39	10
Garner, SF	258	1142	4.4	42	7
Dunn, TB	248	1133	4.6	t70	8
Allen, Chi	290	1120	3.9	29	2
Anderson, Atl	282	1024	3.6	42	6

Total Yards from Scrimmage

	TOTAL	RUSH	REC
Faulk, StL	2189	1359	830
R. Smith, Minn	1869	1521	348
Garner, SF	1789	1142	647
Green, GB	1734	1175	559
Barber, NYG	1725	1006	719
Holt, StL	1642	7	1635
Davis, Wash	1631	1318	313
Dunn, TB	1555	1133	422
Bruce, StL	1482	11	1471
Stewart, Det	1471	1184	287

Interceptions

	NO.	YDS	LG	TD
Sharper, GB	9	109	47	0
McCleon, StL	8	28	23	0
Abraham, TB	7	82	23	0
Schulz, Det	7	53	19	0

Four tied with six.

Sacks

Glover, NO	17.0	Jones, TB	13.0
Sapp, TB	16.5	Coleman, Wash	12.0
Douglas, Phil	15.0	Johnson, NO	12.0

Punting

	NO.	YDS	AVG	NET AVG	TB	IN 20	LG	BLK	RET	RET YDS
Berger, Minn	62	2773	44.7	36.2	11	16	60	0	32	310
Player, Ariz	65	2871	44.2	37.3	5	17	55	0	37	347
Jett, Det	93	4044	43.5	34.8	12	33	59	0	53	498
Knorr, Dall	58	2485	42.8	35.8	8	12	60	0	25	248
Landeta, Phil	86	3635	42.3	36.0	8	23	60	0	47	375
Royals, TB	85	3551	41.8	35.1	8	17	63	0	41	408

Punt Returns

	NO.	YDS	AVG	LG	TD
Hakim, StL	32	489	15.3	t86	1
Howard, Det	31	457	14.7	t95	1
McGarity, Dall	30	353	11.8	t64	2
Mitchell, Phil	32	335	10.5	t72	1
Dwight, Atl	33	309	9.4	t70	1

Kickoff Returns

	NO.	YDS	AVG	LG	TD
Vaughn, Atl	39	1082	27.7	t100	3
Jenkins, Ariz	82	2186	26.7	t98	1
Rossum, GB	50	1288	25.8	t92	1
Howard, Det	57	1401	24.6	70	0
Horne, StL	57	1379	24.2	t103	1

2000–2001 NFL Playoffs

AFC First Round	AFC Divisional Playoff	AFC Championship	Super Bowl XXXV January 28, 2001	NFC Championship	NFC Divisional Playoff	NFC First Round
Denver 3 / Baltimore 21	Baltimore 24	Baltimore 16	**BALTIMORE 34** / NY Giants 7	Minnesota 0	New Orleans 16	St. Louis 28 / New Orleans 31
	Tennessee 10				Minnesota 34	
Indianapolis 17 / Miami 23 (ot)	Miami 0	Oakland 3		NY Giants 41	Philadelphia 10	Tampa Bay 3 / Philadelphia 21
	Oakland 27				NY Giants 20	

Super Bowl XXXV Box Score

BALTIMORE	7	3	14	10—34
NY GIANTS	0	0	7	0— 7

FIRST QUARTER
Baltimore: Stokely 38 pass from Dilfer (Stover kick), 6:50. Drive: 41 yards, 2 plays. Key play: Je. Lewis 34 punt return. **Baltimore 7–0**.

SECOND QUARTER
Baltimore: FG Stover 47, 1:41. Drive: 59 yards, 7 plays. Key play: Dilfer 44 pass to Ismail on 3rd-and-2. **Baltimore 10–0**.

THIRD QUARTER
Baltimore: Starks 49 interception return (Stover kick), 3:49. **Baltimore 17–0**. New York: Dixon 97 kickoff return (Daluiso kick), 3:31. **Baltimore 17–7**. Baltimore: Je. Lewis 84 kickoff return (Stover kick), 3:13. **Baltimore 24–7**.

FOURTH QUARTER
Baltimore: Ja. Lewis 3 run (Stover kick), 8:45. Drive: 38 yards, 6 plays. Key plays: Dilfer 17 pass to Coates; Ja. Lewis 9 run on 3rd-and-1. **Baltimore 31–7**. Baltimore: FG Stover 34, 5:28. Drive: 18 yards, 5 plays. Key plays: Bailey recovers Dixon fumble on kickoff return at New York 34; Ja. Lewis 13 run. **Baltimore 34–7**.

FAREWELLS

DON BUDGE

With his powerful whiplash backhand, Budge was the first tennis player to win all four major championships (Australian, French, Wimbledon and United States) in one year—1938. Only four players have matched his accomplishment.

SI's Frank Deford writes:

"It's doubtful that any American athlete who survived World War II was as penalized by the conflict as was Don Budge, who died on Jan. 26 at 84. When the war came, Budge (right) was in his mid-20s, at the height of his powers. In 1938 he had won the Grand Slam, demonstrating a game without weakness, with a backhand that's generally considered as close to perfection as a stroke has ever been. Then he turned pro, whipped the estimable Ellsworth Vines and Fred Perry and, at that point, might well have become the finest player, before or since, to hit a tennis ball.

"The war all but shut down the sport, and Budge volunteered for the Army. One cool morning, while running an obstacle course, he tore a muscle in his right shoulder. Neither his serve nor his overhead was ever the same. Effectively his career was finished; certainly his majesty was.

"The most storied moment in tennis still belongs to Budge, though. In 1937, just before he and Gottfried von Cramm stepped onto the court in the Davis Cup semifinal at Wimbledon (the tie was held at a neutral site), Hitler telephoned Cramm. '*Ja, mein Führer*,' Cramm said repeatedly into the phone. His victory would most likely have handed the Cup to Nazi Germany and kept it there throughout the war, possibly to be lost forever. But with the magnificent match in Cramm's grasp, 4–1 in the fifth set, Budge changed tactics, started taking the ball on the rise and won 6–8, 5–7, 6–4, 6–2, 8–6.

"Budge would have turned pro after that year, but he dreamed up the concept

of winning the championships of the four nations that had won the Davis Cup—Australia, England, France, and the U.S. Thus did Budge create the Grand Slam. And he positively breezed. I asked him once to describe the highlights. 'You know, not a whole lot happened that year,' he said. Budge was just too good. In fact, what he remembered most about his Grand Slam was earning a private concert from the great cellist Pablo Casals after winning the French."

In Scranton, Pa., of injuries sustained in an auto accident, January 26, 2000.

MAURICE RICHARD

Remembered as one of the greatest players in NHL history, Maurice (Rocket) Richard was the first NHL player to score 50 goals in a season and the first to net 500 career goals.

On December 28, 1944, after spending the day moving his family into a new house, Richard scored an NHL-record eight points (five goals, three assists) against the Detroit Red Wings. To ensure that his legend will live on (Richard also shares the NHL record of five goals in a playoff game and has a record six playoff overtime goals), the NHL created the Maurice Richard Trophy in 1998 to honor the leading goal scorer each season.

Appearing in SI, Montreal hockey broadcaster Dick Irvin writes:

"The first time I saw Maurice Richard play for the Canadiens, he broke his ankle. It was December 27, 1942, and I was the 10-year-old son and namesake of the Canadiens' coach. Early in the game Richard, then a 21-year-old rookie, scored two goals, the fourth and fifth of his career, on Bruins goaltender Frank Brimsek.

"In the third period Boston defenseman Johnny Crawford leveled Richard with a heavy body check. The rookie crumpled to the ice, his right ankle broken. As an amateur Richard had fractured his left ankle and a wrist. Now another broken bone had people saying he was too brittle to play in the NHL. Obviously they had the wrong idea. Richard (above) would go on to play 978 NHL games, score 544 goals and win eight Stanley Cups.

"A few nights before that Bruins game, Richard had arrived for the first time in the Canadiens' dressing room at the Montreal Forum. My father told him he wouldn't be playing that night. Instead of taking the news quietly, as was expected of a rookie, Richard, in an early display of the temper that would become part of his legend, stormed out of the room, slammed the door in his coach's face and went home. His new teammates were shocked by the disrespectful outburst, but my father wasn't offended. 'That's the kind of guy I want on my team,' he told his players. Obviously he had the right idea."

In Montreal, of cancer, May 27, 2000.

FAREWELLS

WALTER PAYTON

Walter Payton retired as the NFL's alltime leader in career rushing yards (16,726). Nicknamed Sweetness for both his nature and his ability on the field, Payton is also the NFL's alltime leader in combined yards, with 21,803. He produced 10 1,000-yard rushing seasons in his 13-year career. In 1977 he was voted the league's most valuable player. He was also a member of the Chicago Bears team that won the Super Bowl after the 1985 season.

SI's Peter King writes:

"The legacy that Walter Payton (right) left the pro game was in full view in February 1999 when the New Orleans Saints were interviewing college prospects in a meeting room at the NFL scouting combine in Indianapolis. The Saints were enamored of Texas running back Ricky Williams; now they were trying to determine just how much they loved him. New Orleans coach Mike Ditka, who had coached Payton for six years with the Chicago Bears, was praying that he'd have a twice-in-a-lifetime chance to get a rusher with the perfect package of power, speed and attitude. So when the Saints' staff interviewed Williams, Ditka asked him what running backs he liked growing up.

" 'Walter Payton,' said Williams. 'Great ability. Great work ethic. Played through pain. Didn't run out of bounds. Won.' Ditka traded eight draft picks to the Washington Redskins so that he could take Williams with the fifth selection. An hour after hearing of Payton's death, Ditka's voice quavered. 'I think that Walter was the greatest player who ever lived,' he said. 'He was a power back, a speed back, a blocking back. People ask me about the play he was involved in that I remember most, and it's probably a block he threw. There's no question he was one of the best blocking backs ever.' ... It's interesting that when remembering Payton, Ditka

and McMahon talked about his blocking.... Meanwhile, opponents recalled Payton's extraordinary running. 'In their Super Bowl year [1985], we played them at Lambeau,' says former Green Bay Packers linebacker Brian Noble. 'It was my rookie season, and we were up 10–9 late in the fourth quarter. They had the ball at about our 30. I weighed 265 pounds, and Walter came right at me with the ball. I teed up, and there was a huge collision. I hit that man as hard as I hit anybody in my career. I knocked him back about four yards, but he stayed up and just kept going. Touch-

down. I was devastated; I cost us the game. Sitting in the locker room afterward, I was ready to quit. But my teammate John Anderson put his arm around me and said, "Believe me, that's not the first time and it won't be the last time that Walter Payton breaks a tackle like that." '

"Noble sighed. 'I had some collisions in my day with great backs, big backs. Without question Walter was the greatest player I played against. Or saw.' Said Ditka, 'He was a coach's dream. I just stayed away from him and tried not to screw him up.' "

In Barrington, Ill., of cancer, Nov 1, 1999.

TOM LANDRY

The legendary coach of the Dallas Cowboys for the first 29 years of the franchise, Landry led the team to five Super Bowls, winning two. Pacing the sidelines in his trademark suit and fedora, Landry won 270 games (more than any other NFL coach except George Halas and Don Shula). From 1966 to 1985 Landry's teams won 13 division titles and had winning records every season.

SI's Paul Zimmerman writes:

"Tom Landry was a New York favorite before he ever put X's and O's to paper. In 1949 he played left cornerback—defensive halfback, as it was called in those days—for the Brooklyn–New York Yankees of the old All-America Conference, and he played the position with a roughneck style that the fans loved. … A year later folks around the NFL learned that there was a brain to go with the muscle. Landry played that season for the Giants, who were coached by Steve Owen. After watching the Browns, New York's next opponent, annihilate the defending champion Eagles in Philadelphia, Owen returned with a new defensive formation that he had devised, the 4-3. The 26-year-old Landry was the man he chose to break down the scheme on the blackboard for the team. 'He can explain it better than I can,' Owen said. … Six years later, in 1956, Landry coached the defense and Vince Lombardi oversaw the offense, giving the NFL champion Giants the most dynamic pair of assistant coaches ever to grace one staff. A visitor of the Giants that season described a walk down the corridor where the coaches' offices were located. 'The first office I passed belonged to Landry,' he said. 'He was busy putting in a defense, running his projector, studying film. The next office was Vince Lombardi's. He was breaking down his own film, putting in an offense. The next office was head

coach Jim Lee Howell's. He had his feet up on the desk, and he was reading a newspaper.' …

"Landry (above) would go on to build the Cowboys from an undermanned expansion team into an NFL power, first with a stunning array of offensive formations and maneuvers, then with a solid organizational structure. Perhaps the most unusual thing about Landry's early years in Dallas was that he devised both an offense and defense for his expansion babies. 'I realized that I couldn't beat anyone with my personnel,' he told me. 'So I had to do it with the motion and formations and gadget plays, the kind of stuff that bothered me most when I was an defensive coach.' …

"In 29 seasons under Landry, Dallas won two Super Bowls, played in three other title games and went 20 consecutive years with a winning record. He ranks third in career NFL victories, with 270. In his 40-year pro career Landry was vital in forging a brand of football that the NFL could hang its hat on."

In Irving, Texas, of leukemia, February 12, 2000.

Front Cover
Clockwise from top left: John Biever (Woods); John Biever (Faulk); V.J. Lovero (Giambi); Jed Jacobsohn/Allsport (Carter).
Back Cover
Clockwise from left: Damian Strohmeyer (McBride); John Biever (Cleaves); Bill Frakes (Sampras).
Front Matter
1, Bill Frakes; 2-3, Chuck Solomon.

6, from left, Al Tielemans; John W. McDonough; Peter Read Miller; Greg Foster; 7, top, l-r, John Biever; Manny Millan; Robert Erdmann; Walter Iooss Jr.; bottom, l-r, Walter Iooss Jr.; Mark Fredrickson; Heinz Kluetmeier; John F. Grieshop/Schwartzman Sports; 8, top left, Walter Iooss Jr.; center, Walter Iooss Jr.; top right, John Biever; bottom left, John W. McDonough; bottom right, Walter Iooss Jr; 9, top, l-r, Chuck Solomon; John Biever; Matt Mahurin; bottom, l-r, John W. McDonough; Walter Iooss Jr.; John W. McDonough; Dave Sandford/2000 NHL Images; 10, top left, John Biever; top center, Stephen Sigoloff/HBO, Arm by Peter Gregoire; bottom left, Chuck Solomon; bottom center, V.J. Lovero; right, Mike Powell/Allsport; 11, top, l-r, Brian Lanker; Heinz Kluetmeier; Photo Illustration by Matt Mahurin; John Iacono; Robert Beck; bottom, l-r, Peter Read Miller; Peter Read Miller; Ed Reinke/AP; Simon Bruty; 12, left, Heinz Kluetmeier; top left, Damian Strohmeyer; top right, Chuck Solomon; bottom left, John Biever; bottom right, Walter Iooss Jr.; 13, top, l-r, Bob Rosato; Al Tielemans; Moshe Brakha; bottom, l-r, Heinz Kluetmeier; John Biever; Gerard Rancinan; Michael O'Neill; 14, David E. Klutho; 16, Andrew D. Bernstein/NBA Photos; 17, Bob Rosato; 18, Manny Millan; 19, John W. McDonough; 20, John W. McDonough; 21, Manny Millan; 22, Don Grayston/NBA Photos; 23, Bob Rosato; 24-25, John W. McDonough; 27, Walter Iooss Jr.; 28, Simon Bruty; 31, John Biever; 34, David E. Klutho; 36, Chuck Stoody/AP; 37, Lou Capozzola; 38, top, David E. Klutho, bottom, Lou Capozzola; 39, Lou Capozzola; 40, David E. Klutho; 41, both, Lou Capozzola; 43, William Coupon; 44, Bob Rosato; 45, Lou Capozzola; 48, John W. McDonough; 50, Al Tielemans; 52, Bob Rosato; 53, David E. Klutho; 54, David E. Klutho; 55, Al Tielemans; 56, David E. Klutho; 57, Manny Millan; 58-59, John Biever; 60, Jonathan Daniel/Allsport; 61, John Biever; 63, Manny Millan; 67, Bill Frakes; 68, Walter Iooss Jr.; 70, Bob Martin; 71, David Guttenfelder/AP; 72, Heinz Kluetmeier; 73, top, Simon Bruty, bottom, John Biever; 74-75, Dan Helms/Newsport; 76, Walter Iooss Jr.; 77, Bill Frakes; 79, Manny Millan; 83, Neil Tingle/Actionplus/Icon SMI; 84, Elsa/Allsport; 85, Mitchell Layton/Newsport; 86, Thomas Kienzle/AP; 87, Scott K. Brown; 88-89, Tom Hauck/Allsport; 90, Mitchell Layton/Newsport; 92, Simon Bruty; 93, John Todd/Newsport; 96, Simon Bruty; 98, Heinz Kluetmeier; 99, Bob Martin; 100, top, Simon Bruty, bottom, Bob Martin; 101, Bob Martin; 102-103, Heinz Kluetmeier; 105, David Allocca/DMI/TimePix; 106, Ron Angle; 107, Clive Brunskill/Allsport; 111, John Biever; 112, Robert Beck; 113, Bob Martin; 114, Robert Beck; 115, John Biever; 116-117, John Biever; 118, Chuck Solomon; 119, John Biever; 121, Todd Bigelow/Aurora; 125, Ronald C. Modra; 126, Joe Robbins/Icon SMI; 127, Scott Jordan Levy; 129, Ronald C. Modra; 130, V.J. Lovero; 131, John Iacono; 132, Tom DiPace; 133, Al Tielemans; 134, both, John W. McDonough; 135, Jed Jacobsohn/Allsport; 137, Peter Read Miller; 139, Tom DiPace; 141, Bernard Weil/*Toronto Star*; 144, Bob Rosato; 146, Al Tielemans; 147, John Biever; 148, Peter Read Miller; 149, Al Tielemans; 150, Bob Rosato; 151, Robert Beck; 152, top, Winslow Townson, bottom, John Biever; 153, Bob Rosato; 155, Peter Read Miller; 157, Bill Frakes; 158, Bill Frakes; 161, John Biever; 165, John Iacono; 166, John W. McDonough; 167, Al Tielemans; 168, Robert Beck; 169, Damian Strohmeyer; 170, John Iacono; 171, Bob Rosato; 172, Brad Mangin; 173, top, Al Tielemans; bottom, John W. McDonough; 174, Al Tielemans; 175, Brad Mangin; 177, John Biever; 179, Jeffrey A. Salter/Saba; 180, Doug Pensinger/Allsport; 184, Pictures Inc./TimePix; 185, Richard Meek; 186, Heinz Kluetmeier; 187, Rich Clarkson.